Mastering Digital SLR Photography

David D. Busch

THOMSON
™
COURSE TECHNOLOGY

Professional ■ Technical ■ Reference

SVP, Thomson Course Technology PTR: Andy Shafran

Publisher: Stacy L. Hiquet

Senior Marketing Manager: Sarah O'Donnell

Marketing Manager: Heather Hurley

Manager of Editorial Services: Heather Talbot

Senior Acquisitions Editor: Kevin Harreld

Senior Editor: Mark Garvey

Associate Marketing Manager: Kristin Eisenzopf

Marketing Coordinator: Jordan Casey

Project Editor: Jenny Davidson

Technical Reviewer: Michael D. Sullivan

PTR Editorial Services Coordinator: Elizabeth Furbish

Interior Layout Tech: Bill Hartman

Cover Designer: Mike Tanamachi

Indexer: Sharon Shock

Proofreader: Nancy Sixsmith

ISBN-10: 1-59200-605-1
ISBN-13: 978-1-59200-605-2

Library of Congress Catalog Card Number: 2004114410

Printed in the United States of America

06 07 08 BU 10 9 8 7 6

THOMSON

COURSE TECHNOLOGY ™

Professional ■ Technical ■ Reference

Thomson Course Technology PTR, a division of Thomson Course Technology
25 Thomson Place ■ Boston, MA 02210 ■ http://www.courseptr.com

For Jonathan and Teryn

Acknowledgments

Once again thanks to Andy Shafran, who realizes that a book about digital photography deserves nothing less than a full-color treatment, and knows how to publish such a book at a price that everyone can afford. It's refreshing to work for a publisher who has actually written best-selling books on imaging, too. Also, thanks to senior editor Kevin Harreld, for valuable advice as the book progressed, as well as project editor, Jenny Davidson; interior layout, Bill Hartman; indexer, Sharon Shock; proofreader, Nancy Sixsmith; and book/cover designer, Mike Tanamachi.

Also thanks to my agent, Carole McClendon, who has the amazing ability to keep both publishers and authors happy.

About the Author

As a roving photojournalist for more than 20 years, **David D. Busch** illustrated his books, magazine articles, and newspaper reports with award-winning images. He's operated his own commercial studio, suffocated in formal dress while shooting weddings-for-hire, and shot sports for a daily newspaper and Upstate New York college. His photos have been published in magazines as diverse as *Scientific American* and *Petersen's PhotoGraphic*, and his articles have appeared in *Popular Photography & Imaging, The Rangefinder, The Professional Photographer*, and hundreds of other publications. He's currently reviewing digital cameras for CNet.

When **About.com** recently named its top five books on Beginning Digital Photography, occupying the #1 and #2 slots were Busch's *Digital Photography All-In-One Desk Reference for Dummies* and *Mastering Digital Photography*. His 78 other books published since 1983 include bestsellers such as *The Official Hewlett-Packard Scanner Handbook* and *Adobe Photoshop CS: Photographers' Guide*. When his last digital photography book, *Digital Photography: From Camera to Printer, Print to Computer, Videotape to DVD, and More!* debuted in October 2004, it appeared on the Amazon.com bestseller list sandwiched between a photography book by Ringo Starr and a thriller from *The Da Vinci Code's* Dan Brown.

Busch earned top-category honors in the Computer Press Awards the first two years they were given (for *Sorry About the Explosion* and *Secrets of MacWrite, MacPaint and MacDraw*), and later served as Master of Ceremonies for the awards.

Contributor Bio

Technical Editor, **Michael D. Sullivan** added a great deal to this book, in addition to checking all the text for technical accuracy. A veteran photographer (in the military sense of the word!), he contributed some of the images in this book and volunteered his expertise in Mac OS X for important behind-the-scenes testing of software and hardware.

Mike began his photo career in high school where he first learned the craft and amazed his classmates by having Monday morning coverage of Saturday's big game pictured on the school bulletin board. Sullivan pursued his interest in photography into the U.S. Navy, graduating in the top ten of his photo school class. Following Navy photo assignments in Bermuda and Arizona, he earned a B.A. degree from West Virginia Wesleyan College.

He became publicity coordinator for Eastman Kodak Company's largest division, where he directed the press introduction of the company's major consumer products and guided their continuing promotion. Following a 25-year stint with Kodak, Sullivan pursued a second career with a PR agency as a writer-photographer covering technical imaging subjects and producing articles that appeared in leading trade publications. In recent years, Sullivan has used his imaging expertise as a technical editor specializing in digital imaging and photographic subjects for top-selling books.

Contents at a Glance

Contents

3 Mastering Your dSLR's Controls49

9 Composition and dSLRs 179

Preface

This book won't cheat you. Unlike most of the "digital photography" books on the shelves, this one doesn't waste half its chapters telling you how to overcome your digital camera's shortcomings in Photoshop. There are a lot of great Photoshop books that can do that. No, the best part about the new breed of digital SLRs is that they have exciting new capabilities that will let you take great pictures *in the camera*, if you know how to use the tools at your fingertips. This book emphasizes digital *photography* rather than software. It shows you how to take compelling pictures and make great images using imaging technology, while taking into account the special strengths of digital SLR cameras. Whether you're a snap-shooting tyro, or an experienced photographer moving into the digital SLR realm, you'll find the knowledge you need here. Every word in this book was written from the viewpoint of the serious photographer.

Introduction

Wow! What a year we've had! The Canon EOS Digital Rebel (or 300D outside the US) brought digital single lens reflex (dSLR) photography to the masses at a sub-$1,000 price that was less than what many serious photographers had been paying for fixed-lens electronic viewfinder cameras. The Nikon D70 brought near-professional-level capabilities to anyone with $1,299 to spend. Konica Minolta finally unveiled its Maxxum 7D at a price only a few hundred dollars higher. Affordable upscale digital SLRs were offered by Canon, Olympus, Pentax, Fuji, and Sigma.

If your budget was $5,000 or more, true pro cameras like the Nikon D2x, Canon 1Ds Mark II (with 16.6 million pixels!), or the Kodak DCS SLR /c or /n could do everything the priciest film camera could do—and a lot more. For the first time, every serious amateur, photo hobbyist, and part-time professional can easily afford a fully featured interchangeable lens digital camera, and the professionals have a lot more to choose from.

These exciting new cameras were introduced at a time when glorified point-and-shoot digital cameras with fixed lenses and optical viewfinders could cost $1,000 or more. Such a low price point suddenly made digital photography more attractive to the millions of serious photographers like you who would settle for nothing less than an SLR, but who couldn't afford the $2,000 tariff on even the least-expensive models.

What's in This Book?

Photography with digital SLR and "SLR-like" cameras isn't exactly like conventional film SLR photography. Nor is it exactly like digital photography with non-SLR cameras. The dSLR has special advantages, special features, and special problems that need to be addressed and embraced. In addition, those of you who work with these cameras tend to expect more from your photography and crave the kind of information that will let you wring every ounce of creativity out of your equipment.

Some of your questions involve the equipment. What are the best and most cost-effective accessories for digital SLRs? What are the best lenses for portrait photography, or sports, or close-ups? What's the best way to deal with shutter lag—or doesn't it exist with dSLRs? Is it possible to use accessories accumulated for a film version of the same vendor's camera?

Other questions deal with photography and how to apply the advanced capabilities of dSLRs to real-world picture taking. What are the best ways to use exposure features creatively? How can pictures be better composed with a dSLR? Selective focus is easier with digital SLRs than with other models; how can it be applied to improve compositions? Now that digital cameras with almost zero shutter lag are available, what are the best ways to capture a critical moment at an exciting sports event? How can you make your family portraits look professional? What's the best way to create a last-minute product shot in time to get it on your company Web site? You'll find the answers in *Mastering Digital SLR Photography.*

This isn't a general digital camera book. It's a book about digital SLR *photography*: how to take great pictures with the newest cameras and make great images that leverage the strengths of computer technology, while taking into account the special needs of digital cameras. Minutes after cracking the covers of this book, you'll be able to grab action pictures that capture the decisive moment at a sports event; create portraits of adults, teens, and children that anyone can be proud of; and understand how to use the controls of your dSLR to optimize your images even before you transfer them to your computer. This is the book that will show you how to explore the fascinating world of photography with digital technology.

The heavy hardware discussions enrich the introductory material in the first few chapters, giving the basic information needed to choose and use a digital SLR camera and to satisfy curiosity about what goes on inside. Readers don't need to understand internal combustion to drive a car, but, even so, it's a good idea to know that an SUV may roll over during hairpin turns. The nuts-and-bolts portions of this book won't teach readers about internal combustion, but will help them negotiate those photographic hairpins.

I'm especially proud of the hefty illustrated glossary I put together for this book. It's not just a word list, but, instead, a compendium of definitions of the key concepts of photography. You'll find all the most important terms from this book, plus many others you'll encounter while creating images. I've liberally sprinkled the glossary with illustrations that help clarify the definitions. If you're reading this book and find something confusing, check the glossary first before you head to the index. Between the two of them, everything you need to know should be at your fingertips.

Why This Book?

There haven't been many books on digital SLR photography because dSLRs are only now becoming practical for vast numbers of photo enthusiasts. Until now, you've had to rely on books on the shelves that concentrate only on the gee-whiz aspects of the technology and stuff that's only peripherally related to picture taking. Many of the other books have only three or four chapters that actually deal with digital photography, prefaced by chatty chapters explaining the history of digital photography, the pros and cons of digital cameras, and acronym-hobbled discussions of CCD, CMOS, and CIS image sensors. There are thick sections on selecting storage media, and each have perhaps half a dozen chapters on image editing.

I've covered some of those topics in this book, too, except for image editing. I figure that if you want a Photoshop book, you will probably buy a Photoshop book, so there is no discussion of image editing in this book, except in passing. This book concentrates on creative techniques for the digital SLR photographer. Anyone who has a Windows PC or Macintosh and a digital SLR camera (or plans to buy one), will find the advanced techniques in this book very useful. If you're looking for image-editing advice from a photographer's viewpoint, I recommend *Adobe Photoshop CS: Photographers' Guide* and *Adobe Photoshop Elements 3.0: Photographers' Guide*, both from Course Technology.

I've aimed this book squarely at digital camera buffs and business people who want to go beyond point-and-click snapshooting to explore the world of photography to enrich their lives or do their jobs better. For anyone who has learned most of a digital camera's basic features and now wonders what to do with them, this is a dream guide to pixel proficiency. If you fall into one of the following categories, you need this book:

- Individuals who want to get better pictures, or perhaps transform their growing interest in photography into a full-fledged hobby or artistic outlet with a digital SLR.

- Those who want to produce more professional-looking images for their personal or business Web site, and feel that digital SLRs will give them more control and capabilities.

- Small business owners with more-advanced graphics capabilities who want to use digital SLR photography to document or promote their business.

- Corporate workers who may or may not have photographic skills in their job descriptions, but who work regularly with graphics and need to learn how to use digital images taken with a digital SLR for reports, presentations, or other applications.

- Professional Webmasters with strong skills in programming (including Java, JavaScript, HTML, Perl, etc.) but little background in photography, but who realize that digital SLRs can be used for sophisticated photography.

- Graphic artists and others who already may be adept in image editing with Photoshop or another program, and who may already be using a film SLR, but need to learn more about digital photography and the special capabilities of the dSLR.

- Trainers who need a non-threatening, but more advanced textbook for digital photography classes.

Who Am I?

You may have seen my photography articles in *Popular Photography & Imaging* magazine. I've also written about 2,000 articles for *Petersen's PhotoGraphic*, *The Rangefinder*, *Professional Photographer*, and dozens of other photographic publications. First, and foremost, I'm a photojournalist and made my living in the field until I began devoting most of my time writing books.

Most digital photography books (I call them digital *camera* books) are not written by photographers. Certainly, the authors have some experience in taking pictures, if only for family vacations, but they have little knowledge of lighting, composition, techie things like the difference between depth-of-field and depth-of-focus, and other aspects of photography that can make or break a picture. The majority of these books are written by well-meaning folks who know more about Photoshop than they do about photons.

Mastering Digital SLR Photography, on the other hand, was written by someone with an incurable photography bug. I've worked as a sports photographer for an Ohio newspaper and for an upstate New York college. I've operated my own commercial studio and photo lab, cranking out product shots on demand and then printing a few hundred glossy 8 × 10s on a tight deadline for a press kit. I've served as a photo-posing instructor for a modeling agency. People have actually paid me to shoot their weddings and immortalize them with portraits. I even prepared press kits and articles on photography as a PR consultant for a large Rochester, N.Y., company which shall remain nameless. My trials and travails with imaging and computer technology have made their way into print in book form an alarming number of times, including a few dozen on scanners and photography.

So, what does that mean? In practice, it means that, like you, I love photography for its own merits and view technology as just another tool to help me get the images I see in my mind's eye. It also means that, like you, when I peer through the viewfinder, I sometimes forget every-

thing I know and take a real clunker of a picture. Unlike most, however, once I see the result, I can offer detailed technical reasons that explain exactly what I did wrong, although I usually keep this information to myself. (The flip side is that when a potential disaster actually looks good, I can say "I meant to do that!" and come up with some convincing, but bogus, explanation of how I accomplished the "miracle.")

This combination of experience—both good and bad—and expertise lets me help you avoid making the same mistakes I sometimes do, so that your picture taking can get better with a minimum of trial-and-error pain.

I hope this book will teach anyone with an interest in computers and/or photography how to spread their wings and move to the next level. This book will reveal the essentials of both photography and only the important aspects of digital technology without getting bogged down in complicated details. It's for those who would rather learn the difference between a digital and optical zoom and how it affects their picture taking, than find out which type of image sensor is the best. I do cover both topics, though, because I think it's possible to feed your technology curiosity without neglecting meaty photographic aspects.

If you like what you see, you might want to check out my other books available from Course Technology:

Adobe Photoshop CS: Photographers' Guide and *Adobe Photoshop Elements 3.0: Photographers' Guide.* These books serve as an introduction to intermediate and more advanced Photoshop techniques, specifically from the photographer's viewpoint.

Mastering Digital Photography. A companion book to this one, it's written for users of both dSLRs and non-dSLR digital cameras. It covers topics such as portraiture, architectural and landscape photography, and sports in more detail than this book.

Digital Retouching and Compositing: Photographers' Guide. Here you'll find everything you need to know to turn your shoebox reject photos into triumphant prize winners. It covers both eliminating defects and repairing pictures to more sophisticated techniques for combining two or more images into a realistic (or, if you choose, fantastic) composite.

Mastering Digital Scanning with Slides, Film, and Transparencies. Shooting pictures on negative films or slides doesn't lock you out of the digital-imaging realm. Low-cost film scanners, as well as flatbed scanners with film scanning capabilities, and third-party scanning services make it easy for *anyone* to manipulate images captured by silver instead of silicon. This book is your introduction to a whole new world of digital imaging possibilities.

Chapter Outline

Chapter 1: Digital SLR Photography Now and in the Future
This chapter focuses on the rapid convergence of conventional photography and digital photography, in terms of features, capabilities, techniques, and price considerations, and examines the changes that will be made now that digital SLRs have become affordable. It outlines the skills SLR-slinging photographers already have that are directly transferable to digital SLR photography and shows how those skills actually become enhanced given the special features of digital cameras.

Chapter 2: Digital SLR Technology Made Easy

This chapter provides an inside look at how digital cameras work now, and some information on how they will work in the very near future when breakthroughs like the Foveon sensor, "Four-Thirds" designs, 8-megapixel-plus cameras, and other innovations become more widely used.

Chapter 3: Mastering Your dSLR's Controls

Although every camera uses different buttons and menus to control key features, nearly every digital SLR image-grabber includes some variation on the basic array of controls. This chapter provides an overview of the controls a digital photographer must master, and includes descriptions of how these controls differ between digital cameras and film cameras.

Chapter 4: dSLR Quirks and Strengths

This chapter shows how to take advantage of the strengths of the digital SLR and deal with the quirks. You'll learn how to use scene modes and protect your sensor from dust bunnies.

Chapter 5: Working RAW

The average amateur photographer with a digital camera just points and clicks, without a thought about which file format, from among those offered by a particular camera, is the best. More serious photographers will want to know why optional formats are offered, and how to choose the right one for a particular shooting session.

Chapter 6: Working with Lenses

Digital SLRs present pixel photographers with a new option: choice of lens. This chapter deals with selecting the most versatile complement of lenses for various categories of photography and how to use those lenses to pull in distant objects, apply selective focus, shoot close-ups, and create special effects with zooms and other tricks.

Chapter 7: Close-Up Photography

Learn how to use your Digital SLR's macro capabilities to capture views of exotic or mundane objects, up-close and personal.

Chapter 8: Capturing Action

Whether it's your kids' Little League or soccer teams, or the company picnic or bowling tournament, you'll need these tips on grabbing fast-moving subjects. You'll learn how to stop action, choose your spots, and use flash.

Chapter 9: Composition and dSLRs

Digital SLRs offer the most control over composition because they show exactly what will be imaged in the digital file. Or do they? This chapter explains why what you see may *not* be what you get, along with basic information on composition and how to apply compositional rules to portraiture, publicity, architecture, and landscape photography.

Chapter 10: Mastering dSLR Special Features

Digital SLRs have loads of special features, most of which will be new to photographers migrating from film photography or point-and-shoot digital cameras. This chapter explains features like image stabilization, infrared photography, time-lapse photography, and how to use them.

Appendix: Illustrated Glossary

1

Digital SLR Photography Now and in the Future

It was the snapshot heard 'round the world.

In the latter half of 2003, Canon introduced the Digital Rebel, also known as the EOS 300D (everywhere but in the US and Japan), and Digital Kiss (Japan). It was a 6.3 megapixel inter-changeable lens single lens reflex with most of the features that digital photographers lacking a fat wallet had been forced to live without for many years. It cost less than $1,000 *with* an 18-55mm zoom lens.

The unveiling of the Digital Rebel was the first skirmish in what was to become the digital SLR revolution. Nikon upped the ante early in 2004 with the Nikon D70, priced at $999 with-out lens or $1,299 with an 18-70mm zoom. That was several hundred dollars less than Nikon's previous "entry-level" dSLR, the D100, which came without a lens and lacked some of the cool features found in the D70.

Other vendors scrambled to jump on the bandwagon, and by late 2004, serious dSLRs like the Olympus EVOLT, Pentax *ist DS, and Konica Minolta Maxxum 7D were available in the $600-$1,500 price range. The big news wasn't that digital SLR cameras were now available; it was that the average photographer could afford to *buy* one.

As the cliché goes, the rest is history. It might be worthwhile to put things in perspective and see why the digital SLR revolution was such an important change.

Digital SLRs for the Masses

Let's be honest. For the serious photographer, a single-lens reflex camera is the Holy Grail. Anyone who's used a point-and-shoot camera of any sort and then graduated to an advanced non-SLR camera with extra features and more control is probably still dissatisfied and is yearn-ing for a digital SLR.. Whether you're shooting film or digital, if you're serious about taking pictures, an SLR is what you really want.

That's not to say that other kinds of cameras don't have their place among enthusiasts and professionals. Leicas and other rangefinder-style film cameras have long been prized for their small size, precision, quiet shutters, and superb optics. Some of the best images ever made have been taken, and will continue to be taken, with Leicas and the like. Twin-lens reflexes like the Rollei have served ably as professional cameras using film sizes larger than 35mm. And view cameras, which accept sheet film holders in sizes up to 8 × 10 (and larger), continue to be important for high-quality illustration and portraiture, although these days view cameras are as likely to be fitted with a digital sensor back as a film back.

SLRs are not the *only* cameras a dedicated photographer would find acceptable, but, if you compile percentages, the single-lens reflex is way ahead of whatever is in second place. Indeed, in the digital photography realm, the success of so-called "SLR-like" cameras such as the shooters with internal electronic viewfinders (EVF) from Konica Minolta, Olympus, Hewlett-Packard, Kodak, and others stems from just how closely they can mimic features that are common to virtually every SLR. In most respects, they are deliberately designed as a "next best thing." Despite their status as a "junior SLR," these imitators are not necessarily cheap. You can pay almost $2,000 for a Leica Digilux and more than $1,000 for many of the leading EVF-style cameras.

This book is for EVF-owners, too!

Much of the information in this book applies equally well to owners of cameras with electronic viewfinders. If you own such a camera, don't be put off by comments that imply that EVF models are nothing more than crippled "wannabes." The difference between a dSLR and an EVF camera is significant, and I don't want to minimize it. However, you'll discover that most of the topics in this book apply to your camera, as well.

You'll find the discussions of anti-shake technology valuable, especially if you own a Nikon, Konica Minolta, or other EVF camera with this feature. The sections on noise reduction, storage, sensors, using various exposure and focus controls, histograms, burst modes, file formats, and lens techniques also apply to you. You'll benefit from the tips on using night and infrared photography techniques, time-lapse photography, and managing electronic flash. This book will serve you well now, and will be even more useful if you upgrade to a dSLR in the future.

With that in mind, try to recall the excitement that resulted when digital SLRs became available in the $1,000 price range. At the time, many SLR-like cameras were selling at that particular price level. They had many of the features of a digital SLR, but they weren't a dSLR. Some models had 7:1 to 12:1 zoom lenses, but these optics weren't interchangeable. A few had zooms with relatively fast f2.8 maximum apertures, but that's a far cry from the f1.8 to f1.4 lenses available for every digital SLR. Their viewfinders provided a view through the lens, but these internal EVFs were relatively dim and more difficult to focus than a digital SLR's optical view.

Non-SLR cameras at the $1,000 price point were usable but had less flexibility and were far from ideal. To step up to a true digital SLR, you had to spend at least $1,500 for the body alone, and more likely $2,000 to $3,000. Professional-grade dSLRs were going for $5,000 to $11,000 and up. And the admission ticket price was only the beginning, unless you already owned a compatible film camera body and a set of lenses that could be used with your pricey

digital SLR. With very good film SLRs going for $400 or less, a minimum investment of a couple thousand dollars for a dSLR that might not have the same versatility was discouraging.

The introduction of affordable digital SLRs with enough resolution to match film for most applications was, if not a death knell, a serious crimp in the future of film cameras among photo enthusiasts. Finally, we could take the kinds of pictures that we wanted with none of the limitations of earlier digital cameras, *and see our results immediately.* Because the digital pictures didn't need film processing, they were available for use immediately too. Any professional who has shot Polaroid instant photos to gauge lighting effects and poses, or worked in a hotel room closet processing film will tell you just how important the digital advantage is.

I made my living as a photojournalist for more years than I care to count, and as I began writing books on image editing with programs like Photoshop more than a decade ago, I always relied on scanned film images for most of my illustrations. Yet, a few months after switching full time to a digital SLR, I found myself looking sadly at a cupboard that held 15 Nikon film SLRs, a couple dozen lenses, a complete 6 × 7 SLR kit with four lenses, several miscellaneous SLR cameras, and even a venerable Leica. I realized, for the kind of work I do, I probably would not use any of them ever again. Anything I need to do, I can do with my dSLR.

And so can you. This book will show you how.

A Little History

As I noted in the companion volume to this one, *Mastering Digital Photography,* digital photography has emerged on the scene in a somewhat bass-ackward manner. We've been able to manipulate and correct digital images using sophisticated programs like Photoshop since the early 1990s. What we didn't have was a cost-effective way to *originate* digital images. Back in the 20th century, the best way to produce a digital image was to shoot it on film and then digitize it with a scanner. Many of us have spent years shooting film, scanning, and fiddling around in Photoshop to produce the kind of pictures we probably could create in a digital camera. Yet, we had to wait. If you want to read a fairly complete discussion of how photography moved into the digital realm, check out the companion book. I'll try to be much briefer here.

Indeed, in this condensed version I'm going to skip right over the first digital/electronic imaging devices (introduced in the 1950s), past NASA's conversion from analog imaging to digital imaging to avoid signal loss during their space missions, and provide nothing more than a brief mention of the first film-free electronic camera patented by Texas Instruments in 1972.

No, the real first digital camera was created by a guy named Steve J. Sasson, who slaved away in Kodak's Research Labs in the mid-1970s (and is still there by last report). Sasson built the first known digital camera, roughly the size of two shoeboxes and weighing 8.5 pounds. It contained 16 AA batteries, a bunch of circuit boards, a new Fairchild black-and-white 10 kilopixel sensor (a 100 × 100-pixel array), and had a lens sticking out the front. It took 23 seconds to record a single image onto a cassette tape. I checked out the patent application for this remarkable device. You can too, at **http://www.uspto.gov/**. Search for Patent #4,131,919.

Sony developed its Mavica (Magnetic Video Camera) line in the 1980s, but these cameras were actually analog video cameras that could capture stills, rather than true digital cameras. Even so, the first Mavica came with interchangeable 25mm wide angle, 50mm normal, and a 16–65mm zoom and could store fifty 570 × 490-pixel images on special two-inch floppy disks.

Kodak driven out of film technology?

One of the big myths of digital photography is that film/camera behemoth Eastman Kodak Company is slowly being pushed out of the film business by digital technology. In truth, if you look at history, Kodak has been a driving force behind the scenes of digital imaging for decades, dating way before Steve Sasson's first digital camera. Kodak scientists *invented* the modern scanner back in the mid-20th century, coined the term *megapixel sensor* for the first CCD capable of capturing more than a million pixels of information, and created the first Photo CD for digital pictures at a time when very few computer owners had a CD-ROM drive with which to view them. By the early 1990s, professional photographers had 55 pound, $30,000, 1.3 megapixel cameras (from Kodak, based on a Nikon F3 body), and amateurs could pick up an Apple QuickTake 100, which offered 640 × 480 pixel resolution, and was actually designed by Kodak and built by Chinon Industries (which is now a Kodak subsidiary). Kodak later offered the DC40 and DC50, built from refined versions of the original design. Although Kodak milked its film and film camera cash cows for well over 100 years, the company has seen the coming digital imaging changes. It has led the charge with products that, while often not the best in their class, have always been appealing to amateurs and photo enthusiasts.

LCD monitors arrived by 1995, and, as the 21st century opened, digital camera resolutions began blossoming, from 1 megapixel to 3MP or more, so that today you can find cameras with as many as 5 megapixels of resolution for a few hundred dollars, like the pocketable camera shown in Figure 1.1. Inexpensive memory cards (I paid around $100 for the last 1GB Compact Flash card I bought) and photo-quality inkjet printers were the last pieces of the puzzle—except for photo enthusiasts, who would settle for nothing less than a digital single lens reflex or SLR-like camera.

Figure 1.1 Today, you can buy a 5 megapixel camera that will fit in a pocket for a few hundred dollars.

And that's where we stand today. If you want visuals to demonstrate just how far we've come, check out Figure 1.2, which shows one of the smallest 5MP digital SLR-like cameras next to an ancient 6 × 7 film SLR. Unless you're making prints larger than 8 × 10, the average amateur probably couldn't differentiate between the photos that each camera produces.

Figure 1.2 SLR-like features in a tiny 5 megapixel camera and a monster 6 × 7 rollfilm SLR.

A Little Future

I'll be covering emerging and future technologies in later chapters, but the view from 50,000 feet looks bright. The "average" resolution of a mid-priced (say, $400) digital camera has been increasing dramatically. As I write this, just about anyone who is serious about photography can afford a 6 megapixel camera, even a single lens reflex model like the Canon, and megapixel monsters from Kodak and others with (what seems to me) an astounding 14 megapixel resolution cost less than a week at Disney World. Expect even more dramatic improvements when the innovative Foveon sensor and other emerging technologies (discussed in Chapter 2) become common.

The changes we can expect in digital photography in general, and digital SLRs in particular include innovations in the near future—the next year or so—as well as those we can expect farther down the road.

The Near Future

Because digital photography sales are exploding, we can expect to see lots of changes as vendors frantically scramble to climb aboard the bandwagon. Many of these changes won't necessarily be good ones. Consider the spate of 8 megapixel cameras in early 2004 from Nikon, Minolta, Olympus, and others, few of which actually produced image quality better than the 5 and 6 megapixel models they replaced. But, hey, they had 8 megapixel sensors! Other changes will be more beneficial.

First, the 6–8 megapixel digital SLRs that make up the low end and middle ground today will soon be supplanted by 11–14 megapixel models that are today considered cameras for professionals only. We're really not that far away from $1,500 dSLRs with 10 megapixel sensors. I have a sneaking suspicion that once that level is reached the emphasis will turn to other ways of improving image quality beyond resolution alone (such as reduced noise levels and/or higher sensitivities), and additional features. Today, very few photographers make enlargements such that the difference between images captured with an 11–14 megapixel camera and one with higher resolution than that would even be discernable. Of course, the original IBM PC was designed to work with 640K of RAM out of 1MB total because no one could imagine that anyone would ever need more than 1 megabyte of memory!

Another avenue open for improvement in the short term is storage, which will get cheaper, smaller, and more capacious. I expect 1GB Compact Flash cards and 4GB teensy hard disks to appear to be laughably small during the life of this book. (This comes from someone who paid $300 to upgrade to 32,768 *bytes* of memory in 1978, and paid $1,000 for a 200-*megabyte* hard drive roughly a decade later.) Indeed, I don't even consider buying a memory card smaller than 1GB when I purchase more digital "film" for my dSLR. I can fit only 90 RAW images on a 1GB card as it is and already find myself swapping cards more often than I'd like. Who needs a 512MB or smaller card that can hold only 40 RAW images or fewer?

Look for Compact Flash and SD cards to top 4GB soon, while retaining a reasonable price, and capacities far beyond that in the future. Faster storage, needed to keep up with dSLRs that can snap off pictures at 3 to 8 frame-per-second rates (and more) will also become standard. Also look for small, portable devices with many gigabytes of capacity that you can carry in your gadget bag and offload images from your camera or flash memory card.

Farther Down the Road

Farther in the future will be the resolution of the question of optimal sensor size. One advantage that 35mm cameras had was a standardized film size (except for half-frame cameras and a couple of other odd-ball formats). The photographer had a solid basis of comparison for film, lenses, and related accessories. A particular lens or film worked exactly the same with every camera it could be used with.

That's not the case in the digital realm. There are many different sensor types and sizes, and even though many of them are used by a number of different vendors, there is nothing even approaching any kind of standardization. The so-called "Four-Thirds" sensor was initially supported only by Olympus, Fuji, and Kodak, so you can see that the industry isn't exactly rushing to embrace this set of specifications, which includes sensor size, lens mounting system, and the useable image circle (that is, lenses designed for Four Thirds will completely fill any sensor, without vignetting, if the sensor's diagonal is 22.3mm). I'll explain more about Four Thirds in Chapter 2.

The only other "standard" we have available is that of the 35mm film frame. Will cameras built around so-called full-frame sensors become the norm? It's hard to say. The full-frame sensors are desirable for those who want to use lenses they've already purchased for their 35mm film cameras without resorting to the "multiplier factor." Full-frame sensors have another advantage: At any given resolution, they have larger pixels, so the sensor can theoretically be more sensitive and produce less noise.

The Case for and Against Full Frame Sensors

The introduction by Nikon of the Nikon D2X, a high-end, 12.4 megapixel professional dSLR that does *not* use a full-frame sensor is one reason to believe that the 24mm × 36mm imager

is not destined to be the standard of the future. (I'll present the flip side of this argument shortly.) On the one hand, when you get right down to it, the only reason why that size is in contention for consideration is that the 35mm film frame has been around for more than three-quarters of a century, and photographers have gotten used to it. Many similar film sizes, most recently APS, have come and gone and 35mm lives on. In simplified form, the case for (or against) the full-frame sensor looks like this:

Full-Frame Sensor Pros:

- **Cameras using sensors smaller than 24mm × 36mm have that pesky lens multiplier factor to fuss with.** They said the same thing about the metric system and the need to mentally convert meters to feet every time we measured something. Once a new generation of photographers grows up using nothing but digital cameras, they'll forget about "35mm equivalents" and adjust to the new benchmarks. Don't think of wide-angle lenses in terms of 18mm, 28mm, or 35mm "equivalents." Assuming the 1.5-multiplier sensor becomes a standard, those same wide-angle lenses are 12mm, 18mm, and 24mm in focal length. A short portrait telephoto lens isn't 85mm, it's 55mm. A good focal length for a sports optic isn't 135mm, it's 90mm. Any photographer who owned a half-frame SLR like the Olympus Pen F some 40 years ago had no problems with this, and we're certainly smarter than *they* were.

- **Smaller sensor sizes lead to extra, (often) unwanted depth-of-field.** Just when dSLRs finally return to photographers some modicum of control over depth-of-field (compared with point-and-shoots that make *everything* sharply focused), some wag notices that the focus depth provided by less-than-full-frame optics is more than you get with the 35mm equivalent. That is, your 85mm "equivalent" portrait lens or zoom setting doesn't offer the depth-of-field you expect. Instead, you get what you'd anticipate from a 55mm "normal" lens. So what? This is another of those "what you're used to" issues. In a generation we'll stop making comparisons, and the depth-of-field offered by particular focal lengths on a digital camera will be what we come to expect.

Full-frame Sensor Cons:

- **Cameras with smaller than full-frame sensors are more compact.** Cameras and lenses designed around sensors that are smaller than full frame can be lighter, smaller, and easier to carry around.

- **The 24mm × 36mm full-frame sensor size is not the natural size for an imager, or even the best size.** The 35mm film frame doesn't even have an aspect ratio that corresponds to the paper we use to make prints. When you make an 8 × 10 inch print, you have to cut off some of the image area from either or both ends, or make the borders on the long side of the image wider. What's so ideal about that? Most digital camera sensor sizes, including Four Thirds, make more sense.

- **Full-frame sensors aren't better simply because they are bigger.** Certainly larger sensors have more room for pixels and produce less noise, but dSLRs already use sensors that are larger than those found in point-and-shoot cameras. Is even bigger even better? Not necessarily so, as I explain below. There is a point of diminishing returns, where larger sensors can actually introduce *new* problems in camera design.

One of the reasons why sensors won't continue to grow much larger is that larger sensors can be more difficult to produce and more expensive. In addition, dSLR vendors, such as Nikon, are designing lighter, more compact, less-expensive lenses specifically for the smaller sensor size, and intend to sell those lenses to customers for their entire product line, from entry level digital SLR to the pro models. Indeed, will camera makers who have invested a lot of money designing lenses specifically for smaller sensor sizes make their own optics obsolete (they can't

be used with full-frame cameras without severe vignetting in the corners)? That's what would happen if a manufacturer replaced current cameras with newer models that use full-frame sensors, and is the reason why such a move is highly unlikely. However, there's a solution to this problem that I'll explain in the next section.

Figure 1.3 shows what would happen if you tried to use a lens designed especially for digital use on a full-frame camera. In the example, the lens is zoomed to the 33mm setting, which provides the equivalent of a 50mm lens view thanks to the digital SLR's 1.5 lens multiplier factor. The green box represents what the digital sensor would see with a dSLR. Mount the same lens on a full-frame digital camera, and the true 33mm focal length produces a wide-angle view, represented by the outer red box. Unfortunately, the lens designed for the smaller sensor produces dark corners, or vignetting, so that the lens can't also be used on a full-frame 35mm film or digital camera.

Figure 1.3 A lens designed for a compact digital SLR covers the smaller sensor's frame (green box) but can't cover the full frame of a film camera or digital camera with a full-frame sensor (red box).

A Full-Frame Compromise

Although I can foresee a future in which cameras with full-frame sensors are relegated to a niche of their own, there are some persuasive arguments in the other direction, particularly as they apply to cameras intended for use by professional photographers. Pros have different needs, and some of the disadvantages of full-frame sensor cameras become advantages in the professional realm. Working photographers don't care about the size and weight of their cameras; if anything, they prefer a heavier, more rugged machine that will stand up to abuse. Nor do they much care about aspect ratios and the "natural" format for a digital picture. Except for artsy-type photographers who insist on using the full frame and (in the film days) print pictures with

the film sprockets included to prove they had visualized the image in its purest form, pros consider cropping part of the job of "making" a picture.

Another consideration driving the full-frame sensor movement is the "war" between Canon and Nikon, again among professional photographers, particularly photojournalists. Canon has overtaken and passed Nikon among the working pros for a variety of reasons, many of them involving lens availability and operational speed, but also the availability of digital cameras with full-frame sensors that use existing lenses with no crop factor.

Canon's actually straddled both sides of the fence. Its EOS-20D, for example, is an 8 megapixel camera with a smaller sensor that produces a 1.6 lens multiplier factor. Yet, the deluxe pro model, the 16.7MP EOS-1DS Mark II, has a full-frame sensor. Canon is clearly not going to abandon full-sized sensors as long as it wants to remain on top among professional photojournalists.

A clue to where we might be going can be found in the Nikon D2X, introduced late in 2004. This is a 12.2 megapixel camera using a 23.7×15.7 sensor that's compatible with Nikon's DX lenses and their 1.5x multiplier factor. *However,* the D2X also has a 6.8 megapixel mode produced simply by cropping the image and using only part of the sensor area (generating a 2X crop factor) ostensibly to provide an 8-frames-per-second burst mode. That suggests a simple solution to Nikon's dilemma: It can have the best of both worlds.

Nikon could easily introduce a high-end pro camera with a full-frame sensor. That would please those who already own lenses for Nikon's film cameras. Yet, this same camera could have an optional "cropped" mode, just like the D2X, that uses a smaller area of the sensor—the 23.7 \times 15.7 portion found on its earlier digital cameras. It would be simple for Nikon to automatically switch into this cropped mode when the camera senses that a digital/DX lens has been mounted. At the same time, a framing box would appear on the focus screen delineating the cropped frame (that's how the D2X's cropping works). That's actually a plus because being able to see "outside" the actual frame being photographed gives you a "sports finder" -like view of what subject matter is headed into or out of the picture.

Such an arrangement would allow photographers to use both "film" and "digital" lenses on the same camera. I'd guess that the camera would have a 16.7 megapixel full-frame sensor (like the Canon 1DS, cropped to 11 megapixel when a "digital" lens was mounted). As I write this, no such product is on the market or even being discussed (to my knowledge), so if it comes to pass during the life of this book, you heard it here first if you bought the book promptly enough.

More Innovations

When the dust has cleared from the sensor size debate, expect that farther down the road we will see even better zoom lenses, smaller cameras designed around the new sensor size standard, more efficient viewing systems, speedier transfer speeds, and dozens of features (such as motor-drive-like "sequence" photography) that we didn't even know we needed.

Within a few years, all digital cameras are likely to have wireless capabilities (and most of our home and business networks will be wireless, too), so you'll be able to transfer images from your camera to your computer just by pressing a button. Also look for wireless control of your digital camera, either from a hand-held remote control device or directly from your computer over a wireless network. You'll be able to set up your dSLR on a tripod facing your front hallway and photograph everyone who comes in and out, or point it at a sunset or blossoming plant and take time-lapse photos cued by your computer.

The most interesting thing about looking to the future is knowing that much of what is headed our way are things that we didn't imagine could exist, used in ways we couldn't have predicted.

Why dSLR?

Perhaps you're not convinced that a dSLR is for you. Don't feel guilty. Many serious shooters are in the same position. You've been getting good results with your non-dSLR camera and wonder if you'll see any improvement with a single lens reflex camera. Perhaps the 28-200mm (35mm equivalent) zoom lens on an SLR-like camera with electronic viewfinder has the range you need for 95 percent of your photographs. Why purchase a dSLR if you won't need interchangeable lenses, or can't afford them?

The truth is that there is a *lot* more to a digital SLR than the Single Lens Reflex part of the equation. I'll get into more detail in Chapter 2, but here's a quick summary of the pros and cons of dSLRs, and why you might get much better results from a dSLR with 6 megapixels when compared with a non-dSLR model with the same nominal resolution. Note that the first bunch of the advantages I'm touting are only incidentally related to the fact that the camera is a single lens reflex.

Four dSLR Advantages Unrelated to Single-Lens Reflexiveness

Some of the strengths that accrue to dSLRs have nothing to do with the fact that they are single lens reflex cameras.

- **Higher sensitivity and reduced noise.** The images from most non-dSLRs begin to break down when sensitivity is increased to ISO 400 or more, primarily because of excessive noise. Few of these cameras have an ISO setting that's usable. In contrast, many dSLRs generate relatively low noise at ISO 800, and produce acceptable images at ISO 1600, ISO 3200, and beyond. The improved quality offered by digital SLRs is due to the larger sensors available in these cameras. As vendors pack more and more pixels into the tiny CCD sensors found in non-SLR cameras, the pixels become smaller and more prone to noise. The larger pixels in the CMOS and CCD sensors of dSLRs have much less of a tendency to produce the random grain we see as noise, and are more sensitive, to boot, producing higher effective ISO speeds.

- **Control over depth-of-field.** The larger sensors require lenses with longer focal lengths, so the dSLR use regains the control over depth-of-field that is such an important creative tool. Ignore those "35mm equivalent" specs you see posted for non-dSLR cameras. That "38mm" zoom setting on your point-and-shoot digital may provide the same field-of-view as the moderate wide angle you've used on your film SLR, but the depth-of-field is more akin to what is native to the 6mm actual focal length of that lens. You'd think the "380mm" setting would give you roughly the same narrow depth-of-field you'd expect from a 400mm lens on your film camera, but what you end up with is the same field of sharpness offered by a 60mm lens. Anyone who's used a consumer digital camera knows that at non-macro shooting distances, virtually everything in the picture is sharp, at any zoom setting and at any f-stop. If you plan to use depth-of-field creatively, as in the photo shown in Figure 1.4, in which the background was thrown out of focus to emphasize the flower, you'll need a dSLR with a larger sensor.

- **Digital SLRs work like a camera, not a VCR.** I own a Nikon CoolPix 995, which was one of the best $1,000 digital cameras of its time, and still a champ among 3.3MP models for sharp images and macro performance. Still, this camera drove me nuts. Even after I'd owned it for a year I had to take along a cheat sheet that told me how to

activate infrequently used features, such as manual focus. I used the 995 a lot, but I still had to refer to my crib notes to see which menu I needed to refer to to activate a particular feature, and then which buttons to press to make it work. It was a great camera, but it didn't *work* like one.

The same situation exists today with the vast majority of non-dSLR cameras. I have the opportunity to test eight or ten point-and-shoot cameras in all price ranges each month, and virtually all of them operate more like VCRs rather than like cameras. When you zoom in and out, do you want to press a couple of buttons and wait while a teeny motor adjusts the lens elements for you, or would you rather twirl a zoom ring on the lens itself and be done with it? To switch to manual focus, wouldn't you prefer to flip an

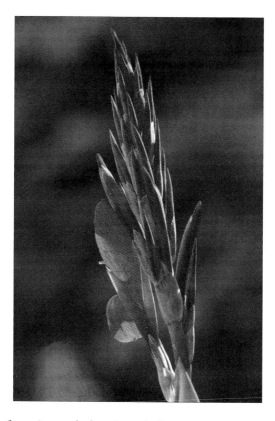

AF/MF button and then twist the focus ring on the lens, instead of pressing a Menu key, finding the Focus setting, switching to Manual focus, and then pressing a pair of left-right cursor buttons?

Photo enthusiasts won't put up with that nonsense when they're trying to take pictures. The dSLR I use has separate buttons for burst mode, ISO settings, white balance, EV adjustments, metering mode, and resolution. To adjust any of those, I hold down the appropriate button and thumb the command dial to choose the setting I want. Set the camera to shutter- or aperture-priority (with a dial, not a menu) and move the command dial to adjust the f-stop or shutter speed. In manual exposure mode, there are separate command dials for shutter speed and aperture.

That might seem like a lot of buttons to master, but, trust me, you'll learn to use them much more quickly than you'll memorize the menu system of the typical point-and-shoot.

■ **Faster operation.** You'll find that dSLRs work much faster than point-and-shoot digital cameras. One of the metrics used to measure point-and-shoot performance is "time to first shot." That is, once you decide to take a picture and switch the camera on, how long must you wait until the camera is actually ready to shoot? Generally, you'll have to wait 3 to 5 seconds or more; then wait another second while the camera autofocuses and calculates exposure after you've pressed the shutter release. Switch a dSLR on, and it's ready to go. On more than one occasion I've spotted an unexpected opportunity, switched my digital SLR on as I brought the camera to my eye, and then took a picture, all within less than *one* second.

Four Major Advantages Unique to dSLRs

Some of the advantages of dSLRs are more closely related to the digital single lens reflex design.

- **Better lenses.** You might argue that a non-dSLR eliminates the need for interchangeable lenses. If your 12X zoom EVF camera offers all the focal length equivalents between 28mm and 336mm, who in their right mind (other than architectural photographers at the wide end, and pro sports photographers at the tele end) would need more? However, I maintain that even if you super glue your lens to a dSLR (transforming it into a non-interchangeable lens camera), the dSLR's zoom lens will provide better, sharper pictures than what you can expect from a non-dSLR's optics.

 There's plenty of room for argument here, but, in general, it's easier to design a high-quality lens for an SLR's larger sensor than it is for a tiny point-and-shoot's CCD. Do you have any idea what compromises have to be made to create a 6mm–60mm zoom lens that will fit one of those dinky cameras?

- **Easier upgrading.** You can enhance the capabilities of a dSLR quite easily, just by purchasing the add-on you need. Conversely, you don't have to load down your camera with features you don't need. As I write this, only a few non-dSLRs offer image stabilization (which minimizes blur caused by camera movement at low shutter speeds). If you want that feature in a non-dSLR, you have to specifically purchase a camera that offers it. Yet, most Nikon or Canon dSLRs of recent vintage can be outfitted with vibration reduction lenses, which you can purchase when and if you need one. (At the time I'm writing this, the Konica Minolta 7D is the only dSLR with anti-shake technology built into the camera body itself.) A more powerful external flash is an easy addition, too, compared with point-and-shoot digital cameras, many of which allow no external flash at all (other than slaved units).

- **Better use of power.** You'll find that your dSLR camera's battery will last much longer than you expect. It's not unusual to take 1,000 to 1,500 shots on a single charge. That's partly because a dSLR may have larger batteries, but, in any case, they make much better use of the power that's available. One thing you'll notice right away is that there's generally no need to turn off a dSLR to save juice. Most digital SLRs switch off their autofocus and autoexposure systems automatically if you haven't used them for a few seconds, and the power-hungry LCD is on only during picture review or menu navigation. You can leave a dSLR switched on for days on end without depleting your batteries. Try *that* with a point-and-shoot! Most non-dSLR cameras turn themselves off automatically at the worst possible time (often "forgetting" any special settings you've made in the meantime), or, if "sleep" mode has been disabled, deplete their batteries within a few hours, whether you've taken any pictures or not.

- **True "what you see is what you get" composition**. A non-dSLR with an optical viewfinder is guaranteed to chop off heads, or worse, as you compose your pictures. The LCD on the back of the camera provides a reasonable facsimile of what the sensor sees, except you can't see it in bright light, and the details on an LCD that can be as small as 1.5 inches are too small anyway. EVF cameras are a little better, especially in bright light, but most of them provide grainy images that can be hard to view or noisy in dim illumination, and that are not optimal for accurate focusing under the best of conditions. Most LCD viewfinders introduce a delay factor: What you're looking at actually happened a large fraction of a second ago. A digital SLR's viewfinder shows you exactly what you will get (although some provide less than 100 percent of the full field-of-view), and you can even preview your depth-of-field. Figure 1.5 shows you your main choices.

Figure 1.5 How would you prefer to compose your photos? On a tiny LCD (upper left), with a grainy electronic viewfinder (upper right), or a big, bright, SLR viewfinder (bottom)?

Five dSLR Downsides

All is not perfect in digital SLR land. There are a few select things that are difficult to do with a dSLR, and some problems that only digital single lens reflex owners have to contend with. This section lists the leading cons.

■ **Lack of superwide lenses.** Unless you own a full-frame dSLR, your digital's focal length multiplication factor must be figured in to calculate the true coverage of the lens. It's nice to have a 200mm lens magically transformed into a 300mm telephoto, but it's not so great when you discover that your 20mm wide angle is now an ordinary 30mm lens that barely qualifies for the wide-angle designation. To get true wide-angle coverage, you'll need a prime (non-zoom) or zoom lens that starts at 17–18mm. Superwide lenses are more expensive and harder to find.

When I added a digital camera body to my film camera kit, my widest existing compatible lens was a favored 16mm semi-fish-eye lens that was the equivalent of a 24mm optic on my new digital SLR. Many digital camera owners have success using similar fish-eye lenses, and then "defishing" the finished pictures to correct for the distortion and produce a conventional wide-angle view. I ended up going a different route and buying a 12mm–24mm zoom (for $1,000—about the same as my dSLR body) to get an 18mm to 36mm (equivalent) viewpoint. If you do like fish-eye views, you can also purchase prime lenses in the 10mm range, but they are even more expensive. Anyone who likes the wide-angle viewpoint can expect to buy extra lenses. Of course, few non-dSLRs, other than one new model from Nikon with a 24–85mm zoom, have zooms that go wider than 28mm, either.

- **No LCD preview or composing.** The LCD on a dSLR can be used only for reviewing photos or working with menus. Not a problem with through-the-lens viewing, you think? Try taking a few pictures using an infra-red filter that blocks visible light. Your SLR view is totally black, yet some non-dSLR camera's LCDs show a dim, serviceable image under such conditions. Moreover, some point-and-shoots have swiveling LCDs or swiveling bodies, so you can hold the camera over your head or down below your waist and still view the image. Want to take a self-portrait? Some non-dSLRs with swiveling lenses automatically invert the image on the LCD so you can point the camera at yourself and still preview the image you're about to take.

- **Dirt and dust.** Make no mistake, if you change lenses *at all* your digital SLR will eventually accumulate dust specks on the sensor that you'll have to remove. I had my dSLR all of two weeks and had changed the lenses maybe four times when I noticed a recurring speck on all my photos. This dust is generally not difficult to remove and may not even show up except in photos taken with a small f-stop, but the mere threat is enough to drive you crazy. I find myself cleaning the sensor every time I go out for an important shoot, fearful of coming home with 500 photos all marred by a dust speck. Oddly, this drawback of the digital SLR is rarely discussed by vendors, yet it's the most common problem a dSLR owner is likely to encounter. Look for more vendors to include widgets like Olympus's Supersonic Wave Filter to shake the dust off before it causes a problem.

- **Size, weight, and general clunkiness.** Your dSLR is going to be much larger and weigh more than whatever point-and-shoot digital camera you may be used to. If you're switching over from a film SLR, you may not notice the difference. Still, a dSLR will generally be clunkier and noisier than a point-and-shoot digital, even with the fake noise turned off.

- **You can't shoot movies with a dSLR.** I actually took some nice sound movies of my son's acting debut in *West Side Story* using a 5MP point-and-shoot digital that could make 640 × 480 videos at 30 frames per second. Because of the way dSLRs operate, movies are beyond their capabilities.

Using What You Already Know

Because most digital SLR photographers were already seasoned veterans before they began using a dSLR, they already have a considerable advantage over neophyte photographers who must master digital technology at the same time they are learning photographic basics.

For example, you already know not to shoot into the sun unless you want to produce a silhouette, and wouldn't think of using your camera's built-in flash from the last row in the balcony to capture a photo of Bono pacing the stage at a U2 concert. You know to hold the camera steady in dim light and how to make a background less prominent by throwing it out of focus. You understand terms like *lens flare*, *motion blur*, and *grain*, and may have more than an inkling about things like *solarization*, *halftones*, *mezzotints*, or *unsharp masking*.

There are other photographic concepts that you already understand that you can put to use with your digital SLR. In my companion book, *Mastering Digital Photography,* you'll find a detailed discussion of these in the "Transferring Skills" section in Chapter 1, but here's a quick summary:

- **Basic composition.** Seasoned photographers know how to line up shots to produce a pleasing composition. You'll find this skill valuable with dSLRs, because their WYSIWYG viewpoint makes composition more precise.

- **Choosing lenses.** Beginners don't choose lenses or zoom settings. They just zoom in or out to make the image appear to be the size they want. Photographers understand that lens choice is an important part of the creative process to, say, compress the apparent distance between objects, emphasize the foreground, or produce pleasing portraits.

- **Using selective focus.** Point-and-shoot cameras generally don't offer much flexibility in applying depth-of-field. Your understanding of selective focus will let you place the emphasis in your pictures exactly where you want it.

- **Choosing a film "look."** If you're a veteran film photographer, you're used to choosing one film because it provides vivid, saturated colors even on overcast days, or another film because it has accurate flesh tones for portraits, or a third because it has extra contrast that makes product shots look their best. You can apply this knowledge to your digital camera to select saturation, contrast, and exposure settings that suit the exact look you want.

- **Knowledge of what you can do in the film and digital darkroom.** Experienced photographers know how and when to take advantage of image-editing techniques, such as retouching, compositing, color correction, and special effects. These can be used to fix problem images, or make a good image a great one.

No image editing here

Most digital photography books expend half their pages discussing image-editing techniques. I won't do much of that at all, and will concentrate on digital *camera* techniques. If you want to learn more about mimicking darkroom and camera effects in Photoshop, or to master advanced image-editing skills, I recommend another book of mine, *Adobe Photoshop CS: Photographers' Guide.* If even more sophisticated image manipulation is your cup of tea, check out *Digital Retouching and Compositing: Photographers' Guide.* Like this book, these are written from the photographers' perspective and are available from Course Technology.

What You'll Use Your dSLR For

Only a few years ago, digital cameras weren't seen as the solution for every possible picture taking situation. Indeed, there were a few select fields of endeavor for which digital cameras seemed ideal and particularly cost-effective (which was a major consideration when a digital SLR cost $10,000 to $30,000). This section outlines the pioneering uses of digital photography and shows how digital cameras have come to predominate them.

Bye Bye Film?

A year ago I never dreamed I'd be seriously questioning the continued viability of film. After all, film cameras were much more inexpensive than digital cameras, and usually produced better results. Today, in the age of $300 6MP cameras and $600 dSLRs, neither of those rationales is still true. The reasons for sticking with film grow fewer in number every day.

Most motion pictures today are still shot on color negative film, but more and more are shot digitally for the gritty look and feel possible with digital video. Sometimes digital origination is obvious from the film itself, but other times you may enjoy an entire motion picture and not realize that it was not shot on film. For example, were you aware that *Star Wars: Episode II: Attack of the Clones* was an all-video production? In these days of $100 million film budgets,

the price of film is not a significant part of the cost, and on-set video systems allow reviewing shots even if they were originated on film. Moreover, it's common to transfer film to digital format for editing. So, the special look of film will continue to be valued for motion pictures for some time yet, with digital cinematography favored for the most effects-heavy productions.

While sales of digital cameras finally surpassed those of film cameras, many still photographs are still produced using negatives or transparencies exposed in a camera. The advantages and disadvantages of electronic image capture versus film will change over the next few years, but, until we have $40 digital cameras, the pros of film cameras will outweigh the cons for many film applications for quite a while.

There are artistic reasons for retaining film capabilities, too, as anyone who shoots a lot of black-and-white film will testify. However, you can't ignore the leanings of the grandfather of all film companies, Eastman Kodak Company, which announced late in 2003 that it was redirecting its business model from conventional film to digital imaging. If Kodak says film is (slowly) being phased out, and has discontinued its Advanced Photo System (APS) camera line, who are we to argue? Ilford is in financial trouble, and Agfa has announced that it's getting out of the film business. This does not bode well for film-based photography.

Where Digital Dominates

Digital photography was quickly embraced in several professional fields of endeavor where the cost of $12,000–$30,000 cameras was easily outweighed by the convenience of having digital images instantly. I list these in detail in *Mastering Digital Photography*, but here's a quick summary:

- **Photojournalism.** Newspapers, news magazines, and news Web sites need visuals quickly, and can't wait for their photographers to fly images back from Afghanistan. Digital images, which could be transmitted by phone lines in the early 1990s, can be zapped across the Internet today, sent by satellite phones, and be ready for publication immediately. However, even if you're not a pro photojournalist, the speed of access to digital images can be vital. I once took a publicity shot for my kids' school and had a print to the local newspaper an hour later. Do you need a picture for that presentation you're giving in one hour? Think like a photojournalist and go digital.

- **Portrait photography.** Digital technology has been important to professional portrait photographers because it gives them the opportunity to sell prints and enlargements immediately after the sitting, when the customers' interest is highest. Digital portraits are easier to retouch, too. If you decide to produce portraits of your own family and friends, or need a passport photo quickly, you'll appreciate digital technology, too.

- **Photoillustration.** Commercial, corporate, and industrial photographers all have taken to digital photography in a big way. Photoillustration can take many forms. For the amateur photographer, it often involves taking attractive photos of hobby collections, such as model ships or Lladró porcelain. Or, perhaps you're interested in photographing flowers or animals, or want pictures for your eBay auctions. For catalog work, digital photography has become *the* way to go because repetitive setups can be shot one after another quickly, and the finished images are immediately ready for placement in a catalog layout, as shown in Figure 1.6.

■ **Everything else.** Although the preceding three fields were the first to adopt digital technology, today every other kind of picture taking is rapidly turning digital. Travel and vacation photography benefit from the ability to reshoot immediately if a picture is not to your liking (rather than schedule a repeat trip back to the Taj Mahal). Family and pet photography thrive on the instant feedback digital photography provides. What better way to encourage your kids to cooperate for that shooting session than to show them each group of pictures on your camera's LCD? There aren't many kinds of photography that won't be predominated by digital technology in the next few years.

Figure 1.6 Arrange a standard setup, and you can plop down items one after another for quick product shots and immediate importing into a catalog page layout.

Next Up

The next chapter looks inside a digital SLR camera to show you how the features work and how they can work for you. While you might not care about the innards of a point-and-shoot camera, the operation of a digital SLR can be crucial in understanding how to best use its features.

2

Digital SLR Technology Made Easy

You don't need to know anything about internal combustion to operate an automobile, and you really don't need to understand digital technology to use a point-and-shoot digital camera, either. Both devices are so automated these days that there's not a lot for the driver/shooter to do other than point the machinery in the right direction and press the gas pedal or shutter release. Even if you decide to use manual controls on a non-dSLR, the only thing you must understand is that this button makes the picture lighter or darker, that one helps freeze action, and this other button changes the way the camera focuses.

It's a different ballgame with a digital SLR, and most of us wouldn't have it any other way. Unlike point-and-shoot digital photography, where it's almost impossible to adjust depth-of-field, and usable ISO ratings range from ISO 100 to ISO 100, the technology built into a dSLR *does* allow you to make a difference creatively and technically, if you know what you're doing. And for the average serious photographer, that's what taking pictures is all about.

With a digital SLR, it's easy to use depth-of-field to manipulate your images, but you need to understand how digital cameras work with lenses and their apertures. The "graininess" of your pictures is under your control, too, but depends heavily on things like the size of the sensor, the sensitivity rating you're using, and what kind of noise reduction technology is built into your camera. Would you like to take a picture in which a runner is frozen in time, but a streaky blur trails behind him like The Flash in comic books? You'd better understand the difference between front-sync and rear-sync shutter settings. Interested in using a super-long telephoto lens without a tripod? Step up and learn about image stabilizers.

If you're who I think you are, you don't see understanding digital SLR technology as a daunting task, but as an interesting challenge. By the time someone is ready to step up to a dSLR, he or she is looking forward to taking greater control over every aspect of the picture-taking process. Similarly, a photo enthusiast who already has SLR experience with film cameras finds the challenge one that's easy to undertake.

That's especially true because the technologies used for film and digital SLRs have converged dramatically over the years. Solid-state technology began to worm itself into conventional

cameras more than 20 years ago, in the form of electronic metering, electronic shutters, programmed exposure modes, and automatic focus. The first digital SLRs were created by grafting a digital sensor into the back of a film SLR and then tacking on some electronics to process and store the images. Even today, when digital SLRs are using fewer off-the-shelf film camera components, there are many models so similar to the film camera counterparts from the same vendor that if you were handed one at random, you'd probably have to check it out for a few seconds to decide if it were the film or electronic version.

The most comforting thing about digital SLR technology is that, for the most part, these cameras were designed by engineers who understand photography. Many of the point-and-shoot digital cameras I have used appear to have been designed by a techie who was creating cell phones or PDAs last week, and then moved over to digital cameras this week. They operate like computers rather than cameras, have features that nobody in their right mind actually needs, and often are completely unusable for the kinds of photography they are intended for. For example, I recently tested a pocket-sized digicam that had *no optical viewfinder at all*. It was necessary to frame every picture using the back-panel LCD, which, unfortunately, completely washed out when used outdoors at any time of the day when the sun was out. Another camera had a sensational burst mode that could snap off six frames in about 1.5 seconds. Casual sports photographers would love that, except this particular model provided no way to set the shutter speed high enough to stop action, nor was there even a Sports shooting mode. Ack!

In contrast, digital SLRs are designed by people who understand your needs. Most of them have been designing film cameras for many years, and know from the feedback they receive what photographers want. So, learning dSLR technology will be rewarding for you because you'll come to understand exactly how to use features that have been designed to help you be a better and more creative photographer.

This chapter explains that technology and will help you in two ways. When you're shopping for your next digital SLR, you'll have a better knowledge of the kinds of technology you should be looking for in your camera. If you already own a dSLR, after reading this chapter you'll know how to put those features to work.

You'll find that this chapter is not one of those "inside a digital camera" exposès with cute diagrams, like the one shown in Figure 2.1, that show light entering a lens, evading capture by the diaphragm, bouncing off the reflex mirror up to your eye, and/or wending its way to the

Pentaprism Viewfinder window

Sensor

Lens Mirror

Figure 2.1 The light path inside a digital SLR looks something like this… but there's a lot more to know.

sensor. Most of the readers of this book already know the basics of SLR mechanics, and Figure 2.1 is probably old hat to them.

Instead, I'm going to go into a little more detail on some of the basic components of a dSLR, such as the sensor, lens, and viewfinder. More-advanced features, including automatic exposure and focus, image stabilization/vibration reduction, and electronic flash settings will be covered in Chapter 3 and beyond, accompanied by suggestions on how you can best use these capabilities. For now, we're just going to explore how an image gets captured in the first place.

Sensors and Sensibility

The sensor in your digital SLR, like the Foveon sensor shown in Figure 2.2, is the key to capturing images, and also the key to many of your creative options. There's a lot more to understand about sensors than the number of megapixels. There are very good reasons why one 6 megapixel sensor and its electronics produce good pictures, while a different 6 megapixel sensor is capable of sensational results. This section will help you understand why and how you can use the underlying technology to improve your photos.

In the broadest terms, a digital camera sensor is a solid-state device that is sensitive to light. When photons are focused on the sensor by your dSLR's lens, those photons are registered and, if enough accumulate, are translated into digital form to produce an image map you can view on your camera's LCD and transfer to your computer for editing. Capturing the photons efficiently and accurately is the tricky part.

Figure 2.2 This advanced Foveon imager is a type of CMOS sensor.

Sensor Overview

Today, there are two main types of sensors used in digital cameras; CCD (for charge coupled device) and CMOS (for complementary metal oxide semiconductor). Until recently, CCDs were the imagers of choice for high-quality image capture, and CMOS chips were the "cheapie" alternatives used for less-critical applications. That's no longer true. While some types of CMOS sensors are still used because they are inexpensive, you'll find sensors using this technology in some of the latest, cutting-edge digital SLRs, including top-of-the-line models for professional photographers offered by Canon and Nikon. So, you can forget about choosing a camera based on whether it has a CCD or CMOS sensor. There are more important factors, which I'll explain shortly.

The first CCD sensors were created around 30 years ago, becoming practical for digital photography when Kodak introduced the first megapixel sensor (with 1.4 million pixels) in 1986. CMOS sensors were developed somewhat later. Both types have seen significant improvements in design, especially related to how images are captured and processed.

The two types of sensors are basically similar in how they capture light. Both types use metal oxide semiconductors and have roughly the same sensitivity to light in both the visible and infrared spectra. They convert photons into electrons in much the same manner, and both

are largely "color-blind," using exterior filters to separate the light they receive into the colors we see.

The chief differences come in how they manipulate the light they capture. A CCD is an analog device. Each photosite is a photodiode that has the ability (called *capacitance*) to store an electrical charge that accumulates as photons strike the cell. The design is a simple one, requiring no logic circuits or transistors dedicated to each pixel. Instead, the accumulated image is read by applying voltages to the electrodes connected to the photosites, causing the charges to be "swept" to a readout amplifier at the corner of the sensor chip.

A CMOS sensor, on the other hand, includes transistors at each photosite, and every pixel can be read individually, much like a computer's random access memory (RAM) chip. It's not necessary to sweep all the pixels to one location, and, unlike CCD sensors, with which all their information is processed externally to the sensor, each CMOS pixel can be processed individually and immediately. That allows the sensor to respond to specific lighting conditions as the picture is being taken. In other words, some image processing can be done within the CMOS sensor itself, something that is impossible with CCD devices.

For a long time, the chief advantage of CMOS technology was that CMOS sensors, like all CMOS chips, are less expensive to produce. They can be fabricated using the same kinds of processes used to create most other computer chips in the CMOS family. CCDs require special, more expensive, production techniques. As I mentioned earlier, the first generations of CMOS sensors tended to produce lower-quality images, but that's no longer true. Canon has been in the forefront of overcoming CMOS limitations and has used these chips in its professional and amateur dSLRs. Kodak is another vendor that has offered high-quality CMOS sensors in its cameras. The latest professional-level Nikon dSLR uses a 12.4 megapixel CMOS sensor created by Sony. Foveon sensors, a special variety of CMOS imager, are used in several Sigma digital single lens reflexes.

If you understand how film works, the basic concepts behind digital sensors are easy to understand. Color film consists of multiple layers, as shown in the cross-section in Figure 2.3. Light falling on the film surface penetrates all of the layers and the amount of red, green, and blue light present in the scene is registered as a latent image and later made visible during the development process.

Figure 2.3 Film captures color images using individual color layers in the emulsion, shown in this cross-section.

Digital sensors also are sensitive to red, green, and blue light, but, because they are digital, the image is divided up into picture elements, or pixels arranged in an array of rows and columns. The number of rows and columns determines the resolution of the sensor. For example, a 6MP digital camera image might have 3,008 columns of pixels horizontally and 2,000 rows vertically. Except in the case of the Foveon sensor, each pixel position or photosite isn't capable of recording all three primary colors of light. Although individual photosites start out sensitive to all colors, with most CCD and CMOS sensors, they are overlaid with a filter that's red, green, or blue, so any particular pixel can record only that particular color. Other colors that may exist in the original scene for that pixel are created using a process called *interpolation*. We'll look at this filter system and interpolation in more detail shortly.

CCDs in Depth

CCDs, like CMOS chips, use microscopic lenses to focus incoming beams of photons onto the photosensitive areas on each individual pixel/photosite on the chip's photodiode grid, as shown in Figure 2.4. In a CCD, the sensitive area of individual photosites relative to the overall size of the photosite itself is relatively large, often amounting to as much as 95 percent of the total area. That makes a CCD particularly efficient in capturing light.

Figure 2.4 A microlens on each photosite focuses incoming light onto the active area of the sensor.

As photons fall into this photosite "bucket," the bucket fills. If, during the length of the exposure, the bucket receives a certain number of photons, called a *threshold*, then that pixel registers an image. If too few pixels are captured, that pixel is considered black. The more photons that are grabbed, the lighter in color the pixel becomes until, when it's full, the pixel is deemed white. In-between values produce shades of gray or, because of the filters used, various shades of red, green, and blue.

If too many pixels fall into a particular bucket, they may actually overflow, just as they might with a real bucket, and pour into the surrounding photosites, producing that unwanted flare known as *blooming*. This effect is often more pronounced in CCD sensors, which can be easily oversaturated with light. The only way to prevent this photon overfilling is to drain off some of the extra photons before the photosite overflows, and the CCD's pixels can't include the circuitry to do this.

Of course, now you have a bucket full of photons all mixed together in analog form like a bucket full of water. What you want though, in computer terms, is a bucket full of ice cubes, because individual cubes (digital values) are easier for a computer to manage than an amorphous mass of liquid. The first step is to convert the photons to something that can be handled electronically, namely electrons. That's done right in the photosite, but the result is still a fluid (analog) collection of information.

So, the analog electron values in each row of a CCD array are "piped" in unison down their individual columns to the bottom row of the sensor. When each row of charges reaches this area, called a *transfer register*, the charges are converted into an analog voltage, amplified, and then piped off the chip to the external electronic circuitry in the digital camera, as you can see in Figure 2.5. The camera's circuitry performs the conversion from analog ("liquid") form to digital (the "ice cubes"). The process is repeated for each row (this is called "sweeping" the image off the chip), and, eventually, the CCD is cleared and the image is completely converted from analog to digital form.

Figure 2.5 The electrons from each row of pixels are swept, in turn, down to the transfer register, where they are converted into a voltage and routed to the digital camera's circuitry.

Unfortunately, because the CCD imager is so "dumb," the external circuitry outside the chip has to be that much smarter, containing oscillators, clock drivers, and timing components to make sure that retrieving an image from the chip happens in an orderly manner. All this pixel crunching requires processing time and power and is theoretically much slower. Worse, this processing involves every photosite on the chip for every picture you take, even if you aren't using the full area of the sensor for a particular photo.

CMOS in Depth

CMOS sensors and their grids of photodiodes operate something like CCD imagers in the sense that each photosite can be compared to a bucket that fills with photons that are directed onto the photosensitive area by a microlens. However, a CMOS sensor photosite contains lots

of circuitry not found in a CCD photosite, so there is less room for the photosensitive area. In some CMOS sensors, the sensitive area may be about 50 percent of the total area of each photosite, as you can see in Figure 2.6.

The same thresholds and bucket-filling analogies apply to how CMOS captures photons. However, unlike CCD chips, the electrons are converted to digital form right within the individual photosites. Circuitry converts the photons to electrons (as in a CCD imager) but then transforms the charge into an amplified voltage value. CMOS sensors can include a kind of pixel-resetting circuitry to, more or less, bleed off excessive photons before they can overflow to the adjacent pixels. So, CMOS chips are much, much less prone to blooming effects.

The whole process is more efficient, because all the signal processing can be handled in parallel and with less energy consumption. "Sweeping" the image off the chip by rows and columns isn't necessary. Every photosite on a CMOS imager can be accessed directly.

The circuitry found in a CMOS imager is basically similar to that in standard chips such as RAM, so CMOS sensors can be produced using the same equipment and production lines, in contrast to CCD chips which require special fabrication methods. So, CMOS sensors can be relatively inexpensive compared to CCD on a pixel-by-pixel basis. On the other hand, the smaller photosensitive area of these chips makes it more difficult to produce high-quality images, and the resulting sensors are less sensitive to light, too.

Figure 2.6 Because circuitry exists within each photosite, the active area of the sensor is much smaller.

Noise and Sensitivity

One undesirable effect common to both CCD and CMOS sensors is noise, that awful graininess that shows up as multicolored specks in images. In some ways, noise is like the excessive grain found in some high-speed photographic films. However, while photographic grain is sometimes used as a special effect, it's rarely desirable in a digital photograph.

Unfortunately, there are several different kinds of noise and several ways to produce it. The variety you are probably most familiar with is the kind introduced while the electrons are being processed, due to something called a "signal-to-noise" ratio. Analog signals are prone to this defect, as the amount of actual information available is obscured amidst all the background fuzz. When you're listening to a CD in your car, and then roll down all the windows, you're adding noise to the audio signal. Increasing the CD player's volume may help a bit, but you're still contending with an unfavorable signal-to-noise ratio that probably mutes tones (especially higher treble notes) that you really wanted to hear.

The same thing happens during long time exposures or if you boost the ISO setting of your digital sensor. Longer exposures allow more photons to reach the sensor, increasing your ability to capture a picture under low light conditions. However, the longer exposures also increase the likelihood that some pixels will register random phantom photons, often because the longer an imager is "hot" the warmer it gets, and that heat can be mistaken for photons.

Increasing the ISO setting of your camera raises the threshold of sensitivity so that fewer and fewer photons are needed to register as an exposed pixel. Yet, that also increases the chances of one of those phantom photons being counted among the real-life light particles, too. The same thing happens when the analog signal is amplified: You're increasing the image information in the signal but boosting the background fuzziness at the same time. Tune in a very faint or distant AM radio station on your car stereo. Then turn up the volume. After a certain point, turning up the volume further no longer helps you hear better. There's a similar point of diminishing returns for digital sensor ISO increases and signal amplification, as well.

But wait! There's more. There's a special kind of noise that CMOS sensors are susceptible to. With a CCD, the entire signal is conveyed off the chip and funneled through a single amplifier and analog to digital conversion circuit. Any noise introduced there is, at least, consistent. CMOS imagers, on the other hand, contain millions of individual amplifiers and A/D converters, all working in unison. Because all these circuits don't necessarily all process in precisely the same way all the time, they can introduce something called fixed-pattern noise into the image data.

Regardless of the source, it's all noise to you, and you don't want it. Digital SLRs have noise reduction features you can use to help minimize this problem, and I'll explain how to use them in Chapter 3.

Dynamic Range

The ability of a digital sensor to capture information over the whole range from darkest areas to lightest is called its *dynamic range*. You take many kinds of photos in which an extended dynamic range would be useful. Perhaps you have people dressed in dark clothing standing against a snowy background, or a sunset picture with important detail in the foreground, or simply an image with important detail in the darkest shadow.

However, sensors have some difficulty capturing the full range of tones that may be present in an image. Tones that are too dark won't provide enough photons to register in the sensor's photosite "buckets," producing clipped shadows, unless you specify a lower threshold or amplify the signal, increasing noise. Very light tones are likely to provide more photons than the bucket can hold, producing clipped highlights and overflowing to the adjacent photosites to generate blooming. Ideally, you want your sensor to be able to capture very subtle tonal gradations throughout the shadows, midtones, and highlight areas.

One way to do this is to give the photosites a larger surface area, which increases the volume of the bucket and allows collecting more photons. In fact, the jumbo photosites in larger dSLR

sensors allow greater sensitivity (higher ISO settings), reduced noise, and an expanded dynamic range. For comparison purposes, the photosites on an 8MP non-SLR digital camera with a 2/3-inch CCD sensor measure 2.7 microns each. The larger sensors on a typical 6MP dSLR measure 7.8 microns—almost three times wider. You can see why a 6 megapixel dSLR might produce better images with lower noise than a non-SLR that has 2 million more pixels. The larger photosites tell it all.

Dynamic range can be described as a ratio that shows the relationship between the lightest image area a digital sensor can record and the darkest image area it can capture. The relationship is logarithmic, like the scales used to measure earthquakes, tornados, and other natural disasters. That is, dynamic range is expressed in density values, D, with a value of, say, 3.0 being ten times as large as 2.0.

As with any ratio, there are two components used in the calculation, the lightest and darkest areas of the image that can be captured. In the photography world (which includes film; the importance of dynamic range is not limited to digital cameras), these components are commonly called Dmin (the minimum density, or brightest areas) and Dmax (the maximum density, or darkest areas).

Dynamic range comes into play when the analog signal is converted to digital form. As you probably know, digital images consist of the three color channels (red, green, and blue), each of which have, by the time we begin working with them in an image editor, tonal values ranging from 0 (black) to 255 (white). Those 256 values are each expressed as one 8-bit byte, and combining the three color channels (8 bits x 3) gives us the 24-bit, full-color image we're most familiar with.

However, when your digital SLR converts the analog files to digital format to create its RAW image files, it can use more than 8 bits of information per color channel, usually 12 bits, 14 bits, or 16 bits. These extended range channels are usually converted down to 8 bits per channel when the RAW file is transferred to your image editor.

The analog to digital converter circuitry itself has a dynamic range that provides an upper limit on the amount of information that can be converted. For example, with a theoretical 8-bit A/D converter, the darkest signal that can be represented is a value of 1, and the brightest has a value of 255. That ends up as the equivalent of a maximum possible dynamic range of 2.4, which is not especially impressive as things go.

On the other hand, a 10-bit A/D converter has 1,024 different tones per channel, and can produce a maximum dynamic range of 3.0; up the ante to 12 or 16 bits (and 4,094 or 65,535 tones) in the A/D conversion process, and the theoretical top dynamic ranges increases to values of D of 3.6 and 4.8, respectively.

These figures assume that the analog to digital conversion circuitry operates perfectly and that there is no noise in the signal to contend with, so, as I said, those dynamic range figures are only theoretical. What you get is likely to be somewhat less. That's why an 16-bit A/D converter, if your camera had one, would be more desirable than a 12-bit A/D converter. Remember that the scale is logarithmic, so a dynamic range of 4.8 is *many* times larger than one of 3.6.

The brightest tones aren't particularly difficult to capture, as long as they aren't *too* bright. The dark signals are much more difficult to grab because the weak signals can't simply be boosted by amplifying them, as that increases both the signal as well as the background noise. All sensors produce some noise, and it varies by the amount of amplification used as well as other factors, such as the temperature of the sensor. (As sensors operate, they heat up, producing more noise.) So, the higher the dynamic range of a digital sensor, the more information you

can capture from the darkest parts of a slide or negative. If you shoot low-light photos or images with wide variations in tonal values, make sure your dSLR has an A/D converter and dynamic range that can handle them. Unfortunately, specs alone won't tell you; you'll need to take some pictures under the conditions you're concerned about and see if the camera is able to deliver.

Sensor cleaning

So far in this book I've mentioned sensor cleaning once or twice. Some cameras are more prone to picking up dirt on the sensor than others. At the very least you'll want to keep an air bulb at hand for dusting off your sensor from time to time (*not* a can of compressed air!). I'll explain the sensor cleaning task in much more detail in Chapter 4. If you've got spots and speckles in the same place on every one of your images (or, at least, on those images taken with a small f-stop, which tends to make the dust more noticeable), feel free to jump ahead!

Controlling Exposure Time

All this wonderful process of collecting photons and converting them into digital information requires a specific time span for this to happen, known in the photographic realm as *exposure time*. Film cameras have always sliced light into manageable slivers of time using mechanical devices called shutters, which block the film until you're ready to take a picture, and then open to admit light for the period required for (we hope) an optimal exposure. This period is generally very brief, and is measured, for most pictures taken with a hand-held camera, in tiny fractions of a second.

Digital cameras have shutters, too. They can have either a mechanical shutter, which opens and closes to expose the sensor, or an electronic shutter, which simulates the same process. Many digital camera have *both* types of shutter, relying on a mechanical shutter for relatively longer exposures (usually 1/500th second to more than a second long), plus an electronic shutter for higher shutter speeds that are difficult to attain with mechanical shutters alone. (That's why you'll find digital cameras with shutter speeds as high as 1/16,000th second: they're electronic.)

Mechanical shutters can work with any kind of sensor. One important thing to remember about a digital SLR's mechanical shutter is that its briefest speed usually (but not always) determines the highest speed at which an electronic flash can synchronize. That is, if your dSLR synchs with electronic flash at no more than 1/125th second, that's probably the highest mechanical shutter speed available. Some special flash systems can synchronize with electronic shutters at higher speeds, but I'll leave a detailed discussion of synching for Chapter 8.

The type of electronic shutter your camera has depends a great deal on the kind of sensor that is built into your camera. In terms of the kind of shutter they can use, sensors fall into one of two categories: *interline* and *full frame*. Both terms deal with how the sensor captures an image.

The interline sensor, developed originally for video cameras, isolates an entire image in one instant, and then gradually shifts it off the chip into the camera electronics for processing and conversion from an analog signal to digital format. While this process is underway, a new image can be accumulating on the chip. That's because the interline sensor is, in effect, two sensors in one; while one sensor is exposed to light, the other is masked. The two sensors exchange places so that the previously masked sensor can then accept light while the sensor that was previously exposed is shielded so it can offload its image to the camera's electronics. This capability was

important for video cameras, which expose their sensors at a rate of 30 frames per second. Because of this ability to isolate an image in a fraction of a second, interline sensors can function as an electronic, non-mechanical shutter.

A full-frame sensor (not to be confused with full-frame sensor *size)*, in contrast, is a single sensor that cannot isolate an image while it is still exposed to light. The sensor must be physically covered, uncovered to make the exposure, and then covered again while the image is transferred to the camera's electronics. If the sensor is still exposed to light when an image is moved from the chip, the image will be smeared by illumination that strikes the photosites while the old image is being shifted. That calls for a mechanical shutter.

How We Get Color

So far, I've ignored how sensors produce color. In one sense, digital camera sensors are color blind. They can register the brightness, or luminance of an image, but have no notion of the color of the light at all. To do that, CCD and most CMOS sensors overlay the photosites with a set of color filters. Each pixel registers either red, green, or blue light, and ignores all the others. So, any particular pixel might see red light (only), while the one next to it might see green light (only), and the pixel below it on the next row might be sensitive to blue light (only).

As you might guess, in the normal course of events, a pixel designated as green-sensitive might not be lucky enough to receive much green light. Perhaps it would have been better if that pixel had registered red or blue light instead. Fortunately, over a 6 million pixel range, enough green-filtered pixels will receive green light, red-filtered pixels red light, and blue-filtered pixels blue light that things average out with a fair degree of accuracy. To compensate for this short-coming, the actual color value of any particular pixel is calculated through a process called *interpolation*. Algorithms built into the camera's circuitry can look at surrounding pixels to see what their color values are, and predict with some precision what each pixel should actually be. For the most part, those guesses are fairly accurate.

For reasons shrouded in the mists of color science, the pixels in a sensor array are not arranged in a strict red-green-blue alternation, as you might expect to be the case. Instead, the pixels are laid out in what is called a Bayer pattern, which you can see in Figure 2.7, which shows just a small portion of a full sensor array. One row alternates green and red pixels, followed by a row that alternates green and blue filters.

Figure 2.7 To allow the sensor to capture color, a matrix of red, green, and blue filters is placed over the photosites.

Green is "over-represented" because of the way our eyes perceive light: We're most sensitive to green illumination. That's why monochrome monitors of the computer dark ages were most often green on black displays.

The arrangement used is called a *mosaic* or *Bayer pattern*, and the process of interpreting the pixel values captured and transforming them into a more accurate representation of a scene's colors is called *demosaicing*. With good algorithms, the process is accurate, but faulty demosaicing can produce unwanted artifacts in your photo (although, almost by definition, artifacts are generally always unwanted).

Of course, use of a Bayer pattern means that a great deal of the illumination reaching the sensor is wasted. Only about half of the green light reaching the sensor is actually captured, because each row consists of half green pixels and half red or blue. Even worse, only 25 percent of the red and blue light is registered. Figure 2.8 provides a representation of what is going on. In our 36-pixel array segment, there are just 18 green-filtered photosites and 9 each of red and blue. Because so much light is not recorded, the sensitivity of the sensor is reduced (requiring that much more light to produce an image), and the true resolution is drastically reduced. Your digital camera, with 6 megapixels of resolution, actually captures three separate images measuring 3 megapixels (of green), 1.5 megapixels (of blue), and 1.5 megapixels (of red).

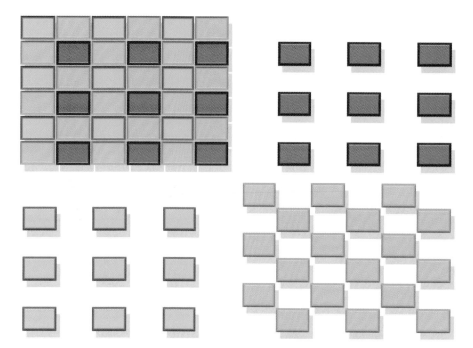

Figure 2.8 There are twice as many green pixels in a raw captured image as red and blue pixels.

Sony's Four-Color CCD

There are three primary colors of light—red, green, and blue—so what gives with Sony's four-color "RGB+E" sensor technology? Should you, as a digital SLR owner, worry about it? As with everything related to digital photography, it's useful to understand what's going on, even if it doesn't apply to your own work. Some day, it might. Who knows?

What Sony is doing is refining the traditional Bayer mosaic pattern by adding a fourth color, a sort of cyanish green, that it calls emerald, ostensibly to match the color response of the sensor more closely to the color perception of the human eye. The problem with a red-green-blue matrix is that human eyes have a quirky response to red at certain frequencies. That can be fixed by applying a blue-green subtractive filter to the red channel, but only at those particular frequencies. The emerald filter over some of the photosites in Sony's RGB+E sensor provides the information used to make that adjustment.

As a result, the RGB+E sensor has 25% red-sensitive pixels, 25% green-sensitive pixels, 25% "emerald"-sensitive pixels, and 25% blue-sensitive pixels, as you can see in Figure 2.9. The emerald-filtered photosites are close enough in response to the green pixels that, under most conditions, the RGB+E sensor responds like a Bayer mosaic (with 25% red, 50% green (actually green+emerald), and 25%

Figure 2.9 Sony's "emerald" pixels allow correcting for defects in the rendition of red tones at certain frequencies.

blue). After capture, the four-color image is processed and converted back to a traditional three-color, RGB image, but one Sony says has more accurate colors.

The Non-Bayer Foveon Imager

The only commonly used digital SLR sensor that doesn't use a Bayer filter (and it's not all that commonly used) is the Foveon sensor found in several Sigma digital cameras. The Foveon imager, a kind of CMOS chip, works in a quite different way. It's long been known that the various colors of light penetrate silicon to varying depths. So, the Foveon device doesn't use a Bayer filter mosaic like that found in a CCD sensor or other CMOS imagers. Instead, it uses three separate layers of photodetectors, which are shown in Figure 2.10, colored blue, green, and red. All three colors of light strike each pixel in the sensor at the appropriate strength as reflected by or transmitted through the subject. The blue light is absorbed by and registers in the top layer. The green and red light continue through the sensor to the green layer, which absorbs and registers the amount of green light. The remaining red light continues and is captured by the bottom layer.

Figure 2.10 The Foveon sensor has three layers, one for each primary color of light.

So, no interpolation (called *demosaicing*) is required. Without the need for this complex processing step, a digital camera can potentially record an image much more quickly. Moreover, the Foveon sensor can have much higher resolution for its pixel dimensions, and, potentially, less light is wasted. Of course, as a CMOS sensor, the Foveon device is less sensitive than a CCD sensor, anyway, so photons are wasted in another, different way. The reason why Foveon-style sensors haven't taken over the industry is that technical problems limit the pixel dimensions of this kind of sensor. Current versions have roughly 3.3 megapixels of resolution, which, it could be argued, is the equivalent of a 10MP CCD or conventional CMOS sensor. However, that doesn't prove to be the case outside the theoretical world, and cameras using the Foveon sensor are not yet regarded as the leading edge in sharpness, color fidelity, or much of anything else. However, don't write this technology off until it has been explored fully.

Fuji's SuperCCD

Yet another sensor innovation is Fujifilm's fourth-generation SuperCCD SR (for Super Dynamic Range). Fuji claims that the new sensor provides four times the dynamic range of conventional CCDs, which is great news if it's true.

Fuji's technology includes two photodiodes at each photosite, as shown in Figure 2.11. The photodiodes are octagonal in shape, which allows fitting both into a single space. There's a large one that has high sensitivity but a relatively narrow dynamic range. It's useful for capturing dark and medium tones. Next to the primary photodiode is a smaller, secondary photodiode that has less sensitivity but boasts four times the dynamic range of its counterpart.

Although both photodiodes are exposed simultaneously, the camera's digital signal processor (DSP) reads the primary (high-sensitivity/low-dynamic range) photodiode first, then the secondary (low-sensitivity/high-dynamic range), and combines the information from the two to create an extended range image. Sony says that this imager produces better results with images taken in bright sunshine, particularly by enhancing detail in clouds, as well as better results with flash and improved exposure tolerance under high-contrast lighting conditions.

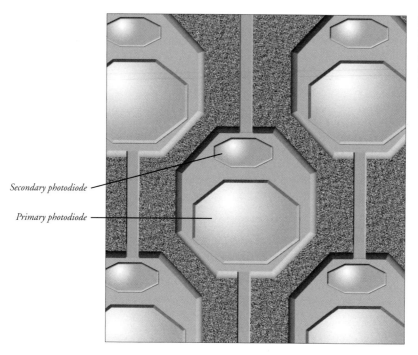

Secondary photodiode —

Primary photodiode —

Figure 2.11 Fuji's SuperCCD uses a high-sensitivity/narrow-dynamic range primary photodiode and a low-sensitivity/wide-dynamic range secondary photodiode at each photosite.

Infrared Sensitivity

The final aspect of sensor nuts and bolts that I'm going to mention is infrared sensitivity. CCD sensors, in particular, are inherently quite sensitive to non-visible, infrared light. Imaging this extra light can produce colors that are not realistic, and therefore inaccurate. For example, a green leaf (which reflects a lot of infrared) might not look the same shade as a non-infrared-reflecting green automobile that, to our eyes, appears to be the exact same hue. So, most camera vendors install infrared blocking filters in front of sensors, or include a component called a *hot mirror* to reflect infrared to provide a more accurate color image. Luckily (for the serious

photographer), enough infrared light sneaks through that it's possible to take some stunning infrared photos with many digital cameras. There are easy ways to determine whether your dSLR can shoot infrared photos. Point your TV's remote control at the lens, and take a picture while a button is depressed; if a light dot that represents the invisible infrared beam appears, your camera has some infrared sensitivity.

There are lots of things you can do with infrared, especially if you're willing to manipulate the photo in an image editor. For example, swapping the red and blue channels, as was done for Figure 2.12, can produce an infrared photo in which the sky regains its dark blue appearance for a strange and wonderful effect.

Figure 2.12 Many digital SLRs can take infrared photos like this one.

Using Interchangeable Lenses

The next most important component of a digital SLR is the lens—or, more properly, lenses—because, unlike other types of digital cameras, the lens of a dSLR is interchangeable. I'm not going to waste a lot of time discussing the science of optics, primarily because it's an ancient technology. Indeed, in the Western world, Romans invented glass in the first century, and found that different shaped pieces of glass could be used for magnifying objects such as insects. In fact, early magnifiers were actually called "flea glasses" for that reason. They could also focus the sun's rays to burn things (probably fleas); they were also called "burning glasses."

After a mere 1,500 years of viewing fleas and setting stuff on fire, two genius Dutch spectacle makers named Janssen (father and son) figured out how to combine several lenses in a tube to produce much greater magnifications. Galileo and Leeuwenhoek came up with improved telescope and microscope gadgets, and most of the optical breakthroughs hence have involved different kinds of shapes of glass and other materials (including non-spherical "aspheric" elements) special coatings, and clever combinations of lenses to create zooms, fish-eyes, and other innovations.

As I noted, I'm not going to tell you much about how lenses work. Most of the rest of this section will deal with practical matters relating to interchangeable lenses on a dSLR. The only things you really need to know about lenses are these:

- Lenses consist of precision-crafted pieces of optical glass (or plastic or ceramic material) called *elements*, arranged into *groups* that are moved together to change the magnification or focus. The elements may be based on slices of spheres, or not (in which case they are *aspherical*), and given special coatings to reduce or eliminate unwanted reflections.

- Lenses contain an iris-like opening called a diaphragm that can be changed in size to admit more or less light to the sensor. In addition to adjusting the amount of light that passes through the lens, the diaphragm and its shape affect things like relative overall sharpness of an image, the amount of an image that is in focus, the brightness of your view through the viewfinder, and even the shape and qualities of out-of-focus highlights in your image. I'll describe these aspects in more detail as they come up.

- Lenses are mounted in a housing that keeps the elements from rattling around and provides a way to move them to adjust focus and magnification. The lens housing can include a microprocessor, a tiny motor for adjusting focus (and, in non-dSLR cameras, for zooming), and perhaps a mechanism for neutralizing camera shake (called *vibration reduction*). Also included are threads or a bayonet mount for attaching filters, a fitting that attaches to your camera, and various levers and electronic contacts for communicating with the camera body. You might find a switch or two for changing from autofocus to manual focus, locking a zoom lens so it doesn't extend accidentally while the camera is being carried, and a macro lock/lockout button to limit the seeking range of your autofocus mechanism so your lens won't seek focus from infinity to a few inches away every time you partially depress the shutter release.

Everything else is details, and we'll look at them in this and later chapters of this book.

Lens Interchangeability

The ability to remove a lens and swap it for another is one of the key advantages of the digital SLR. Interchangeable lenses are not unique to single lens reflex cameras, of course. Film cameras that use optical viewfinder windows (called *rangefinder cameras*), such as the Leica, also have interchangeable lenses. Early in my career I used a Mamiya twin lens reflex camera, which allowed unhooking both lenses (one for viewing, one for taking the picture) and substituting another set. Modern studio cameras (called *view cameras*) can be used with a variety of lenses and are related to those sheet-film press cameras like the Speed Graphic you might remember from movies in the '40s and '50s, and which also used interchangeable lenses.

Interchangeable lenses make a very cool tool because they expand the photographer's versatility in several ways:

- Swapping lenses lets you change the "reach" of a lens, from wide angle to medium telephoto to long telephoto. The zoom lenses on non-SLR cameras provide some of this flexibility, but they can't provide the magnification of the longest telephotos, nor the wide-angle perspective of the shortest focal lengths. Figures 2.13, 2.14, and 2.15 illustrate just how much the right lenses can change your view of a single subject.

- Interchangeable lenses let you choose a lens optimized for a particular purpose. Do-everything zooms are necessarily a compromise that may perform fairly well in a broad range of applications, but excel at none of them. Using an SLR lets you choose a lens, whether it's a zoom or a fixed focal length lens (called a *prime* lens) that does a particular thing very well indeed.

Figure 2.13 With the zoom set to 18mm (the equivalent of a 27mm lens on a full-frame film or digital camera), a farmer's field and two distant trees are the focus.

Figure 2.14 At 70mm (equivalent to a 105mm telephoto lens), we've zeroed in on the two trees.

Figure 2.15 A 150mm lens (providing the same view as a 225mm telephoto on a full-frame camera) crops the image to a single tree and reveals some farm equipment in the background.

For example, a lens with a zoom range extending from wide angle to long telephoto may be plagued with distortion at one end of the range or another (or both!). A multi-purpose lens is probably much slower than an optimized optic, perhaps with an f4.5 or f5.6 maximum aperture. With the availability of interchangeable lenses, you can select a very fast, f1.4 lens when you need one, or choose a lens that's particularly good in a given zoom range (say, 12-24mm). Choose another lens for its exquisite sharpness, or because it provides a dreamy blurry effect that's perfect for portraiture. Use zooms when you need them and prime lenses when they are better suited for a job.

- Lens swaps make it easy for those with extra-special needs to find some glass that fits their specialized requirements. Fish-eye lenses, those with perspective control shifts, or hyper-expensive super-long telephoto optics with built-in correction for camera shake are available to anyone who can afford them.

As you know, however, lenses aren't infinitely interchangeable. Lenses designed to fit on one particular vendor's brand of camera probably won't fit on another vendor's camera (although there are exceptions), and it's highly likely that you'll discover that many lenses produced by the manufacturer of your digital SLR can't be used with current camera models. Unfortunately, I can't provide a comprehensive lens compatibility chart here, because there are hundreds of different lenses available, but you might find some of the guidelines in this section useful.

The first thing to realize is that lens compatibility isn't even an issue unless you have older lenses that you want to use with your current digital camera. If you have no lenses to migrate to your new camera body, it makes no difference, from a lens standpoint, whether you choose a Nikon, Canon, Minolta, Olympus, Pentax, or another dSLR. You'll want to purchase current lenses made for your camera by the vendor, or by third parties such as Sigma or Tamron, to fit your camera. One exception might be if you had a hankering for an older lens that you could purchase used at an attractive price. In that case, you'll be interested in whether that older lens will fit your new camera.

You also might be interested in backward compatibility if you own a lot of expensive optics that you hope to use with your new camera. That compatibility depends a lot on the design philosophy of the camera vendor. It's easier to design a whole new line of lenses for a new camera system than to figure out how to use older lenses on the latest equipment. Some vendors go for bleeding edge technology at the expense of compatibility with earlier lenses. Others bend over backwards to provide at least a modicum of compatibility. The major categories are these:

Not Much Backward Compatibility

Canon and Konica Minolta dSLRs are representative of the class of cameras that work best (or only) with relatively recent lenses made for their respective brands. Both have long and glorious histories in the SLR world and offered optics that were highly compatible until electronics began taking over. For example, Minolta's MC/MD camera mount was used in some form for nearly 30 years, until Minolta replaced it in 1985 with a fully electronic lens mount that had no backwards compatibility.

Canon followed a similar path and replaced its most popular lens mounting system in 1986 when it introduced the Canon EOS line. Today, if you want to get the most from your digital Konica Minolta or Canon camera, you'll want to use the vendors' A-mount and EF lenses, respectively. Again, that's not much of a drawback unless you have a lot of very old lenses available that you want to use. The latest Olympus cameras, which use the Four-Thirds lens mount, also fall into this category. Forget about all those cool older Zuiko lenses you own; you'll want the new Four-Thirds lenses for your Olympus dSLR.

Lots of Backward Compatibility

Pentax and it's *ist line of digital cameras are in the forefront of providing robust compatibility with earlier lenses. You can use KA and K mount lenses, old 35mm Pentax screw-mount lenses, and even some lenses produced for the Pentax 645 and Pentax 67 medium format (120-rollfilm) SLRs. All you need is the proper adapter. Some functions may not operate, such as autofocus, multi-segment metering, and various program modes, but you can use them. Nikon also falls into this category, but it's a special case, with semi-compatibility extending back more than 45 years!

Nikon Compatibility

In the world of lens compatibility, Nikon is indeed a special case. First, Nikon lenses can be used on cameras offered by three different vendors: Nikon, Fuji, and Kodak (although some Kodak dSLRs use Canon lenses instead). Second, Nikon has gone to great lengths to maintain at least a modicum of compatibility with older camera bodies and lenses as its lens systems have evolved over the years. Indeed, lenses introduced with the very first Nikon F in April, 1959 can be fitted and used, sometimes with minor modifications, on the latest digital and film SLRs. That's because the Nikon lens mount has remained basically the same for nearly half a century!

Granted, not *all* Nikon lenses from the previous millennium can be used with the newest cameras. Some lenses, such as the earliest Fish-Eye Nikkors, extend too far into the camera to be used without locking up the mirror. A few others, such as perspective control lenses, may intersect with part of the body of newer cameras when used as intended. All Nikon lenses made prior to 1977 must have some simple machining done to remove parts of the lens mount that interfere with tabs and levers added to later models for functions such as autofocus. The modifications enable safe mounting on the newest cameras and don't interfere with operation on older cameras.

A master technician named John White can perform conversions for you for as little as $25–$35. He's converted many of my older lenses, and his workmanship is superb. If you're confused about which lenses can work with which cameras, you'll find a helpful chart at **http://www.aiconversions.com/compatibilitytable.htm**

Figures 2.16 and 2.17 show examples of new-style and old-style lens mounts. The shiny new lens was introduced by the vendor in 2004, and it bristles with electrical contacts that allow the lens to communicate with the digital camera. The "legacy" lens was built 36 years ago, and the only thing it shares with its newer counterpart is the bayonet mount and automatic diaphragm lever. Yet, because it has been converted it may be safely used in manual focus and exposure modes on the latest cameras.

Figure 2.16 This new lens has electrical contacts (seen at left) to allow communication with the camera.

Figure 2.17 This converted lens can be used in manual focus and exposure modes.

While the automatic diaphragm will operate with the earliest converted lenses (that is, you'll view your subject with the lens wide open, and it will stop down to the taking aperture automatically when the exposure is made), other features, such as autofocus and autoexposure will not work with the oldest lenses, and even lenses from the 1980s that had those features may not operate in exactly the same way with the latest cameras.

Even so, using your stockpile of existing lenses on a newer SLR can be a great way of leveraging an investment you made long ago, and you might not even miss some of the features. For example, close-up photography often works best when you use manual focusing to pinpoint the exact area you want as the center of attention. I focus my macro shots manually even when I'm using an autofocus lens, so I certainly don't mind doing the same thing with a vintage macro lens. I used a hand-held incident light meter for calculating exposure long before I got my first full auto SLR, so I'm perfectly happy setting exposure manually when I'm using an older lens. It's a bit more work, but look how much money I saved not having to buy another 400mm lens (which I don't use very much anyway).

There's a great deal more to be said about lenses and choosing the right optic for the task at hand, so I'm going to devote an entire chapter to the topic. You'll learn more about the creative use of telephotos and wide angles, and I'll unlock the mysteries of "bokeh" (the quality of out-of-focus areas in images) in Chapter 6.

Viewfinders

The third key component of a digital camera is its viewfinder. With a dSLR, the viewfinder is, along with lens interchangeability, one of the distinguishing features between the category and non-dSLR cameras. Certainly, other digital cameras provide a form of through-the-lens viewing by displaying the current sensor image on an LCD. But, as I showed in Figure 1.5 in Chapter 1, an LCD display is hardly the same thing as a big, bright, SLR view, in terms of composition, ease of focus, amount of information provided or viewing comfort.

As you know, there are four basic ways to preview an image with a digital camera.

- **View on the back panel LCD display.** These viewing panels, which operate like miniature laptop display screens, show virtually the exact image seen by the sensor. The LCDs measure roughly 1.6 to 2.5 inches diagonally, and generally display 98 percent or more of the picture view seen by the lens. An LCD may be difficult to view in bright light. Point-and-shoot digital cameras use the LCD display to show the image before the picture is taken, and to review the image after the snapshot has been made. Some of these have no optical viewfinder at all, so the *only* way to compose a shot is on the LCD. In a dSLR, the back panel LCD is used only for reviewing pictures that have been taken; previewing is not possible.

- **View through an optical viewfinder.** Many non-SLR digital cameras have a glass direct-view system called an optical viewfinder that you can use to frame your photo. Optical viewfinders can be simple window-like devices (with low-end, fixed magnification digital cameras) or more sophisticated systems that zoom in and out to roughly match the view that the sensor sees. The advantage of the optical viewfinder is that you can see the subject at all times (with other systems the view may be blanked out during the exposure). Optical systems may be brighter than electronic viewing, too. A big disadvantage is that an optical viewfinder does not see exactly what the sensor does, so you may end up cutting off someone's head or otherwise do some unintentional trimming of your subject.

- **View through an electronic viewfinder (EVF).** The EVF operates like a little television screen inside the digital camera. You can view an image that closely corresponds to what the sensor sees, and is easier to view than the LCD display, but doesn't have nearly the quality of an SLR viewfinder. The EVF goes blank during exposures, however. Because EVF cameras are usually more compact than dSLRs and can cost less, they have become a popular "SLR-like" alternative to the real thing.

- **View an optical image through the camera lens.** Another kind of optical viewfinder is the through-the-lens viewing provided by the SLR camera. With such cameras, an additional component, usually a mirror, reflects light from the taking lens up through an optical system for direct viewing. The mirror reflects virtually all the light up to the viewfinder, except for some illumination that may be siphoned off for use by the automatic exposure and focus mechanisms. The mirror swings out of the way during an exposure to allow the light to reach the sensor instead. Sometimes, a beamsplitting device is used instead. A beamsplitter does what you expect: It splits the beam of light, reflecting part to the viewfinder and allowing the rest of the light to strike the sensor.

As you might guess, because a beamsplitter steals some of the illumination for the viewfinder, neither the sensor nor the viewfinder receives the full intensity of the light. However, such a beamsplitter system does mean that the image needn't blank out during exposure.

An optical viewfinder's image reflected from the mirror is reversed, of course, so it is bounced around a bit more within the camera to produce an image in the viewfinder window that is oriented properly left to right and vertically. Some digital cameras use a *pentaprism*, which is a solid piece of glass and generates the brightest, most accurate image. Others use a *pentamirror* system, lighter in weight and cheaper to produce, but which gives you an image that is a little less brilliant than that created by a pentaprism. Olympus uses a swinging sideways mirror viewfinder system it calls a TTL Optical Porro Finder on its lower-end dSLRs, which has the advantage of allowing a much squatter profile for the camera because the big lump of a pentaprism/pentamirror needn't inhabit the top of the camera.

There are several other important aspects of SLR viewfinders that you need to keep in mind:

- **dSLRs provide no LCD preview.** Because of the way digital SLRs operate it is not possible to view the image on the back-panel LCD before the photo is taken. That doesn't seem like much of a problem at first—after all, the optical view is brighter, easier to focus, and often much larger than an LCD preview—until you go to take an infrared photo or other image using a filter that reduces the visibility of the through-the-lens view or obscures it entirely. An EVF camera with an IR filter mounted may still produce a dim, but viewable LCD image which can be used to compose the photo. With an SLR, you're shooting blind, unless you're using a special or modified camera like the Canon 20Da, which provides a black-and-white "live" image.

- **Vision correction.** Although many point-and-shoot digital cameras don't have diopter correction to allow for near/far sightedness, all digital SLRs have this feature. However, if you have other vision problems that require you to wear glasses while composing photos, make sure your digital camera lets you see the entire image with your eyeglasses pressed up against the viewing window. Sometimes the design of the viewfinder, including rubber bezels around the frame, can limit visibility.

- **Eyepoint.** The distance you can move your eye away from the viewfinder and still see all of the image is called the eyepoint, and it's important to more than just eyeglass wearers, as described above. For example, when shooting sports, you may want to use your other eye to preview the action so you'll know when your subjects are about to move into the frame. Cameras that allow seeing the full image frame even when the eye isn't pressed up

tightly to the window make it easy to do this. In the past, manufacturers of SLR cameras have even offered "extended eyepoint" accessories for sports photographers and others.

■ **Magnification.** The relative size of the viewfinder image affects your ability to see all the details in the frame as you compose an image. It's not something you might think about, but if you compare dSLRs side by side, you'll see that some provide a larger through-the-lens view than others. Bigger is always better, but is likely to cost more, too.

Working with viewfinders will come up again a few times later in this book, but if you remember the basic information presented in this chapter, you'll understand most of what you need to know.

Storage

Once you've viewed your image through the viewfinder, composed and focused it with your lens, and captured the photons with the sensor, the final step is to store the digital image semi-permanently so it can be transferred to your computer for viewing, editing, or printing. While the kind of storage you use in your camera won't directly affect the quality of your image, it can impact the convenience and versatility of your dSLR, so storage is worth a short discussion.

Once converted to digital form, your images first make their way into a special kind of memory called a buffer, which accepts the signals from the sensor (freeing it to take another picture) and then passes the information along to your removable memory card. The buffer is important because it affects how quickly you can take the next picture. If your camera has a lot of this very fast memory, you'll be able to take several shots in quick succession, and use a burst mode capable of several pictures per second for five or six or ten consecutive exposures. Many digital SLRs provide a viewfinder readout showing either how many pictures can be stored in the remaining buffer or, perhaps, a flashing bar that "fills" as the buffer fills and gets smaller as more room becomes available for pictures. When your buffer is completely full, your camera stops taking pictures completely until it is able to offload some of the shots to your memory card.

The buffer is such a limitation on sequence photography that Nikon has introduced a dSLR that crops the center out of an image (creating an 6.8 megapixel picture out of a 12.4 megapixel photo) simply because the smaller images can be moved through the buffer more quickly. Nikon touts this feature as part of its faster burst mode.

The memory card itself has its own writing speed, which signifies how quickly it can accept images from the buffer. There's no standard way of expressing this speed. Some card vendors use megabytes per second. Others label their cards as 40X, 80X, and so forth. Some prefer to use word descriptions, such as Standard, Ultra, Ultra II, or Extreme. I'm not going to tell you which cards are fastest here, because memory card technology and pricing is changing with blinding speed. (When I started writing this book I paid $119 for a 1GB CompactFlash card. Two weeks later I'm up to Chapter 2, and I just bought an identical card for $49 after rebates.) Google the Web for sites that have comparisons of speeds for various current memory cards before you buy.

In recent months, the trend has been toward faster and faster memory cards at lower prices. That's the main reason for the dropping price tags on those 1GB cards I bought. Both were older "standard" cards that were considered outmoded in a time when the leading vendors were pushing 2GB and larger "ultra" cards.

For standard shooting, I've never found the speed of my digital film to be much of a constraint, but if you shoot many action photos, sequences, or high-resolution (TIFF or RAW) pictures, you might want to compare write speeds carefully before you buy. A card that's been tested to write more quickly can come in handy when you don't have time to wait for your photos to be written from your camera's buffer to the memory card. What I always recommend is to buy the fastest memory card you can afford in a size that will hold a decent number of pictures. Then, purchase additional cards in larger sizes at bargain prices as your backups.

For example, if you've got a lot of money to spend, you might want to buy a 2GB "ultra" card as your main memory card for everyday shooting, and stock up on slower, but dirt-cheap 1GB cards to use when your main card fills up. Or, if your budget is limited and you don't need a high-speed card very often, spend your money on a 1GB or larger standard card, and treat yourself to high-speed media in a more affordable size, such as 512MB. That way, if you do need the extra-fast writing speed of an ultra card, you'll have it without spending a bundle on a high-speed/high-capacity memory card. And you'll have plenty of capacity in your standard digital film at an economical price.

You certainly won't be choosing your digital camera based on the kind of storage it uses. Digital SLRs generally rely on CompactFlash for the most part, because CompactFlash media is small enough to be carried around easily and always seems to be on the leading edge of capacities. Smaller form factors, such as the postage stamp-sized Secure Digital card, are not found in as many advanced cameras, and are annoyingly easy to misplace. However, SD cards are rapidly catching up to CompactFlash in capacities, and I'd expect many digital SLRs to have slots for both in the future, similar to the Canon EOS-1Ds Mark II.

Among non-SLR, point-and-shoot digital cameras, the various film card formats are proliferating at an alarming rate. Only the first three formats listed below are likely to see widespread use in digital SLRs, however.

- **CompactFlash.** Among all digital cameras, CompactFlash is the second-most-favored format in the United States and first among digital SLRs. Although larger in size than Secure Digital (SD) cards, CompactFlash cards are still very small and convenient to carry and use. As larger capacities are introduced, they usually appear in CF format first. As a bonus, the CompactFlash slot can also be used for mini hard drives, such as those from IBM, with capacities of a gigabyte or more.

- **Secure Digital.** The SD format overtook CompactFlash as the most popular memory card format in digital cameras with one of the last bastions, Nikon, finally adding an SD card camera to its compact point-and-shoot line. Most other vendors had long since converted for their compact digitals, although Canon continues to offer beginner cameras that use CompactFlash. The postage-stamp-sized SD cards allow designing smaller cameras, are available in roughly the same capacities as CompactFlash, and cost about the same. The chief drawback (to date) is that there are no mini hard drives in the SD format. If you want to use a mini hard disk, you'll need a camera with a CompactFlash slot. Some digital cameras can also use the similar, but slower Multimedia Memory card (MMC). Figure 2.18 shows both CompactFlash and SD memory cards.

- **Mini hard drives.** For a long time, mini hard drives were your only option when you needed more than a gigabyte of storage. If you're using a 6 megapixel or better camera and like to save your images as TIFF files or in another lossless format, you need more than a gigabyte of storage. However, with CompactFlash cards now available in 4GB to 8GB sizes, the mini hard drive is losing its capacity edge, and they have always cost more than the equivalent silicon memory card. Although not excessively prone to failure, mini hard drives do have moving parts and must be handled with more care than memory cards.

Figure 2.18 Although CompactFlash cards are used almost universally for digital SLRs, SD cards are gaining ground, and are already in wide use with compact "SLR-like" cameras using electronic viewfinders.

- **xD and mini-xD.** The xD and mini-XD formats are new, smaller than Secure Digital, and supported by fewer vendors, currently only Olympus and Fuji. Both those companies use CompactFlash cards in their dSLRs, with Fuji offering a slot for xD cards, too. There's little danger that the xD formats will creep over to the dSLR world beyond these two vendors.

- **Sony Memory Stick and Memory Stick Duo.** About the size of a stick of gum, Sony's Memory Sticks are useful because you can also use them with other devices, such as MP3 players. They're not going to replace CompactFlash, though, and are unlikely to find their way into dSLRs.

- **SmartMedia.** I mention this obsolete format only for completeness. These digital film cards were always more popular in Japan than in other countries, chiefly because of their very small size. Because so many digital cameras are made in Japan, there were lots of cameras using SmartMedia. However, because SmartMedia cost more than its chief competitor, CompactFlash, and had lower capacity to boot, these cards have fallen from favor and no new cameras introduced in the past year or so have used them, and you certainly won't find them in dSLRs.

Fortunately, other than write speed, there are few differences among media that are otherwise compatible. SD and MMC (multimedia card) formats are physically and operationally similar. There are some differences between Memory Stick, Memory Stick Pro, and Memory Stick Duo (a smaller version of the Memory Stick), but these will be of little consequence to dSLR users.

False economy

Many serious digital camera shooters are gadget freaks and tinkerers to begin with, so it wasn't a shock when one enterprising soul discovered that a popular $200 MP3 player included a 5GB Hitachi mini hard drive in CompactFlash form factor inside. Because the Hitachi hard drive sold all by itself for twice as much as the MP3 player (the player vendor was obviously getting a huge discount), there was a frantic rush to buy up this particular player, dismantle it, remove the hard drive, and then throw away the MP3 player.

At last report, modifications were made to the hard drives to make them incompatible with digital cameras, and by the time this book is published it's likely that the original MP3 player involved in the scheme will be long since discontinued. Even so, I wanted to make you aware of this fad before, acting on old news, you bought and destroyed an MP3 player for nothing. As I understand it, the latest models of this particular device come in a box with a label that says the internal hard drive is incompatible with digital cameras.

The chief variables involve the CompactFlash line. These cards come in both Type I and Type II varieties. The chief difference between them is that Type I cards are 3.3mm thick, while Type II cards are 5.5mm thick (and thus can have higher capacities). Hitachi Microdrives are actually miniature hard disks in a CompactFlash Type II configuration. Not all digital cameras can accept both Type I and Type II cards, and not all that are compatible with Type II memory cards work with the more power-hungry Microdrives. However, most of the incompatible cameras are older models, and virtually all newer dSLRs have no trouble with any kind of CompactFlash device you care to use.

Choosing the dSLR That's Right for You

You might have studied the explanations of digital SLR technology in this chapter because you're pondering which dSLR to buy. Because technology changes so rapidly, it's unlikely that the camera you buy today will be your last. On the other hand, even the least expensive dSLR is a major investment for most of us, particularly when you factor in the cost of the lenses and accessories you'll purchase. You want to make the right choice the first time.

Indeed, for as long as I've been involved with photography, deciding which SLR family to marry into has been an agonizing decision. No one wants to be locked into a product line that won't do the job, won't keep pace with technology, or, worse, will go belly-up, leaving owners of a particular vendor's equipment orphaned, in a sense. A generation ago, film SLR buyers were committing to cameras produced by companies called Topcon, Miranda, or Yashica. These were fine cameras in their time, but none of them survived to the digital age.

Even among modern digital camera vendors, you have important SLR manufacturers that were late to the party (Konica Minolta, for example) and others with now-you-see-it/now-you-don't products, such as the Contax N Digital, a 6MP digital SLR announced in July, 2000, but later withdrawn from the US market. You can be certain that Konica Minolta is in the digital SLR fray for the long term, but can you be that confident about all the other players in the game?

Digital SLR decision makers often fall into one of four categories:

■ Serious photographers, photo enthusiasts, and professionals who already own lenses and accessories belonging to a particular system, and who need to preserve their investments by choosing, if possible, a dSLR that is compatible with as much of their existing equipment as possible.

- Professionals who buy equipment like carpenters buy routers. They want something that will do the job and is rugged enough to work reliably despite heavy use and mistreatment. They don't necessarily care about cost if the gear will do what's needed, because their organizations or clients are ultimately footing the bill. Compatibility may be a good idea if an organization's shooters share a pool of specialized equipment, but a pro choosing to switch to a whole new system probably won't care much if the old stuff has to fall by the wayside.

- Amateurs and enthusiast photographers with too much money who feel that the only way they will be able to take decent (or better) pictures is to own the very latest consumer-level equipment. These are the people who bought the Canon Digital Rebel when it first came out, but sold everything and switched to the Nikon D70 a few months later to gain some additional capabilities. Six months later they were posting questions in newsgroups about whether they should sell everything again and buy a Canon EOS 20D or maybe a Konica Minolta Maxxum 7D.

- Those who are buying their first dSLR, and either don't own an existing film SLR, or don't particularly care about using their old equipment with a new camera. Often, these buyers don't plan on junking everything and buying into a new system anytime soon, so they are likely to examine all the options and choose the best dSLR system based on as many factors as possible. Indeed, their caution may be why they've waited this long to purchase a digital SLR in the first place.

Questions to Ask Yourself

Once you decide which category you fall into, you need to make a list of your requirements. What kind of pictures will you be taking? How often will you be able to upgrade? What capabilities do you need? Ask yourself the following questions to help pin down your real needs.

How Much Resolution Do You Need?

This is an important question because at the time I write this, dSLRs are available with resolutions from 3.4 megapixels to 16.7 megapixels (and beyond, if you include some exotic camera types). Even more interesting, not all digital SLRs of a particular resolution produce the same results. It's entirely possible to get better photos from a 6 megapixel SLR with a sensor that has low noise and more accurate colors than with a similar 8 megapixel model with an inferior sensor (even when the differences in lens performance is discounted).

Different sensor paradigms can create wildly differing results, too. For example, the Foveon X3 sensor actually has only 3.4 megapixels worth of resolution, but when you consider that each photosite can sense red, green, or blue light without interpolation, the results can theoretically be as good as those produced with sensors having a higher resolution. (In fact, Foveon touts this particular sensor as a 10.2 megapixel imager, though absolute resolution is 2268×1512 pixels.)

Looking at resolution in general, you'll want more megapixels for some types of photography. If you want to create prints larger than 8×10 inches, you'll be happier with a camera having 6 to 10 megapixels of resolution or more. If you want to crop out small sections of an image, you may need a camera with 10 to 12 megapixels. On the other hand, if your primary application will be taking pictures for display on a Web page, or you need thumbnail-sized photos for ID cards or for a catalog with small illustrations, you may get along just fine with a 6 megapixel SLR camera. However, keep in mind that your needs may change, and you might later regret choosing a camera with lower resolution.

How Often Do You Want to Upgrade?

Photography is one field populated by large numbers of technomaniacs who simply must have the latest and best equipment at all times. The digital photography realm rarely disappoints these gadget nuts because newer, more sophisticated models are introduced every few months. If remaining on the bleeding edge of technology is essential to you, a digital SLR *can't* be a long-term investment. You'll have to count on buying a new camera every 18 months to two years because that's how often the average vendor takes to replace a current model with a newer one.

Fortunately, that's a much longer schedule than you'll find in the digital point-and-shoot world, where a particular top-of-the-line camera may be replaced every six months or more often. If you wanted to own the most advanced Nikon non-dSLR over the past five years, you would need to have purchased eight or nine different models. So, don't spend $4,000 for an 8 megapixel dSLR today if you'll be unhappy and unable to upgrade next year when 12 megapixel models cost $1,500.

Trade in—or keep?

Typically, come upgrade time, your old dSLR will be worth more as a hand-me-down to another user than as a trade-in. That's why I'm already looking forward to using my current favorite dSLR as a second or third camera body when I do upgrade to the next generation. When I was using film cameras exclusively, I refused to go anywhere without at least two (and usually three) bodies, and when you consider that while the electronics of dSLRs are more reliable than the mechanical parts of older film cameras, there are more freaky things that can go wrong. An extra body can come in handy.

On the other hand, perhaps you're not on a never-ending quest for a shiny new gadget. You just want great pictures. Once you acquire a camera that does the job, you're not likely to upgrade until you discover there are certain pictures you can't take because of limitations in your current equipment. You'll be happy with a camera that does the job for you at a price you can afford. If your desires are large but your pocketbook is limited, you may want to scale back your purchase to make those inevitable frequent upgrades feasible.

Is a Compact SLR Important to You?

Compared with point-and-shoot digital cameras, all dSLRs are a bit on the chunky side. However, some are more compact than others, and a few, particularly pro models with large battery packs and vertical grips, border on the huge. Before you lay down a large hunk of change for a digital camera, play with it to make sure it's a size that you'll be comfortable lugging around with you. The difference in weight alone can be significant if you're walking around all day with a camera strap around your neck. If you're the sort of photographer who would have been happy with a small, lightweight, virtually silent Leica rangefinder camera (which nevertheless produced superb pictures), you might also prefer a smaller dSLR.

Don't forget to take into account the size of the lenses you'll be using, too. My favorite digital SLR has a 28mm–200mm zoom lens that was touted, on introduction, as the smallest in the world. I'm very happy I have that compact lens with such an extensive zoom range because for many photo outings it's all I need, and I can avoid carrying around a weighty camera bag and a half dozen other lenses. If you need a compact digital SLR, check out the size and weight of the lenses you are likely to use at the same time you examine the heft of the camera body itself.

Do You Want to Share Lenses and Accessories with a Conventional Film Camera?

Do you already own a film camera with lots of lenses and other accessories? You may be able to justify a digital camera built around a camera body similar to the one used by your film camera. The camera need not come from Nikon or Canon, either. Other vendors, such as Kodak and Fuji, build cameras based on models from the two market leaders.

The list of compatible gadgets that can be shared is long, ranging from electronic flash units through filters, close-up attachments, tripods, and so forth. I have a huge stockpile of glass filters and accessories that fit my existing 35mm cameras. I'm able to use some of them using step-up and step-down rings in common sizes, like the adapter shown in Figure 2.19. Make sure that the adapter rings don't cause vignetting of the corners of your image (common with wide-angle lenses) and that your filters have both front and back filter threads so you can stack them. (Some filters, particularly polarizers, may not have a front thread.) You'll pay extra for "thin" adapter rings that keep your filters from projecting out too much in front of your lens, but the premium will be worth it. As an alternative, you may be able to simply zoom in a bit to eliminate those vignetted corners.

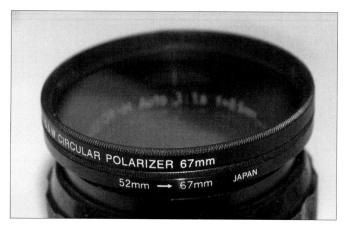

Figure 2.19 Adapter rings let you get double-duty from your filters and other lens accessories.

What Other Features Do You Need?

Once you've chosen your "must have" features for your digital camera, you can also work on those bonus features that are nice to have, but not essential. All digital SLRs share a long list of common features, such as manual, aperture-priority, and shutter-priority exposure modes. All have great autofocus capabilities. Many (but not all) have built-in flash units that couple with the exposure system. Beyond this standard laundry list, you'll find capabilities available in one dSLR that are not found in others. You'll have to decide just how important they are to you as you weigh which system to buy. Here are some of the features that vary the most from camera to camera.

- **Burst mode capabilities.** If you shoot lots of sports, you'll want the ability to shoot as many frames per second as possible for as long as possible. Some cameras shoot more frames per second, and others have larger buffers to let you capture more shots in one burst. For example, one Canon model grabs 4 fps for 32 JPEG images in one burst, or 11 RAW images. Another camera from the same vendor ups the ante to 5 fps, but can capture only 23 JPEG images in one blast. If you've got deep pockets, Canon's top-of-the-

line dSLR blazes through sports photography at an 8.5 fps clip for 40 JPEG or 23 RAW images. And that's just one vendor. You'll find other burst mode capabilities in cameras from Nikon, Minolta, Olympus, Pentax, and others.

- **Anti-shake.** Some dSLRs may have vibration reduction built into the camera (although, as I write this, only one model offers this capability). Other vendors ask you to buy anti-shake lenses, or may not have that capability at all. If you want to hand-hold your camera at low shutter speeds, or need to take rock-steady telephoto shots without a tripod, regardless of shutter speed, you'll want to consider this capability.

- **Higher and lower ISO ratings.** Some cameras offer sensitivities as low as ISO 50 and as high as ISO 6400 and beyond. The need for these depends on what kind of photos you intend to take and how good the results are at the ISO extremes.

- **Special connections.** Most digital SLRs have USB connections to your computer. Some have FireWire (IEEE-1394) links. We're starting to see the ability to exchange photos between camera and computer over wireless connections, too. Although simply removing a memory card and plugging it into a card reader is the most common way of downloading photos, the other options have their place, too. For example, a link between your camera and computer can allow you to take pictures by remote control using the computer as the controller, which might be valuable for surveillance or time-lapse photography.

- **Playback/review features.** You'll find digital SLRs with back-panel LCDs as small as 1.8 inches diagonally, and at least one new model with a 2.5-inch LCD. Guess which LCD is easier to use when it comes time to review your pictures? Not all same-sized LCDs are created equal. Using Canon as an example again, one Canon model with a 2-inch LCD offers 120,000 pixels of resolution, while another is much sharper and brighter at 230,000 pixels. Some systems let you zoom in 3X to 4X on your LCD image, while others offer 10X or more zoom. If reviewing your images in the field is critical, take a close look at how a camera's LCD panel performs.

- **Maximum shutter speed.** Some cameras top out at 1/4,000th second; others go as high as 1/16,000th second. In real life, you'll rarely need such brief shutter speeds to freeze action. It's more likely that the high speeds will come in handy when you want to use wider lens openings at your lowest ISO setting. For example, if you want to use f2.8 on a bright beach or snow scene in full daylight, if your camera's lowest ISO setting is ISO 200, you'll probably need to use a shutter speed of 1/8,000th or 1/16,000th second. If you don't have such fast shutter speeds, you'd better hope you have a neutral density filter or two handy.

I'll look into using these and other special features elsewhere in this book, particularly in Chapter 10.

Next Up

This chapter explained the technology inside your digital SLR. In the next chapter, we're going to look at how you can harness the capabilities of your digital camera's features by using the exposure, controls, focus, burst capabilities, and resolution to best advantage.

3

Mastering Your dSLR's Controls

Although every camera uses different buttons and menus to control key features, each includes some variation on the basic array of controls. This chapter provides an overview of the exposure and focus controls a digital photographer must master, and includes descriptions of how these controls differ between digital cameras and film cameras.

You'll learn about automated exposure modes, using histograms, working with f-stops and shutter speeds, and selecting the right "scene" options. I'll also cover some of the quirks of working with automatic focus systems, too. I'm not going to waste pages on some of the easier controls, like the shutter release, or on setup options such as white balance settings you make using your menu system. The emphasis here will be on the most important controls you use for everyday shooting.

Exposure Controls

After composition, the two most important aspects of getting a great photograph are zeroing in on the correct exposure and having the image focused properly. Your dSLR can take care of both of these for you automatically—most of the time. When exceptions occur, it's time for you to step in and use your camera's controls to fine-tune your images. This section deals with exposure; I'll explain focus later in this chapter.

Correct exposure is a necessity because, as you'll recall from Chapter 2, no digital camera sensor can capture detail at every possible light level. In very dark portions of a scene, there will be too few photons to register in the individual photosites. If part of the scene is very light, the pixel "wells" will overflow and stop collecting additional photons. Some of the excess may spill over onto adjacent pixels, causing a blooming effect.

The goal of setting exposure is to either increase the number of photons available to register details in dark areas (by boosting the exposure) or to decrease the number of photons flooding

the photosites in the dark areas (by reducing the exposure). Like film, sensors are unable to handle high-contrast situations in which there is a large variation in brightness between the dark and light areas. The degree to which a sensor can handle such variations is called its *dynamic range* and was explained in Chapter 2. However, even a sensor with a broad dynamic range won't handle the most extreme lighting conditions, so the "correct" exposure is likely to be a compromise that preserves detail at one end of the brightness scale at the expense of detail at the other end.

Generally, that means avoiding the clipping off of highlight detail caused by overexposure. Once a pixel bucket is "full," that pixel is rendered as pure white with no detail at all. There is no point in collecting additional photons and, as I mentioned, doing so can spoil the image in surrounding pixels. On the other hand, information can often be retrieved from darker areas of an image, even if those areas are underexposed, usually by multiplying the data that is there.

Image-processing algorithms can often do a good job of this, which is why increasing your camera's ISO sensitivity can improve the amount of detail captured in shadows. Enhancing underexposed areas is likely to produce noise, though. You can see how this works at a primitive level in your image editor using the Brightness control. Moving the Brightness slider to the right lightens shadow areas enough that you may be able to see details that were previously cloaked in darkness. However, moving the same slider to the left to darken overexposed highlight areas won't produce additional detail—it will only turn the white blocks into a featureless gray.

Digital camera autoexposure systems are optimized to attempt to preserve highlight detail (which is otherwise lost forever) at the expense of shadow detail (which can sometimes be retrieved). Any changes in how exposure is made that you make will simply be aimed at improving the relationship between the actual brightness levels in a scene, and what is captured by your camera.

Tonal Range

The tonal range of an image is the range of dark to light tones, from a complete absence of brightness (black) to the brightest possible tone (white), and all the middle tones in between. Because all values for tones fall into a continuous spectrum between black and white, it's easiest to think of a photo's tonality in terms of a black-and-white or grayscale image, even though you're capturing tones in three separate color layers of red, green, and blue.

In conventional photography, grayscale images (which we call black-and-white photos) are easy to understand. Or, at least, that's what we think. When we look at a black-and-white photo, we think we're seeing a continuous range of tones from black to white, and all the grays in-between. But, that's not exactly true. The blackest black in any photo isn't a true black because *some* light is always reflected from the surface of the print. The whitest white isn't a true white, either, because even the lightest areas of a print absorb some light (only a mirror reflects close to all the light that strikes it).

Indeed, photographic manufacturers have been engaged in a never-ending quest to find "whiter" photographic papers. You can compare two prints made on different papers and easily see that one may have darker blacks and brighter, whiter whites than the other. That continuous set of tones doesn't cover the full grayscale spectrum.

Of course, in the digital realm, no scale is ever truly continuous. An analog watch divides a minute into the smooth 360-degree movement of a second hand, while a digital clock insists on slicing up that same minute into designated increments (whether they're seconds, tenth-seconds, or some other measurement). Your digital camera does the same thing, slicing up the

grayscale spectrum, by convention, into 256 distinct tones (although the actual number of different tones that can be captured may be much higher, thanks to the sensor's *dynamic range*, discussed in Chapter 2. For simplicity's sake, we can think of the tonal scale as having just 256 different values. Black is assigned a value of 0 (no brightness), while white is assigned a value of 255 (maximum brightness). Every tone in between, from an almost-black dark gray to an almost-white super-light gray, must be represented by one of the other 254 numbers between 0 and 255.

The full scale of tones becomes useful when you have an image that has large expanses of shades that change gradually from one level to the next, such as areas of sky, water, or walls. Think of a picture taken of a group of campers around a campfire. Since the light from the fire is striking them directly in the face, there aren't many shadows on the campers' faces. All the tones that make up the *features* of the people around the fire are compressed into one end of the brightness spectrum, the lighter end.

Yet, there's more to this scene than faces. Behind the campers are trees, rocks, and perhaps a few animals that have emerged from the shadows to see what is going on. These are illuminated by the softer light that bounces off the surrounding surfaces. If your eyes become accustomed to the reduced illumination, you'll find that there is a wealth of detail in these shadow images.

This campfire scene would be a nightmare to reproduce faithfully under any circumstances. If you are an experienced photographer, you are probably already wincing at what is called a *high-contrast* lighting situation. Some photos may be high in contrast when there are fewer tones and they are all bunched up at limited points in the scale. In a low-contrast image, there are more tones, but they are spread out so widely that the image looks flat. Your digital camera can show you the relationship between these tones using something called a *histogram*.

Histogram Basics

Digital SLR cameras, as well as many point-and-shoot models include histogram displays, which are charts on the LCD that show the number of tones being captured at each brightness level. Here, the non-SLR cameras have an advantage: EVF and point-and-shoot models can display a real-time "live histogram" on the LCD as you compose an image. You can then make immediate adjustments to optimize exposure.

A dSLR, on the other hand, can't show a preview image because the flip-up mirror gets in the way of the sensor prior to exposure (see Chapter 9 to learn more), so histograms must be viewed *after* you've taken the picture. Your only recourse is to adjust exposure for the next shot you take.

A histogram is a simplified display of the numbers of pixels at each of 256 brightness levels, producing an interesting mountain range effect, as you can see in Figure 3.1. Each vertical line in the graph represents the number of pixels in the image for each brightness value, from 0 (black) on the left and 255 (white) on the right. The vertical axis measures that number of pixels at each level.

Figure 3.1 A histogram shows the relationship between the number of tones at each brightness level.

The sample histogram shows that most of the pixels are concentrated roughly in the center of the histogram, with relatively few very dark pixels (on the left) or very light pixels (on the right). It represents a fairly good exposure because no image information is being clipped off at either end, even though some of the camera's ability to record information in the dark and light areas is being wasted.

With an image of normal contrast and typical subject matter, the bars of the histogram will form a curve of some sort. Figure 3.2 shows an image with fairly normal contrast. See how the bars of the histogram create a curve across most of the width of the grayscale. However, there aren't really any true black areas in the photo, which you can tell from the histogram: There are no tones at all at the far left.

Figure 3.2 This image has fairly normal contrast, even though there are no true blacks showing in the histogram.

With a lower-contrast image, like the one shown in Figure 3.3, the basic shape of the histogram will remain recognizable, but gradually will be compressed together to cover a smaller area of the gray spectrum. The squished shape of the histogram is caused by all the grays in the original image being represented by a limited number of gray tones in a smaller range of the scale.

Figure 3.3 This low-contrast image has all the tones squished into one end of the grayscale.

Instead of the darkest tones reaching into the black end of the spectrum and the whitest tones extending to the lightest end, the blackest areas are now represented by a light gray, and the whites by a somewhat lighter gray. The overall contrast of the image is reduced. Because all the darker tones are actually a middle gray or lighter, this version of the photo appears lighter as well.

Going in the other direction, increasing the contrast of an image produces a histogram like the one shown in Figure 3.4. In this case, the tonal range is now spread over a much larger area, and there are many tones missing, causing gaps between bars in the histogram. When you stretch the grayscale in both directions like this, the darkest tones become darker (that may not be possible) and the lightest tones become lighter (ditto). In fact, shades that might have been gray before can change to black or white as they are moved toward either end of the scale.

The effect of increasing contrast may be to move some tones off either end of the scale altogether, while spreading the remaining grays over a smaller number of locations on the spectrum. That's exactly the case in the example shown previously. The number of possible tones is smaller, and the image appears harsher.

Figure 3.4 A high-contrast image produces a histogram in which the tones are spread out.

Using the Histogram

The important thing to remember when working with the histogram display in your camera is that changing the exposure does *not* change the contrast of an image. The curves shown in the previous three examples remain exactly the same shape when you increase or decrease exposure. I repeat: The proportional distribution of grays shown in the histogram doesn't change; it is neither stretched nor compressed. However, the tones as a whole are moved toward one end of the scale or the other, depending on whether you're increasing or decreasing exposure.

So, as you reduce exposure, tones gradually move to the black end (and off the scale), while the reverse is true when you increase exposure. The contrast within the image is changed only to the extent that some of the tones can no longer be represented when they are moved off the scale.

To change the *contrast* of an image, you must do one of three things:

- Change your digital camera's contrast setting using the menu system.

- Attempt to adjust contrast in post-processing using your image editor or RAW file converter.

- Alter the contrast of the scene itself, for example by using a fill light to add illumination to shadows that are too dark.

Of the three of these, the last one is the most desirable because attempting to fix contrast by fiddling with the tonal values is unlikely to be a perfect remedy. Adding a little contrast can be successful because you can discard some tones to make the image more contrasty. However, the opposite is much more difficult. An overly contrasty image rarely can be fixed because you can't add information that isn't there in the first place.

What you *can* do is adjust the exposure so that the tones *that are already present in the scene* are captured correctly. Figure 3.5 shows the histogram for an image that is badly underexposed. You can guess from the shape of the histogram that many of the dark tones to the left of the graph have been clipped off. There's plenty of room on the right side for additional pixels to reside without having them become overexposed. So, you can increase the exposure (either by changing the f-stop or shutter speed, or by adding an EV value) to produce the corrected histogram shown in Figure 3.6.

Figure 3.5 A histogram of an underexposed image may look like this.

In addition to a histogram, your dSLR may also have an option for color coding the lightest and darkest areas of your photo during playback, so you can see if the areas that are likely to lose detail are important enough to worry about. For example, if all the dark-coded areas are in the background, you can forget about them, but if such areas appear in facial details of your subject, you may want to make some adjustments.

Figure 3.6 Adding exposure will produce a histogram like this one.

Alternatively, an image may be overexposed, generating a histogram like the one shown in Figure 3.7. Reducing the exposure a stop or two will create the more optimized histogram you saw in Figure 3.6.

Figure 3.7 A histogram of an overexposed image will show clipping at the right side.

What's EV?

EV stands for Exposure Value, and is a shortcut for representing changes in exposure regardless of whether they are made using the aperture or shutter speed controls. As you know, changing the settings from 1/125th second at f8 to 1/60th second at f8 doubles the exposure because the shutter speed has been made twice as long. Similarly, opening up the f-stop while leaving the shutter speed alone (making the exposure 1/125th second at f5.6) *also* doubles the exposure. Sometimes you won't care which method is used because the shutter speed will still be fast enough to freeze whatever action is present, and the aperture will still provide adequate depth-of-field. In those cases, if you're using a programmed exposure mode (in which the camera selects both shutter speed and aperture), you'll find it easiest to use your camera's EV adjustment to add or subtract EV from the exposure. The camera will choose which parameter to change to provide the requested modification. EV values can be added in half-stop or third-stop increments (or some other value). Dialing in a +1/2 EV change will increase exposure by one-half f-stop/shutter speed value. Setting a –1/2 EV change will reduce exposure by the same amount.

Using Aperture Priority, Shutter Priority, and Manual Exposure

Although digital SLRs have fully programmed exposure controls that will choose both aperture and shutter speed for you in a fairly sophisticated way, I've found that most dSLR users prefer to use aperture- or shutter-priority exposure modes most of the time because they, rather than the camera, usually have a better idea of what kind of subject matter is being framed in the viewfinder, and therefore what f-stop or shutter speed might be best for the scene.

For example, if you're shooting sports, you'll probably want to use a relatively high shutter speed as often as possible. That speed may be 1/1,000th second, or 1/500th second, or as slow as 1/125th second if the illumination is sparse, but you need to decide the minimum shutter speed you want to use in this kind of situation. Digital SLRs, like other modern digital and film cameras, have a mode called *shutter priority* in which you set the shutter speed, and the camera uses its metering functions to set an appropriate aperture to create the proper exposure. If not enough light (or too much light) is present for a correct exposure at the chosen shutter speed, an indicator will appear in the viewfinder, perhaps a readout that says LO or HI, or an LED. You can then manually choose a different shutter speed, but the choice is always in your hands.

The reverse is true for *aperture priority*, in which you set the f-stop and the camera chooses the shutter speed. You might want a small aperture to maximize depth-of-field, or a large aperture to reduce it for a selective focus effect. Again, an alert will appear if the f-stop you prefer is out of the comfortable exposure range.

Here's a trick you might not have thought of: you can use the *opposite* exposure mode than the one you might have chosen in some situations. For example, if you want to use the highest possible shutter speed under changing lighting conditions, instead of working in shutter-priority mode, use aperture priority instead and set your camera to the widest possible f-stop. The camera will automatically choose the fastest shutter speed available to ensure correct exposure. Or, if you want a relatively large or small f-stop for depth-of-field reasons, but don't mind if it varies by a stop or two either way, select shutter priority and set whichever shutter speed corresponds to roughly the f-stop you prefer. If the light changes a bit in either direction, your camera will compensate.

Manual exposure mode lets you set both shutter speed and aperture. There are several reasons for using manual exposure:

- **When you want a specific exposure for a special effect**. Perhaps you'd like to deliberately underexpose an image drastically to produce a shadow or silhouette look. You can fiddle with EV settings or override your camera's exposure controls in other ways, but it's often simpler just to set the exposure manually.

- **When you're using an external light meter in tricky lighting situations or for total control**. Advanced photographers often fall back on their favorite hand-held light meters for very precise exposure calculations. For example, an incident meter, which measures the light that falls on a subject rather than the light reflected from a subject, can be used at the subject position to measure the illumination in the highlights and shadows separately. This is common for portraits because the photographer can then increase the fill light, reduce the amount of the main light, or perform other adjustments. Those enamored of Zone System exposure (a marvelously effective and complex system of exposure developed by Ansel Adams, which now has virtual cult status) might also want the added control an external light meter provides.

- **When you're using an external flash that's not compatible with your camera's TTL (through-the-lens) flash metering system**. You can measure the flash illumination with a flash meter, or simply take a picture and adjust your exposure in manual mode.

- **When you're using a lens that doesn't couple with your digital camera's exposure system**. Several digital SLR models can use older lenses not designed for the latest modes of operation, although they must be used in manual focus/exposure mode. I have several specialized older lenses that I use with my dSLR in manual focus/manual exposure mode. They work great, but I have to calculate exposure by guesstimate or by using an external meter. My camera's exposure system won't meter with these optics under any circumstances.

Of course, to use aperture-priority, shutter-priority, or manual exposure, you'll need to master your camera's f-stop and shutter speed controls. Usually, that's ridiculously easy compared with point-and-shoot cameras which, if they have directly selectable exposure controls at all, may require a trip to the menus and pressing some arcane combination of buttons to set f-stop or shutter speed.

With a dSLR, the process is much easier. You'll have separate shutter speed and aperture controls that can be easily adjusted, as long as the camera is not set for a fully automatic exposure mode. One popular convention is to have a jog dial on the front of the camera (near the lens) adjust the aperture, while the dial on the back of the camera (nearest the shutter) is used to adjust the shutter speed.

You might also find an aperture control on the barrel of the lens. However, lenses built for cameras that can control the f-stop electronically sometimes have no aperture ring at all. That's a problem only if you intend to use that lens on an older camera that must use manual aperture selection *or* if you want to use such a lens in manual mode, say, attached to a bellows for extreme close-ups. I retain an older macro lens for exactly that reason. It's been modified to work fine on my dSLR, although only the autodiaphragm operates; I need to focus and calculate exposure manually. When I fasten it to an extension tube or bellows, the aperture ring is there when I need it to set the f-stop.

Programmed Exposures

Digital cameras have modes, usually designated by P and A, which select the f-stop and shutter speed for you. The difference is usually that in P (programmed) mode, you can override the camera's settings. In A (automatic) mode, the camera's settings can't be modified. This is the mode you'd use when you stop a stranger on the street and ask him to take a picture of you and your family posing in front of the Eiffel Tower. Even a klutz won't be able to mess up the settings, assuming your camera does a good job in the first place.

Both modes usually use some incredibly complex intelligence to analyze your scene and choose an appropriate f-stop and shutter speed. For example, the camera may try to use a relatively high shutter speed to counter camera shake, but switch to lower shutter speeds only under very low light conditions. The combinations of best f-stop and shutter settings are built into the camera by the vendor.

Although fully programmed exposures can do a decent job, serious digital photographers might use the P mode only when they first get their dSLRs, and will soon switch to aperture- or shutter-priority, or even manual mode once they learn exactly how much fun it is to tweak settings. You can see a typical dSLR Mode dial's options in Figure 3.8.

Figure 3.8 A dSLR's Mode dial offers various exposure options, including priority modes and scene modes.

Digital SLRs also have a few "Scene" modes, which I call Idiot modes, which adjust settings based on the needs of particular types of pictures, such as sports, landscape, or portrait photos. Some point-and-shoot models have upwards of 25 Scene modes, including some silly ones such as Food (increased saturation to make the food look better) and Museum (locks out the flash even in low light, so you won't get kicked out of the venue). Scene modes make some settings for you, and may limit the other settings you can make by blocking out overrides for focus, exposure, brightness, contrast, white balance, or saturation.

I don't know any dSLR users who work with Scene modes regularly, but they're handy if you're a neophyte and fear that the basic programmed exposure modes won't do the job. Here are some of the common Scene modes found in digital SLRs:

- **Portrait.** This Scene mode uses a large f-stop to throw the background out of focus and generally sets the flash (if used) for red-eye reduction mode.

- **Night.** Reduces the shutter speed to allow longer exposures without flash, and to allow ambient light to fill in the background when flash is used.

- **Night portrait.** Uses a long exposure, usually with red-eye flash, so the backgrounds don't sink into inky blackness.

- **Beach/Snow.** May slightly overexpose a scene to counter the tendency of automatic metering systems to overcompensate for very bright settings.

- **Sports.** Uses the highest shutter speed available to freeze action, and may choose spot metering to expose for fast-moving subjects in the center of the frame.

- **Landscape.** Generally selects a small f-stop to maximize depth-of-field, and may also increase the saturation setting of your camera to make the landscape more vivid.

- **Macro.** Some cameras have a close-up Scene mode that shifts over to Macro focus mode and adjusts how your camera selects focus.

Exposure Metering

Regardless of whether you're using fully automatic, programmed, or aperture/shutter priority, or manual mode using your camera's exposure indicators as a guideline, you'll want to choose a metering method that suits your situation. Metering controls fall into two different categories: *metering mode*, which is the method the camera uses to gather the information it uses to make exposure decisions, and *evaluation mode*, which are the rules used to calculate the correct exposure from the information collected.

Metering Mode

Digital SLRs use light-sensitive electronics to measure the light passing through the lens. In the early days of non-digital SLRs, that capability was considered something of a miracle in itself because cameras of that era frequently captured exposure information through clumsy photocells mounted on the *outside* of the camera body. The alternative was to use a hand-held meter. Such systems were relatively low in sensitivity, and you had to be incredibly lucky for the light captured by the meter to have some correspondence with the illumination that actually reached the film. Of course, if you used a filter or other add-on, all bets were off. Photographers were delighted when cameras were introduced that actually measured light destined for the film itself.

Of course, we now take TTL metering for granted. Digital SLRs use much more refined methods of metering light, too, compared to the earliest through-the-lens models, which captured an amorphous blob of light without much regard to where it originated in the image. Modern metering systems can be divided into several categories:

- **Center weighting.** While early cameras had a form of averaging metering, in which light from all portions of the viewfinder was captured, in truth they tended to emphasize the center portion of the frame. This bug was turned into a feature and center-weighted averaging was born. Most of the exposure information is derived from the middle of the frame.

- **Spot metering.** This method gathers exposure information only from a central portion of the frame. You may be able to choose from a 6mm or 8mm spot, or larger. Light outside the spot area is ignored. Figure 3.9 shows a typical center spot arrangement.

- **Multipoint metering.** Exposure information is collected from many different positions in the frame, and then used to calculate the settings using one of several calculation routines.

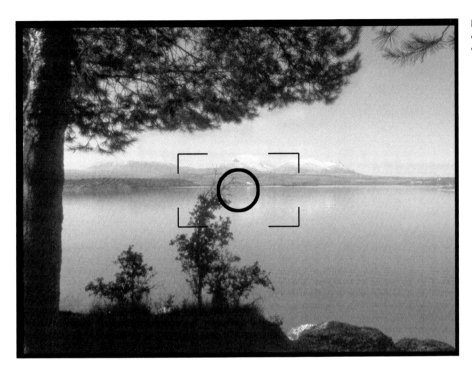

Figure 3.9 Spot metering collects exposure information only from the center of the frame.

Evaluation Mode

Once the camera's metering system has captured the amount of illumination passing through the lens, the information is evaluated and the correct exposure determined. Although metering and evaluation are a continuous process, I've broken it into two pieces to emphasize that not all light metering methods use the same process to evaluate the information to determine the final exposure.

For example, there are center-weighted systems, and there are center-weighted systems. One vendor's camera may calculate exposure based on an average of all the light falling on a frame, but with extra weight given to the center. Others may use a modified spot system with a really large, fuzzy spot, so that light at the periphery of the frame is virtually ignored.

Similarly, spot metering can vary depending on what the camera elects to do with the spot of information, and how much flexibility the photographer is given over the process. For example, as I mentioned, you might be able to choose the size of the spot. Or, you may be allowed to move the spot around in the viewfinder using your camera's cursor controls, so that you meter the subject area of your choice, rather than a central area forced on you by the camera. You'll find this option especially useful for backlit subjects or macro photography.

Multipoint metering in the past has been used in both simple and sophisticated metering systems. For example, if the camera detects that the upper half of the frame is brighter than the bottom half, it may make a reasonable assumption that the image is a landscape photo and calculate exposure accordingly. Figure 3.10 shows an incredibly simplified example of how samples might be allocated. (In modern multipoint systems, hundreds or thousands of different points might be measured. Nikon, for example, uses a 1005-cell CCD in the viewfinder of its D70 to collect individual pieces of exposure data.)

Figure 3.10 A multipoint exposure system uses different zones, as shown in this simplified example.

The most complex evaluation systems use what is called *matrix* or *evaluative* calculation. In these modes, brightness patterns from a large number of metering zones in the frame are collected, and then compared against a large database of sample pictures compiled by the camera manufacturer. Your camera is not only capable of figuring out that you're shooting a landscape photo, it can probably spot portraits, moon shots, snow scenes, and dozens of other situations with a high degree of accuracy.

In addition, these highly sophisticated evaluation systems use a broad spectrum of information to make exposure decisions. In addition to overall brightness of the scene, the system may make changes based on the focus distance (if focus is set on infinity, the image is more likely to be a landscape photo); focus or metering area (if you've chosen a particular part of the frame for focus or metering, that's probably the center of interest and should be given additional weight from an exposure standpoint); the difference in light values throughout the frame (effectively, the contrast of the image); and, finally, the actual brightness values encountered.

As I mentioned earlier, it's often smart to build in some bias towards underexposure because incorrectly exposed shadows are easier to retrieve than blown highlights. Evaluative metering systems use that kind of bias, and other factors to calculate your exposure. For example, in dark scenes, the tendency is to favor the center of the photo. In scenes with many bright values, extra attention is given to the brightest portions, especially if the overall contrast of the image is relatively low. Your best bet is to become familiar with how your own camera's exposure systems work in the kinds of photo situations you favor.

Exposure lock and bracketing

Digital SLRs, as well as other cameras, include an exposure lock/focus lock button you can use to capture the current exposure settings without the need to continuously hold down the shutter release. The exposure and/or focus remains locked until you take the next picture, allowing you to reframe or do other things before you actually depress the shutter release to capture the image.

Another little-used control you might find handy is the bracketing option, which automatically provides settings with less and additional exposure (clustered around your base exposure), using an increment (such as 1/3 or 1/2 stop) that you select. More advanced systems can also bracket other values, such as white balance, either individually or in conjunction with other settings.

Focusing

Correct focus is another critical aspect of taking a technically optimized photograph. You want your main subject to be in sharp focus generally (there are exceptions), and you may want other parts of the image to be equally as sharp, or you may want to let them become blurry to use selective focus techniques (described in more detail in Chapter 6, and shown in Figure 3.11).

With point-and-shoot cameras, focus is seldom a consideration until you enter the macro realm. The short focal length lenses on those models force everything into sharp focus, which is either a good thing or a bad thing, depending on whether you wanted to use focus creatively.

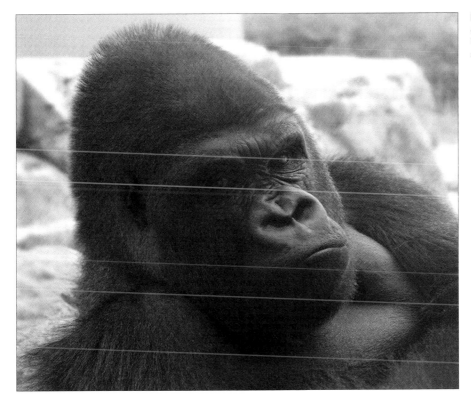

Figure 3.11 Selective focus has the double benefit of blurring the background and making your subject appear sharper by comparison.

Digital SLRs aren't necessarily susceptible to this problem/advantage. You can choose to focus the image yourself, manually, let the camera focus for you, or step in and fine-tune focus after the camera has done its best. There are advantages and disadvantages to each approach.

Manual Focus

With manual focus, you twist the focus ring on your lens until the image you want pops into sharp focus. For some who are new to photography, this may be an almost forgotten skill, but it's easy to learn. Many dSLRs have a cool feature: Even if you're focusing manually, a focus indicator LED may light up when you've achieved correct focus, giving you some helpful extra confirmation. Some points to consider about manual focus are these:

- **Speed.** Manual focus takes more time, compared to the speedy operation of autofocus systems. If you're shooting contemplative works of art, portraits in which your subjects will generally stay put for a period of time, or close-up pictures, the speed of manual focus may be no consideration at all. For action photography, however, you may not be able to change focus quickly enough to keep up. You can read more about manual focus and action in Chapter 8.

- **Non-Memory Effect.** The eye (the brain actually) doesn't remember focus very well. That's why you must jiggle the focus ring back and forth a few times using smaller and smaller movements until you're certain the image is sharply focused. You never really know if optimal focus is achieved until the lens starts to de-focus. So, manual focus may actually be a trial-and-error experience.

- **Difficulty.** Focusing is most easily done when the image is bright and clear, the depth-of-field of the image being viewed is shallow, and there is sufficient contrast in the image to make out details that can be brought in and out of focus. Unfortunately, you'll frequently encounter scenes that are dim and murky, with little contrast, and be using a slow lens that compounds the problem.

- **Accuracy.** On the other hand, tweaking focus manually is the best way to ensure that the exact portion of the image you want to be sharp and clear *is* sharp and clear. If you're using selective focus creatively, manual focus is the only way to go.

- **Following Action.** Today's autofocus systems are sophisticated enough that they can use *predictive focus* to track moving subjects and keep them in focus as they traverse the frame. Even so, it may be easier to manually focus on a point where you know the action is going to be, and trip the shutter at the exact right moment. The human brain still has some applications.

The glass ceiling...

Manual focus is especially helpful if you're shooting through glass. Some autofocus mechanisms focus on the glass pane instead of the subject behind it. That's not a problem if you focus manually.

Autofocus

As with exposure, digital cameras use different kinds of methods to collect focus information and then evaluate it to produce the correct focus. These generally work by examining the contrast of the image as the lens elements are moved back and forth to change focus. The image will be in sharp focus at the position of highest contrast. An autofocus system may rely on the ambient illumination on the subject, or use a special autofocus light source built into the camera to improve the lighting under dim conditions. A few cameras use a wacky hologram-like grid pattern projected onto a subject, and which can be used to focus based on the deformation of the pattern.

Autofocus Considerations

No matter how autofocus is accomplished, there are a host of things to keep in mind when using this feature. I outlined a few of them in the section on manual focus. Here are some more points to ponder.

- **Autofocus speed.** The speed at which your autofocus mechanism operates can be critical. Because autofocus is built into the lens, rather than the camera, this speed is highly dependent on the design of the lens. Some models focus more slowly than others, either because focusing involves lens elements that can't be shifted rapidly, or because the motors and actuators in the system move too darn slowly.

- **Autofocus technology.** Different digital SLRs use different autofocus systems, even among systems offered by the same vendor. These differences can involve the type and number of sensors used to calculate focus. Sensors can consist of lines of pixels that are evaluated, or cross-hatched sections that cover more area. Focus systems might have four to nine different sensor areas (or more), concentrated in different parts of the viewscreen area, or even overlapping. Different sensors may be used in bright light than in dim light. Plus, you may be able to *move* the sensor's viewpoint from place to place in the frame, using your camera's cursor keys.

- **Autofocus evaluation.** How and when your camera applies the autofocus information it calculates can affect how well your camera responds to changing focusing situations. As with exposure metering systems, your camera may use the focus data from the various sensors differently, depending on other factors and settings. You use the equivalent of spot focus, center-weighted focus, and something that operates very much like averaging focus (although the camera will still select a point of interest to zero in on, no matter where it appears in the frame).

Autofocus Parameters

To save battery power, your dSLR doesn't start to focus the lens until you partially depress the shutter release. But, autofocus isn't some mindless beast out there snapping your pictures in and out of focus with no feedback from you after you press that button. There are several settings you can make that return at least a modicum of control to you. Here are some of the parameters you have to work with.

- **Continuous autofocus.** In this mode, once the shutter release is partially depressed, the camera sets the focus, but continues to monitor the subject, so that if it moves or you move, the lens will be refocused to suit. This setting may be your best bet for fast-moving subjects and sports. The chief drawbacks of this system are that it's possible to take an out-of-focus picture if your subject is moving faster than the focus mechanism can follow, it uses more power, and it makes a distracting noise.

- **Single autofocus.** In this mode, once you begin to press the shutter release, focus is set once, and remains at that setting until the button is depressed, taking the picture, or you release the shutter button without taking a shot. For non-action photography, this setting is usually your best choice, as it minimizes out-of-focus pictures (at the expense of spontaneity). The drawback here is that you might not be able to take a picture at all while the camera is seeking focus; you're locked out until the autofocus mechanism is happy with the current setting.

- **Dynamic focus area.** Because your dSLR has more than one focus sensor checking your frame, it may shift among them as focus is calculated. With dynamic area autofocus, the camera may automatically switch from using one sensor to a different sensor if it detects subject motion.

- **User selected focus area.** You switch from one focus area to another using the cursor pad, as shown in Figure 3.12. Autofocus systems frequently use the same general zones applied by the autoexposure system, and use a single on-screen set of indicators to show them. The focus area in use will often be indicated by a glowing red light, as you can see in the figure. (I've filled in the other autofocus zones to make them easier to see; in your viewfinder they are less obtrusive.)

- **Nearest subject.** In this mode, the autofocus system looks for the subject matter that's closest to the camera, no matter where it is located in the frame, and focuses on that.

- **Focus lock.** Your digital SLR has a focus-locking button that lets you fix the focus at the current point until you take a picture.

Figure 3.12 When you switch from one autofocus zone to another, the focus priority area often will be indicated with a green or red glow.

■ **Focus override.** Cameras and lenses generally have an AF/M button you can use to switch between autofocus and manual. Some let you use a mode that focuses automatically, but which can be fine-tuned manually with no danger of grinding gears or gnashing teeth.

■ **Macro lock/lockout.** Some cameras and lenses have a provision for locking the lens into macro position so focus can be achieved only within the narrower close-up range. Or, you might find a macro lockout feature, which keeps the autofocus mechanism from trying to focus closer than a given distance. That can come in handy when you're shooting distant subjects because the lens won't bother seeking close focus, which can be time-consuming.

■ **Autofocus assist lamp.** This is an optional feature that can improve autofocus operation in low-light situations. The light, which is most often either white or red, is rarely strong enough to be of much help beyond a few feet, tends to be annoying to your human or animal subjects, and uses enough power to drain your battery a bit.

Extra focus control

Nikon has pioneered a series of so-called DC-Nikkor lenses, which includes something called *defocus image control,* which actually allows you to change the characteristics of the out-of-focus portions of your image. There's even a DC ring on the lens you can play with and preview the effects in your dSLR's viewfinder. This magic is performed using another one of those bugs-cum-features tricks, in which normally undesirable spherical aberrations produced by the lens are manipulated to generate out-of-focus blur effects that are desirable for portraits and some kinds of close-ups. Available in 105mm and 135mm focal lengths, these lenses have the added bonus of extra speed, with f2 apertures that make selective focus even easier to achieve. Expect to pay $1,000 each or more for these specialized optics.

Next Up

The next chapter is going to continue our exploration of the quirks and advantages of dSLR cameras, with a look at viewfinder anomalies, the terrors of sensor cleaning, and some secrets of in-camera digital storage. If you've been wondering what those funny spots are in your images of late, this chapter is for you.

4

dSLR Quirks and Strengths

If you're accustomed to working with a point-and-shoot digital, or even with an advanced model using an electronic viewfinder, you'll find that digital single-lens reflexes have their own particular set of advantages and quirks that you must learn about. Even if you've been working with film SLRs for years, you'll soon discover that the dSLR is a different type of animal.

While the design of digital SLRs solves many of the problems that may have vexed you with other digital or film cameras, every silver lining can be cloaked in a troublesome cloud. Minor flecks of dust that settle onto your film images can be wiped off or retouched out of the picture quickly and easily, and clean habits can minimize this problem. In contrast, dust that attaches itself to your digital sensor may be almost impossible to avoid (unless you confine your shooting to a clean room) and can mar hundreds of images unless you do something.

Your dSLR has some viewfinder anomalies you should know about, and there are some secrets to storing images efficiently and using the various automated exposure modes. This chapter will clear up some of the confusion around dealing with a dSLR's quirks and strengths, and show you how to use both to improve the quality of your picture-taking experience. Not every topic is 100 percent exclusive to digital SLRs; for example, film SLRs need to deal with mirror bounce, too. However, I'm going to show you how each foible applies to digital cameras.

It's Done with Mirrors

I described some basics of how dSLRs provide their dazzling through-the-lens view in Chapter 2. Now we're going to look a little more closely at how the viewing system affects your photography.

A key component in any SLR camera is the mirror located immediately behind the lens. This mirror reflects all or part of the light that passes through the lens upwards (or sideways, in the case of some odd-ball designs like the Olympus E-300/EVOLT) towards the viewing mechanism. That can consist of a focusing screen that images the picture, plus a prism or set of mir-

rors that takes the screen's upside-down and reversed view and orients it properly. During exposure, the mirror flips up, allowing the light to continue unimpeded to the sensor. Figure 4.1 shows a highly simplified version of the path of light through a digital single lens reflex.

That's the quick version. In practice, there are lots of other factors to consider if you want to understand how your SLR-viewing system works with you and against you. Let's start with the mirror itself. That little reflective rectangle has to be carefully designed and activated so that the light is reflected towards the viewfinder in precise alignment. Otherwise, your view—particularly of focus—would be inaccurate, and mechanisms within the camera that work with the viewfinder's image, such as the autoexposure and autofocus features, wouldn't work properly.

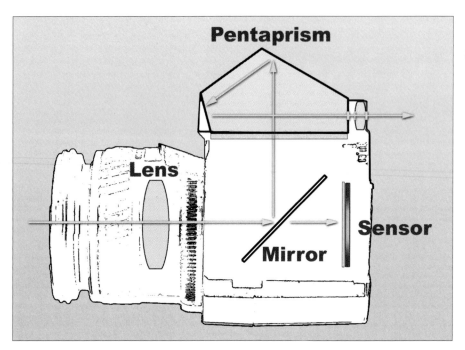

Figure 4.1 Light from the lens bounces off the mirror, through the pentaprism, and out through the viewfinder window.

Mirror Bounce

One thing to keep in mind about the mirror is that, during exposure, its upward travel, brief pause while the picture is made, and then return to the viewing position causes a tiny bit of vibration. Poorly designed mirrors may even "bounce" when they reach their full, upright position. This vibration can, and sometimes does, albeit rarely, affect the sharpness of the photograph, introducing a small amount of "camera shake" during the exposure. Even placing the camera on a tripod and using the self-timer, remote control, or a cable release to trigger the picture can't eliminate this effect. You're most likely to see the consequences of mirror slap on exposures that are long enough for the vibration to have an effect, but not so long that the vibrating portion of the exposure isn't significant. In other words, an exposure of 1/4 second is more likely to be marred by tiny vibrations than one that's 30 seconds long. Mirror movement can spoil images made through a microscope, too, by disturbing the delicate camera/scope setup.

In the past, some camera vendors have tried to get around this problem by using mirrors that were only partially silvered, so that part of the illumination always goes to the viewfinder, and part always continues to the film or sensor. Such *pellicle* mirrors don't need to flip up or down at all. Canon and Nikon have both offered cameras of this type, although in some cases they were special-order or custom-built models.

There are a number of problems with pellicle mirror systems. The most obvious is that with a non-moving mirror, the full amount of light coming from the lens never reaches the viewfinder *or* the film/sensor, so the view is likely to be darker than with a flip-up mirror, and less illumination is available for exposure. The second most important drawback is that pellicle mirrors must be kept very, very clean. Although the mirror itself will generally be out of focus from the film or sensor's point of view, any dust or smudges on the mirror can affect the quality of the picture.

Finally, with a half-silvered mirror, it's possible for light from the viewfinder to find its way into the camera, perhaps to bounce off shiny portions of the rear of the lens and cause ghost images. It's not a good idea to leave the viewfinder window uncovered when shooting with this type of system. Eyepiece light leak can also affect exposure calculations even on cameras with conventional mirror systems, so some dSLRs, like the Canon EOS 1D, have an eyepiece "shutter" to block the light. Or, you can use a clip-on eyepiece light blocker, such as the one offered for cameras like the Nikon D70.

Another way to handle mirror bounce is to lock up the mirror prior to exposure, as shown in Figure 4.2. Because the camera is mounted on a tripod, you can frame your shot before locking up the mirror; then make the exposure free from worries that a pivoting component of your optical system will cause vibration. Unfortunately, not all digital SLRs have mirror lock-up that can be triggered prior to an exposure. Some include a mirror lock-up feature solely to swing the mirror out of the way to permit sensor cleaning. If you fear mirror bounce will plague you, make sure the dSLR you purchase has mirror lock-up, and that it's the real thing.

Figure 4.2 With the mirror locked up, one source of vibration is eliminated.

Faux lock-up

Terrified that your exposure will be spoiled by mirror vibration? Try holding a black card in front of the lens (but don't touch the lens) as a long exposure begins. Remove the card a fraction of a second after the shutter opens (and the mirror is fully flipped up).

Mirror Size and Design

One problem in designing an SLR mirror in these days of compact digital cameras is that the mirror must be large enough to reflect the full field-of-view (or, at least 95 percent of it), but small enough to fit inside the cavity behind the lens. That can become a problem with wide-angle lenses, which can have a shorter *back focus* distance than normal and telephoto lenses.

As you probably know, the focal length of a given lens is the distance from the optical center of the lens to the plane of the film or sensor. With a 20mm lens, that distance is about 0.75 inches, which is obviously impossible. With the average dSLR, the distance from the lens flange to the sensor is more on the order of 1.5 to 1.75 inches, so with the simplest possible lens design, a wide-angle lens' rear elements would have to extend back *inside* the camera, well beyond where the mirror would sit. I actually own such a lens, an ancient 7.5mm Nikkor Fish-Eye lens that pokes back into the camera body almost to the film plane, and that requires that the mirror be locked up out of the way before it can be mounted.

No such nonsense is required with today's lenses, which use what is called *retro-focus* designs (also called *inverted telephoto*) to increase the back-focus distance to a reasonable value. Without such designs, the 10-12mm lenses available for digital cameras (or even most lenses shorter than about 40mm) would be impossible. This is especially true with dSLRs that have smaller than full-frame sensors because the multiplier factor means that shorter and shorter lenses are required to produce the same wide-angle effect as a full-frame digital or film camera. (There's another advantage to retro-focus design, as you'll see in Chapter 6: The longer back-focus distance allows the light to strike the sensor at a less oblique angle so the photo-sites are illuminated more directly. You'll find diagrams of retro-focus and conventional lens designs there, too.)

Even with advanced lenses, dSLR camera designers need to do some fancy footwork to create mirrors that accommodate the rear elements of lenses, yet are still able to flip up as needed. A few cameras use a mirror that actually slides backward a bit before it begins to pivot, allowing extra clearance with the rear elements of the lens. I'll explore other lens quirks in Chapter 6.

Focus Screen

The next stop in our optical grand tour is the focus screen, also called a viewing screen or, in times past, "the ground glass," which is, theoretically, at the exact distance in the optical path as the focal plane of the sensor. Thus, an image that appears to be correctly focused on the viewfinder screen should be in sharp focus when the picture is taken.

Obviously, the screen must be positioned with great accuracy, which is made easier by the fact that in most digital SLRs (at least the non-pro variety), the focus screen is permanently fixed in the camera. Some high-end models, like the Canon EOS 1Ds, Mark II, offer nine or ten different replaceable focus screens optimized for special applications. These can include screens with matte, split-image rangefinder-type focusing, microprism, cross-hairs, or other types. Specialized screens can provide an extra-bright image for viewing under dim lighting condi-

tions with a central spot area for focusing, grids and cross-hairs for aligning images, and other features.

While in the past focus screens were usually precision-made chunks of ground glass, today you're likely to find a laser-etched plastic screen in your digital camera. And where such screens were formerly used simply to provide a way for the photographer to view an image and manually focus, today these screens may be used by your camera's exposure system to measure light from a large matrix of points, play a major part in autofocusing the image, or even to measure and set white balance (although at least one camera measures white balance from a sensor area on top of the camera in incident fashion, independent of the light coming through the lens). (Incident light is the light falling on a subject, as opposed to reflected from the subject.)

Compared to EVF cameras, which use an LCD as a through-the-lens viewfinder and can easily fill up the screen with all kinds of information, the data displayed on a dSLR's focus screen may be rather sparse, as you can see in Figure 4.3. Generally, you'll see little more than the focus-area indicator markings, plus an indicator that shows what area is being measured for spot or center-weighted exposure calculations. These areas may be illuminated to show that they're active.

Figure 4.3 SLR focus screens are relatively uncluttered, with most of the information arrayed at the bottom or sides of the frame.

Additional data, which can include the shutter speed, f-stop, exposure mode, exposure number, focus confirmation light, and "flash needed" indicator, will appear below the focus screen itself, usually as LED or LCD indicators.

Pentaprism/Pentamirrors and so Forth

The view of the focus screen looks properly oriented because the light transmitted through the screen is next bounced two more times off the reflective surfaces of a pentaprism, typically a one-piece optical glass component with silvered surfaces, or a pentamirror or similar system

that consists of a hollow glass/plastic roof mirror hybrid. Some cameras, like the Olympus E-300 I mentioned earlier, use a series of mirrors to produce the same effect, but without the typical pentaprism "hump" on top of the camera. Whichever system is used, these extra bounces are required to rectify the image for normal viewing.

If you've ever seen a traditional view camera at work, you probably noticed that the image on the ground glass was upside-down and reversed left-to-right. Studio photographers learn to work with images presented in this way, but SLR photography is generally a much faster-moving endeavor, so all digital single lens reflex cameras provide a properly oriented view.

The important thing to know about pentaprism/pentamirror systems is that solid glass systems tend to present a much brighter image than poorly designed mirror systems. Early in my career I used a camera that could be fitted with either type, and the difference in brightness was amazing.

Eyepiece

At the end of its long journey (which probably took less than a split second, unless you're photographing the moon or stars), the light that entered your lens exits through the eyepiece of your digital camera, ready for viewing by your eye. The eyepiece will usually have a rubber bezel around it so you can comfortably rest your eye against it, even if you're wearing glasses, and will have a diopter correction dial or slider you can use to customize your view for any nearsightedness or farsightedness in your vision. Most digital SLRs also allow adding a prescription lens to the eyepiece if the normal diopter correction isn't strong enough.

There are several factors related to the overall image that emerges from the eyepiece that you need to know about.

Magnification

This is how large the viewfinder image appears to your eye and, up to a point, bigger is better. If your dSLR's viewfinder provides 1X magnification, then your subject as viewed through the finder will appear to be the same size as when you view it with your unaided eye, *when you're using a normal lens focused at infinity*. A normal lens with a full-frame digital camera (or film camera) is generally defined as around 50mm. So, if you placed your right eye against the viewfinder and kept your left eye open, as you panned the camera the scene would appear roughly the same with either eye. If your digital camera uses a smaller than full-frame sensor, "normal" will be another focal length, such as 38mm using a camera with a 1.3X multiplier, or 31mm with a camera having a 1.6X multiplier.

If you're using any other lens or zoom setting besides normal, or have focused closer than infinity, the image size will change, even at 1X magnification. That's pretty obvious: Zoom a lens from the 38mm "normal" position in to the 114mm telephoto setting, and the subject in the viewfinder will appear to be twice as big. Zoom out to 19mm for a wide-angle shot, and the subject will appear to be half as large.

A 1X magnification factor provides a nice big image for viewing. However, some digital SLRs provide only .80X or .75X magnification. Make sure the dSLR you buy has enough magnification for comfortable viewing.

Coverage

Your viewfinder may not show you 100 percent of what the sensor will see. It's likely that some of the image will be cropped because it's difficult to design an optical viewing system that shows 100 percent of the available view. Pro cameras do a good job of this, but it's likely that your

entry-level dSLR will show you less, perhaps 95 percent of the true field-of-view. That should-n't be a serious problem because it means your final image will actually include *more* than what you saw.

With a 6-megapixel camera at 95 percent coverage, that's roughly the equivalent of clipping 35 pixels each off the left and right sides of the image area (about 1 percent of the width at either end), and 25 pixels from the top and bottom lengths of the frame (also about 1 percent). Figure 4.4 shows you roughly how much image you lose in the viewfinder. The green area represents the portion of the image cropped out with a camera that provides 95 percent coverage.

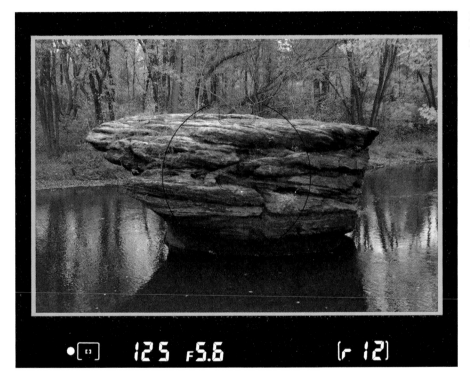

Figure 4.4 With 95 percent viewfinder coverage, you'll lose only the portion of the image shaded in green.

You can always crop back to the original viewfinder framing in an image editor if what-you-saw-is-what-you-want happens to be that important. To a certain extent, magnification and coverage work hand-in-hand: If your dSLR provides 100 percent coverage, the magnification may have to be reduced a little to allow room for the other informational displays in the viewfinder. If your camera's viewfinder has 100 percent magnification, it's likely that the coverage is reduced a little, for the same reason. Those pixels clipped at top, bottom, and sides are allocated to the readouts at the bottom of the viewfinder screen.

Eyepoint

This is the distance you can move your eye away from the eyepiece and still see the entire viewfinder, including the focus screen and the informational displays. An extended eyepoint is useful if you wear glasses because your eyewear won't let you rest your eye right up against the viewfinder. A generous eyepoint figure is also useful when you're shooting sports or action and don't want to have the camera glued to your eye at all times. You might also want to be able to see stuff outside the camera's field-of-view, so you can monitor how a play is unfolding, or make

sure that huge wide receiver that is not currently in the frame isn't headed towards the sidelines and your position! Eyepoint figures are generally given in millimeters, and range from around 12mm (half an inch) to 25mm (a full inch) or more.

Oddity of dSLR Viewfinders

In general, the viewfinder system of dSLR cameras operates very much like their film SLR counterparts. That would be great, except for one thing: Such systems rob you of the use of the digital sensor up until the instant the exposure is made. One of the primo advantages of digital cameras, the ability to see the sensor image prior to exposure, *doesn't apply* to digital SLRs because they operate *too much* like their film ancestors. Here's a quick checklist of how this quirk affects you:

- **No live preview.** You can't preview the image you're going to take, exactly as the sensor sees it because the sensor can't create an image until the mirror flips up and out of the way. The LCD of a dSLR is used *only* for viewing images after the fact, plus for displaying menus and other information.

- **No live histograms.** As you'll learned in Chapter 3, histogram displays are a great way to optimize exposures. If the histogram "chart" is skewed too much in one direction or another, you can add or reduce shutter speed, aperture, or EV value to get the best possible exposure. Non-SLR digital cameras have what are called "live" histograms that show up on the LCD and/or EVF while a shot is being composed, so you can make corrections in real time. That's not possible with a dSLR for the same reason you can't get a live preview: The sensor is blind until the moment of exposure.

- **No sneaky surveillance-type shooting.** You can connect many digital SLRs to a USB cable and use a special program to control the camera from a distance. However, once again, you'll be shooting blind. Your control program probably can download your remote photos to your computer after they are shot, but you can't monitor what the camera sees before taking the picture. If you want to catch a shoplifter in the act, you're better off with a regular video surveillance camera or even a high-end non-dSLR setup to provide a live feed to your monitor or computer.

- **Shooting blind in dim light or with infrared filters.** Here we go again. Because you're limited to viewing through the dSLR's optical viewfinder, if light conditions are very dim or you're using an infrared filter, you have to shoot blind. LCD and EVF viewfinders often have circuitry that boosts the gain under dim conditions, providing you with a fuzzy, sometimes black-and-white image, but one that can still be viewed, even if you're shooting with an infrared filter that blocks visible light.

Protecting the Sensor from Dust

Photographers have had to surmount dirt and dust problems for more than 150 years. Dust can settle on film or photographic plates, marring the picture. Dust can reside on the front or back surfaces of lenses and, if the specks are numerous enough, affect the image. Dirt can even get *inside* the lens. It can infest your dSLR's mirror and focusing screen, too, which shouldn't affect the quality of your photos, but can be annoying nevertheless. Dirty electrical contacts could conceivably affect the ability of your flash memory cards to store information or hinder the operation of an external electronic flash.

These ills infect film cameras, and most of them apply to digital cameras as well. However, the dSLR adds a new wrinkle: dirty sensors. In non-dSLRs, the sensor is sealed inside the camera and protected from dust. Unfortunately, your removable-lens digital camera invites the infiltration of dust, or worse, every time you swap lenses. Dust will inevitably creep inside and come to rest. Some of it will lie in wait for the shutter protecting your sensor to open for an exposure and then sneak inside to affix itself to the imager's outer surface. No matter how careful you are and how cleanly you work, eventually you will get some dust on your camera's sensor. This section explains the phenomenon and provides some tips on minimizing dust and eliminating it when it begins to affect your shots.

Whither Dust

Like it or not, unless you live in a clean room or one of those plastic bubbles, you're surrounded by dust and dirt. It's in the air around you and settles on your digital camera's works without mercy. When you remove a lens to swap it for another, some of that dust will get trapped inside your camera. Most of it will cling to the sides of the mirror box. Some will land on the mirror itself, or stick to the underside of the focus screen. Dust found in any of these locations shouldn't affect your pictures unless enough accumulates to interfere with the autofocus or autoexposure mechanisms, and long before that you'll be seriously distracted by the dust bunnies in your viewfinder.

The real danger lies in the dust particles that cling to the shutter curtain and rear portions of the mirror box. They're likely to be stirred up by the motion of the curtain and waft their way inside to the sensor. Taking a photo with the camera pointed upward will enlist the law of gravity against you.

The dust settles on the outer surface of the sensor, which is a protective filter (often a low-pass, anti-aliasing filter) rather than the sensor itself. Some vendors make an effort to ensure that the dust doesn't take up permanent residence. Olympus, for example, uses an ultrasonic device that should shake any dust particles loose, or at least move them around a little inside your camera. While some digital SLRs are more susceptible to dust on the sensors than others, most will succumb eventually. I owned my latest dSLR for two weeks and had removed the lens perhaps three or four times before I noticed I had my first dust problem.

You may have dust on your sensor right now and not know it. Because the grime settles on a surface that's a tiny fraction of an inch above the actual sensor, it often will not be visible at all at wider lens apertures. If you shoot at f2.8–f5.6 most of the time, the dust on your sensor is probably out of focus and not noticeable, particularly if the particles are small. Stop down to f16 or f22, and those motes suddenly appear in sharp relief. The actual particles may be too small to see with the unaided eye; a dust spot no larger than the period at the end of this sentence (about .33mm in diameter) could obscure a block of pixels 40 pixels wide and 40 pixels tall with a typical dSLR sensor. If a dust spot creates a dark blotch against a light background, a spot as small as 4 pixels wide is likely to stick out like a sore thumb.

Clearly, you do *not* want to have your images suffer from this plague.

Dust vs. Dead Pixels

New dSLR owners who find spots that show up in the same place on a series of images may wonder whether they're looking at a dust spot or a defective pixel in their sensor. Dead pixels aren't as deadly as you might think. A technique called *pixel mapping* can locate non-functioning pixels and permanently lock them out, so the camera will substitute information from surrounding pixels for future images. Some cameras have pixel mapping built into the

camera, which can be automatically or manually applied (depending on how the camera is designed), while others use a firmware upgrade to take care of this chore, or require sending the camera back to the vendor for adjustment. This fix is typically free while the camera is under warranty.

So, how do you tell whether you have a dust bunny or a bad pixel to deal with? Just follow these steps.

1. Shoot several blank frames of both dark- and light-colored backgrounds (so you can see both light and dark pixel anomalies). Do not use a tripod. You do not want the frames to be identical.

2. Shoot variations of dark and light frames using your maximum (largest) f-stop and your minimum (smallest) f-stop, such as f2.8 and f22.

3. Transfer the images to your computer and then load them into your favorite image editor.

4. Copy one of the dark frames and paste it into another dark frame image as a new layer. Make sure you include frames taken at both minimum and maximum apertures. Repeat for another image containing several light frames.

5. Zoom in and examine the images for dark and light spots.

6. If you locate a suspect spot, make the current layer invisible and see if the spot is in the same position in the other layers (from different shots). If that is the case, then the bad pixel(s) are caused by your imager, and not by your subject matter.

7. Use the guidelines below to determine whether the spots are caused by dust or bad pixels.

Bad pixels may be tricky to track down, because they can mask themselves among other components of an image. A hot pixel may be obvious in a clear blue sky, but scarcely noticeable in an image with lots of detail in the affected area. Figure 4.5 shows a best-case (or worst-case) scenario: a hot pixel (actually a cluster of *four* pixels) lurking in a speckled image of some crayons. It's lurking in the third row, but you'll never find it with the naked eye. Figure 4.6 shows the little devils isolated. They were identified by comparison with a completely different picture, which showed the same hot pixels in the same position. Although the crayons have

Figure 4.5 Four bad pixels are lurking here.

speckles of their own, these hot pixels are objectionable because the crayons in question are supposed to be out of focus, without a razor-sharp hot spot. In Figure 4.7, you can see that the four bad pixels are surrounded by other pixels that are incorrectly rendered because demosaicing was unable to interpolate their proper values correctly.

Figure 4.6 Zooming in identifies the hot pixels.

Figure 4.7 The bad pixels will cause an ugly blotch like this in every photo taken.

When you've identified spotty areas in your images, figure out their cause by going through this checklist. If you pinpoint a dust spot, use the cleaning methods described later in this chapter. If it's a bad pixel, activate your camera's pixel-mapping feature, or contact your vendor. You can use the remedial methods described in the next section to fix bad spots that appear in existing images.

- If the spot is light in color when viewed against an area that is overall dark in color, it's probably caused by one or more pixels that are permanently "hot."

- If the spot is dark in color when viewed against an area of lighter pixels, it may be a pixel that is permanently off, or it may be a dust spot.

- A dark pixel that is rectangular (perhaps a black pixel surrounded by pixels of decreasing density), is probably a dead pixel. The additional bad pixels are usually caused by the effects of interpolating surrounding pixels from the dead one.

- A dark pixel that shows up in the frames shot at the smallest f-stop, but which vanishes or becomes out of focus in the wide-open frames, is certainly a dust spot, as you can see in Figure 4.8.

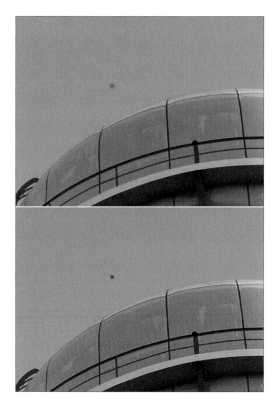

Figure 4.8 If a blotch that's fuzzy at f8 suddenly gets sharper when you stop down to F22, it's a dust spot.

Protecting Your Sensor from Dust

The easiest way to protect your sensor from dust is to prevent it from entering your camera in the first place. Here are some steps you can take:

- Keep your camera clean. Avoid working in dusty areas if you can do so. Make sure you store your camera in a clean environment.

- When swapping lenses, use a blower or brush to dust off the rear lens mount of the replacement lens first, so you won't be introducing dust into your camera simply by attaching a new, dusty lens. Do this before you remove the lens from your camera, and then avoid stirring up dust before making the exchange.

- Minimize the time your camera is lensless and exposed to dust. That means having your replacement lens ready and dusted off, and a place to set down the old lens as soon as it is removed, so you can quickly attach the new lens.

- Face the camera downward when the lens is detached so any dust in the mirror box will tend to fall away from the sensor. Turn your back to any breezes or sources of dust to minimize infiltration.

- Once you've attached the new lens, quickly put the end cap on the one you just removed to reduce the dust that might fall on it.

- From time to time, remove the lens while in a relatively dust-free environment and use a blower bulb (*not* compressed air or a vacuum hose) to clean out the mirror box area. A blower brush is generally safer than a can of compressed air, or a strong positive/negative airflow, which can tend to drive dust further into nooks and crannies.

- If you're embarking on an important shooting session, it's a good idea to clean your sensor *now* using the suggestions you'll find below, rather than coming home with hundreds or thousands of images with dust spots caused by flecks that were sitting on your sensor before you even started.

Fixing Dusty Images

You've taken some shots and notice a dark spot in the same place in every image. It's probably a dust spot (and you can find out for sure using my instructions above), but no matter what the cause, you want to get it out of your photos. There are several ways to do this. Here's a quick checklist:

- Clone the spots out with your image editor. Photoshop and other editors have a clone tool or healing brush you can use to copy pixels from surrounding areas over the dust spot or dead pixel. This process can be tedious, especially if you have lots of dust spots and/or lots of images to be corrected. The advantage is that this sort of manual fix-it probably will do the least damage to the rest of your photo. Only the cloned pixels will be affected.

- Use your image editor's dust and scratches filter. A semi-intelligent filter like the one in Photoshop can remove dust and other artifacts by selectively blurring areas that the plug-in decides represent dust spots. This method can work well if you have many dust spots, because you won't need to patch them manually. However, any automated method like this has the possibility of blurring areas of your image that you didn't intend to soften.

- Try your camera's dust reference feature. Some dSLRs have a dust reference removal tool that compares a blank white reference photo containing dust spots with your images, and uses that information to delete the corresponding spots in your pictures. However, such features generally work only with files you've shot in RAW format, which won't help you fix your JPEG photos. Dust reference subtraction can be a useful after-the-fact remedy if you don't have an overwhelming number of dust spots in your images.

Cleaning the Sensor

Should you clean your sensor? That depends on what kind of cleaning you plan to do, and whose advice you listen to. Some vendors countenance only dust-off cleaning, through the use of reasonably gentle blasts of air, while condemning more serious scrubbing with swabs and cleaning fluids. These same manufacturers sometimes offer the cleaning kits for the exact types of cleaning they recommended against, for sale in Japan only, where, apparently, your average photographer is more dexterous than those of us in the rest of the world. These kits are similar to those used by the vendor's own repair staff to clean your sensor if you decide to send your camera in for a dust-up.

Removing dust from a sensor is similar in some ways to cleaning the optical glass of a fine lens. It's usually a good idea to imagine that the exposed surfaces of a lens are made of a relatively soft kind of glass that's easily scratched, which is not far from the truth (although various multi-coatings tend to toughen them up quite a bit). At the same time, imagine that dust particles

are tiny, rough-edged boulders that can scratch the glass if dragged carelessly across the dry sur-face. Liquid lens cleaners can reduce this scratching by lubricating the glass as a lens cloth or paper is used to wipe off the dust, but can leave behind a film of residue that can accumulate and affect the lens' coating in another fashion. Picture the lens wipes as potential havens for dust particles that can apply their own scratches to your lenses.

You can see why photographers who are serious about keeping their lenses new and bright tend to take preventive measures first to keep the glass clean. Those measures often include protec-tive UV or skylight filters that can be cleaned more cavalierly and discarded if they become scratched. If all else fails, the experienced photographer will clean a lens' optical glass carefully and with reverence.

Most of this applies to sensors, with a few differences. Sensors can be affected by dust particles that are much smaller than you might be able to spot visually on the surface of your lens. The filters that cover sensors tend to be fairly hard compared to optical glass. Cleaning a sensor that measures 24mm or less in one dimension within the tight confines behind the mirror can be trickier and require extra coordination. Finally, if your sensor's filter becomes scratched through inept cleaning, you can't simply remove it yourself and replace it with a new one.

In practice, there are three kinds of cleaning processes that can be used to vanquish dust and gunk from your dSLR's sensor, all of which must be performed with the shutter locked open:

- **Air cleaning.** This process involves squirting blasts of air inside your camera with the shut-ter locked open. This works well for dust that's not clinging stubbornly to your sensor.

- **Brushing.** A soft, very fine brush is passed across the surface of the sensor's filter, dis-lodging mildly persistent dust particles and sweeping them off the imager.

- **Liquid cleaning.** A soft swab dipped in a cleaning solution such as ethanol is used to wipe the sensor filter, removing more obstinate particles.

The first thing to do is to lock up your camera's mirror so you can gain access to the sensor. You'll probably have to access a menu item in your dSLR's setup page to lock up the mirror. Some vendors recommend locking up the mirror for cleaning only if a camera is powered by an AC adapter, rather than by a battery. The theory is that you don't want your battery to fail while you're poking around inside the camera with tools. A damaged mirror, sensor, or both can easily be the result if the mirror flips down before you're finished.

In practice, my digital camera's battery poops out less frequently than I experience brownouts and AC power blackouts. My recommendation is to charge your camera's battery and use that with confidence to keep your mirror latched up. That recommended AC adapter may be an extra-cost option that you'll buy and then not use for anything else (unless you do a lot of work in a studio).

Once the mirror is up, you should work as quickly as possible to reduce the chance that even more dust will settle inside your camera. Have a strong light ready to illuminate the interior of your camera. If you happen to have one of those headband illuminators that blasts light any-where you happen to be gazing, so much the better.

The next few sections will describe each of these methods in a little more detail.

Air Cleaning

Cleaning by air is your first line of defense. If you do it properly, it's difficult to overdo. An extra gentle blast of air isn't going to harm your sensor in any way.

Of course, the trick is to use air cleaning properly. Here are some tips:

- Use only bulb cleaners designed for the job, like the Giotto Rocket shown in Figure 4.9. Smaller bulbs, like those air bulbs with a brush attached sometimes sold for lens cleaning or weak nasal aspirators may not provide sufficient air or a strong enough blast to do much good.

- Do not use compressed air-in-a-can. The propellant inside these cans can permanently coat your sensor if you goof.

- Do not use commercial compressed air compressors. Super-strong blasts of air are as likely to force dust into places you don't want it to be, including under the sensor filter, than they are to remove it.

- Hold the camera upside down and look up into the mirror box as you squirt your air blasts, increasing the odds that gravity will help pull the expelled dust downward, away from the sensor. You may have to use some imagination in positioning yourself.

Figure 4.9 Use a robust air bulb like the Giotto Rocket for cleaning your sensor.

Brush Cleaning

If your dust is a little more stubborn and can't be dislodged by air alone, you may want to try a brush, like the Sensor Brush sold at **www.visibledust.com**. Ordinary brushes are much too coarse and stiff and have fibers that are tangled or can come loose and settle on your sensor. The Sensor Brush's fibers are resilient and described as "thinner than a human hair." Moreover, the brush has a wooden handle that reduces the risk of static sparks.

Brush cleaning is done with a dry brush by gently swiping the surface of the sensor filter with the tip. The dust particles are attracted to the brush particles and cling to them. You should clean the brush with compressed air before and after each use, and store it in an appropriate air tight container between applications to keep it clean and dust free. Although these special brushes are expensive, one should last you a long time. They are offered in various sizes to fit different dSLR sensor widths.

You can also use a brush to dust off the surfaces inside the mirror box.

Liquid Cleaning

The most persistent dust spots may be combined with some grease or a liquid that causes them to stick to the sensor filter's surface. In such cases, liquid cleaning with a swab may be necessary. You can make your own swabs out of pieces of plastic (some use fast food restaurant knives, with the tip cut at an angle to the proper size) covered with a soft cloth. However, I recommend buying commercial sensor cleaning swabs, such as those sold by Photographic Solutions, Inc. (**www.photosol.com/swabproduct.htm**) to get the best results. (Some folks get good

results using homemade swabs and the Pec-Pad cleaning pads sold by Photographic Solutions, but the company itself does not recommend using these pads for this application.) Vendors selling these swabs will recommend the right size for your particular dSLR.

You want a sturdy swab that won't bend or break so you can apply gentle pressure to the swab as you wipe the sensor surface. Use the swab with methanol (as pure as you can get it; other ingredients can leave a residue), or the Eclipse solution also sold by Photographic Solutions. A couple drops of solution should be enough, unless you have a spot that's extremely difficult to remove. In that case, you may need to use extra solution on the swab to help "soak" the dirt off.

Once you overcome your nervousness at touching your camera's sensor, the process is easy. You'll wipe continuously with the swab in one direction, then flip it over and wipe in the other direction. You need to completely wipe the entire surface; otherwise you may end up depositing the dust you collect at the far end of your stroke. Wipe; don't rub. You can see the sensor of a typical dSLR in Figure 4.10.

Figure 4.10 The sensor of a digital SLR is accessible only when the mirror is flipped up and the shutter is open.

Mirrors and focus screens: Handle with caution

You won't find many tips for cleaning your dSLR's mirror or focus screens, other than to use a blast of air. That's because a bit of dust on either one of them is unlikely to affect the operation of your camera, and both are easily scratched. If you become obsessed over mirror or screen dust that you can't easily remove, consider sending the camera back to the vendor for cleaning. Wiping with lens paper, swabs, or cleaning liquids is likely to do more harm than good.

Secrets of dSLR Image Storage

Another quirk of the dSLR involves the storage methods you choose and use. You may have more options and a few more pitfalls than your point-and-shoot toting friends. This section will reveal a few of them.

First, most point-and-shoot and EVF cameras can use just a single type of storage, whether it's CompactFlash, SD card, xD card, or MemoryStick. However, many digital SLRs have multiple memory card slots. Some cameras can accept both a CompactFlash card as well as an SD

card. Olympus and Fuji, because the xD cards they are promoting have not caught on as quickly as they would have liked, are forced to support CompactFlash media as well in their higher-end cameras. I don't expect to see digital SLRs that accept three or more card formats in the near future, but I wouldn't be surprised if more of them appear that accept two types, or which have multiple slots for a pair of the same kind of media.

Key Considerations

Here are some of the things to consider when choosing digital storage for your dSLR:

- **Size.** CompactFlash are slightly larger than the alternative media, but probably more rugged, too. The larger size isn't particularly more difficult to tote around (compared to the volume consumed by a brick of film), and not quite as easy to lose. The smallest card in wide use, the xD card, is less than an inch square, and I've managed to mislay mine more than once.

- **Capacity.** Don't expect one format or another to retain a capacity advantage for very long, but at the time I write this, CompactFlash cards that hold 8G or more are available (if expensive), while SD and xD cards trail a bit behind. Sony MemorySticks bring up the rear, although MemoryStick Pro cards with MagicGate can top 4G. If maximum capacity is important to you, keep track of the latest developments among the vendors, realizing that the top capacity cards are likely to be the most expensive.

- **Form factor.** As I've mentioned several times before, CompactFlash cards are available in both Type I and Type II configurations. Type II cards are thicker, and won't fit in older digital cameras that have only the thinner, Type I slot. That may mean that you can use only older, lower-capacity CompactFlash cards. Fortunately, SanDisk has introduced a 4G memory card in the original Type I size. If you're using a digital SLR that has an original Type I slot, make sure your higher capacity card is of this variety.

- **Cost.** CompactFlash-sized mini hard drives tend to be the least expensive option for storage over 1GB, often half as much as a solid-state CompactFlash card of the same capacity. If you're looking for a 4GB or larger card, a mini hard drive may be your best choice from a cost standpoint, although they are a bit less rugged than their solid-state counterparts. SD cards recently have been priced at about 10 percent more than CompactFlash cards of the same size, with xD cards at an extra 10 percent premium over that. Larger capacity Sony MemoryStick Pro cards can be significantly more expensive than any of these.

- **Eggs in one basket syndrome.** Opting for large memory cards over several smaller ones does more than increase your costs on a per-megabyte basis (a 4G card is often more expensive than 4 cards of 1G capacity). You're also increasing your exposure to loss of images if you lose a card or the media becomes unreadable. Some photographers like to pop in a single card and then shoot all day without the need to switch to a different card. Others prefer to swap out cards at intervals, and keep the exposed memory extra safe. (If all your eggs are in one basket, watch that basket very carefully!)

Using multiple cards is a good way to segregate your images by topic or location. If you're on vacation in Europe, you can use a new card for each city (just as you might shoot one or two rolls of film in each location). Or, photograph cathedrals on one card, castles on a second, landscapes on a third, and native crafts on a fourth.

I tend to prefer using a handful of 1G cards over working with one or more large memory cards. With a 6-megapixel dSLR, I can shoot 150 or more photos in RAW format per 1G card (a lot more than I got with 36-exposure rolls of film), and don't need to swap media very often except when I'm shooting sports. As dSLR resolution increases, the size of a "small" memory card will creep upwards. With my next upgrade to a 12-megapixel model, I'll probably consider 2G cards the smallest practical size.

- **Speed.** When choosing a card, evaluate your needs and the write speed of the card you're considering. As I mentioned in Chapter 2 and will note again in Chapter 8, for most kinds of photography the write speed of the card has little effect on your picture taking. An exception might be if you're shooting sports sequences, or if you're shooting RAW or TIFF files and your camera is particularly slow in saving these files. (I recently tested a camera that took as long as 30 seconds to write a TIFF file to the card.) You'll pay more for the higher-speed cards, perhaps with no discernable benefit. You might be happier with three 1G cards having a 20X write speed than one or two 80X or faster high-speed cards with performance that you rarely require.

FAT Follies

There's more to a digital memory card's format than its physical form factor. One little-considered aspect of digital storage is the logical formatting of the card's individual memory locations, called its FAT (file allocation table) system. If you use only memory cards that are 2G or smaller, and format them only in your camera, you don't have to think about this aspect very much. However, it might be handy to know a little bit about what's going on.

As far as your camera and your computer are considered, your memory cards function more or less like a solid-state hard disk (or an actual hard disk in the case of mini drives.) The FAT is a system for allocating the smallest individual storage units of this "disk"—sectors—into easily managed groups called clusters. Various FAT systems use 12, 16, and 32 bits to record the number of individual units, and, because of the maximum number of clusters that can be tracked by the largest 12-bit, 16-bit, or 32-bit number, effectively put an upper limit on the capacity of any system using FAT12, FAT16, or FAT32 formatting. FAT12 limits capacity to 16MB and is useful only for things like floppy disks. (Remember them?) Digital memory cards may use either FAT16 (up to 2G), or FAT32 (1024G.)

The problems arise when you try to use a memory card larger than 2G in a camera that supports only FAT16, or, often, when you format a memory card in your computer rather than in the camera, and end up with an incompatible format. Before buying one of these larger cards, make sure that your camera can support cards larger than 2G, and then, to ensure compatibility, format the card *only* in your camera.

SanDisk pioneered a 4G CompactFlash card with a three-position switch on one edge that you can use to transform the card from a 4G, FAT 32 card to two separate 2GB, FAT 16 volumes. That innovation allows you to use the larger card in cameras that support only FAT 16.

Next Up

Now that you know how to handle some of the quirks of the digital SLR, it's time to explore another area in which these cameras differ quite a bit from their less-sophisticated cousins: the use of file formats like RAW. Everything you need to know about formats is revealed in the next chapter.

5

Working RAW

When it comes to file formats, digital SLR shooters have many options to choose from. Point-and-shoot photographers using non-dSLRs rarely have to think about file formats at all. They use the default format offered for their cameras and maybe switch from Super Fine to Fine to Standard modes (losing quality with each step down), in order to cram more pictures onto their memory cards.

When it comes to dSLRs, the available formats and reasons for selecting them are much more sophisticated. Any photographer serious enough to purchase a digital SLR has purchased at least enough memory cards to serve any picture-taking situation this side of an extended vacation. Instead of choosing a file format solely to save space, the digital SLR shooter often selects one option over another because of the extra quality that might be provided, or the additional control. It's a little like selecting a film that features a particular kind of rendition—saturated and contrasty, or muted and accurate—to produce a particular result. If your camera allows uploading particular correction curves, that too can offer a degree of control. However, for most dSLR owners, choice of file format is the primary tool for providing as much power over your photos as possible.

In this book I am trying very hard to avoid the trap most "digital photography" books stumble into, that of spending more time discussing manipulations you can make in an image editor than on honest-to-gosh photography. Yet, I'd be doing you a disservice if I explained what a particular format can do without covering the software that makes it possible. So, in this chapter you'll find a bit of explanation about the utilities that can make your digital images shine.

Format Proliferation

It's no secret why there are so many "standard" image file formats. Vendors always think they can do something better than their competitors, or, at the very least, hope that you'll think so. As a result, they invent a new file format with a few extra features that tweak the capabilities a

tad. There's the possibility that you'll be locked into a particular set of tools because you want those extra features.

In some respects, it's a wacky approach. Digital images consist primarily of rows and columns of pixels arranged in a bitmap. Each pixel might store 8 bits, 15 bits, 16 bits, 24 bits, 32 bits, or 48 bits of information. Some of those bits might be set aside to represent selections within an image. You also need the ability to store overlay-like layers, data about fonts used, and other information. Once you begin working on an image in an image editor, not a lot more data is required. You'd think that a single format would do the job. Yet, we've had many variations on TIFF, more than a few Photoshop PSD varieties, plus, in the olden days, proprietary formats like .IFF (Amiga), .TGA (Targa), .PXR (Pixar), .PX1 (PixelPaint), .PIC (SoftImage), or .RLA (Wavefront.)

The latest version of PSD is the closest thing we have to a standard file format, and that's only for image editing. Your digital camera can't read or produce PSD files at all. PSD can't handle the kinds of information that digital cameras can record, such as a specific white balance, sharpness, variable tonal curves, and other data. When you take a picture, a host of this kind of picture information is captured in a raw form, and then immediately processed using settings you've specified in your camera's menus. After processing, the image is stored on your memory card in a particular format, such as TIFF or JPEG. Once that's done, any changes must be made to the *processed* data. If you decide you should have used a different white balance, you can no longer modify that directly, even though color balance changes in your image editor might provide a kind of fix.

So, digital camera vendors provide an alternative file format, generically called RAW, but in practice given other names, such as NEF (Nikon), CRW (Canon), or MRW (Minolta). The different names reflect the fact that each of these RAW formats is different and not compatible with each other. You'll even find differences between RAW formats used by the same vendor. For example, while the RAW files produced by the Canon 20D and 1D Mark II both have a .CR2 extension, they each need their own RAW converter to import the files into a standard TIFF format. To date, there are more than 100 different "RAW" formats.

You'll also find references to EXIF (Exchangeable Image File Format) specifications, which are part of the larger Design Rule for Camera File systems (DCF) that most vendors adhere to. Unfortunately, while EXIF and DCF provide standard methods for transferring information, camera vendors add on bells and whistles of their own in constructing the actual file formats that they use.

Of course, the reason for individual RAW formats is not to lock you into a particular camera system. The vendor has already done that by using a proprietary lens mount design. Ostensibly, the real reason is the one I outlined earlier: to do the job better than the other folks. Of course, in some cases, a particular RAW format is a thinly disguised TIFF file with a new file extension and some extra features, but in others RAW provides an unadulterated copy of the unprocessed data captured by the CCD or CMOS imager.

I don't expect to see any massive reduction in the number of digital camera file formats in the future. It's more likely that we'll see even more formats down the road, but that in addition to the software provided by the camera maker, import filters for Photoshop will follow, and other third-party RAW file handlers, such as BreezeBrowser, Capture1, Irfanview and Bibble, will keep pace.

Whither DNG?

To complicate things, in late 2004, Adobe Systems introduced its new DNG (Digital Negative) specification, which purports to translate RAW files from any camera type to a common RAW format compatible with any camera or software. Of course, the specification allows adding what Adobe calls "private metadata" to DNG files, "enabling differentiation," which is another word for non-standard/non-compatible. If DNG is adopted, *most* of the data from your camera's RAW images might be convertible to the new standard, but there's no guarantee that all of it will be. Because Photoshop can already handle the most common types of RAW files we we work with, most dSLR owners are likely to be underwhelmed by this initiation for the foreseeable future.

Image Size, File Size, and File Compression

One of the original reasons digital cameras offered more than one file format in the first place is to limit the size of the file stored on your memory card. Early dSLRs used tethered hard disk drives slung over a shoulder, enabling the photographer to store 200 megabytes worth of 1.3 megapixel images. PC Card memory that fit the slots still found in notebook computers (but generally used for WiFi plug-ins today) worked for a while, until SanDisk invented the CompactFlash card in 1994. Still, all these memory options were limited in size, so more efficient file formats had to be used. If a digital camera had unlimited memory capacity and file transfers from the camera to your computer were instantaneous, all images would probably be stored in RAW or TIFF format. TIFF might even have gained the nod for convenience and ease of use, and because not all applications can interpret the unprocessed information in RAW files. Both RAW and TIFF provide no noticeable loss in quality.

JPEG was invented as a more compact file format that can store most of the information in a digital image, but in a much smaller size. JPEG predates most digital SLRs, and was initially used to squeeze down files for transmission over slow dialup connections. Even if you were using an early dSLR with 1.3 megapixel files for news photography, you didn't want to send them back to the office over a modem at 1200 bps.

Alas, JPEG provides smaller files by compressing the information in a way that loses some information. JPEG remains a viable alternative because it offers several different quality levels. At the highest quality level you might not be able to tell the difference between the original TIFF file and the JPEG version, even though the TIFF occupies, say, 14MB on your memory card, while the high-quality JPEG takes up only 4MB of space. You've squeezed the image 3.5X without losing much visual information at all. If you don't mind losing some quality, you can use more aggressive compression with JPEG to store 14 times as many images in the same space as one TIFF file.

RAW exists because sometimes we want to have access to all the information captured by the camera, before the camera's internal logic has processed it and converted the image to a standard file format. RAW doesn't save as much space as JPEG (although RAW files can be a lot smaller than TIFF files). What it does do is preserve all the information captured by your camera. Think of your camera's RAW format as a photographic negative, ready to be converted by your camera or, at your option, by your RAW-compatible image-editing/processing software.

You can adjust the image size, file size, and image quality of your digital camera images. The guidebooks and manuals don't always make it clear that these adjustments are three entirely different things. However, image size affects file size and image quality, and image quality affects

file size. File size, while it's dependent on the other two, has no direct effect on image size or quality. No wonder it's confusing! It's a good idea to get these three terms sorted out before we move on, so that we're all talking about exactly the same thing. Here's a quick summary:

- **Image size.** This is the dimension, in pixels, of the image you capture. For example, if you have a 6MP camera, it may offer a choice of 3008 × 2000, 2560 × 1920, 1600 × 1200, 1280 × 960, and 640 × 480 resolutions. Each reduction in resolution reduces the size of the file stored on your memory card. A TIFF file at 2560 × 1920 pixels might occupy 4MB; a 1600 × 1200 pixel image, 1.7MB; a 1280 × 960 pixel image, 1.3MB, and a 640 × 480 pixel image less than 1MB.

- **File size.** This is the actual space occupied on your memory card, hard disk, or other storage medium, measured in megabytes. The size of the file depends on both the image size (resolution) and quality/compression level. You can reduce the file size by reducing the image size or using a lower-quality/higher-compression setting.

- **Image quality.** This is the apparent resolution of the image after it's been compressed and then restored in your image editor. The TIFF format can compress the image, somewhat, with no loss of image quality, but JPEG compression does reduce the image quality, for reasons that will become clear shortly.

Keep the difference between image size, file size, and image quality in mind as we continue our discussion.

Image Compression Revealed

The next thing to clear up is the idea of compression. Compression comes in two varieties: *lossless* compression, like that provided with the RAW and TIFF formats, and *lossy* compression, like that afforded by the JPEG format. Understanding a little about how compression works makes these terms a little more understandable. Note that not all RAW and TIFF files are compressed. For example, Nikon's original NEF format was uncompressed, producing 6 megapixel images that topped 11 megabytes in size, while its latest version is actually compressed, reducing the average size of these NEF files to about 5.7 megabytes. TIFF files can be stored uncompressed, too, either by the camera or by your editing software. (I'll explain later on why TIFF format is dying out among dSLR cameras; your own model may not have TIFF at all.)

Bitmapped images, like all other computer code, are stored as a series of binary numbers, which are the only values a computer can handle. A string of 64 bits might look like this, but probably wouldn't because I've simplified it for the sake of this illustration:

0000000000000001110000000000000000011111100000000000000000000000001

You probably know (although not by choice) that computers can store eight bits in a single byte. So, the computer would need 8 full bytes to store that string of 64 binary numbers. If the image is a standard 24-bit full-color image, those 8 bytes might represent basic information about a mere two (and a fraction) pixels. Clearly, a megapixel image is going to occupy megabytes of storage space unless we can squeeze the information somehow.

That's possible because any string of computer numbers contains *redundant* information. There are bits that aren't needed to reproduce the original string precisely and with no loss of data. Suppose you were doing an inventory for your miniature golf course and lined up 64 of your golf balls as shown in the string above, with the 0s representing red golf balls and the 1s representing green golf balls. If you wanted to describe your lineup, would you say the row consisted of "red, red, red, red, red, red, red, red, red, red, red, red, red, red, red, green, green, green, red, red, red…?" Of course not. You'd say you "had 14 red balls, then 3 greens, 16 reds, 6 greens, 24 reds, 1 green…" as shown in Figure 5.1. You'd save a ton of words!

Figure 5.1 Rather than describe every pixel, you need only to list how many of each pixel appears consecutively.

When describing numbers rather than golf balls, the savings are even more dramatic. A lossless compression scheme, like that used to squeeze a TIFF file, could record a value that would designate how many times a particular set of bits (rather than golf balls) is repeated, so, instead of storing all 64 bits, a code would be used that meant "14 zeroes, followed by 3 ones, followed by 16 zeros, followed by 6 ones…" and so forth. That information would allow reconstructing the string of bits used in the example. Techie types call this kind of abbreviation "run length limited" because it records the lengths of the runs of the same number consecutively.

It gets better. As the compression algorithm worked, it would notice that certain strings of numbers began to repeat. Instead of enumerating only the number of runs of ones and zeros, the code would indicate where to find a string of numbers identical to the one that needed to be recorded next. The second time the line of numbers above turned up, a short code representing where that line is stored in the file would be substituted. In effect, the encoder/decoder would say, "go to location *x,y* in the table I've put together, and use the number you find there." Obviously, the coordinates in a table can be expressed using a very small number, which allows squeezing the size of the file more and more as the size of the cross-referenced strings of numbers grows. For the mathematically inclined (I'm not one of those), Figure 5.2 shows a simplified look-up table.

1000100	01001	10101	11111111
1110111	10111111	00111	10000111
1010101	111000111	10101011	11110101

Figure 5.2 Cross-references to number strings in a table can save space.

To represent a string such as 11110101111000111111111111110001001000100010001001-0001000, you'd need only to list the addresses in the table of those numbers.

We're not done yet. The larger the file becomes, the fewer actual numbers the compression scheme has to record. More and more of the code consists of pointers to strings of numbers. This method, called Huffman encoding, builds a frequency table of the number strings in a file, and assigns the shortest codes to the strings of numbers that occur most often.

Even though all the redundant numbers are eliminated from the file, the decompression algorithm can use the information to reconstruct the original file precisely. Today, more-advanced algorithms, such as the Lempel-Ziv Welch (LZW) algorithm used to compress TIFF files, are very efficient.

LZW was originally developed by Israeli researchers Abraham Lempel and Jacob Ziv in 1977 and 1978. The Lempel-Ziv algorithm was further developed by a Unisys researcher named Terry Welch, who in 1984 published and patented a compression technique that is now called Lempel-Ziv Welch (most often with no second hyphen, although even Unisys isn't consistent in its use) or, simply, LZW.

But Wait! There's More!

It's just starting to get interesting. (If you disagree, feel free to skip ahead. This is the kind of goofy stuff that some people find fascinating, while others do not.) While the compression scheme used with TIFF files works well, TIFF files can still be massive. As transfer of images files over telecommunications lines became popular (this was even before the public Internet), a consortium called the Joint Photographic Experts Group (JPEG) developed a compression scheme particularly for continuous tone images that is efficient, and still retains the most valuable image information. JPEG uses three different algorithms: one called discrete cosine transformation (DCT), a quantization routine, and a numeric compression method like Huffman encoding.

JPEG first divides an image into larger cells, say 8×8 pixels, and divides the image into a special color space that separates the luminance values (brightness) from the chrominance (color) values. In that mode, the JPEG algorithm can provide separate compression of each type of data. Because luminance is more important to our eyes, more compression can be applied to the color values. The human eye finds it easier to detect small changes in brightness than equally small changes in color.

Next, the algorithm performs a discrete cosine transformation on the information. This mathematical mumbo-jumbo simply analyzes the pixels in the 64-pixel cell and looks for similarities. Redundant pixels—those that have the same value as those around them—are discarded.

Next, quantization occurs, which causes some of the pixels that are nearly white to be represented as all white. Then the grayscale and color information is compressed by recording the differences in tone from one pixel to the next, and the resulting string of numbers is encoded using a combination of math routines. In that way, an 8×8 block with 24 bits of information per pixel (192 bytes) can often be squeezed down to 10 to 13 or fewer bytes. JPEG allows specifying various compression ratios, in which case larger amounts of information are discarded to produce higher compression ratios.

Finally, the codes that remain are subjected to a numeric compression process, which can be similar to the Huffman encoding described earlier. This final step is lossless, as all the information that is going to be discarded from the image has already been shed.

Because it discards data, the JPEG algorithm is referred to as "lossy." This means that once an image has been compressed and then decompressed, it will not be identical to the original image. In many cases, the difference between the original and compressed version of the image is difficult to see.

Compressed JPEG images are squeezed down by a factor of between 5:1 and 15:1. The kinds of details in an image affect the compression ratio. Large featureless areas such as areas of sky, blank walls, and so forth compress much better than images with a lot of detail. Figure 5.3 shows an image (a close-up of a goose's eye) at two high compression settings (top) and two low compression settings (bottom).

This kind of compression is particularly useful for files that will be viewed on Web pages and sent as e-mail files. It's also used to squeeze down digital camera files. However, more quality is lost every time the JPG file is compressed and saved again, so you won't want to keep editing your digital camera's JPEG files. Instead, save the original file as a TIFF file, and edit that, reserving the original as just that, an original version you can return to when necessary. In fact, it's a good idea to save this digital negative on a CD or DVD so you can go back to your original file at any time in the future, no matter how much you've butchered (or improved) the image since.

Figure 5.3 High compression (top) yields a blocky appearance. Low compression (bottom) produces a smoother look.

About Those Formats...

This section will list each of the important file formats available for use both with digital cameras and image editors, including a few that you should *avoid* when working with images. I'll discuss their advantages, disadvantages, and the types of image compression used. First, we'll look at the file formats that are *not* used with digital cameras.

Formats Used for Image Editors/Display/Printing Only

Of course, digital cameras are far from the only application for digital image files. You'll commonly work with these files to display them on Web pages (generally JPEG and GIF formats), to show text and graphics in a standardized way for viewing, printing or reproduction (PDF format), or for image editing.

GIF

GIF, or Graphics Interchange Format, was developed as one of the original "squeezed" file formats suitable for distribution online, back in 1987, even before the public Internet. The goal in developing this format was to create a way to share compressed graphics between different

computer platforms. That's a bigger deal than you might think. In those days it was tricky to create image files on one computer that could be readily viewed on another computer, and with 300 to 1200 baud modems, even small image files could take many minutes to upload or download. The online service CompuServe was the first big user of the GIF format.

The GIF format converts images into files with a maximum of 256 colors. Few video cards in those days could display more than 256 colors, anyway, so that sufficed. GIF achieves its small file size by first reducing the colors available in an image to 1 to 256 different hues, then squeezing the file further by applying LZW compression to the indexed color tables that remain. So, GIF can be considered both a lossy and lossless file format. It loses picture information when the number of colors are reduced (but if the number of colors in an image is already 256 hues or fewer, no colors are discarded), but the remaining information is preserved 100 percent.

GIF has some other features that are useful chiefly for Web display, such as interlacing (which allows an image to be displayed progressively as it downloads), transparency (which makes it possible for a GIF image to show the page background in its transparent parts), and animation (several images embedded in one file and shown consecutively, like an animated cartoon).

Because it can handle no more than 256 colors, GIF is a poor choice for digital camera images (which look posterized when converted to 256 tones), and is best used for logos, dialog boxes, line art, charts, and other graphics that don't involve continuous tones. Its compression scheme works great with images that have few colors, producing files that can be even smaller than those afforded by JPEG. Figure 5.4 shows a full-color image that has been reduced to 256 colors. While there is noticeable banding in the sky area, which requires more than a few tones to reproduce accurately, the rest of the image doesn't look too bad. You won't be that lucky most of the time, however.

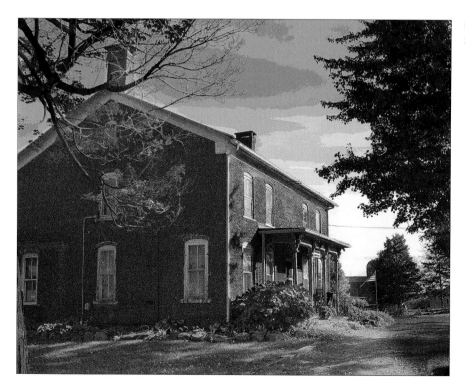

Figure 5.4 Full-color images look posterized when reduced to 256 colors.

JPEG 2000

JPEG 2000 is a relatively new file format, supported by Photoshop CS and some other image editors, but not universally by the applications that we'd find the most useful: Web browsers. At this time, no digital cameras produce files in this format. JPEG 2000 uses a compression scheme called wavelet compression (for roughly 20 percent smaller files), which provides better image quality, but still discards some information. JPEG 2000 files may have extensions like .jpx, jpc, or .jp2.

JPEG 2000 offers the ability of downloading a lower-resolution image first, so you can preview the image in your Web browser and decide whether to continue to download the page. While conventional JPEG works only with RGB images, this new version is compatible with RGB, L*a*b color, and CMYK (cyan, magenta, yellow, black) color models. It can also include color profile information, as well as informational tags such as the owner of the image. JPEG 2000 also offers a lossless compression mode, which reduces the file size by roughly 50 percent, while not discarding any information.

JPEG 2000 has a very cool feature called Region of Interest, which you can use to designate the most important parts of an image. When you've done that, image compression will be concentrated in other areas of the photo, preserving more detail in your Region of Interest. This feature is very easy to use. In Photoshop, just select the region you want to protect (Quick Mask mode works well) and use Selection > Save Selection to store the selection as an Alpha channel. Then when you use Save As and choose the JPEG 2000 format, the dialog box, like the one shown in Figure 5.5, has an option for selecting which, if any, of the Alpha channels (selections) you've stored should be used as the ROI. Keep in mind that anyone trying to read your JPEG 2000 image must have a compatible application or plug-in.

Figure 5.5 Choose any of the alpha channel selections in your image as a Region of Interest when you save in JPEG 2000 format.

PDF

PDF (Portable Document Format) is a format originally developed by Adobe to store PostScript files for printing on PostScript printers. Its advantage is that it preserves the original layout, fonts, and appearance of the file. PDF is often used with Adobe Reader or with browser plug-ins to display documents. I download instruction manuals, IRS tax forms, and other documents in PDF format. You don't need a PostScript printer to print out PDF files, either.

More recently, PDF has gained some favor in the pre-press environment as a way of prepping documents for printing, and in the Macintosh world as a replacement for the PICT format. Because PDF files consist of PostScript text instructions, they can be compressed highly using any lossless compression method.

PICT

PICT is a file format that was developed in 1984 by Apple Computer as the native format for Macintosh graphics. PICT can include both bitmap images and vector (line-oriented) graphics. Although PICT is used primarily to exchange graphics between Mac applications, many PC programs, such as the Windows version of Photoshop, support it. Apple has elected to replace PICT with PDF, beginning with Mac OS X.

PICT supports grayscale images as well as up to 24-bit color images (it also can use 32-bit images, but the extra 8 bits are used for selections as an alpha channel). PICT uses a Huffman-like run-length encoding (RLE) compression scheme.

BMP

BMP was developed by Microsoft as a standard bitmap file format for computers running the Windows operating system. The intent was to produce device-independent bitmaps (DIB) that Windows can display on any type of device. BMP files can include color depths up to 24 bits.

PNG

The PNG (Portable Network Graphics) format was designed as a replacement for GIF, because the compression algorithm used in GIF was patented by Unisys, and developers supporting the GIF format were theoretically required to pay Unisys a royalty. The patent expired in June, 2003 in the United States, and in Canada, Japan, and Europe in 2004, so royalties will be charged only in countries in which the patent has not fizzled out (in other words, virtually nowhere).

That leaves PNG, a format that never saw much favor, even further in limbo than it was before. Even though PNG has some advantages over GIF or even JPEG, it's unlikely to flourish in the future. PNG uses optimized preprocessing filters that improve lossless compression efficiency, particularly in 24-bit images. Unlike GIF, PNG can specify any combination of 256 colors for transparency, embed gamma values so the image displays well on both Macs and PCs (which use different gamma settings), and beats both GIF and TIF for compressing images.

PCX

PCX is an early graphics file format established by Zsoft for its PC Paintbrush software. It supports 24-bit color, and provides decent lossless file compression, but is now used only as a backup format. I sometimes save files in PCX format when the recipient is having trouble reading my TIFF files. Unlike TIFF, PCX doesn't have a wide variety of options and is thus more "standardized" and compatible with a wider variety of software on Mac, PC, and Linux platforms.

No digital cameras use PCX, but most image-editing software supports it.

Formats Used in Digital Cameras

There are three formats used in digital cameras: JPEG, TIFF, and the various types of RAW. There are advantages to each, as well as a few pitfalls to avoid.

JPEG

JPEG is the most common format used by digital cameras to store their images, as it was designed specifically to reduce the file sizes of photographic-type images. It provides a good compromise between image quality and file size, and produces images that are suitable for everyday applications. Those who work with point-and-shoot digital cameras may use nothing else but JPEG, and even many dSLR owners find that the default JPEG settings offer quality that's good enough for ordinary use. Indeed, on a sharpness basis, it can be difficult to tell the difference between the best-quality JPEG images and those stored in RAW or TIFF formats. But, as you'll see, there are additional considerations that come into play.

As you probably know, JPEG allows dialing in a continuous range of quality/compression factors. In image editors, you'll find this range shown as a quality spectrum from, say 0 to 10 or

0 to 15. Sometimes, very simple image editors let you choose only from Low, Medium, or High quality. Those are just different ways of telling the algorithm how much information to discard.

Many digital cameras, on the other hand, lock you into a limited number of quality settings with names like Standard, Fine, Extra Fine, or Super Fine, and don't tell you exactly which JPEG quality settings those correspond to. The names for the quality settings aren't standardized, and a particular setting for one camera doesn't necessarily correspond to the same quality level with another camera. For example, Super Fine may be the highest lossy JPEG setting with one model, and the lossless TIFF setting with another vendor's camera.

You'll usually find no more than three JPEG compression choices with any particular digital SLR. Some Nikon cameras, for example, offer Fine, Normal, and Basic. If you're concerned about image quality, and want to use JPEG, you should probably use the best JPEG setting all the time, or alternate between that and the TIFF or RAW settings. Your choice might hinge on how much storage space you have. When I'm photographing around the home where I have easy access to a computer, I use RAW. When I travel away from home, I switch to JPEG if I think I'm going to be taking enough pictures to exceed the capacity of the 2 to 3 gigabytes of memory cards I carry around with me at all times.

That might be the case when shooting many sports sequence shots. It's easy to squeeze off a burst of 6 to 8 shots on any given play, and a dozen plays later notice you've used up 512MB or more of RAW photos in a relatively short period of time. Although memory cards are relatively inexpensive, even if you carry 4GB or more of digital film, you'll find that Parkinson's law applies to digital photography: Photos taken expand to fill up the storage space available for them.

Some cameras are able to store photos to the memory card more quickly in JPEG format rather than TIFF or RAW, so that is another consideration for sequence shots. If quality isn't critical, then use lower-quality JPEG settings with your camera to fit more images on the available storage.

TIFF

Pure TIFF, one of the original lossless image file formats, is on its way out in the digital camera world. In the past, many of the higher-end point-and-shoot cameras offered JPEG, with TIFF as a higher-quality option. I can't recall the last time I used a brand-new non-dSLR camera that used TIFF, and I test 8 to 10 of these every month. TIFF is even dying out among dSLR cameras. Many of the latest models offer only JPEG and RAW, or, perhaps, a JPEG+RAW mode that stores the same image in both formats. A few still offer TIFF, but their numbers are small.

The original rationale for using TIFF at all was that it provided a higher-quality option in a standard format, without the need for the vendor to develop a proprietary RAW format. Today, the additional advantages of RAW when it comes to tweaking images make RAW well worth the trouble.

TIFF, or Tagged-Image file Format, was designed in 1987 by Aldus (later acquired by Adobe along with Aldus' flagship product, PageMaker) to be a standard format for exchange of image files. It's become that, and was at one time supported by virtually all high-end digital cameras as a lossless file option, even though its use has diminished today. However, because TIFF supports many different configurations, you may find that one application can't read a TIFF file created by another. The name itself comes from the *tags* or descriptors that can be included in the header of the file, listing the kinds of data in the image.

TIFF can store files in black/white, grayscale, 24-bit, or 48-bit color modes, and a variety of color models, including RGB, L*a*b, and CMYK. If you've used Photoshop, you know that TIFF can store your levels and selections (alpha channels) just like Photoshop's native PSD format. It uses a variety of compression schemes, including no compression at all, Huffman encoding, LZW, and something called Pack Bits. Most applications can read TIFF files stored in any of these compression formats.

RAW

As applied to digital cameras, RAW is not a standardized file format. RAW is a proprietary format unique to each camera vendor, and, as such, requires special software written for each particular camera. Each RAW format stores the original information captured by the camera, so you can process it externally to arrive at an optimized image. You'll learn more about RAW in the next section.

Use JPEG, TIFF, or RAW?

Of the three file formats, which should you use? JPEG files are the most efficient in terms of use of space, and can be stored in various quality levels, which depend on the amount of compression you elect to use. You can opt for tiny files that sacrifice detail or larger files that preserve most of the information in your original image.

Some cameras also can save in TIFF format, which, although compressed, discards none of the information in the final image file. However, both JPEG and TIFF files have been processed by the camera before they are created. The settings you have made in your camera, in terms of white balance, color, sharpening, and so forth, are all applied to the image. You can make some adjustments to the image later in an image editor like Photoshop, but you are always working with an image that has *already been processed*, sometimes heavily.

The information captured at the moment of exposure can also be stored in a proprietary, native format designed by your camera's manufacturer. These formats differ from camera to camera, but are called Camera RAW, or just RAW for convenience. You might think of RAW as a generic designation rather than a specific format, just as the trade name Heinz applies to all 57 varieties instead of just one.

A RAW file can also be likened to a digital camera's negative. It contains all the information, stored in 12-bit, 14-bit, or 16-bit channels (depending on your camera), with no compression, no sharpening, no application of any special filters or processing. In essence, a RAW file gives you access to the same information the camera works with in producing a 24-bit JPEG or TIFF file. You can load the RAW file into a viewer or image editor, and then apply essentially the same changes there that you might have specified in your camera's picture-taking options.

Figures 5.6, 5.7, and 5.8 provide an illustration. Figure 5.6 shows a scenic shot as stored in JPEG format by the digital SLR. It's a difficult image to expose properly, with inky shadows and very bright highlights in the sky. The processed image is much too dark and too contrasty. Figure 5.7 shows what happens when you try to salvage such a picture by manipulating curves in Photoshop. The shadows are easy enough to brighten, but there was no detail in the sky area in the JPEG version, so there's not much that could be done.

Because my camera stored both JPEG and RAW versions of the same image, I was able to manipulate the RAW image to arrive at the results in Figure 5.8. Not only could I improve the contrast, but I tweaked the white balance and boosted the saturation at the same time. Clearly, working with the RAW image was the way to go.

Figure 5.6 The JPEG version is too dark and has too much contrast.

Figure 5.7 Photoshop can lighten the shadows, but there's no help for the sky area.

Figure 5.8 Manipulating the RAW file fixed the tonal problems while color balance and saturation were improved, too.

Some RAW formats, such as those deployed by Nikon and Canon for their high-end cameras, are actually TIFF files with some proprietary extensions. That doesn't mean that an application that can read standard TIFF files can interpret them, unfortunately. Usually, special software is required to manipulate RAW files. If you're lucky, your camera vendor supplies a special RAW processing application that is easy to use and powerful. For example, Nikon offers Nikon View to read and manipulate its .NEF files. Canon provides a viewer for its .CRW format. Minolta includes a DiMAGE Viewer for its RAW files.

If you're not so lucky, you'll get a less capable utility, be asked to pay extra for it, or find that none at all is available. Photoshop CS now includes a Camera RAW plug-in (which was formerly an extra-cost option with Photoshop 7) that works quite well. It can be used only with the particular digital cameras that Adobe has elected to support. The list is long, and includes many popular cameras from Nikon, Canon, and Minolta. You'll find that third parties also provide RAW decoders for specific camera models, such as YarcPlus and BreezeBrowser for Canon, and Bibble Pro for Nikon, Canon, Olympus, Pentax, Minolta, Fuji, Kodak, and other dSLRs. The great Windows freeware utility IrfanView can handle many RAW files such as Canon's .CRW format.

As I noted earlier, I sometimes shoot JPEG images when I think it is likely I may exceed my memory card capacity, or when I'm taking test photos that don't really matter. For most dSLR shooters, using JPEG format exclusively may be false economy. You never know when that "unimportant" snapshot might develop into an important photo that you wish you could manipulate in RAW form. JPEG may be "good enough," but if you're using a digital SLR, you probably aren't willing to settle for "good enough" most of the time.

For that reason, many digital photographers, myself included, shoot nothing but RAW images or, sometimes, RAW+BASIC (with a second copy of the image in JPEG format). Here's the rationale as it relates to workflow:

- Some newer cameras take no longer to store RAW files on digital media when in burst mode, so you can shoot sports and other action in RAW without slowing down the camera. Some are even able to store a pair of RAW/JPEG files quickly enough to maintain burst mode. It all depends on the size of the digital SLR's buffer, and how well the camera can multitask: shooting pictures while storing the previous shot on the memory card.

- Because they are several times larger, RAW files *will* take longer to transfer from your camera or memory card to your computer. If you're in a big hurry, the extra wait can be frustrating. So, you'll want to use the fastest transfer method available, such as a card reader that is USB 2.0 compatible.

- When you shoot RAW exclusively, you may end up with files that cannot be collected by your favorite image management/cataloging/albuming program. My own preference is for an older application that doesn't read RAW files, so when I transfer my RAW files I have no way of reviewing them quickly.

 I have two solutions. If I am in a particular hurry, I shoot RAW+BASIC so I am able to catalog the JPEG versions quickly for immediate review. If I am in less of a hurry, I use a conversion program to duplicate each RAW image in TIFF format, in batch mode. The TIFFs can be catalogued and reviewed, and are sometimes good enough to work with directly in Photoshop. If not, I always have my RAW original.

- As one of the last steps in your workflow, you should archive a copy of the original RAW files to CD-R or, more common today (because a CD-R may hold only 100 RAW images), to DVD. That will preserve your original negative so you can return to it any time in the future. Although I am supposedly fairly skilled at using Photoshop, I constantly learn new things, and many times have been able to go back and reprocess images that I'd already "optimized" to get new and improved versions from my RAW files.

RAW Applications

Your software choices for manipulating RAW files are broader than you might think. Camera vendors always supply a utility to read their cameras' own RAW files, but sometimes, particularly with those point-and-shoot cameras that can produce RAW files, the options are fairly limited. Most Canon dSLR users have gone beyond the Canon File View Utility to something better from third parties, such as Capture1. Other vendors, such as Nikon (with its Nikon Capture) offer RAW file handling that is much more flexible and powerful.

Because of the spotty capabilities among proprietary RAW converters offered by digital camera vendors, there is a flourishing market for third-party solutions. These are usually available as standalone applications (often for both Windows and Macintosh platforms), as Photoshop-compatible plug-ins, or both. Because the RAW plug-ins displace Photoshop's own RAW converter, I tend to prefer to use most RAW utilities in standalone mode. That way, if I choose to open a file directly in Photoshop it automatically opens using Photoshop's fast and easy-to-use Camera RAW plug-in. If I have more time or need the capabilities of another converter, I can load that, open the file, and make my corrections there. Most are able to transfer the processed file directly to Photoshop even if you aren't using plug-in mode.

This section provides a quick overview of the range of RAW file handlers, so you can get a better idea of the kinds of information available with particular applications. I'm going to include both high-end and low-end RAW browsers so you can see just what is available.

Converters Offered by Camera Vendors

As I mentioned, the file converters offered by camera vendors is a mixed bag. Some are great, some are acceptable, and some are abominable. The best part is that they are generally bundled with the camera and offered at no cost. Nikon offers a basic RAW converter with its cameras, but if you want the real thing, you'll have to pay $99 for Nikon Capture. Here are some of the utilities available from camera vendors.

Kodak Professional DCS Photo Desk

This is the viewer used with Kodak's 14MP DCS Pro 14n and its variations. (*n* is the Nikon model; Kodak also offers a similar camera based on the Canon system.) As you might guess, the amount of information at your fingertips is astounding. For example, look at the sorts of data you can discover in the Image Info window, shown in Figure 5.9. It includes things like the camera serial number (useful if you're working with several digital cameras and want to know which was used to produce the image), resolution, file size, ISO setting, type of metering used, flash sync mode, the focal length of the lens, and the exact time and date the photo was taken. If you annotated the image with a sound bite at the time you took the picture, you can play that back through your computer's speakers.

Professionals will love the Job Tracker dialog box, which lets you enter more information, including caption and credits, in an approved International Press and Telecommunications (IPTC) format. Anyone shooting digital pictures for publication will find this capability useful. The dialog box is shown in Figure 5.10.

Other controls, shown in Figure 5.11, allow you to compensate for exposure, change the white balance and lighting, add noise reduction, or improve sharpness, exactly as you could with the camera.

Figure 5.9 A wealth of information is available in the Image Info dialog box.

Figure 5.10 Embed job information right in your TIFF file.

Figure 5.11 Adjust other camera settings using the Photo Desk controls.

Nikon Capture

First introduced in 1999, Nikon Capture is an extra-cost RAW converter/editor application that works with JPEG, TIFF, or NEF (Nikon's RAW format) files. You can make modifications to a RAW format file, and then resave it as a RAW file with adjustments, while retaining the original information in case you want to revert to an earlier state or make additional changes later on. Nikon Capture is shown in Figure 5.12.

Figure 5.12 Nikon Capture 4 provides access to all options in a Nikon NEF (RAW) file.

Figure 5.13 Expandable palettes reveal hidden controls.

One handy feature is the ability to "defish" images taken with fisheye lenses, producing a non-distorted rectilinear image that no longer has the fisheye qualities. Supported lenses include the DX Nikkor 10.5mm fisheye, which produces an image equivalent to a 16mm lens on a 35mm film camera. When such images are defished, they produce super-wide rectangular photos with some loss of sharpness in the corners, but which are still quite usable. Nikon Capture gives you direct control over curves, levels, brightness/contrast, color balance, unsharp masking, optional color noise reduction, and exposure compensation.

Most settings are accessed by expanding the Tool Palette to produce controls like those shown in Figure 5.13. These include the LCH Editor, which lets you make adjustments to lightness, chroma, and hue separately. There's also an Image Dust Off feature: Take a dust reference image with your camera, and Nikon Capture will remove dust spots from a batch of images.

Batch processing lets you convert a whole folder of images using the same settings. A folder can be set on "watch" status, and Nikon Capture will process any new images dropped into the folder as they arrive. Those who want to control their camera remotely can use the application's Remote Capture feature to take pictures on cue or on a regular schedule in time-lapse mode.

Canon EOS File Viewer Utility/EOS Capture/Digital Photo Professional

Canon provides these software utilities for viewing/converting images taken with Canon cameras, and for controlling the camera remotely. The File Viewer Utility is not highly regarded by Canon users, who often opt for a third-party solution. Or, Digital Photo Professional is preferred for those Canon dSLR cameras that are supported by it.

DPP, shown in Figure 5.14, offers much higher-speed processing of RAW images than was available with the sluggardly File Viewer Utility (as much as six times faster). Canon says this utility rivals third-party standalone and plug-in RAW converters in speed and features. It supports both Canon's original .CRW format and the newer CR2 RAW format, along with TIFF, Exif TIFF, and JPEG.

You can save settings that include multiple adjustments and apply them to other images, and use the clever comparison mode to compare your original and edited versions of an image either side by side or within a single split image. The utility allows easy adjustment of color channels, tone curves, exposure compensation, white balance, dynamic range, brightness, contrast, color saturation, ICC Profile embedding, and assignment of monitor profiles. A new feature is the ability to continue editing images while batches of previously adjusted RAW files are rendered and saved in the background.

Figure 5.14 Canon's Digital Photo Professional offers a full array of conversion features.

Other Proprietary RAW Converters

There isn't room in this chapter to provide even these brief overviews of the similar software available from the manufacturers of the other dSLRs. You'll find that Olympus, Pentax, Minolta, and other vendors of digital SLRs provide similar programs with the same types of features. If your particular camera's RAW converter doesn't do everything you like, you'll want to explore one of the third-party solutions discussed next.

Note that most of the products with a price tag can be downloaded for 30-day free trials, including the likes of Bibble and Capture One. The URLs for these downloads change frequently (Phase One, for example, is based in Denmark, but makes its products available for download through other distributors), so if you'd like to try one of these out, do a Google search for the latest link.

Third-Party Solutions

You'll find that RAW file utilities are available from a wide range of suppliers and can cost you nothing (in the case of IrfanView and Corel RawShooter Essentials) or be included in the cost of other software (which is the case with Photoshop). Or, you can pay $129 for a sophisticated program like Bibble Professional, or as much as $500 for a top-of-the-line program like PhaseOne's Capture One Pro (C1 Pro).

IrfanView

At the low (free) end of the scale is IrfanView, a Windows freeware program you can download at **www.irfanview.com**. It can read many common RAW photo formats, like the Minolta format shown in Figure 5.15. It's a quick way to view RAW files (just drag and drop to the IrfanView window) and make fast changes to the unprocessed file. You can crop, rotate, or correct your image, and do some cool things like swapping the colors around (red for blue, blue for green, and so forth) to create false color pictures.

The price is right, and IrfanView has some valuable capabilities.

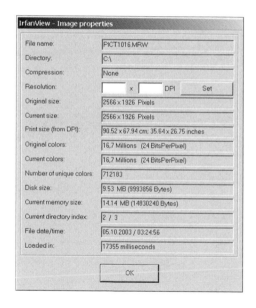

Figure 5.15 IrfanView is a freeware program that can read many RAW file formats.

Phase One Capture One Pro (C1 Pro)

If there is a Cadillac of RAW converters for Nikon and Canon digital SLR cameras, C1 Pro has to be it. This premium-priced program does everything, does it well, and does it quickly. If you can't justify the price tag of this professional-level software, there are "lite" versions for consumer, serious amateur, and cash-challenged professionals called Capture One dSLR, and Capture One dSLR SE.

Aimed at photographers with high-volume needs (that would include school and portrait photographers, as well as busy commercial photographers), C1 Pro (shown in Figure 5.16) is available for both Windows and Mac OS X, and supports a broad range of Nikon and Canon digital cameras. Phase One is a leading supplier of megabucks digital camera backs for medium and larger format cameras, so they really understand the needs of photographers.

Figure 5.16 Phase One's C1 Pro is fast and sophisticated.

The latest features include individual noise reduction controls for each image, automatic levels adjustment, a "quick develop" option that allows speedy conversion from RAW to TIFF or JPEG formats, dual-image side-by-side views for comparison purposes, and helpful grids and guides that can be superimposed over an image. Photographers concerned about copyright protection will appreciate the ability to add watermarks to the output images.

Bibble Pro

One of my personal favorites among third-party RAW converters is Bibble Pro (shown in Figure 5.17), which just came out with a new version as I was writing this book. It supports one of the broadest ranges of RAW file formats available, including NEF files from Nikon D1,D1x/h, D2H, D100; .CRW files from the Canon C30/D60/10D/300D; .CR2 files from the Canon 1D MKII; .ORF files from the Olympus E10/E20/E1/C5050/C5060; .DCR files from the Kodak 720x/760/14n; .RAF files from the Fuji S2Pro; .PEF files from Pentax ISTD; .MRW files from the Minolta Maxxum; and .TIF from Canon 1D/1DS.

The utility supports lots of different platforms, too. It's available for Windows, Mac OS X, and, believe it or not, Linux.

Bibble works fast because it offers instantaneous previews and real-time feedback as changes are made. That's important when you have to convert many images in a short time (event photographers will know what I am talking about!) Bibble's batch-processing capabilities also let you convert large numbers of files using settings you specify without further intervention.

Its customizable interface lets you organize and edit images quickly, and then output them in a variety of formats, including 16-bit TIFF and PNG. You can even create a Web gallery from within Bibble. I often find myself disliking the generic filenames applied to digital images by cameras, so I really like Bibble's ability to rename batches of files using new names that you specify.

Figure 5.17 Bibble Pro supports a broad range of RAW file formats.

Bibble is fully color managed, which means it can support all the popular color spaces (Adobe sRGB, and so forth) and use custom profiles generated by third-party color-management software. There are two editions of Bibble, a Pro version and a Lite version. Because the Pro version is reasonably priced at $129, I don't really see the need to save $60 with the Lite edition, which lacks the top-line's options for tethered shooting, embedding IPTC-compatible captions in images, and cannot also be used as a Photoshop plug-in (if you prefer not to work with the application in its standalone mode).

BreezeBrowser

BreezeBrowser, shown in Figure 5.18, has long been the RAW converter of choice for Canon dSLR owners who run Windows and who were dissatisfied with Canon's lame File Viewer Utility. It works quickly, and has lots of options for converting CRW files to other formats. You can choose to show highlights that will be blown out in your finished photo as flashing areas (so they can be more easily identified and corrected), use histograms to correct tones, add color profiles, auto rotate images, and adjust all those raw image parameters, such as white balance, color space, saturation, contrast, sharpening, color tone, EV compensation, and other settings.

You can also control noise reduction (choosing from low, normal, or high reduction), evaluate your changes in the live preview, and then save the file as a compressed JPEG, or as either an 8-bit or 16-bit TIFF file. BreezeBrowser can also create HTML Web galleries directly from your selection of images.

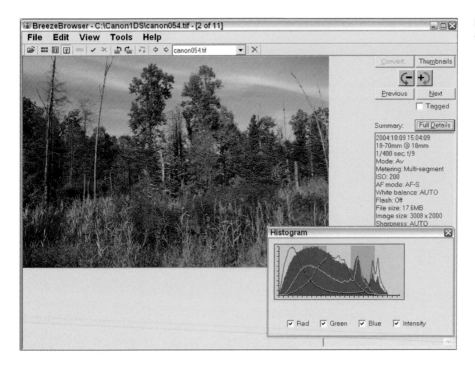

Figure 5.18 BreezeBrowser makes converting Canon RAW files a breeze.

Photoshop CS

The latest version of Photoshop includes a built-in RAW plug-in that is compatible with the proprietary formats of a growing number of digital cameras, both new and old. This plug-in also works with Photoshop Elements 3.0. The list of supported cameras at the time this book was published is a long one, shown in Table 5.1.

Table 5.1 RAW Digital SLR Camera Formats Photoshop CS Supports

Camera Vendor	Models Supported
Canon	EOS-1D, EOS-1Ds, EOS-1D Mark II, EOS-10D, EOS-20D, EOS 300D, EOS-D30, EOS-D60
Nikon	D1, D1H, D1X, D2x, D70, D100
Minolta	Maxxum 7D
Fujifilm	FinePix S2 Pro, FinePix S20 Pro, FinePix S3 Pro
Olympus	E-1, E-10, E-20, EVOLT
Leaf	Valeo 6, Valeo 11, Valeo 22
Contax	N Digital
Pentax	* ist D
Sigma	SD9, SD10
Kodak	DCS 14n, DCS Pro 14nx, DCS 720x, DCS 760, DCS Pro SLR /n, DCS 460

To open a RAW image in Photoshop CS, just follow these steps (Elements 3.0 users can use much the same workflow):

1. Transfer the RAW images from your camera to your hard drive.

2. Choose Open from the File menu, or use Photoshop's File Browser.

3. Select a RAW image file. The Camera RAW plug-in will pop up, showing a preview of the image, like the one shown in Figure 5.19.

4. Rotate the preview image using the Rotate Preview buttons.

5. Zoom in and out using the Zoom tool.

6. Adjust the RGB levels using the Histogram and RGB Levels facilities.

7. Make other adjustments (described in more detail below).

8. Click OK to load the image into Photoshop using the settings you've made.

Photoshop's Camera RAW plug-in lets you manipulate many of the settings you can control within your camera. Here are some of the most common attributes you can change. This is an overview only. Check your Photoshop HELP files for more detailed information on using these controls.

- **Color Space.** It's possible your digital camera lets you choose from among several different color space profiles, such as Adobe RGB or sRGB. The RAW file will be saved by the camera using the camera's native color space. You can change to another color space using the Space drop-down list shown at lower left in Figure 5.19.

Figure 5.19 The Camera RAW plug-in shows a preview of the image.

- **Depth.** Here you'll choose 8 bits or 16 bits per color channel. Photoshop CS now supports more functions using 16-bit channels, so you might want to preserve the full depth of information available.

- **Pixel Size.** Usually, you'll choose to open the image at the same resolution it was recorded at. If you plan to resample to a larger or smaller size, you might find that carrying out this step on the RAW file yields better results because of the new algorithm incorporated in this version of the plug-in.

- **Resolution**. This is the resolution that will be used to *print* the image. You can change the printing resolution to 300 or 600 pixels per inch (or some other value) to match your printer.

- **White balance.** You can change this to a value such as Daylight, Cloudy, Shade, Tungsten, Fluorescent, or Flash, or leave it at As Shot, which would be whatever white balance was set by your camera (either automatically or manually). If you like, you can set a custom white balance using the Temperature and Tint sliders.

- **Exposure.** This slider adjusts the overall brightness and darkness of the image. Watch the histogram display at the top of the column change as you make this adjustment, as well as those for the four sliders that follow.

- **Shadows.** This slider adjusts the shadows of your image. Adobe says this control is equivalent to using the black point slider in the Photoshop Levels command.

- **Brightness.** This slider adjusts the brightness and darkness of the image, similarly to the Exposure slider, except that the lightest and darkest areas are clipped off, based on your Exposure and Shadow settings, as you move the control.

- **Contrast.** This control manipulates the contrast of the midtones of your image. Adobe recommends using this control after setting the Exposure, Shadows, and Brightness.

- **Saturation.** Here you can manipulate the richness of the color, from zero saturation (gray, no color) at the –100 setting to double the usual saturation at the +100 setting.

Additional controls are available on the Detail, Lens, and Calibrate tabs, shown in Figures 5.20, 5.21, and 5.22.

- **Sharpness.** This slider applies a type of unsharp masking using a sophisticated algorithm that takes into account the camera you're using, the ISO rating you used, and other factors. If you're planning on editing the image in Photoshop, Adobe recommends not applying sharpening to the RAW image.

- **Luminance Smoothing/Color Noise Reduction.** Both these sliders reduce the noise that often results from using higher ISO ratings. Each control works with a different kind of noise. Luminance noise is the noise caused by differences in brightness, while color noise results from variations in chroma.

- **Lens Tab settings.** These are technical adjustments you can use to compensate for weaknesses in your lens' design. Most of us don't have the slightest idea what these are, and can safely ignore them.

Figure 5.20 The Detail tab lets you adjust sharpness and noise attributes of your image.

Figure 5.21 The Lens tab has settings for technical lens corrections.

Figure 5.22 The Calibrate tab provides a way for calibrating the color corrections made in the Camera RAW plug-in.

■ **Calibrate Tab settings.** These settings let you make calibrations in the way the Camera RAW plug-in adjusts hues, saturation, or shadow tints. If you consistently find your images end up too red, blue, or green, or have a color cast in the shadows, you can make an adjustment here.

Next Up

In the next chapter, we're going to start working with lenses, exploring some of the optical illusions and delusions that surround digital SLRs, and seeing how various lens concepts can be applied to our photography. You'll also learn some clever ways of circumventing the small-sensor wide-angle dilemma.

6

Working with Lenses

Those who own single lens reflex cameras suffer from a singular disease: Lens Lust. I didn't make that term up. You'll find references to Lens Lust all over the Internet, in user groups, and any gathering that includes two or more photographers. Lens Lust isn't limited to digital SLRs; it infects anyone who owns a camera with removable lenses, including those of the film SLR and rangefinder persuasions.

I've fallen victim to it myself. I worked for two years as the manager of a camera store, and a hefty chunk of what I earned was diverted to my favorite vendor's dealer personal purchase program, as well as to acquiring good used equipment brought to me for trade-in. I ended up with 16 different lenses for my 35mm SLR, including optics like 7.5mm and 16mm fish-eye lenses, a 35mm perspective-control lens, and other specialized lenses. Additional lens collections for my 120/220 SLR camera and Leica rangefinder followed.

These lenses served me well for a number of years and, in fact, should have been sufficient when I went all-digital because they could be used with my new dSLR, too. But then Lens Lust struck again. I wanted, *needed* newer lenses optimized for digital photography. My initial 27mm–105mm zoom (35mm equivalent), furnished with the camera, was soon supplemented by a 42mm–300mm (equivalent) zoom and an 18mm–36mm (equivalent) wide-angle zoom. If enough of you buy this book, a better macro lens, another image-stabilized lens, and a 1.4X teleconverter will follow. Lens Lust is incurable.

If the symptoms are familiar, you should read this chapter. It will tell you more than you need to know about lenses, but, then, you're probably going to acquire more lenses than you need, anyway. There's a little bit more detail on how lenses work (which will help you in selecting your next optic) and some advice for choosing the right lens for the job.

I can't promise a remedy for Lens Lust. I can promise you that I will *not* refer to lenses in this book as "glass," as in "I'm really loaded up on Nikon glass" or "I find Canon glass to be better than Minolta glass." Using that term as a generic substitute for "lens" is potentially confusing

and probably inaccurate. Lens elements aren't necessarily glass, in any case. In Chapter 10 there's mention of a UV lens that uses elements made of quartz, which is a crystallized form of the same silicon dioxide compound that's one of the components of glass. Some very good lens elements can be made of plastic, and research into ceramic lens elements continues. If I happen to mention "glass" in this book, I'll be referring to amorphous silica, not a lens. If I need a synonym to keep from using the word *lens* three times in one sentence, I'll substitute *optics*, instead.

Lenses and dSLRs

Most of the vendors who sell both film and digital SLRs, including Nikon, Canon, and Minolta, produce one line of optics that fit both their film-based and digital cameras. Some, such as Nikon and Olympus, have a second line of lenses that work *only* with digital SLRs. Olympus, in particular, with its "Four-Thirds" systems, has pioneered a start-from-scratch, built-for-digital SLR product line. (You can read more about the Four-Thirds standard in Chapter 2.)

Although you can use lenses designed for film SLRs on your digital SLR, there are good reasons not to. Lenses designed for digital cameras with sensors that are smaller than full-frame size can be made more compact and lighter. There are also some technical reasons why lenses designed for dSLRs can produce better results than "full-size" lenses.

Of course, if you own a digital camera with a full-frame sensor, you have no choice. You must use the lenses offered by your vendor (or by third parties) for the film version. However, as you'll soon learn, even if you do, you may not be working with lenses that are optimized for digital photography.

Digital Differences

Although lenses designed for film and digital use all operate on the same basic principles, sensors react to the light transmitted by those lenses in different ways than film does. Digital lens designs need to take those differences into account. Here are some of the key digital differences.

Some Sensors Are Smaller Than Film Frames

You already know about this. Because many sensors are smaller than the 24mm × 36mm standard film frame, lenses of a particular focal length produce what you think of as a larger image, but which is actually just a cropped version of the same image. No "magnification" takes place; you're just using less than the full amount of optical information captured by the lens.

The most obvious result is the infamous *lens multiplier factor*. Because only part of the image is captured by the sensor, your cropped version appears to be 1.3, 1.5, 1.6, or even 2.0 times larger. (Nikon's D2x has a high-speed burst mode that crops the already cropped image even further to produce a 2X lens multiplier.) While this multiplier factor can be, seemingly, a boon to those needing longer lenses, it's a hindrance in the wide-angle realm. A decently wide 28mm full-frame lens becomes the equivalent of a 45mm normal lens when mounted on a camera with a 1.6X multiplier.

There are other ramifications. Because a smaller portion of the lens coverage area is used, the smaller sensor effectively crops out the edges and corners of the image, where aberrations and other defects traditionally hide. If you use a full-frame lens on a dSLR with a smaller sensor, you may be using the best part of the lens. This is nothing new; users of pro film cameras have a much more intimate knowledge of coverage circles. They know that, say, a 200mm telephoto lens for a 2 1/4 × 2 1/4 SLR like a Hasselblad may cover a square no larger than 3 × 3 inches, whereas a 200mm lens for a view camera may have an image circle that's 11 to 20 inches in diameter.

Still, you'd probably be surprised to realize that an inexpensive 200mm lens developed for a 35mm film camera is a great deal sharper within its 24mm × 36mm image area than a mondo-expensive 200mm "normal" lens for a 4 × 5 view camera cropped to the same size. Because 4 × 5 film is rarely enlarged as much as a 35mm film image—or digital camera image—lenses produced for that format don't need to be as sharp, overall. Instead they need to be built to cover *larger areas*.

Conversely, when creating a lens that's designed to cover *only* the smaller sensor, the vendor must make the lens sharper to concentrate its resolution on the area to be covered. Olympus claims that its Four-Thirds lenses have double the resolution of similar lenses it builds for its 35mm cameras.

Of course, if the coverage area is made smaller, that can re-introduce distortion problems at the periphery of the coverage circle. This is particularly true of ultrawide-angle lenses, which are difficult to produce in short focal lengths anyway, including the 12mm–24mm zoom I favor.

Figures 6.1, 6.2, and 6.3 illustrate the coverage circle and cropping concepts more visually. Imagine three different 50mm lenses, each designed for a different kind of SLR camera. The magnification of each lens would be identical, but the coverage area would be different in each case.

Figure 6.1 A 50mm lens on a 6 × 6 cm SLR produces a wide-angle view from its generous coverage circle.

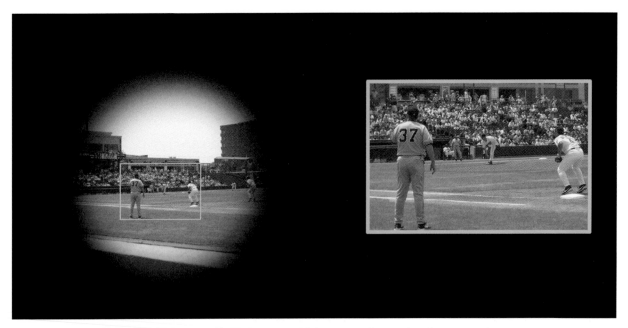

Figure 6.2 The same 50mm focal length creates a "normal" viewpoint on a full-frame SLR, and requires less of a coverage circle.

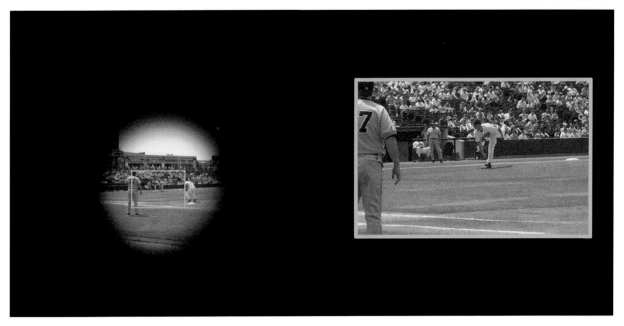

Figure 6.3 Lenses for digital SLRs with smaller sensors can be smaller and more compact, as with this 50mm lens that is the equivalent of a short telephoto.

For example, Figure 6.1 represents a 50mm lens used as a wide-angle optic on a 6 × 6 cm single lens reflex. The coverage area is just a little larger than necessary to cover the full frame. If it were any smaller, you can see that vignetting in the corners would result. At the right side of the illustration is the image that the camera crops out of the lens's coverage area to produce a slightly wide-angle view.

Figure 6.2 might be a full-frame SLR, with a slightly smaller coverage area to produce a "normal" view from the 50mm lens. Figure 6.3 would correspond to a 50mm lens designed for a smaller sensor, and would have a commensurately smaller coverage area. The 1.5X crop factor, compared to the full-frame image in Figure 6.2, results in a short telephoto effect, roughly the same as if a 75mm lens were used on the full-frame camera.

Extreme Angles

Film's "sensors" consist of tiny light-sensitive grains embedded in several different layers. These grains respond about the same whether the light strikes them head on or from a slight or extreme angle. The angle makes a difference, but not enough to degrade the image.

As you learned in Chapter 2, sensors consist of little pixel-catching wells in a single layer. Light that approaches the wells from too steep an angle can strike the side of the well, missing the photosensitive portion, or stray over to adjacent photosites. This is potentially not good, and can produce light fall-off in areas of the image where the incoming angles are steepest, as well as moiré patterns with wide-angle lenses.

Fortunately, the camera vendors have taken steps to minimize these problems. The phenomenon is more acute with lenses with shorter back-focal distances, such as wide-angles. Because the rear element of the lens is so close to the sensor, the light must necessarily converge as a much sharper angle. Lens designs that increase the back-focal distance (more on this later) alleviate the problem. With normal and telephoto lenses that have a much deeper back-focal distance anyway, the problem is further reduced.

Another solution is to add a microlens atop each photosite to straighten out the optical path, reducing these severe angles. Figure 6.4 (which originally appeared in Chapter 2; I'm not going to ask you to flip back) shows how such a microlens operates. Newer cameras employ such a system, so you can use lenses designed for either film or digital use without worry.

Olympus's clever Four-Thirds design is perhaps the best approach. Although the overall concept was developed in conjunction with Fuji and Kodak, Olympus is the first vendor to bring the Four-Thirds approach to a digital SLR. The company's dSLRs and their lenses were designed from scratch for use with digital sensors that measure 22.5mm diagonally. So, the camera was designed with a longer back-focal distance to mate with lenses that had a matching back-focal distance. Even the Olympus wide-angle optics focus the light at an angle that is more friendly to the digital sensor's needs.

Reflections

If you've ever looked at film, you noticed that the emulsion side—the side that is exposed to light—has a relatively matte surface, due to the nature of the top antiabrasion coating and the underlying dyes. Take a glance at your sensor, and you'll see a much shinier surface. It's entirely possible for light to reflect off the sensor, strike the back of the lens, and end up bouncing back to the sensor to produce ghost images, flare, or other distortions. While lens coatings can control this bounce-back to a certain extent, digital camera lenses are more prone to the effect than lenses used on film cameras.

Figure 6.4 A pattern of microlenses above each photosite corrects the path of the incoming photons.

Lens Designs

You can understand why designing lenses for digital SLRs can become extremely complex if you know a little about how lenses are created. Although typical dSLR lenses contain many elements in several groups, I'm going to explain some basic principles using just a minimal number of pieces of glass.

Figure 6.5 shows a simple lens with one positive element. This is known as a *symmetrical* lens design because both halves of the lens system are mirror images. The optical center of this lens is in the center of the single element, and the distance from the center to the focal plane (in this case, the sensor) is the same as the focal length of the lens. Assuming it's a 75mm lens, that distance, the back-focus distance, would be 75mm, or about 3 inches. All you'd need to do to use this configuration would be to design a lens that positioned the single lens element at 75mm to bring the lens into sharp focus.

Things get more complicated when you start designing a longer lens. With a 500mm optic, you'd need to design the lens so the optical center was 20 inches from the sensor. That would be quite a long lens! Indeed, so called *mirror lenses* exist that use a series of reflecting surfaces to fold this long optical path to produce a lens that is much shorter for its particular focal length.

But there's another way, through the use of an *asymmetrical* lens design. Place a negative lens element *behind* the positive element, spreading the incoming light farther apart again, causing the photons to converge farther from the optical center than they would otherwise, as you can see in Figure 6.6. The negative element has the effect of lengthening the effective focal length and moving the optical center in front of the front element of the lens. The result: a "shorter" telephoto lens.

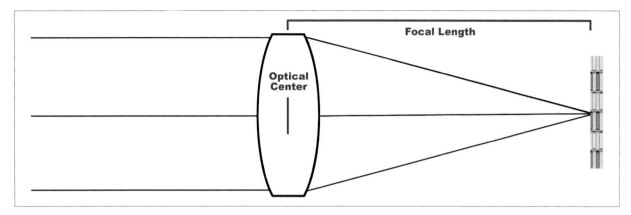

Figure 6.5 In a simple lens, the optical center is in the center of the element or group.

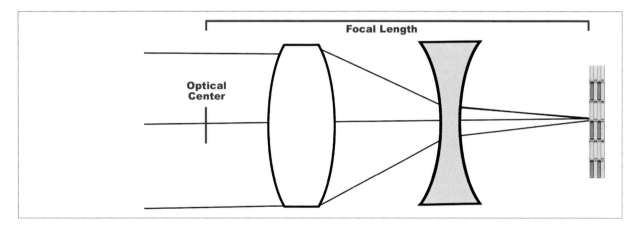

Figure 6.6 A telephoto lens uses a negative element to move the optical center out in front of the lens.

With wide-angle lenses, we have the reverse problem. The photons focus too close to the rear of the lens, creating a back-focus distance that's so short that it doesn't allow room for the mirror. Without the mirror to worry about, it wouldn't matter if some of the elements of a wide-angle lens extended far into the camera body, very close to the focal plane itself. Indeed, that's the arrangement found in rangefinder cameras (which have no mirror) and with some lenses from the dark ages (like my 7.5mm fish-eye), which was viable on an SLR only if the mirror was locked up out of the way.

The solution here is to create an inverted telephoto lens, usually called *retro-focus*, which inserts the negative lens element ahead of the positive element, spreading the beam of light so that when the positive lens element focuses it again on the sensor, the focal point is much farther back than it would be otherwise. The optical center has been moved *behind* the center of the lens, as you can see in Figure 6.7.

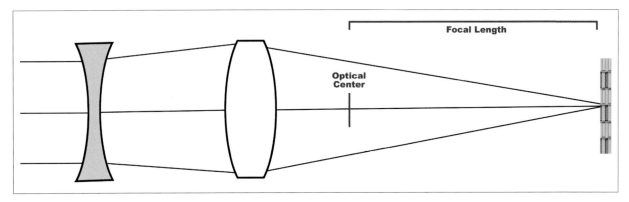

Figure 6.7 A retro-focus design solves the back-focus distance problem by moving the optical center behind the lens, increasing the distance between the lens and the focal plane.

You can see that an inverted telephoto design helps digital camera lens designers produce wide-angles that are physically "longer" than their focal lengths, just as the traditional telephoto configuration produced lenses that were physically "shorter" than their focal lengths. Unfortunately, these more complex lens designs lead to undesired effects in both telephoto and wide-angle lenses. A primary symptom is *chromatic aberration*, or the inability of a lens to focus all the colors of light at the same point, producing a color fringing effect. This color effect is caused by the glass's tendency to refract different colors of light in different ways, much like a prism. There are actually two types of chromatic aberration: *axial* (in which the colors don't focus in the same plane) and *transverse*, in which the colors are shifted to one side. The partial cure is the use of low diffraction index glass (given an ED code by Nikon, and UD by Canon), which minimizes the effect.

Other ailments include barrel distortion, which is a tendency for straight lines to bow outwards, and various spherical aberrations. Lens designers have countered with *aspherical* lens elements. As you might guess, aspherical optics are lenses with a surface that is not a cross-section of a sphere. These lenses are precisely ground (or, more recently in some consumer cameras, molded) to the required shape, and do a good job of correcting certain kinds of distortion.

Note that none of the lens designs I've cited are exclusive to digital SLR cameras. Such lenses can be developed for any sort of camera, but some of their characteristics come in particularly handy in the dSLR realm.

If It Ain't Bokeh, Don't Fix It

Lens Lust isn't the only malady that can befall a new dSLR owner. Another illness is the search for the perfect bokeh. The term has almost become a buzzword, and is used to describe the aesthetic qualities of the out-of-focus parts of an image, with some lenses producing "good" bokeh and others offering "bad" bokeh. *Boke* is a Japanese word for "blur," and the h was added to keep English speakers from rhyming it with *broke*.

You've probably noticed that out-of-focus points of light become disks, which are called *circles of confusion*. These fuzzy discs are produced when a point of light is outside the range of an image's depth-of-field. Most often, circles of confusion appear in close-up images, particularly those with bright backgrounds, as shown in Figure 6.8. The circle of confusion is not a fixed size, nor is it necessarily always a perfect circle. The viewing distance and amount of enlargement of the image determine whether we see a particular spot on the image as a point or as a disc. The shape of the lens's diaphragm can determine whether the circle is round, nonagonal, or some other configuration.

Figure 6.8 The quality of those disks of out-of-focus light in the background determines a lens's bokeh.

Good bokeh and bad bokeh derives from the fact that some of these circles are more distracting than others. Some lenses produce a uniformly illuminated disc. Others, most notably *mirror* or *catadioptic* lenses, produce a disk that has a bright edge and a dark center, producing a "doughnut" effect, which is the worst from a bokeh standpoint. Lenses that generate a bright center that fades to a darker edge are favored because their bokeh allows the circle of confusion to blend more smoothly with the surroundings.

Evenly illuminated disks, or, worst of all, those with lighter edges (like those of a mirror lens) are undesirable. If you look carefully at Figure 6.9, you can detect some bokeh of the most objectionable sort. The bokeh characteristics of a lens are most important when you are using selective focus (say, when shooting a portrait) to deemphasize the background, or when shallow depth-of-field is a given because you're working with a macro lens, long telephoto, or with a wide-open aperture. Figure 6.10 shows what the three general varieties of bokeh look like when captured and isolated from their native habitats so you can see them more clearly.

Figure 6.9 Light edges around the out-of-focus disks reveal the worst kind of bokeh.

Figure 6.10 Good bokeh (left), neutral bokeh (middle), and bad bokeh (right).

Understanding Lens Requirements

You've got a little background in lenses now, and you're ready to learn exactly what you should be looking for when choosing lenses for your digital SLR. After all, the lenses you own affect the quality of your images as well as the kinds of pictures you can take. The most important factors in choosing a lens are the quality of the lens, the resolution of the images it produces, the amount of light it can transmit (that is, its maximum lens opening), its focusing range (how close you can be to your subject), and the amount of magnification (or zooming, in a zoom lens) that it provides. Here are some of the things you should consider.

Image Quality

If you're graduating from a digital point-and-shoot camera, one of the first things you notice is how concerned your colleagues are over lens sharpness. Most point-and-shooters don't worry about it that much because there is little they can do about it other than purchasing another camera. The lens on a non-SLR is what it is; it may be sharp or it may be less sharp, and that's it. The situation is similar to the horsepower question in an econobox automobile. Horsepower is not what you purchased the vehicle for. You'd be more interested in engine power if you had a sports car that, perhaps, could be souped up a little with some aftermarket components.

Lenses are the dSLR's primary aftermarket component. If you frequent the dSLR newsgroups and forums, you'll notice the attention paid to how sharp a particular lens is. Visit any such venue and you'll find multiple postings inquiring about the resolution of this lens or that lens, and whether it has good or bad bokeh. A good rule of thumb is that most general purpose lenses produce good enough image quality for general purpose shooting. When you start to get into specialized areas—ultrawide lenses, extra long telephotos, super-fast optics with large f-stops—the compromises necessary to produce those expensive toys sometimes involve compromises in image quality. If you're contemplating one of these lenses, it's a good idea to read the magazines and Web sites that have formalized, standard testing, and check around among your friends, colleagues, and others who can provide you with tips and advice.

Lens Aperture

If you're a veteran SLR user, you know all about lens apertures. If not, you need to know that the lens aperture is the size of the opening that admits light to the sensor, relative to the magnification or focal length of the lens. A wider aperture lets in more light, allowing you to take pictures in dimmer light. A narrower aperture limits the amount of light that can reach your sensor, which may be useful in very bright light. A good lens will have an ample range of lens openings (called "f-stops") to allow for many different picture-taking situations.

You generally don't need to bother with f-stops when taking pictures in automatic mode, but we'll get into apertures from time to time in this book. For now, the best thing to keep in mind is that for digital photography a lens with a maximum (largest) aperture of f2 to f2.8 is "fast" while a lens with a maximum aperture of f8 is "slow." If you take many pictures in dim light, you'll want a camera that has a fast lens.

Zoom lenses tend to be slower than their prime lens (non-zooming) counterparts. That's because digital optics are almost always zoom lenses, and zoom lenses tend to have smaller maximum apertures at a given focal length than a prime lens. For example, a 28mm non-zoom lens for a 35mm camera might have an f2 or f1.4 maximum aperture. Your digital camera's zoom lens will probably admit only the equivalent of f2.8 to f3.5, or less, when set for the comparable wide-angle field-of-view.

The shorter actual focal length of digital camera lenses when used with cameras that have a lens multiplier factor also makes it difficult to produce effectively large maximum apertures. For example, the equivalent of a 28mm lens on a full-frame camera with a camera having a smaller 1.6X multiplier sensor is an 18mm lens. There's a double-whammy at work here. Although providing the same field-of-view as a 28mm wide-angle, the 18mm optic has the same depth-of-field as any 18mm lens (much more than you'd get with a 28mm lens). Worse, the mechanics of creating this lens complicates producing a correspondingly wide maximum f-stop. So, while you might have used a 28mm f2 lens with your film camera with a workable amount (or lack) of depth-of-field wide open, you'll be lucky if your 28mm (equivalent) digital camera lens has an f-stop as wide as f4. That increases your depth-of-field at the same time that the actual focal length of your wide angle (remember, it's really an 18mm lens) is piling on even *more* DOF.

What about the minimum aperture? The smallest aperture determines how much light you can block from the sensor, which comes into play when photographing under very bright lighting conditions (such as at the beach or in snow) or when you want to use a long shutter speed to produce a creative blurring effect.

Digital cameras don't have as much flexibility in minimum aperture as film cameras, partly because of lens design considerations and partly because the ISO 100 speed of most sensors is slow enough that apertures smaller than f22 or f32 are rarely needed. A digital camera's shutter can generally reduce the amount of exposure enough. So, your lens probably won't have small f-stops because you wouldn't get much chance to use them anyway. If you do need less light, there are always neutral density filters.

Of course, as I will point out in Chapter 7, while smaller apertures increase depth-of-field, there are some limitations. In practice, a phenomenon known as *diffraction* reduces the effective sharpness of lenses at smaller apertures. A particular lens set at f22 may offer significantly less overall resolution than the same lens set at f5.6, even though that sharpness is spread over a larger area.

Zoom Lenses

A zoom lens is a convenience for enlarging or reducing an image without the need to get closer or farther away. You'll find it an especially useful tool for sports and scenic photography or other situations where your movement is restricted. Only the least-expensive digital non-SLR cameras lack a zoom lens. Some offer only small enlargement ratios, such as 2:1 or 3:1, in which zooming in closer produces an image that is twice or three times as big as one produced when the camera is zoomed out. More-expensive cameras have longer zoom ranges, from 4:1 to 10:1 and beyond.

Digital SLRs, of course, can be fitted with any zoom lens that is compatible with your particular camera, and you'll find a huge number of them in all focal length ranges and zoom ratios. There are wide-angle and wide-angle-to-short telephoto zooms, which cover the range of about 18mm to 70mm (35mm equivalent), short telephoto zooms from around 70mm to 200mm (equivalent), high-power zooms in the 80mm to 400mm range, and lenses that confine their magnifications to the long telephoto territories from about 200mm to 600mm or more.

Digital SLRs generally rely solely on what is now called *optical zoom*, the relationship of the individual elements of the lens are changed to produce the changes in magnification. Because the lens elements can be finely tuned, this produces the sharpest image at each lens magnification. For example, a typical zoom might be described as having 10 elements in eight groups. Each of the groups can be moved individually to provide the desired magnification and the best image. The optical science behind these relationships is complex, and we should be thankful that our spanking-new digital cameras have 50 years or more of research backing the optical component.

Thankfully, dSLR owners are spared the problems caused by that feature-without-portfolio found in point-and-shoot cameras: the *digital zoom*, in which the apparent magnification is actually produced simply by enlarging part of the center of the image. I tend to think of digital zoom as a feature-turned-bug (the exact opposite of a bug that's promoted as a useful feature). Digital zoom is less sharp than optical zoom. Indeed, you can invariably do a better job by simply taking the picture at a point-and-shoot camera's maximum optical zoom setting and enlarging the image in your image editor.

Because the elements of a lens are moving around in strange and mysterious ways, the effective aperture and focus of a lens may vary as the magnification settings change. A lens that has an f2.8 maximum aperture at its wide angle setting may provide only the amount of light admitted by an f3.5 lens at the tele position. Focus can change, too, so when you focus at, say, the wide-angle position and then zoom in to a telephoto view, the original subject may not technically still be in sharpest focus (although the huge amount of depth-of-field provided by digital camera lenses may make the difference impossible to detect). You'd notice the differences only when using the camera in manual exposure or focusing mode, anyway. When set to autofocus and autoexposure, your camera will provide the optimum setting regardless of zoom magnification.

Focusing

The ability to focus close is an important feature for many digital camera owners. One of the basic rules of photography is to get as close as possible and crop out extraneous material. That's particularly important with digital cameras because any wasted subject area translates into fewer pixels available when you start cropping and enlarging your image. So, if you like taking pictures of flowers or insects, plan to photograph your collection of Lladró porcelain on a table-top, or just want some cool pictures of your model airplane or stamp collections, you'll want to be able to focus up close and personal.

What's considered close can vary from model to model; anything from 12 inches to less than an inch can be considered "close-up," depending on the vendor. Fortunately, those short focal length lenses found on digital cameras come to the rescue again. Close focusing is achieved by moving the lens farther away from the sensor (or film) and an 18mm wide-angle lens doesn't have to be moved very far to produce an image of a tiny object that fills the viewfinder. You'll find more about macrophotography in the next chapter.

Add-On Attachments

Photographers have been hanging stuff on the front of their lenses to create special effects for a hundred years or more. These include filters to correct colors or provide odd looks, diffraction gratings and prisms to split an image into pieces, pieces of glass with Vaseline smeared on them to provide a soft-focus effect, and dozens of other devices. These range from close-up lenses to microscope attachments to infrared filters that let you take pictures beyond the visible spectrum. Add-on wide-angle and telephoto attachments are also available, along with slide-copy accessories and other goodies. If you're serious about photography, you'll want to explore these options.

Unfortunately, dSLRs come with lenses that have all different sizes of filter threads. One of Nikon's strong selling points in olden times was that virtually all its general purpose lenses used a 52mm filter thread, so you could invest hundreds of dollars in filters and add-ons and be able to use them with a whole range of optics. Of course, a 52mm thread size is hardly practical for modern dSLR lens designs. You're more likely to need 62mm accessories for many of your lenses, probably will require 67mm add-ons for many of them, and needn't be surprised if your faster lenses, longer zooms, and widest optics require 72mm or 77mm filters.

Of course, you won't want to choose a lens based on its filter thread, but it's a good idea to look at how you plan to use your lenses before purchasing filters. If only one of your lenses requires a 72mm filter, but the lenses you use most use 62mm and 67mm filters, you might want to standardize on 67mm filters and use a step-down ring to mount those same filters on the lenses that accept 62mm accessories. Buy only those 72mm filters you actually need. Filters are so much more expensive in the larger sizes that you probably won't need much prompting to make your plans carefully.

Construction Quality

The final consideration when choosing a lens is the quality of its construction. See if the key lens components are made of metal or plastic. Believe it or not, some lower-cost lenses have mounts that are made of non-metallic components. They're less sturdy, and more likely to wear if you attach and detach them from your camera often.

Also check for play in the focusing and zooming mechanisms. You don't want any looseness, stickiness, odd noises, or other qualities that signify cheap or poor construction. Your investment in lenses will probably exceed your cost for your digital camera body after a few months, so you want your lenses to hold up under the kind of use and abuse you'll subject them to.

Remember that, most likely, the lenses you purchase after each bout with Lens Lust will probably work just as well with your *next* dSLR as with your current model, so you can consider them a long-term investment. I have lenses that I purchased early in my career that are still in use a dozen camera bodies later. So, don't be afraid to spend a little more for lenses that are constructed well and have all the features you need. I own more than one lens that originally cost more than my dSLR body, and I don't consider the expenditure extravagant.

Next Up

The next three chapters are going to provide some tips for particular types of photography. You'll learn about action photography, architectural work, people pictures, and landscape photography. But first, you can turn to the next chapter to learn about shooting up close and personal.

7

Close-Up Photography

Many of the most enjoyable types of digital photography are, unhappily, seasonal. If you love to shoot baseball or football sports action, you'll have to wait until baseball or football season kicks off. Should your passion be shooting autumn colors as the leaves change after summer's end, you'll have to wait until September and October of each year. Wildlife and nature photography isn't impossible during the winter months, but it's usually more exciting during the Spring. Architectural photos often look their best with leaves on the surrounding trees. Weddings seem to proliferate in June. Just when you get really involved in a particular type of photography, the "season" for it ends.

But close-up photography is a photographic pursuit you can enjoy all year long. Each April, I'm out there chasing down blossoming flowers and looking for interesting bugs to capture on digital film. In July, I end up at the beach shooting shells and shore creatures. Come late September, I grab close-up shots of leaves. And during the long winters, I have my macro table-top set up so I can shoot pictures of anything that captures my fancy. Indeed, close-up photography and portraits are what I photograph most during the cold months.

I'm hoping this chapter will encourage you to try out macrophotography yourself because digital SLRs are the perfect tool for this kind of picture taking. You'll discover whole new worlds in a water drop, teeming life under any bush or tree, and fascinating patterns in common household objects.

You'll find a pretty good chapter on macrophotography in my companion book, *Mastering Digital Photography,* and, as always, I'm not going to repeat all that information here. Instead, I'll recap some of the high points and then concentrate on the aspects of close-up work that apply directly to digital SLRs.

Why dSLRs Are Better

Point-and-shoot digital cameras are ballyhooed as great close-up gear because the LCD display makes it easy to frame your photo accurately without fear of accidentally clipping off part of the image due to the parallax error difference between what the optical viewfinder sees and what the sensor actually captures. Yet, can you really view an image and check focus on an LCD with a 1.5-inch diagonal measurement? I've used non-SLR digital cameras with generous 2.5-inch LCDs and worked with EVF cameras with decent-sized internal LCD viewfinders, and none of them were as good as the least expensive dSLR when it comes to framing and viewing an image.

If it seems as if shutter lag and other features of digital cameras were designed to make action photography difficult, the reverse is true for the macrophotographic realm. Many features built into every digital camera make these image grabbers ideal for taking close-up pictures. If you've been doing macrophotography with film cameras, a few sessions with a digital camera will convince you that digital technology is exactly what you've been waiting for. Back panel LCDs are no picnic to use outdoors in bright sunlight, either. The image is often washed out and difficult to see. Although an increasing number of point-and-shoot cameras boast close focusing capabilities down to less than one inch, they really aren't the ideal camera you'd choose for macrophotography.

On the other hand, dSLRs not only provide a big, bright look at what you're shooting, you can press the depth-of-field preview to gauge the sharpness, too. Their zoom lenses focus close even at telephoto positions—something lacking in many snapshooter-oriented digital cameras, which work in macro mode only at the wide-angle setting. Digital SLR autofocus is faster, and the lack of shutter lag means you can snap off a picture the instant your dragonfly hovers into the field-of-view—not a second or two later. A dSLR is more likely to have an external flash connection than a non-dSLR, so your close-up lighting setups can be more sophisticated. There are special macro lenses and other close-up accessories like ringlights for digital SLRs that aren't readily available for fixed-lens cameras.

Pixel for pixel, dSLRs do a better job in close-up modes. When I needed a cover shot of a digital SLR for this book, what did I do? I took one of my own cameras, set it on a seamless background, and fired away with another dSLR, producing the image shown in Figure 7.1.

Figure 7.1 A dSLR portrait taken with a dSLR.

Macro Terminology

It's easy to get confused over some of the terms applied to macrophotography. Even the name itself is sometimes misunderstood. Macrophotography is *not* microphotography, which involves microfilm and other miniature images; nor is it photomicrography, which is taking pictures through a microscope. Nor, necessarily, is it close-up photography, which, strictly speaking, applies to a tight shot in cinematography. Macrophotography is generally the production of close-up photos, usually taken from a foot away or less. Because the terms macrophotography and close-up photography are nevertheless used interchangeably these days, I'll do so in this book.

There are several other terms that cause confusion:

■ **Magnification.** In macrophotography, the amount of magnification is usually more important than how close you can get to your subject. For example, if you're photographing a coin and want it to fill the frame, it makes little difference whether you shoot the coin using a 50mm lens from 4 inches away or with a 100mm lens from 8 inches away. Either one will produce the same magnification. Because of this, close-up images and the macro capabilities of cameras and lenses are usually described in terms of their magnification factor, rather than the camera/subject distance. Moderate close-ups may involve 1:4 or 1:3 magnifications. Larger-than-life-size images may involve 2:1 or 4:1 (or 2X or 4X) magnifications. The small stone carving in Figure 7.2 was photographed at approximately a 1:4 ratio.

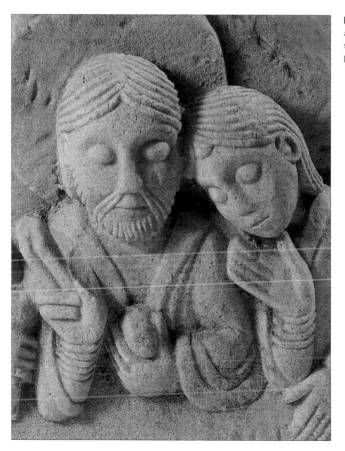

Figure 7.2 Sometimes getting up close and photographing a detail of a larger subject provides an interesting perspective.

- **Perspective.** Subject distance *does* make a difference in terms of perspective, however. Although the same size image can be taken from farther away or closer to produce the same magnification, the apparent perspective of the image will change. Objects in a scene that are significantly closer to the lens than other objects will look larger and out of proportion. I'll address this aspect in more detail later.

- **Backfocus.** This is the tendency of some autofocus systems to focus *behind* the intended subject rather than spot on it. (Frontfocus errors also exist, but they are less common.) The phenomenon is not limited to macrophotography, but does tend to be more obvious in close-up shots. You can diagnose this problem by laying out a tape measure, photographing it on a slant with focus set on some mid-point, and then seeing if the point of focus is where it should be. Frequently, backfocus problems can be fixed by the camera's vendor. (Note that this backfocus *problem* is not the same thing as the backfocus *distance* I discussed in Chapter 6.)

- **Depth-of-field/depth-of-focus.** *Depth-of-field* is the range of a subject that appears acceptably sharp at a particular lens opening. Changing to a smaller f-stop increases depth-of-field, while opening up a lens reduces it. Wide-angle lenses have more depth-of-field than telephoto lenses at the same magnification. *Depth-of-focus* is the amount you can increase the distance between the imaging sensor or film and the subject and still retain sharpness. Although often confused with depth-of-field, this term is most often applied to "fixed" setups where the sensor/film or flat subject is moveable, such as photoreproduction cameras or scanners.

Getting Practical

Of course, macrophotography isn't all about terms and definitions. You need to understand how to apply these concepts to your picture taking. This section will look at some of the practical aspects of shooting close-up images.

Lens Choice

The selection of a lens for macrophotography can be important because not all lenses do a good job of taking close-up pictures. Some, particularly zoom lenses with a long range, may not focus close enough for practical macro work. Others may not be sharp enough, or might produce distortion, color aberrations, or other image problems that become readily apparent in critical close-up environments. Or, you might find that a particular lens or focal length is not suitable because, to get the magnification you want, the lens itself must be so close to the subject that it intrudes on properly lighting the setup. Here are some things to think about:

Macro or General Purpose Lens?

Many general purpose lenses can be pressed into service as close-up optics and do a fine job if they have sufficient sharpness for your application and are relatively free of distortion. If you frequent the photography forums, you'll see paeans of praise for this lens or that when used for macro shots. It's entirely possible to work with a lens you already own and get good results.

However, if you do a lot of close-up work, you'll be happier with a lens designed specifically for that job. Such lenses will be exquisitely sharp and be built to focus close enough to produce 1:1 or 1:2 magnification without any add-on accessories.

Focal Length

Focal length determines the working distance between your camera/lens and the macro subject at a given magnification. As with most real-world decisions, the choice of focal length is necessarily a compromise.

To focus more closely, the lens elements of a general purpose or macro lens must be moved farther away from the sensor, in direct proportion to the magnification. (To simplify things, I'm going to assume we're using a fixed-focal-length, or *prime* lens, rather than a zoom lens.) So, the optical center of a 60mm lens must be moved 60mm from the sensor (about 2.4 inches) to get 1:1 magnification. That's a relatively easy task with a 60mm lens. To get the same magnification with a 120mm lens, you'd have to move the optical center much farther, 120mm (or almost 5 inches), to get the same 1:1 magnification. (As I mentioned in Chapter 6, the "optical center" can be somewhere other than the physical center of the lens; with a long lens, the optical center may be close to the front element of the lens.)

For this reason, most so-called "macro" zoom lenses actually produce 1:4 or 1:5 magnifications. There are specialized macro prime lenses for digital cameras in the 60mm, 80mm, 105mm, and 200mm range, but these are special optics and tend to be expensive. However, they might still be a better choice for you if you do a lot of close-up photography.

That's because of the increased working distance the longer lenses offer. At extreme magnifications, a shorter lens may have the front element less than an inch from the subject. That introduces perspective problems and makes it difficult to get some light in there to illuminate your subject. Your camera may be so close to the subject that there isn't room to light the front of the subject. Forget about your built-in flash: It is probably aimed "over" the subject and either won't illuminate it at all or will only partially illuminate it, and may even be too powerful. Or, your lens may cast a shadow on the subject.

So, your choice of focal length may depend on the desired working distance and whether a particular focal length produces the perspective you need. Figure 7.3 shows how a wide-angle lens can be used effectively for close-ups.

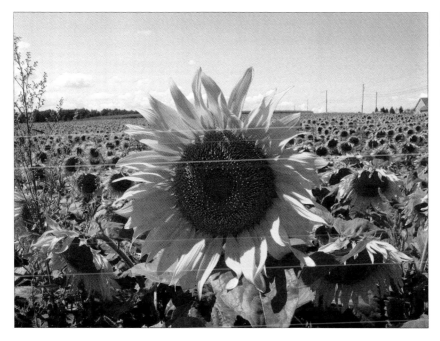

Figure 7.3 Wide-angle lenses provide an interesting perspective for close-up shots.

Depth-of-Field

The depth of sharp focus with three-dimensional subjects can be a critical component in macrophotography. You'll find that depth-of-field is significantly reduced when you're focusing close. Although the relatively short focal length of the lenses used with digital cameras provides extra depth-of-field at a given magnification, it still may not be enough. You'll need to learn to use smaller apertures and other techniques to increase the amount of sharp subject matter. A lens that has a wider range of f-stops, with, perhaps stops as small as f32 or even smaller, can be helpful to increase depth-of-field. Of course, you need to know that any DOF gains made with smaller f-stops can be lost to a phenomenon known as *diffraction,* which crops its ugly head as you stop down. (Diffraction is why most lenses produce their best results one or two f-stops from wide open, and actually lose a bit of sharpness as you stop down, even while depth-of-field increases.)

Figure 7.4 shows three different versions of a photo of an array of crayons, taken with a 60mm macro lens. In all three cases, focus was on the yellow-green crayon in the upper middle of the frame. The image on the left was shot at f4, the middle version at f11, and the one at right at f22. You can easily see how the depth-of-field increases as the lens is stopped down.

Figure 7.4 Depth-of-field increases as the f-stop is changed from f4 (left) to f11 (middle) and f22 (right).

You'll also need to learn how to *use* your available depth-of-field. Typically, the available DOF (which, as you've just seen, varies by f-stop) extends two-thirds behind the point of sharpest focus and one-third in front of it. Figure 7.5 shows the same crayons in a slightly different arrangement, all taken at f4. In the version at left, I've focused on one of the crayons in the front row. The middle shot, taken at the same f-stop, was focused on the middle crayon. The version at the right was focused on the rear-most row. With the lens almost wide-open, depth-of-field is so shallow that only the crayon focused on is sharp. I could use that creatively to apply selective focus, or I could have stopped the lens down, focused on the center crayon, and perhaps brought all of them into focus.

I also could have increased depth-of-field by changing angles so that more crayons were approximately the same distance from the lens. For Figure 7.6, I cranked the tripod up a little higher and shot down from a different angle. The f-stop is still f4, but more of the crayons are in focus.

Figure 7.5 See how depth-of-field changes when the lens is focused on the crayon in front, middle, or back rows.

Figure 7.6 Raising the viewing angle spreads the depth-of-field over a broader area than shooting head-on.

Perspective

As you just learned, close-up pictures can be taken from a relative distance (even if that distance is only a few feet away) with a telephoto lens or long zoom setting. The same magnification can also be achieved by moving in close with a shorter lens. The same apparent perspective distortion that results from using a wide-angle lens close to a subject and the distance compression effects of a telephoto apply to macrophotography.

So, if you have a choice of tele/wide-angle modes for macrophotography, you'll want to choose your method carefully. Relatively thick subjects without a great deal of depth and those that can't be approached closely can be successfully photographed using a telephoto/macro setting. Subjects with a moderate amount of depth can be captured in wide-angle mode. If you find

that a wide setting tends to introduce distortion, settle for a focal length somewhere in between wide and telephoto. Figure 7.7 shows an image I produced one day when I had nothing to photograph. I decided to do some "figure studies" of a shapely miniature jug, using close-up techniques. I used light and a telephoto zoom set to macro mode to capture images of portions of the jug.

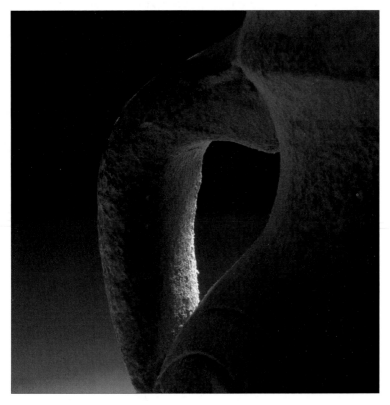

Figure 7.7 A telephoto perspective and a creative use of light make this photo of part of a jug interesting.

The most important types of subjects affected by perspective concerns are table-top setups such as architectural models and model railroad layouts. Use the right perspective, and your model may look like a full-scale subject. With the wrong perspective, the model looks exactly like what it is, a tiny mock-up.

You can see the difference perspective makes by comparing the images at the top and bottom of Figure 7.8. Objects that are closer to the camera appear proportionately larger in the wide-angle shot at top compared to the version shot with the longer zoom setting at bottom. It's most noticeable if you compare the pepper in front with the pepper in back in both photos. In the top version, the rear pepper looks smaller because it's proportionately farther away thanks to the wide-angle perspective. In the bottom picture, the two peppers are more compressed together and similar in size. For a given magnification, you'll want to choose the focal length of your lens carefully to provide the kind of perspective that you're looking for.

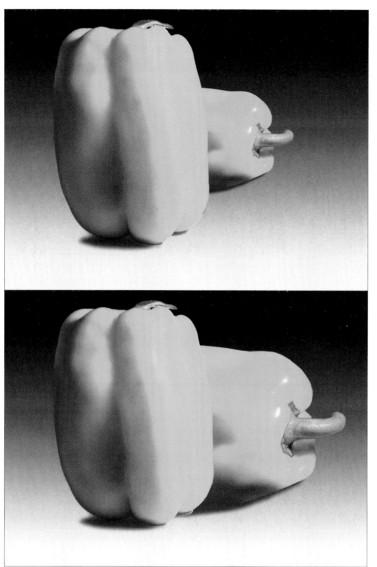

Figure 7.8 The wide-angle shot (top) has a different perspective than the telephoto picture at bottom.

Close-Up Gear

In addition to a close-up lens, there are other pieces of equipment that can come in handy for macrophotography, ranging from special close-up attachments that fit on the front of the lens, lens "extenders" that move the optical center of the lens farther away from the sensor, and accessories like ringlights that make illuminating your subject easier.

Close-Up Lenses

Close-up lenses differ from macro lenses, despite their confusingly similar names. Macro lenses, discussed earlier, are prime lens or macro zoom lenses designed to focus more closely than an ordinary lens. The add-ons that have traditionally been called close-up lenses are screw-on, filter-like accessories that attach to the front of your camera's prime or zoom lens.

These accessories are useful when you want to get even closer than your camera's design allows. They provide additional magnification like a magnifying glass, letting you move more closely to the subject. Close-up lenses, like the one shown in Figure 7.9, are generally labeled with their relative "strength" or magnification using a measure of optical strength called "diopter." A lens labeled "No. 1" would be a relatively mild close-up attachment; those labeled "No. 2" or "No. 3" would be relatively stronger. Close-up lenses are commonly available in magnifications from +0 diopter to +10 diopters.

Figure 7.9 A close-up lens can bring you even closer than your camera's minimum focusing distance.

The actual way close-up magnification is calculated is entirely too complicated for the average math-hating photographer because there's little need to apply mumbo-jumbo like *Magnification at Infinity=Camera Focal Length/(1000/diopter strength)* in real life. That's because the close focusing distance varies with the focal length of the lens and its unenhanced close-focusing capabilities.

However, as a rule of thumb, if your lens, a telephoto, say, normally focuses to one meter (39.37 inches; a little more than three feet), a +1 diopter will let you focus down to one-half meter (about 20 inches); a +2 diopter to one-third meter (around 13 inches); a +3 diopter to one-quarter meter (about 9.8 inches), and so forth. A +10 diopter will take you all the way down to about 2 inches—and that's with the lens focused at infinity. If your digital camera's lens normally focuses closer than one meter, you'll be able to narrow the gap between you and your subject even more.

In the real world, the practical solution is to purchase several close-up lenses (they cost roughly $20 each and can often be purchased in a set) so you'll have the right one for any particular photographic chore. You can combine several close-up lenses to get even closer (using, say, a +2 lens with a +3 lens to end up with +5), but avoid using more than two close-up lenses together. The toll on your sharpness will be too great with all those layers of glass. Plus, three lenses can easily be thick enough to vignette the corners of your image.

One of the key advantages of add-on close-up lenses is that they don't interfere in any way with the autofocus or exposure mechanism of your dSLR. All of your lenses will continue to work in exactly the same way with a close-up lens attached. There are some disadvantages, too. As

with any filters, you must purchase close-up lenses in sizes to fit the front filter threads of your lenses. You'll either need close-up lenses for each filter size appropriate for the optics you want to use them with or use step-up/step-down rings to make them fit.

Finally, close-up lenses come at a sharpness penalty, especially when you start stacking them together to achieve higher magnifications. A photo taken with a close-up lens will be a little less sharp than one taken without. Figure 7.10 was taken with a zoom lens that didn't focus close enough to capture the buds. I slapped a close-up lens on the front, and moved to within a few feet.

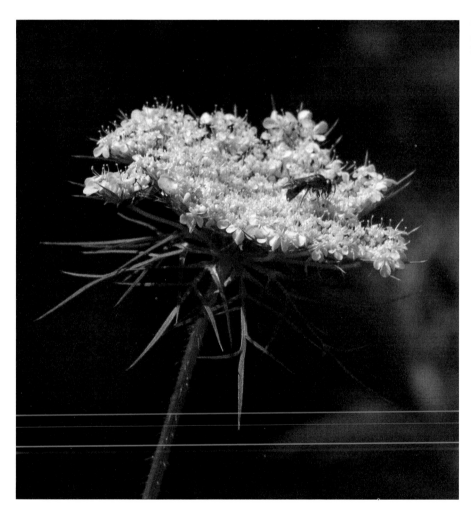

Figure 7.10 A close-up lens on the front of a tele-zoom allowed getting a little closer for this shot.

Extension Tubes and Bellows

One of the coolest things about digital SLRs is that if you can't move the lens far enough away from the sensor to get the magnification you want, you can pop off the lens and insert gadgets that provide that extension for you. The simplest variety is called *extension tubes.*

These are nothing more than hollow tubes with a fitting on the rear similar to that on the back of a lens, and which connects to the lens mount of your camera. The front of the extension tube has a lens mount of its own, and your lens is attached to that. Extension tubes look a little like teleconverters (which increase the focal length of your lens), except they have no optics inside. They do nothing but what their name says: extend. Extension tubes are available in multiple sizes, often as a set, with, say, 8mm, 12.5mm, and 27.5mm tubes that can be used alone or in combination to produce the amount of extension needed.

Some tubes may not couple with your camera and lens's autofocus and autoexposure mechanisms. That doesn't preclude their use because you may be focusing manually anyway when you're in macrophotography mode, and setting the f-stop and shutter speed manually may not be much of an inconvenience, either. Newer sets are compatible with your lens's full set of features, except, possibly, image stabilization, making them even more convenient to use.

Some wacky combinations

I discovered that the deliberate and contemplative nature of macrophotography has an interesting advantage. Once you've freed yourself from fretting over the lack of autofocus and/or autoexposure with your macro setup, you'll find you can attach a wider variety of lenses to your camera than you might have thought. For example:

- **Nikon lenses on Canon dSLRs**. There are adapters that allow fitting Nikon lenses to Canon SLR cameras for use in manual mode. If you'll be working manually for macrophotography anyway, such adapters are more practical.

- **Old-school compatibility**. Pentax dSLRs that accept older Pentax lenses may also be able to use original extension tubes and lenses in manual mode. The same is true for lenses and accessories produced for Nikon and other camera lines. Even though older Nikon lenses ordinarily must be converted for use on modern Nikon dSLRs, you'll find that if a non-automatic extension tube can be mounted safely on your Nikon, you can then attach just about any older lens to that extension tube without fear of damaging your camera body.

- **Lens flip-flops**. Reversing rings, like the one shown in Figure 7.11, are available that let you attach your lens to your camera in reverse fashion, with the lens mount facing *away* from the camera. This configuration can let you focus closer and may produce sharper results. If you're working in manual mode, this setup is no more inconvenient than the normal mode.

Figure 7.11 A reversing ring lets you mount a lens backwards, which sometimes lets you focus more closely and can improve image quality.

A bellows is an accordion-like attachment that moves along a sliding rail to vary the distance between lens and camera continuously over a particular range. Where extension tubes each provide a fixed amount of magnification, bellows let you produce different magnifications, as much as 20:1 or more. I favor an older bellows attachment, used with a correspondingly ancient macro lens. It has a tilt and shift mechanism on the front column, which allows you to vary the angle between the lens and the back of the camera (where the sensor is). This shifting procedure can help you squeeze out a little more depth-of-field by tilting the sharpness "plane" in the same direction your subject matter "tilts" away from the camera.

A bellows attachment, like the one shown in Figure 7.12, frequently has a rotating mechanism that allows you to shift the camera from horizontal to vertical orientation. Some bellows have two rails: one for adjusting the distance of the lens from the camera, and a second that allows moving the whole shebang—bellows, camera, and all—closer or farther away from the subject. That allows it to function as a "focusing rail." Once you've moved the lens out far enough to achieve the magnification you want, you can then lock the camera/bellows distance and slide the whole components back and forth to achieve sharpest focus.

Be careful when attaching bellows or extension tubes to your camera to avoid damaging your lens mount or camera body. Even if a bellows is nominally compatible, you may have to attach an extension tube to the camera body first to allow the mechanism to clear projecting parts of the camera.

Of course, bellows, extension tubes, and similar attachments can be expensive, so you won't want to make the investment unless you do a lot of close-up photography. Another downside is that the farther you move the lens from the sensor, the more exposure required. You can easily lose 2 or 3 f-stops (or much more) when you start adding extension.

Figure 7.12 A bellows with slide and tilt capabilities lets you tweak a little extra depth-of-field out of your extreme close-up photos.

Other Gear

You'll probably need a tripod to support your camera during macrophotography sessions. Tripods steady the camera for the longer exposures you might need and allow consistent and repeatable positioning, which might be necessary if you were, perhaps, taking pictures of your toy soldier collection one figure at a time. Get a sturdy tripod with easily adjustable legs, sure-grip feet, and a center column that lets you change the height over a decent range without the need to fiddle with the legs again. A center column that's reversible is a plus because you can use it to point the camera directly down at the flower or shoot from low angles that are less than the minimum height of the tripod. A ball head, which lets you rotate the camera in any direction, is easier to use and more versatile than a tilt-and-swing type tripod head.

If you take pictures of small, flat objects (such as stamps, coins, photographs, or needlepoint), you might want to consider a special kind of camera support called a *copystand*. These are simple stands with a flat copyboard and a vertical (or slanted) column on which you fasten the camera. The camera can be slid up or down the column to adjust the camera-subject distance. A slanted column is best because it ensures that the camera remains centered over a larger subject area as you move the camera up. Copystands provide a much more convenient working angle for this type of photography, particularly if your digital camera allows swiveling the lens and viewfinder in different directions.

Although you can work with existing light, you'll find your creative possibilities are broader if you use external light sources. Macro subjects other than living creatures will usually sit still for long exposures, so incandescent lighting—perhaps something as simple as a pair of desktop gooseneck lamps—may suffice.

Or, you can use electronic flash to freeze action. As I mentioned earlier, your dSLR's built-in electronic flash isn't ideal for macro work, so you should investigate external, off-camera flash units. Frequently, your camera's internal circuitry may be able to trigger the same vendor's external flash attachments by radio control. Or, you can set your internal flash to its very lowest power setting and use that to set off an external flash through a triggering device called a *slave unit*. In that case, the internal flash may provide nothing more than a little fill on your subject, with most of the illumination coming from the external flash.

There is also a device called a ringlight, which is a circular light shaped like a round fluorescent tube (and may in fact be one in its incandescent incarnation). A ringlight can solve your close-quarters illumination problems by providing an even, shadow-free light source at short camera/subject distances.

Consider using reflectors, umbrellas, and other light modifiers to optimize your lighting effects. A simple piece of white cardboard can work well and can double as a background. Aluminum foil or Mylar sheets can provide a bright, contrasty reflection source. I also use pure-white pocket rain umbrellas that cost me $5, but which unfold to 36 inches or more to create great, soft-light reflectors. If you want diffuse, omni-directional lighting for photographing things like jewelry, nothing beats a tent, which is an enveloping structure of translucent material that fits over your subject, with a hole to fit the lens through. Light can then be applied to the outside of the tent to illuminate your picture. You'll find suggestions for making a tent out of a gallon milk jug in my book *Mastering Digital Photography*.

Some Shooting Tips

You're ready to start shooting close-ups. I'm ready to give you some helpful tips. Try these on for size as you shoot your first macros.

- **Focus carefully.** Some cameras allow switching autofocus to a center-oriented mode or spot mode or let you choose which focus sensor to use, as you'll recall from Chapter 4. Use those features if your subject matter is indeed in the middle of the picture or somewhere within one of the focus zones. Or, switch to manual focus if your camera offers it. You might want to use aperture-priority mode and select the smallest f-stop available to increase the depth-of-field. And keep in mind what you learned about how depth-of-field is arranged: Two-thirds is allocated to the area in front of the plane of sharpest focus, and only one-third to the area behind it.

■ **Watch alignment.** If you're shooting your subject head-on, check to make sure the back of the camera (where the sensor is located) is parallel to the plane in which your main subject lies. That's the plane you'll be focusing on and where the maximum amount of sharpness lies. If the camera is tilted in relation to the plane of the main subject, only part of the subject will be in sharp focus. In Figure 7.13, almost all the image components are located in relatively the same plane so that all of them are in sharp focus.

Figure 7.13 Keep the back of the camera parallel to your subject to maximize depth-of-field.

■ **Stop that jiggle!** If your subject is inanimate and you're using a tripod, consider using your digital camera's self-timer or remote control to trip the shutter after a delay of a few seconds. Even if you press the shutter release button cautiously, you may shake the camera a little. Under incandescent illumination with a small f-stop, your camera will probably be using a slow shutter speed that is susceptible to blurring with even a little camera shake. Use of the self-timer or remote control will let the camera and tripod come to rest. (You may also want to lock up your mirror, as I pointed out in Chapter 4.)

■ **Stop, look, listen!** Wait a few seconds after you hear the camera's shutter click before doing anything. You might have forgotten that you're taking a long time exposure of a couple seconds or more! The click might have been the shutter opening, and the camera may still be capturing the picture. If you have picture review turned on, wait until the shot shows up on the LCD before touching the camera.

Next Up

The next chapter deals with action photography. By that, I don't necessarily mean sports photography. Action is where you find it, and it needn't involve organized play or games. Even if you never make it to a football or baseball game, don't have kids playing soccer, and aren't a NASCAR fan, you can take great digital action pictures with your dSLR. I'm going to show you how to freeze action when it's a good idea, and how to get good *blurry* pictures, too.

8

Capturing Action

The essence of all still photography is to capture a moment in time. That's never truer than when you're photographing action, whether it's your kids' Little League or soccer teams, a volleyball game at your company picnic, a bowling tournament, or a quick snap of a fast-moving ride at an amusement park. Whether the action is frozen or blurred (perhaps intentionally), it's apparent that the photograph has sliced off a little piece of motion.

Other types of photography also isolate a moment, although it may not appear to be so at first glance. Architectural photos freeze a moment, but a structure can sit stolidly for decades or centuries and change very little. Photographs taken from a certain hilltop location outside Toledo, Spain look very much like the vista captured in El Greco's 16th century masterpiece *View of Toledo*.

Still-life photos and portraits also capture a moment in time. That bowl of fruit you photographed may become a snack an hour later or over-ripe if left for a week. You'll recognize nostalgically that a particular instant is represented in a portrait of your child years later when the child has grown to adulthood. Even so, there's something special about action photography. I think it's because a good action picture provides us with a view of an instant that we can't get in ordinary life. A snap of hummingbird frozen in mid-air lets us study the fast-moving creature in a way that isn't possible in nature. A picture of a home run ball the moment it is struck by the bat offers a perspective of a home run that even the umpire never gets to see.

Digital cameras have brought a new excitement to action photography because you can immediately review that moment you grabbed on the LCD screen. Digital cameras have also generated some new problems, chiefly from the interminable shutter lag found in most point-and-shoot models. Action photography, particularly sports, is no fun at all when the picture is taken a second or two after you press the button! Fortunately, dSLRs have just about eliminated the shutter lag dilemma, making action photography fun again for the enthusiast.

This chapter will concentrate on techniques for capturing action with a digital SLR. If you want more information on sports photography, in particular, you'll want to check out the chapter in my companion book, *Mastering Digital Photography*. I'll recap some of the key points here, but I plan to concentrate on the special needs and features of SLR photography in this chapter, and will cast my net far outside the sports arena when fishing for action-shooting opportunities.

Sports in a Nutshell

Before we take a closer look at specific action-shooting techniques, we might as well get some of the special aspects of sports photography out of the way. That's because several of the keys to getting good sports photos have nothing to do with photography *per se*. It probably won't surprise you that knowing how to position yourself and learning where to point the camera, and deciding the exact moment to press the shutter can be as important to your success as understanding the right ways to expose and compose your picture.

If you stop to think about it, sports action is a continuous series of moments, each a little different from the last, all leading up to *the* decisive moment, when the bat strikes the ball, the power forward releases the basketball at the apex of a jump, or when the puck slides past the goalie into the net. A decisive moment can follow the peak action, too, as when a pitcher slumps in defeat after giving up a walk-off home run. The best sports photography lies in capturing the right moment and the right subject under the right circumstances. You don't want a technically perfect shot of a third-string receiver catching a football at the tail end of a 57–0 blowout. You want to capture the hero of the game at the turning point of the contest.

Figure 8.1 shows my first published photo as a professional photographer. It's one of those classic "basketball instead of a head" shots, taken with flash back in the dark ages prior to digital photography when action shots with inky-black backgrounds were acceptable. This particular picture was published partially because of the basketball/head juxtaposition, and partially because it showed a local college basketball hero blocking a shot (or committing a foul, depending on your bias). Lacking one of those two elements, it probably wouldn't have been printed at all because it didn't illustrate a truly decisive moment in the game, and it suffered from more than one technical problem.

Figure 8.1 An unusual viewpoint and star power got this otherwise mundane photo published.

The Importance of Position

Where you position yourself at a sports event can have a direct bearing on your photo opportunities. If you're up in the stands, your view of the game or match is likely to be limited and fixed. You'll have better luck if you are able to move down close to the action, and, preferably, given the option of moving from one position to another, to take a variety of shots.

After you've taken a few sports photographs, you'll find that some places are better than others for both opportunities and variety. In or near the pits at an auto race provides a great view of the track as well as close-ups of the incredible pressure as crews service vehicles. At football games you'll get one kind of picture at the sidelines and another from the end zone. Soccer matches seem to revolve around the action at the net. Golf is at its most exciting on the greens. Each sport has its own "hot" spots.

You probably won't gain access to these locations at professional or major college-level contests. However, unless you're a pro sports photographer, you'll find that shooting lower-level events can be just as exciting and rewarding. If you want to get a good spot at a high school or college match, start out with some of the less-mainstream or more offbeat sports. You're more likely to be given field access at a Division I-A lacrosse match than at a Division I-A football game. However, at Division II and III levels you might still be able to get the opportunities you need if you call ahead and talk to the sports information director. One Division III school near me has been NCAA champion in football seven times in the last decade and, as I write this, is working on a 104-game regular-season winning streak. Yet, the folks at this mini-powerhouse can be quite accommodating to visiting photographers. Ask, and ye shall photograph a receiver!

Key Sports: Play by Play

Every sport is a little different when it comes to coverage. With some, like football, the action is sporadic, punctuated by huddles and time-outs, but lightning-fast when underway. Others, such as soccer, may have things going on all the time. Golf sometimes seems like it consists mostly of walking, interrupted by a few moments of intense concentration. You'll do best with sports that you understand well, so take the time to learn the games. Simply knowing that if a football team is down by 14 points with six minutes left in the game and it's third down with 20 yards to go, you probably aren't going to see a running play, can be an advantage.

Here are some quick guidelines for shooting some of the most popular sports.

■ **Football.** Get down on the sidelines and take your pictures 10 to 20 yards from the line of scrimmage. It doesn't really matter if you're in front of the line of scrimmage or behind it. You can get great pictures of a quarterback dropping back for a pass, as shown in Figure 8.2, handing off, or taking a tumble into the turf when he's sacked. Downfield, you can grab some shots of a fingertip reception, or a running back breaking loose for a long run. Move to one side of the end zones or a high vantage point to catch the quarterback sneaking over from the one-yard line, or the tension on the kicker's face when lining up for a field goal.

■ **Soccer.** You can follow the action up and down the sidelines, or position yourself behind the goal to concentrate on the defender's fullbacks and goalie and the attacking team's wings and strikers. I don't recommend running up and down the field to chase the action. Soccer games usually last long enough that you can patrol one end of the field during the first half, then remain there when the teams switch goals in the second half to cover the other team.

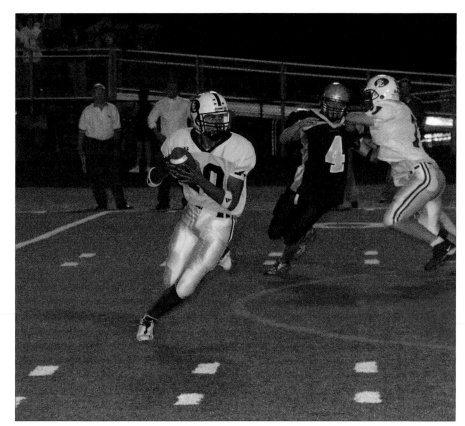

Figure 8.2 Football, soccer, and other field sports lend themselves to shots taken from the sidelines.

- **Baseball.** Everyone wants a seat behind home plate, but that's not where you'll want to shoot your pictures. Although the grimaces on the pitcher's face are interesting, the back-stop netting will tend to diffuse your photos somewhat. I take a lot of photos at professional baseball and softball games, and, lacking press privileges, I try to buy seats in the front row next to the visitor or home team's dugouts. Those vantage points let you photograph the batters at work, get good shots of the pitchers, plus the action at the bases. There tends to be more going on at the first base side, and that's a good choice if you want to photograph a right-handed pitcher after the ball is delivered. (You'll see the pitcher's back during the wind-up.) Reverse sides for a left-handed pitcher.

- **Basketball.** One of the advantages of basketball is that the sport is more compact. The majority of the action will happen around the backboards. High angles (from up in the stands) are generally not very good, and low angles (perhaps seated in the first row) are less than flattering for an array of very tall people. Shots from almost directly under or above the rim can be an exception to these rules, however. If you can shoot from eye-level close to the basket, you'll get the best shots.

- **Golf.** Golf is one of the most intimate of sports because it's entirely possible to position yourself only a few feet from world-famous athletes as they work amidst a crowded gallery of spectators. Distracting a golfer before a shot will get you booted from the course quickly, and digital SLRs, unlike their point-and-shoot brethren, don't have fake shutter-click noises that can be switched off. That clunk you hear when the mirror flips up and the

shutter trips is the real thing! You might want to move back, use a telephoto lens, remain as quiet as a mouse, and remember to time your photography to minimize intrusion.

- **Hockey.** This form of warfare-cum-athletic event can look good from a high vantage point because that perspective makes it easier to shoot over the glass, and the action contrasts well with the ice. However, if you can sit in the front row, you'll find a lot of action taking place only a few feet from your seat. You might want to focus manually if your dSLR's autofocus tends to fixate on the protective glass rather than the players.

- **Skating.** Skating events also take place in ice arenas, but eye-level or low-angles and close-ups look best. Catch the skaters during a dramatic leap, or just after.

- **Wrestling.** Unless you have a ring-side seat and are prepared to dodge flying chairs, wrestling is often best photographed from a high, hockey-like perspective.

- **Gymnastics.** Look for shots of the athlete approaching a jump or particularly difficult maneuver, or perhaps attempting a challenging move on the parallel bars or rings.

- **Swimming.** Some great shots are possible at swimming events, particularly if you are able to use a fast enough shutter speed to freeze the spray as the swimmer churns through the water. You'll get good pictures from the side if you can get down very low and close to water level. At the end of the pool, turns are fairly boring, but you can get some exciting head-on shots at the finish.

- **Track and Field.** There are so many different events that it's hard to classify track and field as a single sport. If you can get under the bar at a pole vault, or position yourself far enough behind the sand pit to shoot a long jumper without being distracting, you can come up with some incredible shots. Or, move next to the starting blocks of a dash or relay.

- **Motor sports.** Racing action will challenge your action-stopping capabilities. If you shoot these events as a car or motorcycle is headed down the straight-away towards you, a slower shutter speed can do the job. On one hand, the action can be a bit repetitive. But that can be an advantage because you have lap after lap to practice and fine-tune your technique to get the exact photo you want.

- **Horse racing.** Sports action and beautiful animals all in one sport! What could be better? As in motor sports, you might get the best pictures shooting head-on or as the steeds make a turn. Finish line photos are likely to look like those automated finish-line photos used for instant replays, but if you get the opportunity, try a low angle for an interesting perspective.

- **Skiing.** It's unlikely you'll be out all over the slopes taking photos during the race, but if you can find an interesting turn or good angle at the finish line, go for it. Remember to keep your camera warm and watch out for condensation, and keep your batteries warm.

Dealing with Shutter Lag

Lack of shutter lag is one of the most popular features of the digital SLR. The most common question I receive from frustrated point-and-shooters is how is it even feasible to take sports or action photos when the camera pauses for a second (or more) after the shutter release is pressed before actually taking the picture? Fortunately, most digital SLRs more or less eliminate the problem. They're instant on/instant shoot with a lag time that's virtually unnoticeable in many cases, particularly if the camera's autofocus does its stuff.

The dSLRs I've tested generally snap a picture within 0.1 to 0.2 second of pressing the shutter release. In contrast, I've checked out dozens of point-and-shoot digital cameras, and very few of them produce shutter lag times less than 0.5 seconds. The average performers clock in at 0.8 seconds under contrasty lighting conditions that don't challenge the autofocus mechanism, but usually take at least 1.1 to 1.3 seconds under low-contrast lighting, even if they have a focus assist lamp. The worst performers may have shutter lags of more than a second at best, and as long as 2.0 seconds or more under unfavorable lighting. That's an intolerable delay.

When I was shooting sports with my old Nikon CoolPix 995, I had to train myself to press the shutter release well in advance of when I anticipated the peak action would be. I used a Konica Minolta 7HI for a lot of action photography, found the shutter lag still objectionable, but partially compensated by disabling autofocus, manually setting exposure, and shooting lots of sequence bursts.

Point-and-shoot cameras require a lot of planning for action photography. Most of them take 3–5 seconds to power up before your first picture is taken, and automatically power down if you haven't taken a photo for a few minutes. If you disable the automatic sleep feature, battery life suffers, even if the LCD is switched off.

If you shoot almost exclusively with dSLRs, you can forget about that nonsense. Many dSLRs power up in an instant (an exception being the Canon Digital Rebel, which seems to take about 3 seconds to come to life, or to resume shooting after it's been powered on but idle for a few minutes). Because the LCD of a dSLR isn't used for previewing photos, and autofocus and metering generally switch off after a few seconds of non-use (to revive instantly when you tap the shutter release), a digital SLR can easily be left powered up for hours or days at a time without draining the battery. The camera is always ready for use. And shutter lag times, while they exist, can be so short that they're hard to detect. With rapid response, you can perfect your timing, so instead of photos like the one shown in Figure 8.3, you end up with the version shown in Figure 8.4.

You can test your own camera for shutter lag by photographing a clock face with a second hand, taking a picture of a stopwatch, or by using one of the many available software applications that produce a stopwatch image on your computer screen. (Google a few if you're serious about measuring shutter lag.) Windows users can find a free timer utility at **www.xnotestopwatch.com**.

Figure 8.3 Shutter lag and a slow trigger finger will net you photos like this one that miss the mark.

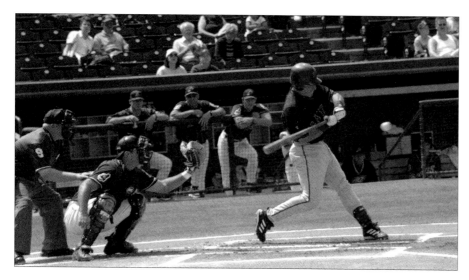

Figure 8.4 The fast response of a dSLR can let you capture the peak moment.

Should you experience objectionable shutter lags, try anticipating the decisive moment. Press the shutter release a fraction of a second before the action peaks. Partially depress it to lock in focus and exposure even before your subject enters the frame. Set your camera to manual exposure and focus. Use your camera's burst mode to grab a sequence of shots and improve your chances of catching the key instant.

Burst Mode Basics

When I worked as a sports photographer, my first purchase after a long, fast telephoto lens was a motor drive that let me shoot an entire 36-exposure roll of film in about 12 seconds at a 3 fps clip. Despite those awesome film-burning capabilities, I was a bit more frugal in my use of film, but the motor drive offered a way to capture exciting sports sequences and, sometimes, grab just the right shot from continuous action.

Today, the digital equivalent of the motor drive is called burst or sequence mode, and dSLR technology makes this technique much more practical. Instead of being limited to 36 shots (or 250 shots if you used a special motor drive with bulky 33-foot film cassettes), you can take many photos without "reloading," typically 300 or more shots with a 1GB film card. Best of all, digital bursts don't waste film. If your sequence shots turn out to be duds, you can erase them and take more pictures using the same media. Nor do you need a special accessory for your digital "motor drive." All digital SLRs and most digital point-and-shoots have the capability built in.

One important thing to keep in mind is that burst mode is not a cure-all for poor timing. The typical digital SLR can fire off 3 to 8.5 frames per second (or more) for as long as the camera's buffer holds out. A few cameras write to their film cards so quickly that in some modes the buffer never really fills, so you can shoot continuously until your card fills. Even so, you still might not capture the decisive moment in your sequence. The action peak can still happen *between* frames, or, if your dSLR is limited to bursts of a few seconds in length, after your buffer fills and the camera stops firing sequence shots. A brawny burst mode is no replacement for good timing and a bit of luck. Clicking off a picture at exactly the right moment will almost

always yield better results than blindly capturing a series of frames at random. Use your camera's sequence mode as a supplement to your customary techniques, to grab a few pictures you might not have gotten otherwise, or to create sequences that are interesting in themselves, like the one shown in Figure 8.5.

Figure 8.5 Burst mode can let you capture a sequence of shots in a split second.

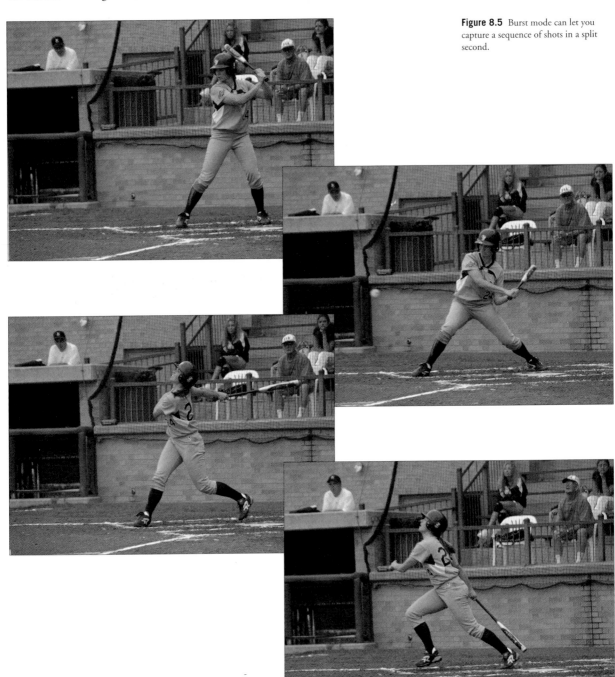

Selecting Your Burst Modes

Your dSLR may have just a single burst mode, and your choices may range from turning it on to turning it off, and nothing more. Other digital cameras, particularly SLR-like cameras using an electronic viewfinder, may have several frames-per-second speeds to choose from. These are often grouped under the category "drive" mode, in honor of the original motor drives found in film cameras. Here is a list of the most common burst/drive/shot modes:

■ **Single frame advance.** This is the default mode of your camera. One picture is taken each time the shutter release is pressed. Because of the capacious and speedy buffers found in dSLRs, you can probably take single frames as quickly as you can keep pressing the button. Only the most fleet of finger, using low-end cameras with deficient buffers, will be able to outrun the camera's recording capabilities in single-frame advance mode. You'll know when the buffer is nearly full by an indicator in your viewfinder. Some cameras have an LED that blinks when you must wait; others have a bar indicator that grows or shrinks. I prefer systems that provide a constant update of the available room left in the buffer through a numeric indicator. This will count down from, say, 4, through 3, 2, and 1 until the buffer fills, then count up again as additional room is made available for more shots.

■ **Continuous advance.** This is the default burst mode, and may be the only one your dSLR has. The camera continues to take photographs, one after another, for as long as you hold down the shutter button, or until the buffer fills. Most dSLRs have frame rates of at least 2–3 frames per second (such as entry-level models from Canon), to 4 fps or more (with entry-level Nikons and other digital SLRs), up through 8 or more fps with the pro gear favored by sports photographers who make their living snapping off sequences. The number of frames you take is usually limited by the size of your camera's buffer and the size of the files you're grabbing. That is, you'll usually be able to take more JPEG shots in a row than RAW photos or RAW+JPEG shots. However, some dSLRs are so speedy that the file format makes little difference. If you're lucky, you'll be able to squeeze off 10–20 or more shots in one burst. If you're not so lucky, your camera may choke after 6 to 9 exposures.

■ **High-speed continuous advance.** In this mode, the camera takes pictures continuously as you hold down the shutter release, at a frame rate of 8 frames per second or more. The Nikon D2X takes the unusual approach of capturing a middle-of-the road 5 fps at 12 megapixel resolution, but offers a high-speed 8 fps mode that crops the picture down to 6.8 megapixels (and increases the lens multiplier from 1.5X to 2.0X).

■ **Ultra high-speed continuous advance.** This mode has been pioneered in point-and-shoot digital cameras, but should find its way into dSLRs soon. Ultra high-speed modes always reduce the resolution (as with the Nikon D2X described above) to allow higher frame rates.

■ **Multi-shot.** A few cameras, chiefly non-dSLRs, can produce a quick blast of 16 tiny pictures on a single frame. Such images might be okay for analyzing your golf stroke, but may be too small for other applications.

■ **Mini-movie.** You'll generally find this option only in EVF cameras and point-and-shoot digitals because it's not excessively practical to shoot movies with a dSLR. (You'd have to shoot blind, because no dSLR is going to flip its mirror up and down 30 times a second!) Digital cameras, which have the ability to shoot short video clips (typically 20–30 seconds up to the capacity of the memory card), do so at 320×200 to 640×480 resolution (or higher). You can use the movies as-is, or save and edit individual frames.

- **Time lapse/interval.** Although this is a sequence mode, it operates over a period that can extend for many, many seconds, and is best used for taking pictures of slow-moving events, such as the opening of a flower. Some cameras have time lapse/interval mode built in. Others require the use of a USB tether to your computer to allow software to trigger the camera's individual exposures.

- **Bracketing/Best Shot.** Bracketing is a "drive" mode if the camera takes several pictures in sequence, using different settings for each picture. This improves your chances of getting one shot that has a better combination of settings. The most common bracketing procedure is to make several pictures at different exposures, with some underexposed and some overexposed (based on the meter reading). Many digital cameras can bracket other features, such as color correction, color saturation, contrast, white balance, or special filters. Some cameras have a "best shot" mode that snaps off several pictures, but saves only the best (usually sharpest) exposure. Best shot and auto bracketing are found in EVF or point-and-shoot cameras. With dSLRs, each bracketed picture is usually triggered manually by the photographer pressing the shutter release. The camera adjusts the bracketed values for you after each individual picture.

Sequence shooting is one application where having a faster memory card can pay off. The more quickly your camera can offload its buffer to the memory card, the more pictures you can capture in one burst. As I mentioned earlier, the file format and amount of compression chosen can affect the burst length with some (but not all) dSLRs. You'll usually find a chart in your camera's manual showing the number of shots you can expect to get in a particular sequence mode.

Another thing to keep in mind is that you generally won't be able to use your camera's electronic flash when shooting more than one frame per second, unless you happen to own a special flash unit designed for rapid-fire shooting. Even so, you'll probably be limited to close-up photos because fast-recycle flash units operate by using only a fraction of the available power for each shot. At such a reduced power setting, the flash is able to fire over and over relatively quickly, but doesn't provide as much illumination and can't reach out as far as the same flash in full power mode. Frequent flashes can overheat a flash unit, too. You'll do better if you plan on shooting your sequences without flash.

If you're leery about the accuracy of the specs for your camera's sequence-shooting capabilities, photograph an actual stopwatch (or substitute an on-screen timer utility), as I described earlier when measuring shutter lag. Compare the time shown on the first and last shots of a sequence, and you'll be able to calculate both the number of individual shots you can take as well as the frames-per-second rate. You can also experiment with different camera settings to see which provide the best burst mode results.

Choosing Your Lenses

With money matters, it may be all about the Benjamins, but with dSLRs, the topic always seems to focus on lenses. Of course, the ability to *choose* which lens you use is one of the undeniable advantages of the dSLR in the first place. That's why you'll find so much coverage of lenses in this book. There was a bit in Chapter 2 when we explored the inside of the digital SLR. Chapter 6 was devoted entirely to lens topics, and you'll find a bit more in Chapter 10 when we look at specialized features like Image Stabilization/Vibration Reduction, which is found in some lenses, but which also can be built right into a dSLR.

Now we're taking a closer look at action photography, and it's time to talk about lenses once again. Indeed, lenses are one of the *key* aspects of action photography. When you're taking portraits, you'll probably use (or wish you could use) a prime lens of a focal length considered ideal for portraits, but then settle for a zoom lens of the appropriate range. For close-up pictures, you'll want a special micro/macro lens if you can afford one, or will make do with what you have. There really aren't that many choices. There are a few lenses and focal lengths that are best for portraits, macro photography, and other applications, but selecting the one you use won't take weeks out of your life.

Not so with action photography. The online forums I frequent are rife with never-ending discussions on the best lenses for action photos, with criteria ranging from focal length, maximum aperture, bokeh, or presence/lack of vibration reduction placed under the magnifying glass. This section explains some of the factors to consider.

Zoom or Prime Lens?

If you've been paying attention, you'll recall that, like many of you, I started in photography during the film era, and of the first 40 or so lenses I purchased, only one of them was a zoom lens. It had a pitiful slightly-wide to slightly-telephoto 2:1 zoom ratio, and was well-known for the distortion it produced. I purchased it not because I wanted to vary my perspective from 43mm to 86mm frequently (the range was barely enough to do any good), but expressly for special effects such as the legendary "zoom during exposure" effect. Until very recently, zoom lenses simply didn't offer sufficient quality for everyday use for the serious photographer. The only real exception was for sports photography because a zoom lens can be the most efficient way to follow fast-moving action. Reduced image quality came with the territory, and non-zoom, prime lenses were still the preferred optic.

Early zoom lenses were extremely slow in terms of maximum aperture, often didn't focus very close, and frequently changed both focus and f-stop as you zoomed in and out.

Things have changed! Today's zoom lenses can provide excellent quality. Some of them are sharp enough and focus close enough that they can be used for macro photography. Modern autofocus and autoexposure systems make focus and aperture shifts largely irrelevant. However, one thing hasn't changed: Zooms that normal people can afford to buy are still relatively slow. Affordable zooms typically have f4.5 maximum apertures at the widest setting, and 5.6 or worse in the telephoto position. That can be a drawback for available light action photography at night, indoors, or outdoors on very cloudy days.

If you're shooting outdoors in full daylight most of the time, a zoom may be your ideal lens. A 28mm–200mm lens on a camera with a 1.5X multiplier gives you the equivalent of a 42mm to 300mm zoom lens, which from the sidelines of a football game will take you from the bench to the opposite side of the field. A 70mm–300mm zoom sacrifices a little of the wide-angle view in favor of a really long telescopic perspective. Zooms can be great.

However, if you want the absolute sharpest image, or will be shooting under very demanding lighting conditions, you'll want to consider a prime lens. I have an 85mm f1.8 lens that, through the magic of the digital crop, gives me the equivalent of a 128mm f1.8 telephoto that's perfect for low-light action photography. My 105mm f2 lens has only a little less reach than a very expensive 180mm f2 optic. I also own a 200mm f4 lens that works well, even though I could never afford a 300mm f4 telephoto. Because of this lens' speed, I'm able to get shots like the one shown in Figure 8.6.

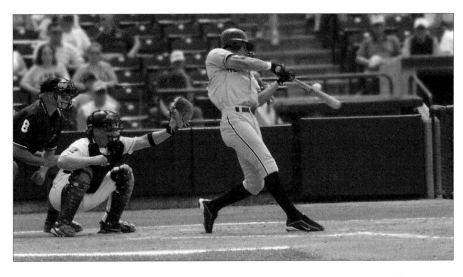

Figure 8.6 A fast prime lens lets you get in close, use a higher shutter speed, and get images like this one.

Remember that a fast telephoto lens lets you use higher shutter speeds to stop action or reduce the effects of camera shake, without needing to resort to boosted ISO, which can increase the amount of noise in your picture. Also keep in mind that truly fast telephotos cost an arm and a leg. One vendor's 300mm f2.8 prime lenses cost $4,500, 500mm or 600mm f4 top $7,000, and the same manufacturer's 400mm f2.8 can set you back close to $8,000. So, your quest for a fast, super-long telephoto lens may be brought quickly to Earth by incredible price tags.

Prime lenses may offer better quality and faster maximum aperture, but can get pricey. Zooms are usually economical in the 70mm to 300mm range, even if they're a bit slow. (However, there's a very nice 200mm–400mm f4 zoom available for a mere $6,000.)

What's the best f-stop?

To get the sharpest images, you'll almost always want to stop down one or two f-stops from the widest available aperture your lens provides. That is, an f2.8 lens often produces its best results at f5.6. Unfortunately, with action photography, a high shutter speed is often desirable, so you'll find yourself shooting wide open more than you'd like.

In that case, the maximum aperture of your lens can be important when shooting action in low-light situations. A "slow" lens can limit the maximum shutter speed you can use, thus affecting your ability to freeze action. For example, if your lens opens no wider than f8 (a common limitation for longer lenses and zoom settings), the best you can do with your camera set to ISO 100 in full daylight is 1/500th second at F8. Your camera may have 1/1,000th or briefer setting, but you can't use it without increasing the ISO setting to 200 or higher, thus increasing your chances of detail-robbing noise in your photos. If daylight is waning or you're shooting indoors, an f8 lens may limit you to sluggish 1/250th or 1/125th second speeds.

So, a larger maximum aperture is better, assuming that the lens performs well wide open; an optic that is a bit fuzzy at its maximum aperture is no bargain. Keep in mind that the maximum opening of some zoom lenses varies, depending on the focal length setting. That is, a lens that rates an f4.5 aperture at the 28mm setting may provide only the equivalent of f6.3 or slower when zoomed all the way to the telephoto position.

Focal Lengths Needed

For most action photos, the longest zoom setting is more important than the shortest. Few sports require a really wide-angle lens. Most of the time you can't get as close to the action as you'd like. Many benefit from the equivalent of a 135mm to 150mm telephoto optic, particularly if you're unable to patrol the sidelines and must shoot from the stands. Sports like basketball and volleyball do call for shorter focal lengths and wider angles because you may be literally on top of the action.

For indoor sports, your best focal lengths might range from 35mm to 105mm. Outdoors, you'll probably need 70mm to 200mm or 300mm, unless you're forced to shoot from up in the stands. Non-sports action photography may still limit where you can stand to make your shot, as you can see in Figures 8.7 and 8.8. Don't forget that as your lens gets longer, you'll need to use higher shutter speeds or a tripod to reduce or eliminate blur from camera/lens shake (or use a vibration reduction lens to compensate; more on VR/IS in Chapter 10).

Figure 8.7 At the short tele position, your zoom can take in the big picture.

Figure 8.8 Zoom in, and you're right in the middle of the action.

Those using some digital SLR cameras can benefit from using lenses designed for 35mm cameras with a sensor that's smaller than the 24mm × 36mm film frame. As you've learned, when mounted on a non-full-frame dSLR, the focal length of a lens is multiplied, so a 200mm tele actually produces the same field-of-view as a 320mm long lens (when used with one particular digital camera with a 1.6X "multiplier" factor).

Many dSLRs can be fitted with attachments called teleconverters that provide additional magnification. The extra focal length comes at a cost: The effective aperture is reduced by the add-on optics, robbing you of an f-stop or more. For example, one popular 1.4X teleconverter eats up one full f-stop's worth of exposure; the same vendor's 1.7X teleconverter demands an extra stop and a half of exposure, while the 2X version needs two extra stops. The good news is that if you're willing to settle for less magnification, these add-ons don't reduce the resolution of the final image by very much.

Digital zoom: Just say no

Most dSLR cameras don't bother with what is known in the point-and-shoot and SLR-like realms as digital zoom. Digital zoom doesn't capture any more information. It simply fills the frame with the pixels captured at the center of the image and uses interpolation in the camera to provide a magnified image. Theoretically, this processing can be done more effectively in the camera, producing better results than you'd get by simply enlarging the same pixels in your image editor. But that's rarely what happens. Most digitally zoomed images are frightfully pixelated. Thankfully, this "feature" is found mostly in cameras that don't have removable lenses. In addition to point-and-shoot and EVF cameras, this category can include a new breed popularly called ZLRs (for Zoom Lens Reflex), which are SLRs with fixed lenses. Digital zoom is primarily a way of providing the illusion of a longer focal length lens. If you have it, don't use it. Trust me.

Action Exposure Concerns

You'll find a more complete discussion of exposure modes and features in Chapter 3. However, for action photography, you'll want to choose the right exposure mode for the job at hand. Here's a quick recap of the kind of options you may have, and how they relate to action pictures.

- **Fully automatic.** Serious photographers don't use fully automatic mode very much, particularly for action photography. It's usually not wise to let the camera's logic choose both shutter speed and aperture using its built-in rules, simply because the camera has no way of knowing what it's being pointed at. For example, the camera may elect to shoot at f8 using whatever shutter speed provides the correct exposure until the exposure becomes long enough to encourage hand-held blurring (at, say 1/30th second). Then it will switch to a wider f-stop, as necessary. This is not the best mode for action photography.

- **Programmed automatic.** Digital SLRs have more sophisticated programming that takes into account the shooting environment when deciding exposure settings. For example, if photographs are being taken in dim light, the camera assumes that you're indoors; in bright light, that you're outdoors. Lens openings and shutter speeds are selected based on typical shooting situations in these environments. In program mode, unlike full auto, you may be able to bump the shutter speed up or down from the recommended setting, and the camera will change the aperture to compensate. This is something like a dumber version of shutter priority, discussed shortly.

- **Programmed scene modes.** Your digital camera has selective programs you can choose for automatic exposure under specific conditions. The one you want to opt for is the action/sports setting. In such cases, the camera will try to use the shortest shutter speed possible. It might even automatically boost the ISO rating (if you've set ISO to Auto) or use other tricks to optimize your exposure for fast-moving subjects. If you must use fully automatic exposure, this may be your best choice. At least the camera can be "told" that it's shooting action pictures and be trusted to compensate a bit.

- **Aperture priority.** In this mode, also called *Av* mode by some vendors, you set the lens opening, and the camera automatically chooses a shutter speed to suit. Use this if you want to select a specific f-stop, say to increase/decrease depth-of-field. Because aperture priority offers little control over shutter speed, you probably won't use it frequently for sports photos.

- **Shutter priority.** In this mode, sometimes called *Tv* mode by Canon and some other vendors, you choose a preferred shutter speed, and the camera selects the lens opening. That lets you select 1/500th or 1/1,000th second or shorter to stop action, yet retain the advantages of automatic exposure. This is the mode to use if you're taking photos under rapidly changing light conditions. I use it for outdoor sports on partly cloudy days in which a playing field may alternate between bright sunlight and overcast within the space of a few minutes, depending on how the clouds move. It's also a good choice for photos taken as the sun is setting because the camera automatically compensates for the decreasing illumination as the sun dips below the horizon.

- **Manual exposure.** I end up using manual exposure for some of my action photographs. Indoors, the illumination doesn't change much. Most sports arenas, gymnasiums, and other sites have strong overhead illumination that allows taking pictures at 1/250th second at f2.8 using ISO 400 or 800 settings. I might also use flash indoors. Outside, I carefully watch the lighting and change exposure to suit.

Attaining Focus

With action photography, the speed and accuracy of automatic focus can be crucial. Manual focus is frequently impractical when you're trying to capture subjects that may be racing toward you, away from you, or across your field of vision. The autofocus of most dSLRs operates quickly enough for action photography that the operation doesn't introduce massive shutter lag delays into the picture-taking equation.

Here are some tricks you can use to optimize your results:

- Choose your autofocus mode carefully to suit the kind of action you're capturing. Your dSLR probably gives you a choice between multi-point, spot, or user-selectable focus. If your subject will usually be in the center of the frame, spot focus may be your best bet. If your fingers are fast and your brain is faster, and you can train yourself to choose a focus point as you shoot, you can sometimes select the autofocus area as you compose the picture. Some cameras offer the option to lock in on the object closest to the camera, which can work well for action (assuming the closest subject is the one you want to capture, and not, say, a referee).

- Your dSLR lens might have a lock feature that disables macro focus distances. That keeps the lens from seeking focus all the way from infinity down to a few inches away. When you're shooting action, it's unlikely that your subject will be closer than a few feet, so go ahead and lock out the macro range to speed up autofocus.

■ Some lenses/cameras have an autofocus/manual override setting, which uses the autofocus mechanism first, but allows you to manually refocus if you need to. That can come in handy to fine-tune focus if you have time or can think quickly.

■ You might be able to prefocus on a specific point where you expect the action to take place if you partially depress the shutter button. Some cameras also have a focus lock/exposure lock button that fixes either or both settings at the value selected when you depress the shutter release. With locked focus, you can take the photograph quickly by depressing the shutter button the rest of the way when your subject is where you want within the frame.

■ Manual focus might be a good choice when you know in advance where the action will be taking place (for example, around the hoop in a basketball game) and can help your camera operate more quickly than in autofocus mode. Manual focus works especially well with shorter lenses and smaller apertures because the depth-of-field makes precise focus a little less critical.

■ Manual focus also works when you're concentrating on a specific area, or want to control depth-of-field precisely. For example, at baseball games I may decide to take a series of shots of the batter, pitcher, or first baseman. I can prefocus on one of those spots and shoot away without worrying about autofocus locking in on someone moving into the field-of-view. My focus point is locked in. Selective focus can also concentrate attention on the subjects in the foreground, as shown in Figure 8.9.

Figure 8.9 Selective focus is a good way to emphasize the subjects in the foreground.

Selecting an ISO Speed

By now you're aware that the lower the ISO setting on your digital camera, the less noise you'll get, and usually the better the quality. But low ISO settings and action photography don't mix well. If you're trying to freeze action, you'll want to use the highest shutter speed possible, while retaining a small enough f-stop to ensure that everything you want to be in focus will be in focus. When available light isn't especially available, the solution may be to increase your dSLR's ISO setting, as was done for the shot of the amusement park ride in Figure 8.10.

Figure 8.10 You don't have to stop shooting action when the sun sets: just boost your ISO setting.

Fortunately, ISO speeds are another area in which digital SLRs often excel. Because of their larger sensors, a dSLR can usually function agreeably at higher ISO settings without introducing too much noise (see Chapter 2 for a longer discussion of this relationship). Many digital SLRs produce good results at ISO 800, and may still offer acceptable images at ISO 1600 or above. You'll get better-looking pictures than point-and-shoot cameras at ISO 400 or ISO 800, or, possibly, even better than film cameras using ISO 800 or faster emulsions.

Your digital camera may automatically set an appropriate ISO for you, bumping the value up and down even while you're shooting to provide the best compromise between sensitivity and image quality. Or, you can set ISO manually. The easiest way to settle on an ISO rating is to measure (or estimate) the amount of illumination in the venue where you'll be working, and figure some typical exposures (even though your camera's autoexposure mechanism will be doing the actual calculation for you once you're shooting).

Outdoors, the ancient "Sunny 16" rule works just fine. In bright sunlight, the reciprocal of an ISO rating will usually equal the shutter speed called for at an f-stop of f16. The numbers are rounded to the nearest traditional shutter speed to make the calculation easier. So, at f16, you can use a shutter speed of 1/100th–1/125th second at ISO 100; 1/200–1/250th second with an ISO rating of 200; 1/400–1/500th second at ISO 400; and perhaps up to 1/1000th second at ISO 800. Select the ISO setting that gives you the shutter speed you want to work with. If the day is slightly cloudy (or really cloudy), estimate the exposure as one-half or one-quarter of what you'd get with Sunny 16.

Indoors, the situation is dimmer, but you'll find that most venues are illuminated brightly enough to allow an exposure of f4 at 1/125th second at ISO 800. For a faster shutter speed, you'll need either a higher ISO setting or a brighter venue. In modern facilities, you probably will have more light to work with, but it's always safe to use a worst-case scenario for your pre-event estimates. Don't forget to set your white balance correctly for your indoor location. If one of your camera's manual choices doesn't produce optimal results, consider running through your system's custom white balance routine to create an especially tailored balance for your venue.

Electronic Flash—or Not?

One of the chief benefits of high-speed films in the film era, and higher ISO ratings in the digital age, is the ability to use higher, action-freezing shutter speeds without resorting to supplemental illumination such as electronic flash. Flash-less action photography has led to more realistic, more exciting images without much loss in quality.

Still, there is a place for electronic flash in the action arena, and there are ways to get around the drawbacks of using strobe for sports and other fast-moving subjects. In years past, I've watched pros string radio-controlled electronic flash units into every nook and cranny at NCAA basketball games just to provide ample illumination for high-speed photography without the deadly direct flash look. Today, sophisticated electronic flash units with through-the-lens metering and multiple flash heads are available to dSLR photographers with relatively modest budgets. Should you consider flash, or not?

Electronic flash has some significant advantages. The brief duration of the flash can freeze fast action even more effectively than your dSLR's fleetest shutter speed, as you can see in Figure 8.11. High-powered flash can illuminate action venues that are too dim for photography by available light, even using your camera's highest ISO setting. Indeed, you'll usually get much better results at ISO 400 and f8 with flash than you will at ISO 3200 and f2.8 without.

Figure 8.11 Electronic flash can freeze the fastest action.

Freezing a drop of water

Catching a drop of water in mid-air is easier than you think. The illustration was made using a few drips of water squeezed out of a turkey baster into a wine glass. I placed an off-camera electronic flash to the right of the shot and pressed the shutter release just after squeezing some water out of the baster. The ultra-brief duration of the electronic flash froze the bouncing water drops in mid-air, and a little colored gel over the flash head added some color. No special triggering mechanism was used: thanks to the economy of digital photography, all I had to do was take a dozen or so shots until I lucked into one that looked interesting.

Unfortunately, action flash has some disadvantages, too. If your shutter speed is slow enough that two exposures result (one sharp image from the electronic flash, and one blurry one from the ambient light), you'll get a ghosting effect. Conversely, if your shutter speed is high enough to eliminate the ambient light completely, you can end up with photos that have an inky black background. You'll also find that using your camera's built-in electronic flash will deplete your camera's batteries more quickly. If that isn't enough, some venues won't tolerate use of electronic flash.

If you want to experiment with action flash photography, the next sections will tell you everything you need to know.

Which Flash to Use?

In the old days, most flash units were compatible with most film cameras. That's because the flash mechanisms themselves had few automated features that relied on the camera. Some flash were strictly manual: you'd use a value called a guide number (GN) to calculate the correct f-stop to set. If you were smart, you had a flash meter, which was most often placed at the subject position and used to measure the actual amount of illumination arriving at that location.

Next came automated flash units that measured the amount of light reflecting back from the subject. They incorporated an electronic component called a *thyrister,* and, once proper exposure was reached, "dumped" the extra flash power remaining in the unit's capacitor before it could reach the flash tube. These systems worked well, but didn't measure the actual light falling on the film, so they were often slightly inaccurate. Dedicated flash units were developed to solve this problem. These devices work closely with the electronics of the camera to measure the actual flash exposure being received and make adjustments accordingly. These TTL flash use various mechanisms (including almost-invisible preflashes used to measure exposure) that aren't particularly important. The important thing to remember is that if you want to use the flash exposure features of your digital SLR, you'll need to use a flash unit designed for your camera. Often, that means using only flash sold by your camera's vendor, although some of the larger third-party manufacturers produce compatible flash units.

That doesn't mean you can't work with other electronic flash units, especially if you're willing to set exposure manually, either by guesstimate or through the use of a flash meter. You may have problems mounting the flash on your camera, or connecting it to your camera's flash-triggering circuitry. Many dSLRs don't have the PC connection, like the one shown in Figure 8.12, required to connect a standard

Figure 8.12 If you're lucky, your dSLR has a PC connection like this one. If not, you can purchase an adapter for your hot shoe.

electronic flash, or require purchasing an add-on accessory to provide this PC connection. (Incidentally, PC does not stand for Personal Computer in this case; it represents Prontor-Compur, early shutter manufacturers who developed a connector to synch their products with early flash bulb and [later] electronic flash devices.)

Don't fry your camera!

Electronic flash units run a triggering voltage through your camera, which closes the circuit to set off the flash. If you're using a flash that's not designed for your camera, you should know that triggering voltages of 200-250V are not uncommon, and some flash units have voltages as high as 600V or more. That's not good news for some cameras that are designed to handle voltages in the 10V range. While many cameras can work with the higher voltages, many more cannot, and it can sometimes be difficult to determine the requirements of your dSLR, or the voltage output of a particular flash.

I had some studio flash units I wanted to use with my digital SLR, and an older massive "potato masher" flash that comes in handy for sports photography. I didn't bother doing any research. Instead, I purchased a Wein Products Safe Synch voltage regulation device, and connect my flash using that. Don't experiment! If you don't know whether a certain flash unit will work with your camera, avoid seeing if the flash circuitry makes a good fuse. Buy a Safe Synch like the one shown in Figure 8.13, and be safe. This protective device works with hot shoe flashes, and includes a PC connector for off-camera flash units that use them.

Figure 8.13 A voltage regulator can isolate your camera's flash circuitry from excess juice.

Power

Generally, the built-in electronic flash found in most dSLRs is a step up from the dinky units included with point-and-shoot models. Amateur cameras may have a flash range that reaches out no farther than 10–15 feet, tops, because their flashes are so puny. A good dSLR's flash will have a bit more pop. A typical ISO 200 guide number for a dSLR is 15, measured in meters. (You'd divide the GN by the distance in meters to determine the f-stop to use in manual mode.) With a guide number of 15, you'd need to use f2.8 at a distance of 6 meters (about 20 feet.) You can see that even this boosted capability is barely adequate for action photography at a reasonable distance.

An add-on external flash unit might have an ISO 200 guide number of 55 or more, letting you use f9 at 6 meters, or open up your lens to f2.8 and shoot objects almost 20 meters distant (roughly 60 feet.) Obviously, an external flash is the way to go for anything farther away than a few paces.

Getting square with the inverse

When shooting action with flash, keep the inverse-square law in mind. A subject twice as far away receives only one-quarter as much illumination from any given light source, including flash. So, if you're shooting a subject that's 12 feet away, anything a mere 6 feet distant will get 4 times as much light and be seriously overexposed. Similarly, something 24 feet away will get one-quarter as much light and be significantly underexposed. In sports, your "depth of flash" can be just as important as depth-of-field.

You may be able to adjust the power level when less illumination is required, but it's more likely you'll simply depend on your unit's TTL metering system to provide the proper exposure.

Multiple Flash

You may be able to increase your flash range, or stop down an extra stop or two, or even out nasty depth-of-flash problems by using multiple flash units. If you're able to mount the extra flash units securely, using additional flash illumination can make a big difference. Of course, the multiple units will have to be triggered by some sort of slave system, usually a radio-control mechanism. If there are other photographers shooting, make sure you coordinate your frequencies!

Understanding Flash Synch

Perhaps you haven't fiddled much with your dSLR's flash synch settings because the default setting probably works well for most photos. That's not necessarily true with action photography, particularly if you're looking to reduce or enhance the ghosting effect produced by intentional/unintentional double exposures from flash and ambient light. Now's a good time to learn just how flash synch settings can affect you.

As you learned in Chapter 2, dSLRs generally have two kinds of shutters; a mechanical shutter that physically opens and closes, much like the focal plane shutter on a film camera, and an electronic shutter, which controls exposure duration by limiting the time during which the sensor can capture pixels. It's usually most efficient to use a mechanical shutter for "slower" shutter speeds (from 30 seconds up to around 1/500th second) and switch to an electronic shutter for the really fast speeds (up to 1/16,000th second on some models.)

An electronic flash unit's duration is often much briefer than any of these, as short as 1/50,000th second with some models at some power settings. So, as far as the electronic flash is concerned, the shutter speed of your camera is irrelevant as long as the shutter is completely open during the time the flash fires. If you've used flash with a film camera at a shutter speed that was too high, you probably noticed that your exposed image was only one-quarter, one-eighth or some other fraction of the full frame. That's because the focal plane shutter (which moves immediately above the film plane) was open only partially as it traveled across the film, and that opening was exposed by the flash.

Your digital camera has a maximum flash synch speed, which can be as slow as 1/125th second or as fast as 1/500th second (or more) because that interval is the shutter speed at which the sensor is fully exposed and ready to capture a brief flash. Oddly enough, with some cameras this maximum speed applies only when you're using a flash's through-the-lens automatic exposure system. In manual mode, or when using external flash units that can't use the dSLR's autoflash features, you can sometimes synch at much higher speeds.

Because the shutter is open for a longer period than is needed to record the flash alone, you'll end up with that ghost image caused by a secondary exposure from ambient light. If the subject is moving, the ghost will trail or precede the flash image (I'll tell you why in a moment). If you're holding the camera unsteadily, the ghost image may be jerky due to camera movement.

If you don't want ghost images, use the highest shutter speed practical to reduce the impact of ambient light, without producing a completely black background. Experiment until you find a shutter speed that eliminates ghosting, but still allows the background to be illuminated a bit.

Here are the most common synchronization options found on digital cameras:

- **Front-synch.** In this mode (also called *front-curtain synch*), the flash fires at the beginning of the exposure. If the exposure is long enough to allow an image to register by existing light as well as the flash, and if your subject is moving, you'll end up with a streak that's in front of the subject, as if the subject were preceded by a ghost. Usually, that's an undesirable effect. Unfortunately, front-curtain synch is generally the default mode for most dSLRs. You can be suckered into producing confusing ghost images without known the reason why. Figure 8.14 shows an example of a photograph taken using front-synch flash.

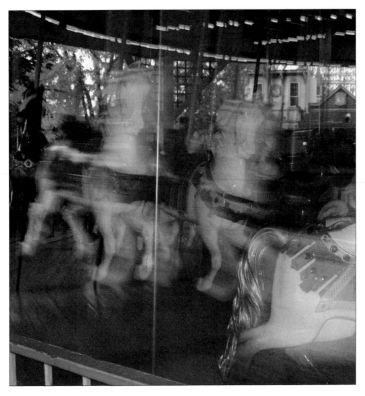

Figure 8.14 With front-curtain synch, the blur precedes the sharp flash image.

- **Rear-synch.** In this mode (known as *rear-curtain synch*), the flash doesn't fire until the *end* of the exposure, so the ghost image is registered first, and terminates with a sharp image at your subject's end position, with the well-known streak (like that which followed The Flash everywhere) trailing behind. That can be a bad thing or a good thing, depending on whether you want to use the ghost image as a special effect. Figure 8.15 shows the improved effect you get when you switch to rear-synch when using a slow shutter speed.

- **Slow-synch.** This mode sets your camera to use a slow shutter speed automatically, to record background detail that the flash, used to expose a subject closer to the camera, fails to illuminate. This mode can improve your flash images if you hold the camera steady and the subject is not moving. So, slow-synch is best reserved for non-sports images, or photographs in which the subject is approaching the camera. Otherwise, you can almost guarantee ghost images.

Figure 8.15 With rear-curtain synch, the blur trails the sharp flash image and looks more natural.

Choosing a Flash Exposure Mode

Digital SLR vendors apply fancy names to their dedicated flash units, such as d-TTL, or i-TTL, or Creative Lighting System so you'll know that massive technology innovation is behind you. However, this nomenclature can be confusing. Learn what your flash unit's most common exposure modes do, and how they can help you. Here are some typical options:

- **TTL (through the lens) metering.** With this type of exposure, the camera measures the flash illumination that reaches the sensor (often by diverting some of the light elsewhere) and adjusts the exposure to suit. If you're photographing a subject that reflects or absorbs a lot of light, the exposure setting may not be accurate.

- **Pre-flash metering.** The camera fires a pre-flash and uses that information only to calculate exposure. This is the best mode to use when your exposure is "non-standard" in some way, as when you put a diffuser on the flash, a darkening filter on your lens, or use an external flash unit.

- **Integrated metering.** The camera triggers a pre-flash just before the exposure, measures the light that reflects back, and then integrates that information with distance data supplied by your camera's focus mechanism. The camera knows roughly how far away the subject is and how much light it reflects, and can calculate a more accurate exposure from that.

- **Manual control.** In this mode, the flash fires at whatever power setting you specify for the flash (full power, half power, and so forth), and you calculate the exposure yourself, using a flash meter or various formulas using guide numbers (values that can be used to calculate exposure by dividing them by the distance to the subject.)

Electronic flash units may have firing modes, too, in addition to exposure modes. The most common modes you'll encounter are these (not all are available with every digital SLR camera, and some models may have additional modes):

- **Always flash.** Any time you flip up the electronic flash on your camera, or connect an external flash, the flash will fire as the exposure is made.

- **Autoflash.** The flash fires only when there isn't enough light for an exposure by available light.

- **Fill flash.** The flash fires in low light levels to provide the main source of illumination, and in brighter conditions such as full sunlight or backlighting, to fill in dark shadows.

- **Red-eye flash.** A pre-flash fires before the main flash, contracting the pupils of your human or animal subjects, and reducing the chance of red-eye effects.

- **Rear synch/front synch.** As described earlier, these options control whether the flash fires at the beginning or end of an exposure.

- **Wireless/remote synch.** In this mode, the camera triggers an external flash unit using a wireless synch unit. As with all such remote controls, a selection of perhaps four or more channels are available, so you can choose one that's not in use by another nearby photographer who also happens to be using wireless control. Unless you're covering a major event, you probably won't experience many conflicts when using wireless control. Some remote control/slave flash setups trigger by optical means: The camera's flash is detected and sets off the remote flash. You may be able to set the camera flash to low power so the main illumination comes from the remote.

Using a Tripod or Monopod

All the big long lenses, even those with image stabilization built in, have a tripod socket for mounting the camera on a support (or, if they don't, they should). A tripod, or its single-legged counterpart the monopod, steadies your camera during exposures, providing a motion-damping influence that is most apparent when shooting with long lenses or slow shutter speeds. By steadying the camera, a tripod/monopod reduces the camera shake that can contribute to blurry photos. Although tripods are used a bit less these days, they can still be an important accessory.

You might not want to use a tripod at events where you need to move around a lot because they take up a bit of space and are clumsy to reposition. Tripods are most useful for sports like baseball, where the action happens in some predictable places, and you're not forced to run around to chase it down. Monopods are a bit more portable than tripods, but don't provide quite as much support. Some action photographers rely on chestpods that brace the camera against the upper torso, but today the trend is toward image stabilization lenses and cameras (discussed in Chapter 10) which accommodate and correct for slight camera movement although their operation may be too slow for sports.

How much camera shake can you expect? One rule of thumb is that if you're not using anti-vibration equipment, the minimum shutter speed you can work with is roughly the reciprocal of the focal length of the lens. That is, with a 200mm lens, if you're not using a tripod you should be using 1/200th second as your slowest shutter speed. Step up to a 500mm optic, and you'll need 1/500th second, and so forth. Your mileage may vary because some lenses of a particular focal length are longer and more prone to teetering, and some photographers are shakier than others.

Basics of Freezing Action

To freeze or not to freeze? That is a question? Actually, for many types of action photos, totally freezing your subjects can lead to a static, uninteresting image. Or, as you can see in Figure 8.16, completely stopping the action can produce an undesirable effect. A little selective motion blur can add to the feeling of movement. However, including a little, but not too much blur in your pictures is more difficult and challenging than simply stopping your subjects in their tracks. Some of the best action pictures combine blur with sharpness to create a powerful effect. This section will show you how to put the freeze and partial freeze on your action subjects.

Figure 8.16 No, this helicopter's rotors haven't stopped, and no crash is impending. They were frozen in mid-spin by a fast shutter speed.

Motion and Direction

From your dSLR's perspective, motion looks different depending on its speed, direction, and distance from the camera. Objects that are moving faster produce more blur at a given shutter speed if the camera remains fixed. Subjects that cross the field of view appear to move faster than those heading right toward the camera. Things that are farther away seem to be moving more slowly than those in our immediate vicinity. You can use this information to help apply the amount of freeze you want in your image.

■ **Parallel motion.** If a subject is moving parallel to the back of the camera, in either a horizontal, vertical, or diagonal direction, it will appear to be moving fastest and cause the highest degree of blur. A high pop fly that's dropping into the infield will seem to be moving faster than one that's headed out of the ball park (away from the camera) for a home run, even though, in reality, Barry Bonds can probably propel a baseball *much* faster than the impetus the laws of gravity will apply to a falling popup. A racing car crossing the frame is likely to appear to be blurry even if you use a high shutter speed.

- **Head-on motion.** Motion coming toward the camera appears to move much slower, and will cause a much lesser amount of blur. That same race car headed directly toward you can be successfully photographed at a much longer shutter speed.

- **Motion on a slant.** Objects moving diagonally towards the camera will appear to be moving at a rate that's somewhere between parallel and head-on motion. You'll need a shutter speed somewhere between the two extremes. Motion coming toward the camera on a slant (perhaps a runner dashing from the upper-left background of your frame to the lower-right foreground) will display blur somewhere between the two extremes.

- **Distant/close motion.** Subjects that are closer to the camera blur more easily than subjects that are farther away, even though they're moving at the same speed. That's because the motion across the camera frame is more rapid with a subject that is closer to the camera.

- **Camera motion.** Blur is relative to the camera's motion, so if you pan the camera to follow a fast-moving object, the amount of blur of the object you're following will be less than if the camera remained stationary and the object darted across the frame. On the other hand, if the camera motion isn't smooth, but is jittery and not in conjunction with the movement of the subject, it can detract from the sharpness of the image.

Some Interesting Anomalies

When attempting to stop action, there are a few anomalies you might want to consider. Some of them may not have a great impact on your pictures, but they're interesting to know about nonetheless.

- A moving subject isn't all moving at the same speed, so you can get a sharp image and some blurriness in the same subject. For example, you might be able to freeze a runner's body as she passes in front of your lens, but find that her furiously pumping hands and feet are still blurry. Notice that while the ball carrier in Figure 8.17 is captured in mid-stride, his left and right hands, and both feet are a little blurry because they are moving faster than the rest of his body.

- Sometimes you'll notice that subjects crossing your frame may appear to be elongated. If an object is moving fast enough and is going in the same direction that your camera's focal plane shutter travels, you might get this stretching effect. Faster, all-electronic shutter speeds aren't prone to this phenomenon, however.

Figure 8.17 Faster-moving objects, like this runner's hands, may blur even at a relatively high shutter speed.

- Reciprocal exposures sometimes aren't. It's well-known that very long exposures may suffer from a phenomenon known as *reciprocity failure* with both film and digital cameras. A 60-second exposure might not provide twice as much illumination as a 30-second exposure, because the response of the film or sensor begins to decrease over such long exposures. Action photographers may notice the same effect when using very brief exposures, particularly from flash units that clip off durations of 1/50,000th second or less.

- It's been observed that some cameras produce blocky artifacts at very high shutter speeds, usually 1/8,000th second or less. The cause is thought to be some kind of electronic shenanigans, and there is no known cure other than using a slower shutter speed (which most of us do, anyway.)

Action Stopping Techniques

This section will summarize the basic techniques for stopping action under the most common types of shooting situations. Your particular photo opportunity may combine elements from more than one of these scenarios, and you're free to combine techniques as necessary to get the best results.

Stopping Action with Panning

The term *panning* originated in the motion picture industry, from a camera swiveling motion used to follow action as it progresses from one side of the frame to the other. Derived from the term *panorama*, a pan can be conducted only in a horizontal direction. The vertical equivalent is called a *tilt*, which is why your tripod's camera mount may be called a *pan and tilt* head. You'll rarely need to "pan" vertically, unless you're following a rocket as it takes off for outer space.

Suppose a marathon runner is racing across your field of view. If she's close enough and moving fast enough, even your highest shutter speed may not be able to stop the action. So, instead, you move the camera in the same direction that the runner is moving. Her apparent speed is much slower, relative to the camera, so a given shutter speed will be able to freeze the action more readily. Blur from subject motion is reduced. Yet, the background will display more blur, due to camera motion. Or, if you're shooting a baseball game, your photograph may have a tack sharp base runner surrounded by a blurry background, as in the example shown in Figure 8.18. That's probably a more exciting and dramatic photograph.

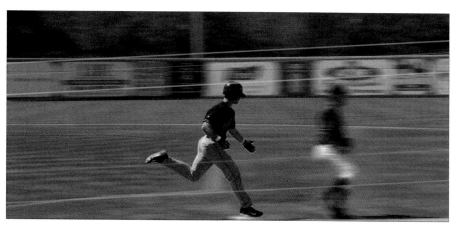

Figure 8.18 Panning the camera with this base runner stopped the action at a relatively low 1/125th second shutter speed.

Panning can be done with a hand-held camera (just plant your feet firmly and pivot at the waist), or with a camera mounted on a tripod that has a swiveling panorama (pan) head. The more you practice panning, the better you'll get at following the action. You might find that if your panning speed closely matches the subject's actual speed, a shutter speed as slow as 1/60th to 1/125th second can produce surprisingly sharp images. Use of a lower shutter speed causes the background to appear more blurry, too.

To pan effectively, you should try to move smoothly in the direction of the subject's movement. If your movement is jerky, or you don't pan in a motion that's parallel to the subject's motion, you'll get more blurriness than you anticipate or want. Take a step back, if you can. The farther the subject is from the camera, the longer you'll have to make your pan movement, improving potential sharpness.

Panning is a very cool effect because of the sharpness of the subject, the blurriness of the background, and some interesting side effects that can result. For example, parts of the subject not moving in the direction of the overall pan will be blurry, so your marathon runner's body may be sharp, but her pumping arms and legs will blur in an interesting way.

Freezing Action Head On

Another way to stop action is to photograph the subject as it heads towards or away from you. A runner who is dashing towards the camera can be effectively frozen at 1/250th or 1/125th second, but would appear hopelessly blurred when crossing the frame (if you're not panning.) Head-on shots can be interesting, too, so you might want to use this angle even if you're not trying to boost your effective shutter speed. The water skier and boat in Figure 8.19 were moving at a pretty good clip, but because they were headed away from the camera (albeit at a slightly diagonal angle,) it was possible to freeze the action at 1/125th second. The fact that the water spray is a little blurry probably adds to the picture, rather than detracting from it.

Figure 8.19 Movement toward or away from the camera can be captured at lower shutter speeds.

Freezing Action with Your Shutter

A third way to stop motion is to use the tiny time slice your shutter can nip off. A fast shutter speed can stop action effectively, no matter what the direction of the motion. The trick is to select the shutter speed you really need. A speed is that is too high can rob you of a little sharpness because you've had to open the lens aperture a bit to compensate, or use a higher ISO rating that introduces noise. There are no real rules of thumb for selecting the "minimum" fastest

shutter speed. As you've seen, action stopping depends on how fast the subject is moving, its distance from the camera, its direction, and whether you're panning or not.

Many cameras include shutter speeds that, in practice, you really can't use. The highest practical speed tops out at around 1/2000th second. With a fast lens and a higher ISO rating, you might be able to work with 1/4000th second under bright illumination. Yet, there are digital cameras available that offer shutter speeds as brief as 1/16,000th of a second. So, the bottom line is usually that to freeze action with your shutter speed alone, you'll probably be using a speed from 1/500th second to 1/2000th second, depending on the illumination and what your camera offers.

A shutter speed that's fast enough can freeze even the fastest-moving objects, such as the ski-jumping daredevil (doing his thing during a snowfree summer demonstration) shown in Figure 8.20.

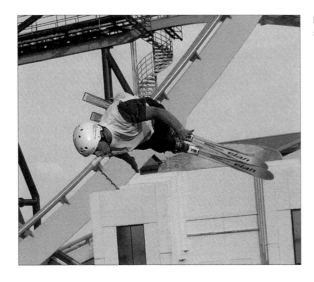

Figure 8.20 A fast enough shutter speed can stop just about any action.

Freezing Action with Electronic Flash

Electronic flash units, originally called "strobes" or "speedlights," are more than a great accessory for artificial illumination. The duration of an electronic flash is extremely brief, and if the flash provides the bulk of the illumination for a photograph, some great action-stopping results. One of the earliest applications of electronic flash was by Dr. Harold Edgerton at MIT, who perfected the use of stroboscopic lights in both ultra-high-speed motion and still (stop-motion) photography capable of revealing bullets in flight, light bulbs shattering, and other phenomena.

Some flash units have a duration of 1/50,000th second or less, which is very brief, indeed. One way of controlling an automated flash unit is to vary the duration of the flash by using only part of the stored energy that's accumulated in the unit's capacitors.

If the subject is relatively far away, the entire charge is fed to the flash tube, producing the longest and most intense amount of illumination. If the subject is relatively close, only part of the charge is required for the photograph, and only that much is supplied to the flash tube, producing an even briefer flash. Yet, even the longest flash exposure is likely to be shorter than your camera's shutter speed, so electronic flash is an excellent tool for stopping action.

The chief problem with electronic flash is that, like all illumination, it obeys that pesky inverse-square law. Light diminishes relative to the inverse of the square of the distance. So, if you're photographing a subject that's 12 feet away, you'll need *four* times as much light when the subject is twice as far away at 24 feet, not twice as much. Worse, if an athlete in your photograph is 12 feet away when you snap a picture, anything in the background 24 feet away will receive only one quarter as much light, giving you a dark background.

That generally means that a digital camera's built-in electronic flash is probably not powerful enough to illuminate anything two-dozen feet from the camera. You might be able to use your camera's flash at a basketball game, but not at a football game where the distances are much greater. A more powerful external flash unit, like the ones discussed earlier in this chapter, might be called for.

However, flash is especially adept at freezing close-up action, as illustrated by the water drop picture earlier in this chapter.

Freezing Action at Its Peak

The final method for freezing fast motion is simple: Wait for the motion to stop. Some kinds of action include a peak moment when motion stops for an instant before resuming again. That's your cue to snap a picture. Even a relatively slow shutter speed can stop action during one of these peak moments or pauses. Figure 8.21 shows a gymnast on a trampoline, captured at the very top of his upward movement when he finished a backflip.

Figure 8.21 Capture action at its peak and you can use a slower shutter speed.

The end of a batter's swing, a quarterback cocking his arm to throw a pass, a tennis player pausing before bringing a racket down in a smash. These are all peak moments you can freeze easily. Other peaks are trickier to catch, such as the moment when a basketball player reaches the apex of a leap before unleashing a jump shot. If you time your photograph for that split second before the shooter starts to come down, you can freeze the action easily. If you study the motion of your action subjects, you'll often be able to predict when these peak moments will occur.

When Blur Is Better

Some kinds of action shouldn't be frozen at all, as we saw in the helicopter photo earlier in this chapter. Better yet, you can use blur as a creative effect to show movement without freezing it. Figure 8.22 shows a 4-second exposure of a Ferris wheel, shot at ISO 1600 while I was testing my dSLR's noise-reduction features. The blur turns the moving lights into an interesting pattern, making a much better image than a static shot of the ride at rest.

Figure 8.22 Some subjects are more interesting in a long exposure.

Figure 8.23 is a shot from the same test, an 8-second exposure of the amusement park's midway. Notice that stationary objects are rendered just fine, but that people and other moving objects are rendered ghost-like, appearing multiple times in the frame as they stopped for a second during the exposure. The folks who kept moving while I made this shot don't show up at all!

Figure 8.23 Very long exposures can render moving people as blurry ghosts.

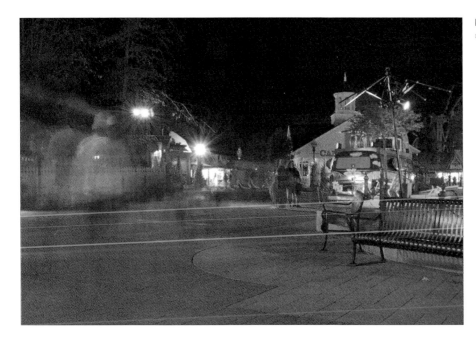

Some Final Tips

I know this chapter has you psyched up to take some great action photos, but there are a few additional points to consider before you embark on your photo assignment. As with any other kind of shoot, it's always best to be well prepared. There are things you should never leave home without, and not all of them are your MasterCard. Make yourself a checklist like this one:

■ **Take spares.** One of the first things I learned as a professional is that excuses like "My flash cord didn't work!" won't fly. I used to carry at least three of everything, including camera bodies and key accessories. I duplicated only the most essential lenses, but always had a spare along that would suffice in a pinch, such as an f1.4 normal lens as well as an f1.4 35mm wide angle. You don't need to be a pro to have a lot invested in your pictures. Don't let your vacation or once-in-a-lifetime shot be ruined. Take along extra batteries, extra digital film cards, and perhaps a backup flash unit. You might not be able to afford a spare dSLR body, but you can always squeeze an extra point-and-shoot digital camera into your gadget bag to use if all else fails.

■ **Charge your batteries.** Some dSLRs can shoot 1000 to 2000 pictures on a single charge, but those figures can be achieved only if you're starting out with a fully charged battery. Nickel Metal Hydride and Lithium Ion batteries can be recharged at any time without causing any detrimental side-effects, so you'll want to give all your batteries a fresh jolt just before embarking on any important photo journey. Have a spare battery if you think you might be taking more pictures than your original set will handle. And remember that if you expect to use your flash a lot, battery life will be reduced significantly.

■ **Offload your photos and reformat your memory cards.** You don't want to grab a new card, get ready to take a crucial picture, and then discover that the card contains older photos that you haven't transferred to your computer yet. Nothing is more painful than having to decide whether to preserve some junky but interesting photos currently residing on your film card, or to erase them so you'll have some space for new pictures. Transfer your old pictures to other storage, and then reformat the card so it's fresh and ready to go.

■ **Review your controls.** Perhaps you want to take some pictures using rear-synch. Do you know how to activate that mode? Can you switch to burst mode quickly, particularly if the light isn't great? Do you know how to use shutter priority mode, or select a fast shutter speed? Practice now, because the pressures of trying to get great pictures of fast-moving action can prove confusing.

■ **Set up your camera before you leave.** If you're planning on using a particular ISO method, want to change from your camera's default focusing mode, or intend to use a particular exposure scheme, make those settings now, in calmer surroundings. In the excitement of the shoot, you may forget to make an important setting. I once shot a whole batch of action photos in full daylight, not remembering that I'd manually set white balance to tungsten for some table-top close-ups the night before. If you're shooting in RAW format, you can fix goofs like that, but if you're not, you can't provide perfect correction, even with an advanced image editor like Photoshop.

■ **Clean and protect your equipment.** Unless you're looking for a soft-focus look, you'll want to make sure your lenses and sensor are clean. If you expect rain or snow, use a skylight filter. If necessary, make a "raincoat" for your camera out of a resealable sandwich bag with a hole cut in it for the lens to stick out of.

Next Up

Digital SLRs offer the best control over composition because they show exactly what will be imaged in the digital file. Or do they? In the next chapter, I'm going to explain why what you see may not be what you get, and some tips on composing your photos for portraiture, publicity, architecture, and landscapes.

9

Composition and dSLRs

There's a big difference between taking a picture and *making* a picture.

Even if you're using a digital SLR, there are times when you'll take a grab shot, bringing the camera to your eye to catch a fleeting moment and relying, mostly, on instinct to frame and compose your image a split second before you press the shutter release. If your camera's auto-focus and autoexposure mechanisms do their stuff, you can end up with a fine photograph, despite a shooting technique that's not far removed from a point-and-shoot impulse shot. Some great pictures, including more than a few Pulitzer Prize winners, were taken on the spur of the moment without a great deal of planning.

For example, you've surely seen the chilling photograph of a woman falling 11 stories from a burning Atlanta hotel in 1946. The 26-year-old Georgia Tech student and amateur photographer captured the shot using his very last flashbulb, certainly took the picture on the fly (so to speak), and earned a Pulitzer Prize and $500 for his effort. Memorable pictures can be taken without careful attention to the technical and artistic aspects.

Yet, if you enjoy photography, you'll want to spend as much time making an image as taking a photo. Ansel Adams spent figurative eons awaiting the perfect weather conditions and conjunction of the moon, planets, and stars to make his legendary images (and then spent additional time carefully crafting the result in the dark room). You probably won't work with such deliberation, but, in general, if you spend a few moments or seconds contemplating your picture, you'll end up with better results from both a technical and compositional standpoint.

Digital SLRs offer the most control over composition because they show exactly what will be imaged in the digital file. However, sometimes what you see may not be what you get. This chapter looks at that aspect and provides some basic information on composition. Then, we'll apply these rules to several of the most common picture-taking situations, ranging from portraiture, to architectural photography, to landscapes and a few other types.

If you want a more complete look at these particular genres, you'll want to check out my book *Mastering Digital Photography,* which has a full chapter devoted to each of them.

The SLR View

You learned how SLR viewfinders work in Chapters 2 and 4. Now it's time to see how the SLR view applies to composing your photos.

As you know by now, a dSLR shows you through the viewfinder exactly what you're going to get in your finished image, right? Or does it? I explained some of the dSLR's viewfinder anomalies earlier in this book, but didn't cover all of them as they apply to picture making. The next sections provide a checklist to consider.

Focus

Your dSLR's viewfinder will generally show you what portion of the image is in sharpest focus, as an aid for manual focusing, or as a double-check as to whether your autofocusing mechanism has correctly recognized the distance of your primary subject. You can use this view to make a manual correction, or change to a different focus area or method (usually simply by pressing a button or key).

However, unless you'll be shooting the final picture at the maximum, wide-open f-stop, what is actually in focus in your finished image *may differ sharply* from what you saw in the viewfinder. Keep these points in mind:

- The view through the viewfinder is shown at the lens' maximum aperture, which has the least depth-of-field. So, it's more likely that areas of the image not in the primary plane of focus will appear less sharp and more blurry in this view.

- The actual picture may be taken at a smaller f-stop, which provides more depth-of-field, so the final photo may be very different from what you saw through the viewfinder. Figures 9.1 and 9.2 show a pair of images taken with the same lens wide open, and stopped down, with a dramatic difference between them.

- Depth-of-field can be important in applying selective focus as a creative tool (making parts of the image blurry to isolate the main subject in the image), so the difference between what you saw and what you got can be crucial.

- If you're used to working with point-and-shoot digitals, you're probably accustomed to the massive depth-of-field their shorter focal lengths provide and may not be aware of the pitfalls and advantages of the shallower depth-of-field offered by some dSLR camera/lens systems.

- The longer the focal length or zoom setting used, the less depth-of-field you'll have at wide open apertures, which may make the increased field of sharpness at smaller f-stops have even more of an impact on your finished work.

As I noted, point-and-shoot digital cameras don't have this problem. Everything is more or less in focus from a few feet out to infinity, so depth-of-field isn't a factor unless you're taking close-up pictures. In addition, the optical viewfinders of a point-and-shoot camera don't show depth-of-field at all, and while the digital LCD of such cameras may indicate what portions of the image are in focus, they're usually too small to see the exact planes of focus clearly.

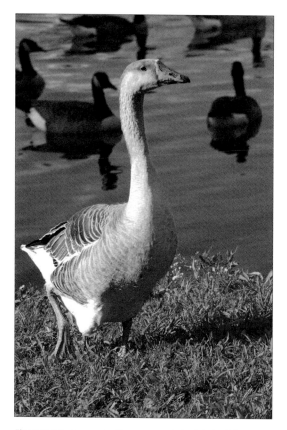

Figure 9.1 At the actual taking aperture, the birds behind this mother goose are relatively sharp and obtrusive.

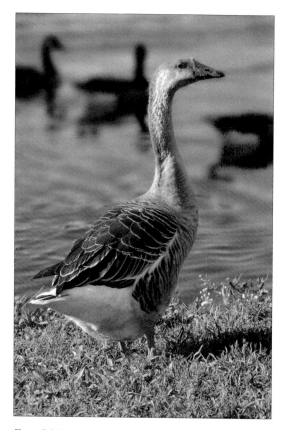

Figure 9.2 But through the viewfinder they looked blurry and out of focus. Using the depth-of-field preview would have helped.

Digital SLRs, with their longer lenses, introduce all the depth-of-field considerations described previously. How do you determine whether or not the areas you want to be in focus are in focus, and the parts of the image that you want to be blurry are, in fact, blurry? Experienced photographers allow their past shooting results to guide them somewhat; they know, roughly, what is going to be sharp and what is going to be out of focus. However, experienced photographers are also likely to use their dSLR's *depth-of-field preview button* to get an idea of what depth-of-field is going to be ahead of time. Or, they make take a quick glance at the color-coded depth-of-field scale printed on the barrels of many older lenses.

What? You've never used this control? If you're new to dSLR photography, you might have to look in your manual to find the depth-of-field preview button. It's usually located somewhere near the lens mount. When you hold this button down, the lens stops down to the current taking aperture and provides you with a more-or-less accurate view of your effective depth-of-field. The accuracy of this view can be affected by the type of focusing screen used in your camera, how well you can *see* the image (which will be darker and less easy to view when the lens aperture is partially closed), and whether or not you've adjusted the diopter setting of your eyepiece to provide a sharp, clear view of the focus screen.

The multiplier factor and depth-of-field

Your camera uses a smaller-than-full-frame sensor, so your 50mm normal lens is magically multiplied 1.6X to become an 80mm short telephoto lens, right? That means the decent depth-of-field of your 50mm lens is now equivalent to the shallower DOF of an 80mm "portrait" lens, doesn't it?

Bzzt. Wrong answer. That 1.6X multiplier (or 1.3X or 1.5X, depending on your camera) is a *cropping* factor. Depth-of-field depends *solely* on the focal length of the lens, the aperture used, and the distance of the subject from the camera. It makes no difference how much of the image you use. An image taken with a 50mm lens (or a lens at the 50mm zoom position) will have precisely the same depth-of-field, whether you use the full 24mm × 36mm 35mm frame, crop out the center 62 percent of the image for a dSLR photo, or use only the tiniest section to simulate a long telephoto lens with a point-and-shoot camera. (For that matter, depth-of-field will be the same if that 50mm lens is mounted as an extreme wide-angle on a 6 × 7 cm film camera, assuming the lens will cover the full 2 1/3 × 2 3/4-inch frame.)

Coverage and Magnification

I described the dSLR anomalies involving coverage and magnification in Chapter 4, but they bear mentioning again here. Your viewfinder may not show the entire area that will be captured in the finished image, but, generally, you'll get *more* image area, rather than less, so this should not be a problem. If you find extraneous image area that detracts from your composition, you can always crop it out.

The magnification factor impacts your images only to the extent that lack of magnification in your viewfinder (generally, anything less than about 75 percent) makes it more difficult to view details and compose your image precisely.

Layout Aids

Some dSLRs have optional grids or other layout aids, as shown in Figure 9.3, that can be invoked to make it easier to compose your image in the viewfinder. Film SLRs have long had special focus screens with grids, cross-hairs, framing marks, and other such aids. You'll find them useful for helping you line up the horizon for landscape photographs, positioning buildings and other structures in your viewfinder for architectural shots, or even for lining up the family crew for group portraits.

However (you knew there was a catch, didn't you?), the viewfinders of some dSLRs may not be precisely aligned. This may be particularly true for entry-level, consumer-oriented digital SLRs for which viewfinder precision is not a high priority. It's entirely possible that, no matter how carefully you line up the horizon in your scenics, you'll find that it's askew in your finished photo. You can always fix this in your image editor, or even create an image editor macro command (called an Action in Photoshop) to rotate your pictures the exact amount needed to correct his. Or, you can learn to tilt your camera a bit to the side.

Or you can ignore the problem because for many types of pictures, it's not a big deal. Just be aware of it, and be prepared to work with or around it. I don't use viewfinder grids very much myself, but you might find them to be a valuable aid in your own work.

Figure 9.3 Viewfinder grids can make it easier to align images with strong horizontal or vertical lines.

Aspect Ratios

Finally, you'll want to consider that the proportions of your viewfinder's layout, while they will conform to the proportions of your sensor's dimensions, may not coincide with the dimensions of your intended finished output. For example, if you're shooting with a full frame dSLR, the aspect ratio of your viewfinder and final image will be proportional to the 36mm × 24mm frame of a 35mm film camera, or 1.5:1. Or, perhaps your camera's sensor produces images that are 3008 pixels wide and 2000 pixels tall, roughly the same 1.5:1 ratio (more commonly referred to as 3:2 in the digital camera world).

Neither aspect ratio traditionally fits well with most print sizes, particularly 4 × 5 or 8 × 10-inch prints, and doesn't even exactly fit intermediate sizes, such as 5 × 7 or 11 × 14 inches. It's likely that your digital camera produces pictures that will have to be cropped at either or both ends when you make hard copies, or else you'll need to leave a wide white border at top and bottom, wasting paper. You need to keep this disparity in mind when composing your photos and making prints.

Basics of Composition

Except for the factors listed above, composition with digital SLRs proceeds much as it does with any other type of photography. You can move around, change your angles, get closer or farther away (within practical constraints), and otherwise alter your perspective enough to vary your compositional choices before you ever bring the camera to your eye. You can also ask your

living subjects to move around, or you may physically relocate objects that are movable, such as rocks, debris, undesired automobiles in the background, and so forth. Then, you can use your lenses to refine the area included in your photo, changing focal lengths or zooming in or out to narrow or expand your field-of-view. If anything, the dSLR owner has a leg up on other digital camera photographers because the digital SLR has a wider range of lenses available than can be found on the most ambitious point-and-shoot or EVF models, which are generally limited to 12X zooms, and focal lengths from about 28mm to 340mm (35mm equivalent).

Of course, you might find yourself in situations where your compositional flexibility is severely limited. A soccer team is not going to stop and pose for you, nor even arrange itself in a pleasing composition at your suggestion. If you happen to catch Colin Farrell on his way out of a restaurant, he might stop and pose for a quick photograph, or he might not. You might yearn for a closer vantage point to capture that stunning volcanic eruption in the distance, but getting closer might not be practical. You'd love to photograph the façade of a 15th century cathedral, but even with your most expansive wide-angle lens, you find yourself backed up against a 21st century vegetable stand set up in the plaza across the street.

In most cases, though, you'll have enough leeway to compose your shots the way you want them. Then, you'll want to follow my Nine Simple Rules for composing photos effectively.

- **Understanding your intent.** Before you snap the picture, you need to know what your intent is. Are you telling a story? Making a statement? Trying for humor? Capturing a warm, emotional moment? The kind of photograph you're taking can affect how you compose the image. For example, preserving an intimate moment calls for a very tight composition with no distracting elements. One designed to show the majesty of a scenic landscape may call for a broader, more inclusive composition.

- **Simplicity.** Most effective compositions call for including only the elements that are needed to illustrate your idea. By avoiding extraneous subject matter, you can eliminate confusion and draw attention to the most important part of your picture.

- **Choosing a center.** Your photos should always have just one main subject that captures the eye. Figures 9.4 and 9.5 show how simply zooming in can improve a composition.

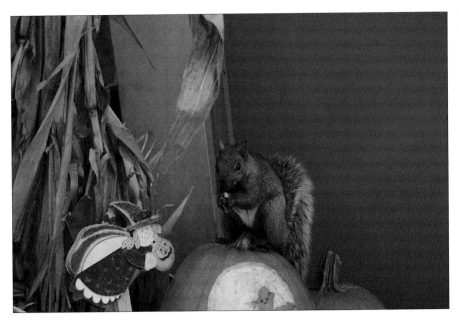

Figure 9.4 Lack of a clear center of interest weakens this photo.

Figure 9.5 A closer look lets us know who the star of the picture is.

Figure 9.6 This is clearly a vertical composition, reinforced by the framing effect of the building's structure.

- **Selecting an orientation.** Some images look best in vertical orientation, as you can see in Figure 9.6. Others look best composed in horizontal landscape mode. You need to decide which view to use.

- **The Concept of Thirds.** Placing interesting objects at a position located about one-third from the top, bottom, or either side of your picture makes your images more interesting than ones that place the center of attention dead-center (as most amateurs tend to do).

- **Lines.** Objects in your pictures can be arranged in straight or curving lines that lead the eye to the center of interest, often in appealing ways.

- **Balance.** We enjoy looking at photographs that are evenly balanced with interesting objects on both sides, rather than everything located on one side or another and nothing at all on the other side.

- **Framing.** In this sense, framing is not the boundaries of your picture but, rather, elements in a photograph that tend to create a frame-within-the-frame to highlight the center of interest. Figure 9.6 also shows the use of parts of an image to create a series of frames, each bounding the next part of the reducing geometric pattern.

- **Fusion/Separation.** When creating photographs, it's important to ensure that two unrelated objects don't merge in a way you didn't intend, as in the classic example of the tree growing out of the top of someone's head.

Understanding Your Intent

Are you taking a portrait, a sports photo, or attempting to capture amber waves of grain in a scenic masterpiece? The kind of picture you want to take can have a dramatic affect on your composition. High-school portraits might include props, from iPods to tripods, to indicate the teenager's lifestyle or avocations. Your sports photo may require a high angle or an up-close-and-personal viewpoint to portray the action.

Something as simple as a scenic photo can be affected by your intent. If you're photographing the Grand Canyon, you might want to emphasize the grandeur of the chasm with a wide-angle lens. But if your intent is to show the environmental impact of humans on this ageless masterpiece of nature, your composition might possibly include trash left behind by some careless visitors.

Perhaps you're looking for some humor, as shown in Figure 9.7. There are as many different motives for a photograph as there are photographs to be taken. Once you understand the intent of your photo, you're in a better position to understand the needs of your composition.

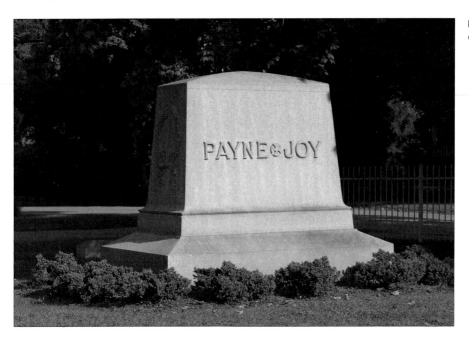

Figure 9.7 Perhaps your intent is to evoke some humor.

Simplicity

The old saw says that fine sculptures start with a block of marble, from which everything is subtracted that doesn't look like the finished subject. The same is true of photographs. Exclude everything that doesn't belong in your picture, including cluttered backgrounds, extra people, or extraneous objects. You might want to stick with a plain or neutral background, or one that helps tell the story. A portrait might rely on a seamless paper or textured background, or, for a politician, include a wall of law reference books or a flag. A soldier returning from battle might be pictured up close, with little or no background at all, or shown surrounded by debris and crumbled buildings.

In composing your shots with simplicity in mind, crop out unimportant objects by moving closer, stepping back, or using your zoom lens. Remember that a wide-angle look emphasizes the foreground, adds sky area in outdoor pictures, and increases the feeling of depth and space. Moving closer adds a feeling of intimacy while emphasizing the texture and details of your subject. A step back might be a good move for a scenic photo; a step forward a good move for a photograph that includes a person.

Even if you're working with an 8–16 megapixel camera, careful cropping means you have more pixels to work with in your image editor. The more you crop in your camera, the better image quality you'll end up with. But don't go to extremes and cut off heads. Remember that with a digital camera, careful cropping when you take the picture means less trimming in your photo editor, and less resolution lost to unnecessary enlargement. Finally, when eliminating "unimportant" aspects of a subject, make sure you really and truly don't need the portion you're cropping. For example, if you're cropping part of a boulder, make sure the part that remains is recognizable as a boulder and not a lumpy glob that viewers will waste time trying to identify. And cutting off the heads of mountains can be just as bad as cutting off a person's head in a portrait!

Finding Your Center

Find a single center of interest. It doesn't have to be in the center of your photograph (and in most cases *shouldn't be*) but it should be the most important subject in your picture. The viewer's eye shouldn't have to wander through your picture trying to locate something to look at. The center of interest should be the most eye-catching object in the photograph; it may be the largest, the brightest, or most unusual item within your frame.

Avoid having more than one main center of attention. You can have several centers of interest to add richness and encourage exploration of your image, but there should be only one *main* center that immediately attracts the eye. Include other interesting but subordinate things in your photograph, but they should be subordinate to the main subject.

Visual Orientation

Photographs can be composed using a tall, vertical, portrait orientation, or a wide, horizontal, landscape orientation. The biggest mistake beginners make (aside from not getting close enough) is to shoot everything horizontally. As a dSLR photographer, you probably don't have this problem, but may still be tempted to shoot more photos than you need to in landscape mode, particularly if your particular camera doesn't have a comfortable vertical grip with a separate shutter release button making that orientation natural and easy to use. You might also want to turn on your dSLR's auto-rotate feature so your vertical shots automatically will be displayed on-screen upright (although this tends to make the image smaller and more difficult to evaluate).

Still, you won't want to shoot a tall building or an NBA player in landscape orientation, nor will you want to take pictures of sweeping scenic expanses in vertical orientation—unless you plan to use our natural viewing bias as a creative element. Square compositions tend to be static and are not used much (which means you ought to try some square compositions as a creative exercise).

Rule of Thirds

Every book I've written on photography mentions the concept of dividing your images into thirds. It's a useful guideline, but you probably shouldn't fear breaking this "rule" frequently. Like many rules of conventional wisdom, the Rule of Thirds is sometimes more conventional than wise.

It derives from the idea that placing subject matter off-center is usually a good idea. Things that are centered in the frame tend to look fixed and static, while objects located to one side or the other imply movement because they have somewhere in the frame to go. If you follow the rule of thirds, you'll divide your picture area into a grid with pairs of imaginary horizontal and vertical lines placed about one-third of the distance from the borders of the frame. The intersections of these lines create four points where you might want to place your center of interest. You don't have to position your subject *exactly* at one of these points; just use them as a guideline, as shown in Figure 9.8. Other interesting things in the photo can be positioned at any of the other three points.

You can use these gridlines in many ways besides locating a center of interest. For example, in landscape photos you might want to place the horizon at the lower-third grid line if you want to emphasize the sky, or at the upper-third grid line if the important parts of your composition are in the foreground and distance. (Horizons should rarely be placed in the exact middle of the photograph.)

Linear Thinking

Lead your viewer to your center of interest through the use of straight or curved lines, as well as strong geometric shapes. Vertical and horizontal lines force our attention up, down, or side to side, while diagonals lead the gaze from one bottom corner to the top opposite corner of the picture (for various reasons, we don't usually follow a diagonal line from top to bottom). Curved lines are most pleasing of all. Your lines can consist of parts of the image such as fences, roads, skylines, or other components. Look for natural lines in your subjects and use them in your composition.

Balance

Your images should have a balanced arrangement of shapes, colors, lightness, and darkness so your picture doesn't have a lopsided look. That doesn't mean your photograph must be perfectly symmetrical. You can have a larger, brighter, or more colorful object on one side balanced by a smaller, less bright, or less colorful object on the other.

Framing

Framing is a technique of using objects in the foreground to create an imaginary picture frame around the subject. A frame concentrates our gaze on the center of interest that it contains, plus adds a three-dimensional feeling. A frame can also be used to give you additional information about the subject, such as its surroundings or environment.

You'll need to use your creativity to look around your subject to find areas that can be used to frame your subject. Windows, doorways, trees, surrounding buildings, and arches are obvious frames. Frames don't even have to be perfect or complete geometric shapes. Generally, your frame should be in the foreground, but with a bit of ingenuity you can get away with using a background object, such as the bridge, as a framing device. Figure 9.6, earlier in this chapter, shows the power of framing.

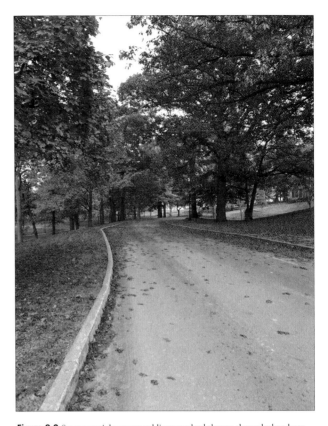

Figure 9.8 Don't be a slave to the Rule of Thirds, but it does make a good guideline for positioning your subjects.

Figure 9.9 Strong straight or curved lines can lead the eye through the photo.

Fusion/Separation

Our vision is three-dimensional, but photographs are inherently flat, even though we do our best to give them a semblance of depth. So, while that tree didn't seem obtrusive to the eye, in your final picture it looks like it's growing out of the roof of that barn in your otherwise carefully composed scenic photograph. Or, you cut off the top of part of an object, and now it appears to be attached directly to the top of the picture.

You always need to examine your subject through the viewfinder carefully to make sure you haven't fused two objects that shouldn't be merged, and have provided a comfortable amount of separation between them. When you encounter this problem, correct it by changing your viewpoint, moving your subject, or by using selective focus to blur that objectionable background.

Composing with People

Composing your photographs with people is a special challenge, if only because every person pictured will end up being a critic of your work. Yet, digital cameras in general, and dSLRs in particular are perfect tools for shooting people. You can immediately check your picture to make sure no one had her eyes closed, or happened to look away from the camera, or, perhaps,

had a stray pen peeping out of a shirt pocket. When you're done, you can show your photographs to your victims, and perhaps ensure they'll pose for some more pictures.

When shooting formal, informal, or candid portraits, you'll want to have a camera with as many megapixels as possible to give you the most flexibility when it comes time to retouch your images or make enlargements for display. You'll also need a modest zoom lens or prime lens of equivalent focal length, in the 80mm-to-100mm range for individual or small group portraits, and 50mm or wider for larger groups. These are absolute focal lengths I'm talking about, not multiplication factor equivalents. Remember that the lens multiplication factor is a cropping factor, not a true focal length. So, because 80mm to 100mm lenses provide the most attractive perspective for portraits, that's what you'll need with your digital SLR, even though your camera crops the lens' view internally. You might have to step back a bit or use a slightly shorter lens (70mm to 80mm instead of 100mm).

Lighting

You also should consider using external lights, whether incandescent or, preferably, electronic flash (because flash is better for moving subjects, like people, plus it's more comfortable for your subjects than hot lights). Erect a plain background indoors, or incorporate the natural indoor or outdoor background into your composition, if it's uncluttered. If you're using electronic flash, you probably won't need a tripod, unless you want to take a series of pictures using the same fixed point of view. If you're using incandescent lights, you may need a tripod to steady the camera for longer exposures. In some shooting environments, the existing illumination may work perfectly fine, particularly if you have some reflectors to use to soften dark shadows. Overcast days provide a nice, diffuse light, too, as you can see in Figure 9.10, which shows how soft light outdoors can be flattering.

Figure 9.10 Outdoors, avoid strong sunlight in favor of the soft light in shadows.

The quality of the light you use is also important. Soft, flattering lighting is better than harsh illumination when photographing people. It softens wrinkles and facial defects and makes for a more attractive photo. Even a grizzled old-timer proud of the character lines on his or her face will look better if the light is a little softer. Conversely, the silky-soft smooth skin of a newborn babe can look blotchy under harsh lighting. If you're using electronic flash, umbrellas are good choices as reflectors to soften the light.

Using several lights or light sources will let you use light to provide shape and form to faces and figures. Most photographers use a main light to illuminate the face, accompanied by a fill light to soften shadows, perhaps a hair light to add a little sparkle to the hair, and a background light to separate the subject(s) from the background.

There are a number of standard lighting arrangements for these multiple light sources, all described in detail with complete lighting diagrams in my book *Mastering Digital Photography*. Here's a quick summary:

- **Short lighting.** This is a form of three-quarter lighting, with the face turned to one side so that three quarters of the face is turned toward the camera, and one quarter of the face is turned away from the camera. The main light illuminates the side of the face turned away from the camera, and because three-quarters of the face is in some degree of shadow and only the "short" portion is illuminated, this type of lighting tends to emphasize facial contours, portraying a face as narrower than it really is. You can see short lighting and its complement, broad lighting, in Figure 9.11.

- **Broad lighting.** This is the flip side of the three-quarter lighting coin, with the main light illuminating the side of the face turned toward the camera. The soft main light de-emphasizes facial textures and widens narrow or thin faces.

Figure 9.11 Short lighting (left) illuminates the side of the face away from the camera, while broad lighting (right) floods the side of the face closest to the camera with light.

- **Butterfly lighting.** This is a type of glamour lighting effect, with the main light placed directly in front of the face above eye-level, casting a shadow underneath the nose. This is a great lighting technique to use for women because it accentuates the eyes and eye-lashes, and emphasizes any hollowness in the cheeks, sometimes giving your model attractive cheekbones where none exist. Butterfly lighting de-emphasizes lines around the eyes, any wrinkles in the forehead, and unflattering shadows around the mouth. Women love this technique for obvious reasons. Butterfly lighting also tends to emphasize the ears, making it a bad choice for men and women whose hairstyle features pulling the hair back and behind the ears. You can see an example of this kind of lighting in Figure 9.12.

- **Rembrandt lighting.** This is a flattering lighting technique, also shown in Figure 9.12, that is better for men. It's a combination of short lighting and butterfly lighting. The main light is placed high and favoring the side of the face turned away from the camera. The side of the face turned towards the camera will be partially in shadow, typically with a roughly triangular shadow under the eye.

- **Side lighting.** This is a kind of lighting with the illumination coming primarily directly from one side. You can place the main light slightly behind the subject to minimize the amount of light that spills over onto the side of the face that's toward the camera.

- **Backlighting.** Backlit photos have most of the illumination coming from behind the subject, defining its edges. Use additional fill light to provide for detail in the subject's front.

Outdoors, you can use these same lighting techniques, but work with the available light, reflectors, or perhaps some fill flash provided by your camera's built-in strobe.

Figure 9.12 Butterfly lighting (left) and Rembrandt lighting (right) are good for glamour effects.

Posing

Your subjects will look more natural if you pose them comfortably so they're not stiff or awkward. Let them sit comfortably if you can. A stool is a good seat because there is no back to intrude into the photograph and it discourages slouching. If you're posing a group, you may want several stools of different sizes to arrange your subjects in a pleasing composition, or arrange them as in Figure 9.13, so the heads of each individual are at different levels in the photograph. Outdoors, you can find comfortable seats in the form of logs, rocks, picnic tables, and other objects.

If you're photographing an individual, you can try different poses as you work. When working with young children, you may have to make a game of the session to put them at ease and enjoy posing for the camera. For Figure 9.14, I asked the young lady to sit on a picnic bench facing away from me; then look toward the camera over her shoulder.

For group pictures, you'll probably want to try and arrange everyone in a pleasing way and take several sets of pictures with each pose before moving on. Use basic compositional rules to arrange your subjects. Vary your camera's viewpoint slightly to portray your subject in a more flattering way. For example, raise the camera slightly above eye-level if you want to elongate a nose or narrow a chin, broaden a "weak" forehead or de-emphasize a prominent jaw line. If your subject has a wide forehead, long nose, or weak chin, lower the camera a little. If you encounter someone with a strong jaw and long nose, however, you're in a heap of trouble.

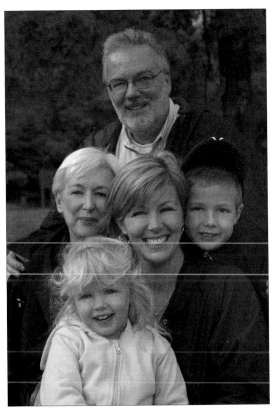

Figure 9.13 Arrange your subjects in a group photo so their heads are on different levels.

Figure 9.14 You can try lots of different poses with individuals, if you can gain their cooperation!

Remember that the edges of hands are more attractive than the backs or palms, and bare feet should be avoided entirely, particularly the bottoms thereof. While bald heads are almost a fashion accessory these days, you can minimize a shiny pate by having your subject elevate his chin while you lower the camera bit. Faced with a subject with a large or angular nose, have your victim face directly into the camera to avoid a profile shot of the schnozz. Prominent ears can be minimized by shooting in profile, or taking a three-quarters shot with the nearest ear in shadow. Wrinkles or scars can be hidden with softer light. Bad reflections off glasses can often be eliminated by having your subject raise or lower his or her chin slightly, as was done for Figure 9.15.

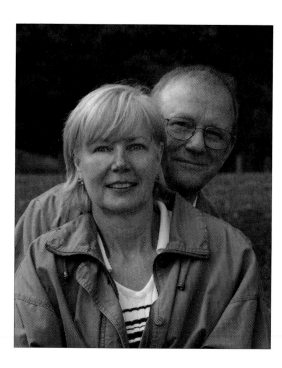

Figure 9.15 Ask your subject to raise or lower the chin slightly to eliminate reflections from glasses.

Landscape Photography

Digital SLRs are great for landscape photography because you can usually fit them with wider lenses than those available for point-and-shoot and other digital camera. I paid a bundle for my 12mm–24mm zoom lens, but it's paid for itself over and over when I've shot scenic pictures. Some kinds of scenics call for longer lenses, too, so that 200mm or longer optic will come in handy when you can't drive a few miles closer to that erupting volcano.

Other than an occasional tripod and use of a self-timer or remote control so you can get into the picture yourself, landscape photos are remarkably gadget-free. You'll seldom need an electronic flash, unless you're taking night photos or want to "paint with light" in a time exposure (this technique is a special project in my book *Mastering Digital Photography*). Your dSLR, a few lenses, and lots of digital memory cards are all that you need to take great pictures.

Scenic photos fall into several types of compositions. These include:

- **Mountains and other vistas.** This kind of picture embraces your typical stunning panorama views, whether captured in panorama mode or not. Generally, groups of people, buildings, and, frequently, even animals are absent from this kind of photograph. Your composition will depend heavily on your choice of lens focal length. A wide-angle view makes distant objects appear to be farther away, emphasizing the foreground of your photo. A longer telephoto setting brings far away objects like mountains closer, but compresses everything in the foreground.

- **Sunsets and sunrises.** These are popular subjects because they're beautiful, colorful, and often look as if a lot of thought went into them even if you just point the camera and fire away. Your digital SLR may even have a Sunrise or Sunset white-balance control, or programmed exposure mode especially suited to this kind of picture. Experiment with darker,

silhouette-heavy images, and watch out for glare caused by the sun. Consider using a star filter or gradient filter to add a special effect or even the exposure between the brighter sky and darker foreground. And don't forget to work fast: Sunrises and sunsets can be over in a few minutes! Figure 9.16 shows a sunset captured at just the right moment.

■ **Sea and water scenes.** Moving water can be captivating, but you'll need to monitor your exposure carefully. Bright sand and reflective water can fool your exposure meter. Experiment with incorporating reflections in the water into your compositions. Or, use a neutral density filter and a long exposure to blur the water while the surrounding shoreline and rocks remain sharp.

■ **Snow scenes.** Snow photos are a lot like sea and beach images from the standpoint of the possibility for glare and underexposures caused by improper metering. You'll also need to be wary of condensation and poor battery performance caused by cold temperatures.

Figure 9.16 Sunsets are one of the most popular types of scenic photography.

Architectural Photography

Architectural photography is another contemplative form of photography (most of the time) because it involves structures that will happily pose for you for hours on end without complaining. Of course, architecture is often accompanied by humans who can add or detract from the composition, and by changing weather conditions. It's a lot of fun, though, and well suited for digital SLRs because the larger sensors on these cameras, compared to point-and-shoot models, makes them more suitable for long exposures at night (which is one of the most interesting kinds of architectural photography).

Shooting Outdoors

Because the best structures are often surrounded by other buildings, you'll need a wide-angle lens or zoom equipped with a fairly wide-angle setting for your outdoors shots. Indoors, the wider, the better, unless you're shooting inside the Superdome or a towering cathedral. A wide lens will help you incorporate foreground details, such as landscaping, into your compositions. For Figure 9.17, I used a 12mm extreme wide angle for a special effect. The broad marble "sidewalk" is actually a long bench, only about three feet wide.

Figure 9.17 An extreme wide angle emphasizes the foreground, making this three-foot wide bench look like a vast sidewalk.

A fast lens with a maximum aperture of f2 will help you capture images under difficult lighting conditions. Architectural photos are often very carefully composed, so you might find yourself working with a tripod frequently, not so much to steady the camera as to provide a perspective that changes only when you want it to.

The things to watch out for are various distortions. One type is caused by lenses themselves. Certain wide-angle optics are known to be blurry in the corners of the image, mostly because filling the entire frame with a wide perspective taxes the coverage of even expensive dSLR lenses. Or, your lens can produce *barrel distortion*, in which the straight lines are bowed outwards toward the edges of the photo, or *pincushioning*, with lines that curve inward towards the center.

Unless you're photographing barrels or pincushions, neither condition is desirable. Your lens may have one of these defects, although probably not dramatically, which would make it less than ideal for architectural photography. Test your lens by photographing a grid and then visually looking to see if the vertical and/or horizontal lines bow in or out. Andromeda makes a Photoshop-compatible plug-in called LensDoc that not only can correct for both kinds of distortion, but has built-in corrections for the tested distortion already found in some common Canon, Nikon, and Olympus digital camera lenses.

Another kind of distortion is called *perspective distortion*, and it is produced when the camera is tilted up or down to photograph a tall building or other vertical structure. Tilting the camera lets you take in the top of the structure, but then the subject appears to be falling back, as you can see in Figure 9.18. The same thing happens when you angle the camera to either side to grab a picture of a receding object, such as a stone wall, but the results aren't as apparent or, usually, as objectionable. The most obvious solution—to step backwards far enough to take the picture with a longer lens or zoom setting while keeping the camera level—isn't always available.

I happen to own a special lens for my 35mm film cameras, a so-called perspective control lens which lets you raise and lower the view of the lens (or move it from side to side; perspective control can involve wide subjects as well as tall) while keeping the camera back in the same plane as your subject. However, I've found that the amount of raising and lowering that can be applied isn't really enough for most situations.

One workaround, if you're lucky, is to locate a viewpoint that's about half the height of the structure you want to photograph, with no intervening buildings, flagpoles, or other objects in between. Shoot the picture from that position, keeping the back of the camera parallel with the structure, and both the top and base of the building will be roughly the same distance away from the camera. You'll get a much more natural-looking picture. Finally, you may be able to adjust the perspective of your image in your image editor.

If you find that shooting the exterior of a building is difficult from a perspective viewpoint, consider capturing parts of the structure, such as doorways, entrances, roofs, or decorations. These details may tell you more about the building or monument than an overall view would. Cobblestone steps on a 15th century palace, worn by the incessant pounding of human feet or the weathered siding on an old barn can express ideas effectively when incorporated into your compositions.

Figure 9.18 Perspective distortion is caused by tilting the camera backwards.

Shooting Indoors

Indoor architectural photography is particularly challenging. Your widest wide angle may not be wide enough, and your fastest f-stop or ISO setting may not provide sufficient exposure. The natural lighting indoors is likely to be less attractive in photographs than it appears in real life, is probably uneven, may be harsh, and can even involve tricky combinations of bluish daylight streaming in the windows to mix with orangish incandescent illumination.

A tripod and a long exposure may help, and let you use a lower ISO setting with less noise, to boot. Or, if you have a modicum of control over the lighting used, you may be able to add more lighting, soften additional lighting, or use reflectors to distribute the available illumination.

If the lighting is mixed, match daylight with electronic flash, or close the blinds to confine the illumination to the interior incandescent lights.

Next Up

The last chapter in this book concentrates on some of the special features found in many (but not all) digital SLR cameras and their lenses. These include image stabilization, night and infrared photography, and special shooting modes.

10

Mastering dSLR Special Features

All digital SLRs have special features that you'll need to master before you can become truly proficient with your camera. These range from image stabilization to time-lapse photography, which can improve your photos or give you whole new avenues of picture taking to explore.

Some special features aren't intentional. For example, dSLR manufacturers go to great lengths to reduce the amount of infrared illumination reaching your sensor, because too much light in the long wavelengths can reduce the quality of your image. However, enough IR sneaks through to make infrared photography possible with most digital cameras, opening up one more door to creativity.

This chapter describes some of the special and optional features available for digital SLRs, and I hope it will spark your interest enough that you'll explore some of them once you've mastered all the other features of your camera.

Image Stabilization

Camera shake is one of the banes of photography at all levels. It doesn't matter whether you're a tyro shooting a film or digital point-and-shoot, a serious photo enthusiast looking to express bottled-up creativity with photography, or a seasoned pro who should know better: Over the entire spectrum of users, as many images are "lost" through camera-induced blur as through poor exposure or bad focus.

Amateurs bring me their photographs asking how they can make them "sharp and clear" and a quick glance is enough for me to tell them not to "punch" the shutter button. I've seen examples of camera shake so egregious it was possible to tell whether an aggressive downward stroke on the shutter release was vertical or slightly diagonal. You'd think automated point-and-shoot cameras would set a shutter speed high enough to prevent these blurry pictures, but, as you'll see, that's not always possible. As light levels drop, so do shutter speeds, and blur is an inevitable result.

More serious photographers who pride themselves on the ability to hand-hold their cameras and get sharp images at 1/30th second or slower are sometimes shocked at how much sharpness they've actually lost when they compare their hand-held shots with those taken at the same settings using a tripod or other steadying aid. Of course, a hand-held shot may be good enough for its intended use, or even *better* for artistic or practical reasons than one taken with a tripod.

The chief difference between photographic neophytes and experienced photographers when it comes to camera shake is that the veterans are equipped to recognize the problem (usually) when it occurs, and take corrective measures. Photo enthusiasts will know enough to brace the camera by digging their arms into their sides, using a handy nearby support such as a ledge or fence, or switching to a higher shutter speed.

Figure 10.1 shows a real-life example of how camera shake can be produced. I was hurrying along a country road at sunset one night on my way to an appointment and was taken by the brilliant hues the setting sun created in the changing colors of a tree I'd just passed. I didn't have time to stop and get out of the car, but my dSLR is always next to me, ready to go, so I grabbed it and took the picture at left. The image is so blurry I probably didn't even wait for the camera to stop moving before snapping the shot.

At that point, I looked up and down the road and there were no cars coming, so I steadied myself and took the photo at right *using the exact same shutter speed and f-stop*. Simply remembering to steady myself produced a much sharper picture.

Camera and lens manufacturers are starting to come to the aid of all of us by producing products with features that are called, variously, image stabilization, vibration reduction, or anti-shake, and which make themselves known in product names by acronymic appendages like IS (image stabilization), VR (vibration reduction), or AS (anti-shake). No insult is intended towards Nikon, Minolta, and other vendors of these anti-blur technologies, but for the purposes of this chapter I'm going to adopt Canon's terminology and call it image stabilization, or

Figure 10.1 A quick grab shot (left) and one taken a second later after the photographer remembered to steady himself.

IS. In any case, Canon was the first to introduce this feature, back in the 1990s. Some form of IS is now found in many lenses, built right into cameras (with Minolta pioneering this approach), and into other kinds of products, including binoculars.

Causes of Camera Shake

Sharpness-robbing camera shake is insidious because it can come from so many sources. Punching the shutter release, as rank amateurs (as well as careless photographers with more experience) do, can jar the entire camera, often producing motion in a downward or diagonal direction sufficient to blur the image when slow shutter speeds are used. A more gentle finger on the release can eliminate some of the worst problems.

The normal, inevitable motion of the hand during a longer exposure can also produce camera shake. Some people have an almost imperceptible amount of tremor in their grips that is not caused by serious problems in the brain, my neurologist assures me. But the steadiest hands will tremble slightly, and the results will show in photographs taken with a normal or wide-angle lens at 1/30th second, or even, amazingly, at 1/125th second.

Shakiness can be exacerbated by several other factors. A camera or camera/lens combination that is poorly balanced is prone to additional camera shake. Turning the camera from a horizontal to a vertical orientation can produce more shake if the rotated grip is uncomfortable, or if there is no second "vertical" shutter release and the photographer's hand is forced into an awkward position.

Camera shake is magnified by longer focal lengths. It's bad enough that a long telephoto will induce vibration by making the camera front-heavy. But vibrations that are almost imperceptible when shooting photos with a 25mm lens will be seemingly magnified 10X at 250mm. The rule of thumb that suggests using a minimum shutter speed that's the reciprocal of the focal length of the lens (e.g. 1/250th second with a 250mm lens) is a good one, even if it doesn't go far enough.

Enlarging your photo to extremes can produce the same magnification effect. Figure 10.2 shows both telephoto and enlargement-induced blur in a single pair of shots. The image at top of a distant ultralight aircraft was taken with a 400mm lens on a dSLR with a 1.5 lens multiplier effect, so the magnification caused by the multiplier crop was the equivalent of using a 600mm lens. I further cropped out only the center section of the final photo in my image editor, producing even more magnification. A shutter speed of 1/750th second wasn't fast enough to eliminate the camera shake in this case. (The ultralight aircraft itself was moving very slowly, so the shutter speed was enough to freeze *that* motion.)

The version at the bottom of the illustration was taken at 1/2,000th second, when the craft began to make a turn (which you can tell by the slightly changed shape of the wing) and appears to be much sharper.

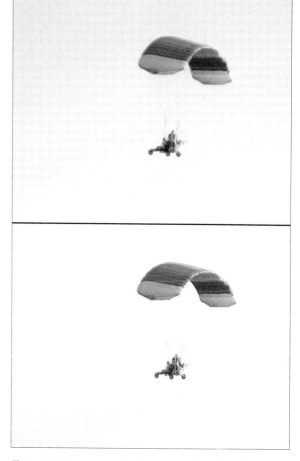

Figure 10.2 This long telephoto shot at 1/750th second (top) is much sharper with a 1/2,000th second shutter speed.

One final cause of camera shake is the internal motion of the camera's innards as the photograph is taken. For digital SLRs, the one source that's a proven culprit is the slapping of the mirror as it flips up out of the way prior to the opening of the shutter. This kind of vibration can happen even when the camera is firmly mounted on a tripod, and the photographer takes himself or herself out of the movement equation by using a shutter release or remote control to trigger the exposure. The solution here is to lock the mirror up before taking the picture. Not all dSLRs offer mirror lock-up, however, but, fortunately, mirror vibration is not a concern in most picture-taking situations. It's likely to cause some effects under extreme magnifications (with very long lenses), or for close-up pictures with longer exposures. There's a longer discussion of mirror-caused vibration in Chapter 4.

Diagnosing Camera Shake

The big shocker for many experienced photographers is that the recommended minimum shutter speed is not a panacea. The only true way to eliminate camera shake is to prevent the camera from shaking. If that's not possible, one of the image stabilization technologies available from camera vendors will probably help.

Most photographers are surprised to learn just how much camera shake they fall victim to even at "high" shutter speeds. Even the steadiest hands are likely to see some camera shake in their photos at 1/125th second, or even higher, if only under extreme magnification. It may be virtually invisible in normal picture-taking circumstances, but it's there.

Very serious camera shake is easy to diagnose. There are four possible causes for a blurry photo (and don't forget that some pictures can contain elements of all four causes):

- **The picture is out of focus.** If you or your camera's autofocus mechanism goofed, some of your subject matter, or in the worst cases *all* of it, will be out of focus and blurry. You can spot this kind of blur by looking at pinpoints of light in your image. Absent camera shake or subject movement, fixed spots of light will be enlarged and blurry, but will maintain their shape. Figure 10.3 shows an image that is simply out of focus. The camera had

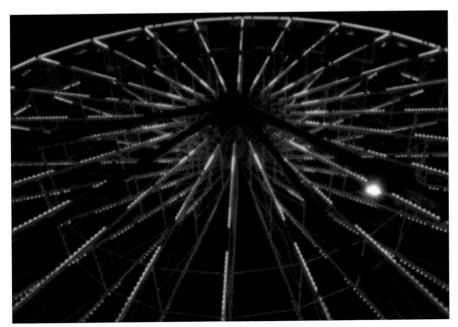

Figure 10.3 Blur caused by an out of focus image.

been manually focused on an object fairly close to the camera, and not adjusted when the lens was pointed at the Ferris wheel that was, effectively, at infinity.

■ **The subject was moving.** You can tell if subject movement is the main cause of image blur if the subject itself is blurry, but the background and surroundings are not. Figure 10.4 shows the same Ferris wheel, this time with the camera on a tripod and the wheel is moving. Spots of light in the image will be blurred in the direction of the subject's travel, in this case producing an interesting blur effect.

Figure 10.4 Blur caused by subject movement.

■ **You zoomed during the exposure.** Racking the zoom lens in or out during a long exposure is a time-honored special effect, but it's easy to do it accidentally. You're zooming in on an interesting subject and happen to press the shutter release on impulse before the zoom is finished. If your zoom movement is fast enough, you can see this effect in exposures as long as 1/60th second. Points of light will move inward towards the center of the image or outward as the magnification decreases or increases while you zoom. Figure 10.5 shows an intentional zoom during exposure. The Ferris wheel was also moving, so a combination of zoom and movement blurs result.

■ **Your camera shook.** The final primary cause of a blurry photo is camera shake. You can spot this kind of blur by looking at spots of light or other objects in the picture. They'll be deformed in the direction of the camera shake: up and down, diagonally, or, in the worst cases, in little squiggles that show that the camera was positively trembling. Figure 10.6 shows an example of camera shake.

If you want a measurable way of seeing just how badly camera shake affects your own photos, it's easy to construct a diagnostic tool. Get yourself a large piece of aluminum (aluminum foil will do in a pinch) and poke some tiny holes in it using a pattern of your choice. I prefer a cross shape because that simplifies seeing blurs in horizontal, vertical, and diagonal directions; the cross pattern doesn't interfere with the blurs you produce.

Figure 10.5 Light trails caused by zooming during exposure.

Figure 10.6 Camera shake causes distinctive blur patterns.

Then mount the sheet 10 to 20 feet away and back-illuminate it so the tiny holes will form little dots of light. The correct distance will depend on the focal length of the lens or zoom you'll be testing. You want to fill the frame with the testing sheet. Focus carefully on the sheet, and then take a series of exposures at various shutter speeds, from 1/1,000th down to 1 full second. Repeat your test shots using various methods of steadying yourself. Brace the camera against your body with your arms. Take a deep breath and partially release it before taking the photo. Try different ways of holding the camera.

Then, examine your test shots. As the shutter speed lengthens, you'll notice that the tiny circles in the aluminum sheet will become elongated in the vertical, horizontal, or diagonal directions, depending on your particular brand of shakiness. You may even notice little wavering trails of light that indicate that you weren't merely shaking but were more or less quivering during the exposure.

You'll probably be shocked to discover some discernable camera shake at shutter speeds you thought were immune. With a normal lens, you might find some blur with hand-held shots at 1/125th second; with short telephotos, blur can be produced at 1/250th or shorter exposures. Figure 10.7 shows some typical results.

Figure 10.7 These backlit test patterns were photographed at 1/1,000th second (upper left); 1/30th second (upper right); 1/4 second (lower left); and 1 second (lower right).

Preventing Camera Shake

The least expensive way of countering camera shake is to hold your camera steady. You probably don't want to carry a tripod around with you everywhere, but there are alternative devices that are easier to transport, ranging from monopods to the C-clamp device shown in Figure 10.8. I carry mine with me everywhere; it fits in an outside pocket of my camera bag and can be used to convert anything from a fence post to a parking meter into a tripod-like support. It even has a sturdy screw fitting so you can attach it to utility posts or other wooden objects. (Please don't kill trees!) Once, when I was nursing a gimpy hip, I coupled this clamp with a walking cane to create a handy instant monopod. Most of the Ferris wheel photos earlier in this chapter were all taken with this clamp and a handy railing.

Lacking any special gear, you can simply set your camera on any available surface and use your self-timer to take a shake-free picture. The two versions shown in Figure 10.9 were taken with the camera hand-held (top) and with the camera resting on top of a trash receptacle (bottom). Sometimes you can rest a long lens on a steadying surface to reduce the front-heavy effect. Veteran photographers carry around bean-bags they can place

Figure 10.8 A light-weight C-clamp adapter can convert many rigid objects into a tripod.

on an object and use to cradle their long lens gently. Another trick is to attach a strong cord to the tripod socket of your lens (most telephotos have them) with a tripod fitting, loop the other end of the cord around your foot, and pull it taut, adding some stability to your camera/lens combination.

You can also follow any of the well-known prescriptions for holding your body more steady, such as regulating your breathing, bracing yourself, and, above all, *not punching the shutter release.*

Figure 10.9 Steady a hand-held shot by placing the camera on a handy object.

Using Image Stabilization

Your camera may be able to help stabilize your images. One of the most popular features of some current cameras and lenses is hardware stabilization of the image. By countering the natural (or unnatural) motion of your camera and lens, IS can provide you with the equivalent of a shutter speed that is at least four times faster, effectively giving you two extra stops to work with. That can be important under dim lighting conditions.

For example, suppose you're shooting in a situation with a 400mm lens that calls for a shutter speed of 1/500th second at f2.8 for acceptable sharpness. Unfortunately, you're using a zoom lens with a maximum aperture at that particular focal length of only f5.6. Assume that you've already increased the ISO rating as much as possible, and that a higher ISO either isn't available or would produce too much noise. Do you have to forego the shot?

Not if you're using a camera or lens with IS. Turn on your IS feature, and shoot away at the equivalent exposure of 1/125th second at f5.6. If the image stabilizer works as it should, blur caused by camera shake should be no worse than what you would have seen at 1/500th second. Your picture may even be a little sharper if your lens happens to perform better at f5.6 than a faster lens at f2.8 (which isn't uncommon).

There are some things to keep in mind when using image stabilization:

- Image stabilization mimics the higher shutter speed *only* as it applies to camera shake. It will neutralize a wobbly camera, but won't allow you to capture faster-moving objects at a slower shutter speed. If you're shooting sports with IS-enabled gear, you'll still need a shutter speed that's fast enough to freeze the action.

- Some image stabilizers produce *worse* results if used while you're panning. The intentional camera movement may confuse the IS, or provide only partial compensation, so you'll end up with a picture that is not as good as if IS were switched off. Not all equipment suffers from this problem, however.

- Image stabilization can slow down your camera a little. The IS process takes some time, just as your autofocus and autoexposure do, but unlike either of those, does not necessarily cease when you partially depress the shutter release. Image stabilization can produce the equivalent of shutter lag, and, oddly enough, may not work as well as you think for sports photography. IS is great for nature photography, long-range portraits, close-ups, and other work with subjects that aren't moving at a high rate of speed, but less suitable for fast action.

- Remember that image stabilization can be used for applications besides long-range telephoto or close-up photography, and doesn't require macro or tele settings to be of benefit. For example, if you find yourself in an environment where flash photography is not allowed, such as a museum or concert, IS can be a life-saver, letting you shoot with normal or wide-angle settings at shutter speeds as slow as 1/4 second. Nikon's 24mm to 120mm AFS-VR optic is an example of a "walking around" lens that's ideal for many ordinary picture-taking situations in which a slower than optimum shutter speed is desirable.

Despite my final caveat, image stabilization can be used effectively for sports photography, particularly if you're careful to catch peak moments. Figures 10.10 and 10.11 show two different shots of a base runner diving back to first base, both taken with 400mm long lenses at about 1/500th second. In both pictures, subject motion isn't really a problem. The sliding base runner has already skidded to a halt, and the first basewoman has caught the ball and prepares to make the tag (too late), in Figure 10.10, or is waiting for the ball to arrive (in Figure 10.11). The 1/500th second shutter speed was sufficient to stop the action in either case.

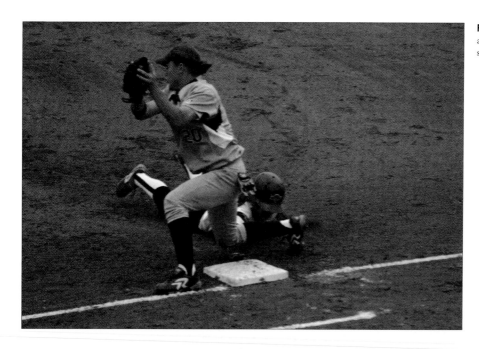

Figure 10.10 No vibration reduction and a long lens lead to visible camera shake, even at 1/500th second.

Figure 10.11 The same shutter speed works fine with image stabilization at work.

However, camera shake proved to be the undoing in the first example, but image stabilization saved the day in the second photo.

How It Works

There are several ways of achieving image stabilization. Some electronic video cameras use an electronic form of IS by capturing an image that's slightly larger than the final frame and shifting the pixels in the proper direction to counter the motion of the camera; then saving the displaced pixels as the final image for that frame, repeating the process many times each second. This works, but is not the ideal method.

Optical image stabilization is better. Gyros in photographic equipment sense the slight movements of the camera and lens, and use prisms or adjustments in several "floating" lens elements to compensate. The glass can be shifted along the optical axis to cancel undesired lens movement and vibration.

Minolta pioneered a system built into the camera, rather than the lens, in which the *sensor* is moved in response to camera motion. The advantage of this method is that you don't have to purchase a special lens that incorporates IS; Minolta's anti-shake technology is in the camera and therefore works with (almost) every lens you use. (Minolta's system isn't compatible with every lens it produces.) If you like working with lots of different lenses and don't want to purchase an array of IS-enabled optics, this approach has its advantages.

I mentioned earlier that image stabilization can become confused by intentional panning of the camera, and produce inferior results. Some lenses, including several models from Canon, incorporate two IS modes, including a special one for panned images.

Night, Ultraviolet, and Infrared Photography

Some digital SLRs and SLR-like cameras have features that lend themselves to some exciting fields of photography, including night, ultraviolet, and infrared imaging. Not all cameras are suited for each of these, so I'm going to provide a quick discussion of each type to help you decide if you want to explore these fascinating avenues of experimentation. I have to warn you: any of them can easily turn into a mania!

Night Photography

I've actually covered most of what you need to know about night photography in other portions of this book, but there are some new tricks to learn about, and a few new considerations to ponder. Here are some of the things to think about.

Camera Sensitivity and Noise

Higher ISO settings mean you can take some pictures at night in relatively well-lit locations hand-held, and if you must use a tripod, boosted sensitivity settings can lead to shorter exposures. Sometimes you'll *want* longer exposures to create streaking or ghost effects, but other times you'll want to use a reasonably short shutter speed, if only to increase the number of shots you can take in a given timeframe.

If your camera offers ISO settings higher than ISO 800 (some well-known dSLRs don't), you can go to ISO 1,600 or ISO 3,200 to cut your shutter speeds drastically, or, keep the same speed and use a smaller, more forgiving f-stop. You may be able to "cheat" and fake higher ISOs if you're willing to experiment.

ISO cheating

Need an ISO setting higher than the maximum provided by your camera? You may be able to cheat. Shoot in RAW format. Set the camera to its highest ISO, then use the EV control to reduce the exposure by –1 or –2 EV. That gives you the same result as shooting at double and quadruple the marked ISO setting. When you convert your RAW files, you can try to resurrect your severely underexposed photo using the exposure, contrast, brightness, and histogram/curves controls in your RAW converter. Your final image may be very noisy and have poor tonal rendition, but what did you expect from ISO 6400 or ISO 12,800?

When shooting at higher ISO settings, make sure that your camera's noise reduction feature is sufficient to cut down on that noxious, multicolored hash that results from boosted ISOs. (You'll find a discussion on the causes and effects of noise in Chapter 2.) Too much noise in an image can render it useless.

As you'll recall from earlier in this book, noise reduction involves the camera taking a second, blank exposure, and comparing the random pixels in that image with the photograph you just took. Pixels that coincide in the two represent noise and can safely be suppressed. Most noise reduction systems effectively double the amount of time required to take a picture, and are applied only for longer exposures (typically those that are one second or more). The extra time comes from the follow-up, dark frame that's exposed for the same length of time as your original shot. A warning will probably appear in your dSLR's viewfinder, telling you the cause of the delay. This form of noise reduction, also called *dark frame subtraction,* can be turned on and off, so you can apply it only when you need to. Figure 10.12 shows a pair of images shot at ISO 1,600. The one on the left was taken with noise reduction turned off; the version on the right uses in-camera noise reduction.

You can also apply noise reduction to a lesser extent when converting RAW files to some other format, using your favorite RAW converter, or an industrial-strength product like Noise Ninja (**www.picturecode.com**) to wipe out noise after you've already taken the picture.

Noise Ninja

Two things that I like most about Noise Ninja is that it can suppress noise without significantly degrading your image, and it can be used with photos taken at relatively low ISO settings as well as your "pushed" shots. It uses a sophisticated approach that can identify and recognize noise that presents itself at different frequencies, parts of your image, and in varying color channels.

Unlike your camera's built-in noise reduction feature, Noise Ninja gives you control over how its algorithms are applied, using easy-to-operate sliders with real-time previews for feedback. There's also a "noise brush" you can apply to selectively modify the noise in those parts of the image where it is particularly troublesome.

This application tailors itself for your particular digital camera, using a profile that characterizes how your model performs at particular ISO settings and under given sets of conditions. For example, if your camera is prone to developing more noise in a particular color channel, Noise Ninja can take that into account. You'll find downloadable profiles for dozens of different cameras and scanners at the PictureCode Web site.

Figure 10.12 No noise reduction (left) provides a much grainier image than the version at right with noise reduction.

Exposure and Focus

Determining the correct exposure for night photography can be tricky. Your dSLR's autoexposure system will probably do a good job, but can still be thrown off by bright lights or other deceptive parts of your scene. It's a good idea to bracket your exposures when shooting at night, to increase your chances of getting one that's just right. Keep in mind that the phenomenon known as reciprocity failure (discussed earlier in the book) will mean that, with extended exposure times, leaving the shutter open twice as long *won't* give you twice as much exposure.

Focus can also be problematic if you're shooting subjects that are closer than 10 feet or so. Generally, night scenes are taken at a distance, so manual focusing at infinity can do the trick. Taking photos at night of closer subjects means your camera had better have a focus-assist light or other system for focusing under dim illumination. It's likely your dSLR's optical viewfinder won't be usable if it's really dark.

Taking Your Best Night Shots

Sony has pioneered a technology called Night Shot, used in both its camcorders and Cybershot digital cameras, to allow taking pictures in what Sony claims is total darkness. Of course, it's not really absolutely dark: Sony's system takes advantage of the infrared sensitivity of its CCD sensors to produce images by long wavelengths of light that we can't see. Like virtually all digital cameras, Sony's Cybershot models include an IR Cut Filter (ICF) to reduce the CCD's sensitivity to infrared and ultraviolet light. That's a great idea for pictures taken under full daylight, because these wavelengths can degrade the image and modify the relationships between the colors we see.

In Night Shot mode, the cutoff filter is swung out of the way, allowing all the wavelengths of light to reach the sensors. That increases the sensitivity of the camera at night, making it possible to take photos when there is too little light to see by.

Ultraviolet Photography

Ultraviolet photography with digital SLRs is largely undiscovered country, but one worth your exploration, because some interesting effects can be produced by the unexpected way some subjects absorb or reflect ultraviolet light. You'll find many challenges in your path, including the fact that the sensors in digital cameras are not very sensitive to UV light, and the lenses used with them are very good at filtering UV out. You can purchase a special lens produced especially for UV photography (made of a phosphate glass, and used for specialized medical and scientific applications). Expect to pay thousands of dollars for one, if you can even find an example for sale.

The problems are not insurmountable. Andrew Davidhazy at the Rochester Institute of Technology has done some interesting experiments with the Canon Digital Rebel, using an 18A ultraviolet transmitting filter. He's gotten some strange, but fascinating results photographing Black Eyed Susans, sunflowers, and buttercups. Find his Web page on the topic at **www.rit.edu**, and see what happens when a world-class creative mind starts fooling around to see what will happen.

Infrared Photography

Infrared imaging is one type of photography that holds a little more promise. Although digital cameras include an infrared-blocking filter, or "hot mirror," enough infrared light leaks through to make it possible to take pictures by the wavelengths that remain. You'll need a special filter and long exposures, but infrared photography is entirely practical with a dSLR. Infrared photography is a "special project" exercise in my book *Mastering Digital Photography*, but I'm going to tell you everything you need to know here.

But first, a warning. As a dSLR owner, you'll be shooting blind! As I mentioned earlier in this book in Chapter 4, because the infrared filters you'll use block visible light, your optical viewfinder will appear to be totally black, and, of course, your LCD can't be used for previewing pictures.

Still, infrared pictures look cool because your subjects, particularly plant-life, absorb or reflect infrared light in proportions that are different from what you see with visible light. The tonal relationships can be wildly weird, with black skies and white foliage. People will appear pale and washed out, perhaps even ghastly. Indeed, because infrared photography is not particularly people-friendly, it's most often used for landscapes and scenic photos.

A side effect of infrared imaging is that the photos tend to look grainy and soft in focus, because of the different way in which your lens and camera handle IR illumination. Most of the time, you'll want to convert your infrared images to grayscale, but some interesting color effects can be achieved, too. Figure 10.13 shows an infrared image that's been converted to monochrome.

You can also get some "color" infrared effects through a process known as channel swapping. After you've produced your infrared photo, apply your image editor's auto-levels control to adjust tonal values. Then exchange the red and blue values by editing each of those two channels separately. In Photoshop, use the Channel Mixer to edit the Red channel, moving the Red slider to 0 percent and the Blue slider to 100 percent. Then, do the opposite to the Blue channel, changing its Red slider to 100 percent, and its Blue slider to 0 percent.

Figure 10.13 Some interesting grayscale effects can be produced with infrared photography.

You can end up with a photo like the one shown in Figure 10.14, where the sky is blue, but the foliage has a neutral white or faintly magenta appearance.

Figure 10.14 Channel swapping can give you color infrared pictures.

What You Need

You'll need to use a digital SLR that doesn't completely filter out infrared light with a hot mirror. An easy way to check for IR capability is to photograph your television remote control. Point the remote at your camera, depress a button on the remote, and take a picture. If your camera can register IR light, a bright spot will appear on the photograph of the remote at the point where the IR light is emitted.

Next, you'll need an IR filter to block the visible light from your sensor. Find a Wratten #87 filter to fit your digital camera. You can also use a Wratten 87C, Hoya R72 (#87B), or try #88A and #89B filters. Your local camera dealer may let you try out several of these filters in the store to see which works best for you, which is a much better idea than purchasing one blind, because they can easily cost $100 or more. You'll probably need to decide which of your lenses you'll be using the IR filter with, because they are too expensive to purchase one for every filter size. I paid $80 for my R72 filter, and I purchased it in a 67mm size that fits my most-used lens. It will also work with another lens that takes 62mm accessories, using a step-up ring. My most extreme wide-angle lens, a 12mm–24mm zoom, unfortunately, requires a 77mm filter, which, in the case of an IR add-on, costs more than twice as much. Because of the additional cost, I decided that my infrared photography was going to be limited to images that could be taken in the 18mm to 200mm focal length range.

You'll also need a tripod for most of your shooting, because IR photos typically require exposures of 1/15th second to 1/4 second, or longer, even under bright daylight. A tripod is also a good idea because you can line up your shot with the filter off (so you can view the image through the viewfinder), then fasten the IR filter without disturbing the camera position before you take your shot.

IR Considerations

Infrared photography requires some accommodations because of the way your camera works with long-wavelength light. Here are some things to keep in mind.

- **Light loss.** The IR filter blocks the visible illumination, leaving you with an unknown amount of infrared light to expose by. Typically, you'll lose 5 to 7 f-stops, and will have to boost your exposure by that much to compensate. A tripod and long exposures, even outdoors, may be in your future.

- **Metering problems.** Exposure systems are set up to work with visible illumination. The amount of IR reflected by various subjects differs wildly, so two scenes that look similar visually can call for quite different exposures under IR.

- **Shooting blind.** Because the visual light is eliminated, you'll be in a heap of trouble trying to view an infrared scene through a digital SLR. The LCD review may be a little weird, too. If I don't have a tripod handy, I tend to set my zoom to a wide angle, then point the camera and hope for the best.

- **Focus problems.** Infrared light doesn't focus at the same point as visible light, so your autofocus system might or might not work properly. Lenses used to have an infrared marking on them that could be used in conjunction with the focus scale on the lens to correct the point of focus after you'd manually adjusted the image. Of course, we don't use manual focusing much these days, so you may have to experiment to determine how best to focus your camera for infrared photos. If you're shooting landscapes, setting the lens to the infinity setting probably will work (even though *infrared infinity* is at a different point than visible light infinity).

- **Lens coatings.** Some lenses include an anti-IR coating that produces central bright spots in IR images. A few Canon lenses fall into this category. Test your lens for this problem before blaming the artifacts on your filter or sensor.

■ **Shoot in color.** Even though your pictures will be, for the most part, black and white, or, rather, monochrome (usually magenta tones or a color scheme described as "brick and cyan"), you still need to use your camera's color photography mode. Experts in digital infrared photography recommend setting your camera's white balance manually, using grass as your sample. That white balance will provide the best overall grayscale images in your final picture. If your camera allows it, save the custom white balance as a preset to use later on the next time you take infrared photos under similar conditions.

You'll find lots more information on the Internet about digital infrared photography, including the latest listings of which cameras do or do not work well in this mode. If you ever tire of conventional scenic photography, trying out digital IR can respark your interest and give you a whole new viewpoint.

Time-Lapse Photography

Who hasn't marveled at a time-lapse photograph of a flower opening, a series of shots of the moon marching across the sky, or one of those extreme time-lapse picture sets showing something that takes a very, very long time, such as a building under construction?

You probably won't be shooting such construction shots, unless you have a spare digital camera you don't need for a few months (or are willing to go through the rigmarole of figuring out how to set up your camera in precisely the same position using the same lens settings to shoot a series of pictures at intervals). However, other kinds of time-lapse photography are entirely within reach.

Some digital cameras have the ability to schedule time-lapse delays built in, and I'm hoping this will become more common on dSLRs in the future. You might need to resort to an EVF camera or point-and-shoot camera to get the time-lapse flexibility you need. For example, the Olympus E-20 pioneered a nifty system that lets you take pictures at intervals ranging from every 30 seconds to once a day, for as long as your memory card and batteries hold out. (An AC adapter is always a good idea for time-lapse photos.)

With dSLRs, you're more likely to have to use methods like those found in Fuji and Nikon cameras, among others, which can shoot time-lapse pictures through computer software control, with the camera tethered to the computer using a USB cable. You can also trigger your camera using its infrared remote control, either to make manual exposures, or, like some enterprising souls we know, by programming a Palm Pilot to provide the trigger.

Here are some tips for effective time-lapse photography:

■ If you're shooting a long sequence, consider connecting your camera to an AC adapter, as I mentioned earlier.

■ Unless your memory card has enough capacity to hold all the images you'll be taking, you might want to change to a higher compression rate or reduced resolution to maximize the image count.

■ While time-lapse stills are interesting, you can increase your fun factor by compiling all your shots into a motion picture using your favorite desktop movie-making software.

- If your camera will be set up for an extended period of time (longer than an hour or two), make sure it's protected from weather, earthquakes, animals, young children, innocent bystanders, and theft.

- Experiment with different time intervals. You don't want to take pictures too often, or less often than necessary to capture the changes you hope to show in your images.

Next Up

That's all I have for you this time out. The next step is yours, and the ball is firmly in your court. I hope this book has answered your basic questions about using a digital SLR camera, and inspired you enough to take what you've learned and go out and capture some prize-winning photos. With any luck, your imagination is fired up and brimming over with new ideas.

Although I've been taking pictures with SLRs for a ton of years, and with digital cameras since they first came on the market, I still have a lot to learn, and so do you. In fact, one of the things I like best about photography is that each outing provides the opportunity to try something new, experiment with a technique that hasn't been tried before, and to scratch deeper below a surface that's barely been nicked. Photography's been a fascinating field for more than 165 years, and as we make the transition from film to digital technology, there will be new capabilities and new opportunities to delight and amaze our friends, family, and colleagues.

After all, as much as you tell yourself that your photographic work is done for your own benefit and pleasure (assuming it's an avocation and not a profession for you), you'll probably admit that nothing pleases you more than having someone look at one of your pictures and exclaim, "Wow! How did you do that?" With any luck, you'll even be asking yourself, very soon, "Wow! How did *I* do that?"

A

Illustrated Glossary

If you've turned to this portion of the book, there's probably a technical term you don't fully understand, or, perhaps, you'd like to see how related photographic concepts or techniques fit together. So, I've stuffed it with all the most common words you're likely to encounter when working with your digital camera and the photographs you create. This glossary includes most of the jargon included in this book, and some that is not within these pages, but which you'll frequently come across as you work. Most of the terms relate to digital cameras or photography, but I've sprinkled in a little information about image editing and photo reproduction.

16-bit images So-called "48-bit" image files that contain 16 bits of information (65,535 different tones) per channel, rather than the 8 bits per channel found in ordinary, 24-bit 16.8 million color images. Photoshop CS can work with 16-bit channels to provide more accurate colors in the final image.

additive primary colors The red, green, and blue hues which are used alone or in combinations to create all other colors you capture with a digital camera, view on a computer monitor, or work with in an image-editing program like Photoshop. See also *CMYK*.

AE/AF lock A control that lets you lock the current autoexposure and/or autofocus settings prior to taking a picture, freeing you from having to hold the shutter release partially depressed.

airbrush Originally developed as an artist's tool that sprays a fine mist of paint, the computer version of an airbrush is used both for illustration and retouching in most image-editing programs.

ambient lighting Diffuse nondirectional lighting that doesn't appear to come from a specific source but, rather, bounces off walls, ceilings, and other objects in the scene when a picture is taken.

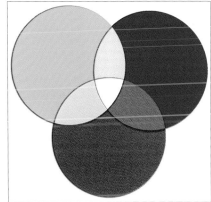

Figure A.1 The additive primary colors, red, green, and blue combine to make other colors, plus white.

analog/digital converter In digital imaging, the electronics built into a camera or scanner that convert the analog information captured by the sensor into digital bits that can be stored as an image bitmap. See also *bitmap.*

angle-of-view The area of a scene that a lens can capture, determined by the focal length of the lens. Lenses with a shorter focal length have a wider angle-of-view than lenses with a longer focal length.

anti-alias A process in image editing that smoothes the rough edges in images (called jaggies or staircasing) by creating partially transparent pixels along the boundaries that are merged into a smoother line by our eyes.

aperture-preferred A camera setting that allows you to specify the lens opening or f-stop that you want to use, with the camera selecting the required shutter speed automatically based on its light-meter reading. See also *shutter-preferred.*

aperture ring A control on the barrel of many SLR lenses that allows for setting the f-stop manually. Some lenses have the aperture set by the camera only and lack this ring.

artifact A type of noise in an image, or an unintentional image component produced in error by a digital camera or scanner during processing.

aspect ratio The proportions of an image as printed, displayed on a monitor, or captured by a digital camera. An 8 × 10-inch or 16 × 20-inch photo each has a 4:5 aspect ratio. Your monitor set to 800 × 600, 1024 × 768, or 1600 × 1200 pixels has a 4:3 aspect ratio. When you change the aspect ratio of an image, you must crop out part of the image area, or create some blank space at top or sides.

autofocus A camera setting that allows the camera to choose the correct focus distance for you, usually based

Figure A.2 A dramatic view of an amusement park taken at the 70mm zoom setting (top) becomes even more dramatic at the 35mm wide-angle setting.

on the contrast of an image (the image will be at maximum contrast when in sharp focus) or a mechanism such as an infrared sensor that measures the actual distance to the subject. Cameras can be set for *single autofocus* (the lens is not focused until the shutter release is partially depressed) or *continuous autofocus* (the lens refocuses constantly as you frame and reframe the image, as the shutter release has been partially depressed).

autofocus assist lamp A light source built into a digital camera that provides extra illumination that the autofocus system can use to focus dimly lit subjects.

averaging meter A light-measuring device that calculates exposure based on the overall brightness of the entire image area. Averaging tends to produce the best exposure when a scene is evenly lit or contains equal amounts of bright and dark areas that contain detail. Most digital cameras use much more sophisticated exposure measuring systems based in center-weighting, spot-reading, or calculating exposure from a matrix of many different picture areas. See also *spot meter.*

B (bulb) A camera setting for making long exposures. Press down the shutter button and the shutter remains open until the shutter button is released. Bulb exposures can also be made using a camera's electronic remote control, or a cable release cord that fits to the camera. See also *T (Time).*

background In photography, the background is the area behind your main subject of interest.

backlighting A lighting effect produced when the main light source is located behind the subject. Backlighting can be used to create a silhouette effect, or to illuminate translucent objects. See also *front-lighting, fill lighting,* and *ambient lighting.* Backlighting is also a technology for illuminating an LCD display from the rear, making it easier to view under high ambient lighting conditions.

balance An image that has equal elements on all sides.

barrel distortion A lens defect that causes straight lines at the top or side edges of an image to bow outward into a barrel shape. See also *pincushion distortion.*

beam splitter A partially silvered mirror or prism that divides incoming light into two portions, usually to send most of the illumination to the viewfinder and part of it to an exposure meter or focusing mechanism.

bilevel image An image that stores only black-and-white information, with no gray tones.

bit A binary digit, either a 1 or a 0, used to measure the color depth (number of different colors) in an image. For example, a grayscale 8-bit scan may contain up to 256 different tones (2^8), while a 24-bit scan can contain 16.8 million different colors (2^{24}).

bitmap A way of representing an image as rows and columns of values, with each picture element stored as one or more numbers that represent its brightness and color. In Photoshop parlance, a bitmap is a bilevel black/white-only image.

black The color formed by the absence of reflected or transmitted light.

black point The tonal level of an image where blacks begin to provide important image information, usually measured by using a histogram. When correcting an image with a digital camera that has an on-screen histogram, or within an image editor, you'll usually want to set the histogram's black point at the place where these tones exist.

Figure A.3 Backlighting produces a slight silhouette effect, and also serves to illuminate the translucent petals of this flower.

blend To create a more realistic transition between image areas, as when retouching or compositing in image editing.

blooming An image distortion caused when a photosite in an image sensor has absorbed all the photons it can handle, so that additional photons reaching that pixel overflow to affect surrounding pixels producing unwanted brightness and overexposure around the edges of objects.

blowup An enlargement, usually a print, made from a negative, transparency, or digital file.

blur In photography, to soften an image or part of an image by throwing it out of focus, or by allowing it to become soft due to subject or camera motion. In image editing, blurring is the softening of an area by reducing the contrast between pixels that form the edges.

bokeh A buzzword used to describe the aesthetic qualities of the out-of-focus parts of an image, with some lenses producing "good" bokeh and others offering "bad" bokeh. *Boke* is a Japanese word for "blur," and the h was added to keep English speakers from rhyming it with *broke.*

Out-of-focus points of light become discs, called the *circle of confusion.* Some lenses produce a uniformly illuminated disc. Others, most notably *mirror* or *catadioptic* lenses, produce a disk that has a bright edge and a dark center, producing a "doughnut" effect, which is the worst from a bokeh standpoint. Lenses that generate a bright center that fades to a darker edge are favored because their bokeh allows the circle of confusion to blend more smoothly with the surroundings. The bokeh characteristics of a lens are most important when you are using selective focus (say, when shooting a portrait) to de-emphasize the background, or when shallow depth-of-field is a given because you're working with a macro lens, long telephoto, or with a wide open aperture. See also *mirror lens, circle of confusion.*

bounce lighting Light bounced off a reflector, including ceiling and walls, to provide a soft, natural-looking light.

Figure A.4 The out-of-focus discs in the background are slightly lighter at the edges than in the center, producing "bad" bokeh.

bracketing Taking a series of photographs of the same subject at different settings to help ensure that one setting will be the correct one. Many digital cameras will automatically snap off a series of bracketed exposures for you. Other settings, such as color and white balance, can also be "bracketed" with some models. Digital SLRs may even allow you to choose the order in which bracketed settings are applied.

brightness The amount of light and dark shades in an image, usually represented as a percentage from 0 percent (black) to 100 percent (white).

broad lighting A portrait lighting arrangement in which the main light source illuminates the side of the face closest to the camera.

buffer A digital camera's internal memory which stores an image immediately after it is taken until the image can be written to the camera's non-volatile (semi-permanent) memory or a memory card.

burn A darkroom technique, mimicked in image editing, which involves exposing part of a print for a longer period, making it darker than it would be with a straight exposure.

burst mode The digital camera's equivalent of the film camera's "motor drive," used to take multiple shots within a short period of time.

calibration A process used to correct for the differences in the output of a printer or monitor when compared to the original image. Once you've calibrated your scanner, monitor, and/or your image editor, the images you see on the screen more closely represent what you'll get from your printer, even though calibration is never perfect.

Camera RAW A plug-in included with Photoshop CS and Photoshop Elements 3.0 that can manipulate the unprocessed images captured by digital cameras.

camera shake Movement of the camera, aggravated by slower shutter speeds, which produces a blurred image. Some of the latest digital cameras have *image stabilization* features that correct for camera shake, while a few high-end interchangeable lenses have a similar vibration correction or reduction feature. See also *image stabilization*.

candid pictures Unposed photographs, often taken at a wedding or other event at which (often) formal, posed images are also taken.

cast An undesirable tinge of color in an image.

CCD Charge-Coupled Device. A type of solid-state sensor that captures the image, used in scanners and digital cameras.

center-weighted meter A light-measuring device that emphasizes the area in the middle of the frame when calculating the correct exposure for an image. See also *averaging meter* and *spot meter*.

chroma Color or hue.

chromatic aberration An image defect, often seen as green or purple fringing around the edges of an object, caused by a lens failing to focus all colors of a light source at the same point. See also *fringing*.

chromatic color A color with at least one hue and a visible level of color saturation.

chrome An informal photographic term used as a generic for any kind of color transparency, including Kodachrome, Ektachrome, or Fujichrome.

CIE (Commission Internationale de l'Eclairage) An international organization of scientists who work with matters relating to color and lighting. The organization is also called the International Commission on Illumination.

circle of confusion A term applied to the fuzzy discs produced when a point of light is out of focus. The circle of confusion is not a fixed size. The viewing distance and amount of enlargement of the image determine whether we see a particular spot on the image as a point or as a disc.

close-up lens A lens add-on that allows you to take pictures at a distance that is less than the closest-focusing distance of the lens alone.

CMOS Complementary Metal-Oxide Semiconductor. A method for manufacturing a type of solid-state sensor that captures the image, used in scanners and digital cameras.

CMY(K) color model A way of defining all possible colors in percentages of cyan, magenta, yellow, and frequently, black. Black is added to improve rendition of shadow detail. CMYK is commonly used for printing (both on press and with your inkjet or laser color printer). Photoshop can work with images using the CMYK model, but converts any images in that mode back to RGB for display on your computer monitor.

color correction Changing the relative amounts of color in an image to produce a desired effect, typically a more accurate representation of those colors. Color correction can fix faulty color balance in the original image, or compensate for the deficiencies of the inks used to reproduce the image.

Color Replacement A new tool in Photoshop and Photoshop Elements that simplifies changing all of a selected color to another hue.

comp A preview that combines type, graphics, and photographic material in a layout.

Figure A.5 The subtractive colors yellow, magenta, and cyan combine to produce all the other colors, including black.

composite In photography, an image composed of two or more parts of an image, taken either from a single photo or multiple photos. Usually composites are created so that the elements blend smoothly together.

composition The pleasing or artistic arrangement of the main subject, other objects in a scene, and/or the foreground and background.

compression Reducing the size of a file by encoding using fewer bits of information to represent the original. Some compression schemes, such as JPEG, operate by discarding some image information, while others, such as TIF, preserve all the detail in the original, discarding only redundant data. See also *GIF, JPEG*, and *TIF*.

continuous autofocus An automatic focusing setting in which the camera constantly refocuses the image as you frame the picture. This setting is often the best choice for moving subjects. See also *single autofocus*.

continuous tone Images that contain tones from the darkest to the lightest, with a theoretically infinite range of variations in between.

contrast The range between the lightest and darkest tones in an image. A high-contrast image is one in which the shades fall at the extremes of the range between white and black. In a low-contrast image, the tones are closer together.

contrasty Having higher than optimal contrast.

crop To trim an image or page by adjusting its boundaries.

dedicated flash An electronic flash unit designed to work with the automatic exposure features of a specific camera.

densitometer An electronic device used to measure the amount of light reflected by or transmitted through a piece of artwork, used to determine accurate exposure when making copies or color separations.

density The ability of an object to stop or absorb light. The less light reflected or transmitted by an object, the higher its density.

depth-of-field A distance range in a photograph in which all included portions of an image are at least acceptably sharp. With a dSLR, you can see the available depth-of-field at the taking aperture by pressing the depth-of-field preview button, or estimate the range by viewing the depth-of-field scale found on many lenses.

depth-of-focus The range that the image-capturing surface (such as a sensor or film) could be moved while maintaining acceptable focus.

desaturate To reduce the purity or vividness of a color, making a color appear to be washed out or diluted.

diaphragm An adjustable component, similar to the iris in the human eye, which can open and close to provide specific sized lens openings, or f-stops.

diffuse lighting Soft, low-contrast lighting.

diffusion Softening of detail in an image by randomly distributing gray tones in an area of an image to produce a fuzzy effect. Diffusion can be added when the picture is taken, often through the use of diffusion filters, or in post-processing with an image editor. Diffusion can be beneficial to disguise defects in an image and is particularly useful for portraits of women.

digital processing chip A solid-state device found in digital cameras that's in charge of applying the image algorithms to the raw picture data prior to storage on the memory card.

digital zoom A way of simulating actual or optical zoom by magnifying the pixels captured by the sensor. This technique generally produces inferior results to optical zoom.

diopter A value used to represent the magnification power of a lens, calculated as the reciprocal of a lens' focal length (in meters). Diopters are most often used to represent the optical correction used in a viewfinder to adjust for limitations of the photographer's eyesight, and to describe the magnification of a close-up lens attachment.

dither A method of distributing pixels to extend the number of colors or tones that can be represented. For example, two pixels of different colors can be arranged in such a way that the eye visually merges them into a third color.

dock A device furnished with some point-and-shoot digital cameras that links up to your computer or printer, and allows interfacing the camera with the other devices simply by dropping it in the dock's cradle.

Figure A.6 Depth-of-field determines how much of an image, such as the prairie dog in this photo, is in sharp focus, and what parts, such as the background and foreground, are out of focus.

Figure A.7 Diffusion can hide defects and produce a soft, romantic glow in a female subject.

dodging A darkroom term for blocking part of an image as it is exposed, lightening its tones. Image editors can mimic this effect by lightening portions of an image using a brush-like tool.

dot A unit used to represent a portion of an image, often groups of pixels collected to produce larger printer dots of varying sizes to represent gray or a specific color.

dot gain The tendency of a printing dot to grow from the original size to its final printed size on paper. This effect is most pronounced on offset presses using poor-quality papers, which allow ink to absorb and spread, reducing the quality of the printed output, particularly in the case of photos that use halftone dots.

dots per inch (dpi) The resolution of a printed image, expressed in the number of printer dots in an inch. You'll often see dpi used to refer to monitor screen resolution, or the resolution of scanners. However, neither of these uses dots; the correct term for a monitor is pixels per inch (ppi), whereas a scanner captures a particular number of samples per inch (spi).

dummy A rough approximation of a publication, used to evaluate the layout.

dye sublimation A printing technique in which solid inks are heated and transferred to a polyester substrate to form an image. Because the amount of color applied can be varied by the degree of heat (and up to 256 different hues for each color), dye sublimation devices can print as many as 16.8 million different colors.

electronic viewfinder (EVF) An LCD located inside a digital camera and used to provide a view of the subject based on the image generated by the camera's sensor.

emulsion The light-sensitive coating on a piece of film, paper, or printing plate. When making prints or copies, it's important to know which side is the emulsion side so the image can be exposed in the correct orientation (not reversed). Image editors such as Photoshop include "emulsion side up" and "emulsion side down" options in their print preview feature.

equivalent focal length A digital camera's focal length translated into the corresponding values for a 35mm film camera. For example, a 5.8mm to 17.4mm lens on a digital point-and-shoot camera might provide the same view as a 38mm to 114mm zoom with a film camera. Equivalents are needed because sensor size and lens focal lengths are not standardized for digital cameras, and translating the values provides a basis for comparison.

Exif Exchangeable Image File Format. Developed to standardize the exchange of image data between hardware devices and software. A variation on JPEG, Exif is used by most digital cameras, and includes information such as the date and time a photo was taken, the camera settings, resolution, amount of compression, and other data.

existing light In photography, the illumination that is already present in a scene. Existing light can include daylight or the artificial lighting currently being used, but is not considered to be electronic flash or additional lamps set up by the photographer.

export To transfer text or images from a document to another format.

exposure The amount of light allowed to reach the film or sensor, determined by the intensity of the light, the amount admitted by the iris of the lens, and the length of time determined by the shutter speed.

exposure program An automatic setting in a digital camera that provides the optimum combination of shutter speed and f-stop at a given level of illumination. For example a "sports" exposure program would use a faster, action-stopping shutter speed and larger lens opening instead of the smaller, depth-of-field-enhancing lens opening and slower shutter speed that might be favored by a "close-up" program at exactly the same light level.

exposure values (EV) EV settings are a way of adding or decreasing exposure without the need to reference f-stops or shutter speeds. For example, if you tell your camera to add +1EV, it will provide twice as much exposure, either by using a larger f-stop, slower shutter speed, or both.

eyedropper An image-editing tool used to sample color from one part of an image so it can be used to paint, draw, or fill elsewhere in the image. Within some features, the eyedropper can be used to define the actual black points and white points in an image.

feather To fade out the borders of an image element, so it will blend in more smoothly with another layer.

fill lighting In photography, lighting used to illuminate shadows. Reflectors or additional incandescent lighting or electronic flash can be used to brighten shadows. One common technique outdoors is to use the camera's flash as a fill.

filter In photography, a device that fits over the lens, changing the light in some way. In image editing, a feature that changes the pixels in an image to produce blurring, sharpening, and other special effects. Photoshop CS includes several new filter effects, including Lens Blur and Photo Filters.

FireWire (IEEE-1394) A fast serial interface used by scanners, digital cameras, printers, and other devices.

flash sync The timing mechanism that ensures that an internal or external electronic flash fires at the correct time during the exposure cycle. A dSLR's flash sync speed is the highest shutter speed that can be used with flash. See also *front curtain sync* and *rear curtain sync*.

flat An image with low contrast.

flatbed scanner A type of scanner that reads one line of an image at a time, recording it as a series of samples, or pixels.

Figure A.8 Fill flash has brightened the shadows on this mascot's jersey.

focal length The distance between the film and the optical center of the lens when the lens is focused on infinity, usually measured in millimeters.

focal plane An imaginary line, perpendicular to the optical access, which passes through the focal point forming a plane of sharp focus when the lens is set at infinity.

focus To adjust the lens to produce a sharp image.

focus lock A camera feature that lets you freeze the automatic focus of the lens at a certain point, when the subject you want to capture is in sharp focus.

focus range The minimum and maximum distances within which a camera is able to produce a sharp image, such as 2 inches to infinity.

focus servo A dSLR's mechanism that adjusts the focus distance automatically. The focus servo can be set to single autofocus, which focuses the lens only when the shutter release is partially depressed, and continuous autofocus, which adjusts focus constantly as the camera is used.

focus tracking The ability of the automatic focus feature of a camera to change focus as the distance between the subject and the camera changes. One type of focus tracking is *predictive*, in which the mechanism anticipates the motion of the object being focused on and adjusts the focus to suit.

four-color printing Another term for process color, in which cyan, magenta, yellow, and black inks are used to reproduce all the colors in the original image.

framing In photography, composing your image in the viewfinder. In composition, using elements of an image to form a sort of picture frame around an important subject.

frequency The number of lines per inch in a halftone screen.

fringing A chromatic aberration that produces fringes of color around the edges of subjects, caused by a lens' inability to focus the various wavelengths of light onto the same spot. *Purple fringing* is especially troublesome with backlit images.

front-curtain sync The default kind of electronic flash synchronization technique, originally associated with focal plane shutters, which consists of a traveling set of curtains, including a front curtain (which opens to reveal the film or sensor) and a rear curtain (which follows at a distance determined by shutter speed to conceal the film or sensor at the conclusion of the exposure).

Figure A.9 Extreme magnification reveals fringing, a chromatic aberration caused by the lens' inability to focus all the colors of light on the same spot.

For a flash picture to be taken, the entire sensor must be exposed at one time to the brief flash exposure, so the image is exposed after the front curtain has reached the other side of the focal plane, but before the rear curtain begins to move.

Front-curtain sync causes the flash to fire at the *beginning* of this period when the shutter is completely open, in the instant that the first curtain of the focal plane shutter finishes its movement across the film or sensor plane. With slow shutter speeds, this feature can create a blur effect from the ambient light, showing as patterns that follow a moving subject with subject shown sharply frozen at the beginning of the blur trail (think of an image of The Flash running backwards). See also *rear-curtain sync*.

front-lighting Illumination that comes from the direction of the camera. See also *backlighting* and *sidelighting*.

f-stop The relative size of the lens aperture, which helps determine both exposure and depth-of-field. The larger the f-stop number, the smaller the f-stop itself. It helps to think of f-stops as denominators of fractions, so that f2 is larger than f4, which is larger than f8, just as 1/2, 1/4, and 1/8 represent ever smaller fractions. In photography, a given f-stop number is multiplied by 1.4 to arrive at the next number that admits exactly half as much light. So, f1.4 is twice as large as f2.0 (1.4 × 1.4), which is twice as large as f2.8 (2 × 1.4), which is twice as large as f4 (2.8 × 1.4). The f-stops which follow are f5.6, f8, f11, f16, f22, f32, and so on.

full-color image An image that uses 24-bit color, 16.8 million possible hues. Images are sometimes captured with more colors, but the colors are reduced to the best 16.8 million shades for manipulation in image editing.

gamma A numerical way of representing the contrast of an image. Devices such as monitors typically don't reproduce the tones in an image in straight-line fashion (all colors represented in exactly the same way as they appear in the original). Instead, some tones may be favored over others, and gamma provides a method of tonal correction that takes the human eye's perception of neighboring values into account. Gamma values range from 1.0 to about 2.5. The Macintosh has traditionally used a gamma of 1.8, which is relatively flat compared to television. Windows PCs use a 2.2 gamma value, which has more contrast and is more saturated.

gamma correction A method for changing the brightness, contrast, or color balance of an image by assigning new values to the gray or color tones of an image to more closely represent the original shades. Gamma correction can be either linear or nonlinear. Linear correction applies the same amount of change to all the tones. Nonlinear correction varies the changes tone-by-tone, or in highlight, midtone, and shadow areas separately to produce a more accurate or improved appearance.

gamut The range of viewable and printable colors for a particular color model, such as RGB (used for monitors) or CMYK (used for printing).

Gaussian blur A method of diffusing an image using a bell-shaped curve to calculate the pixels which will be blurred, rather than blurring all pixels, producing a more random, less "processed" look.

GIF An image file format limited to 256 different colors that compresses the information by combining similar colors and discarding the rest. Condensing a 16.8-million-color photographic image to only 256 different hues often produces a poor-quality image, but GIF is useful for images that don't have a great many colors, such as charts or graphs. The GIF format also includes transparency options, and can include multiple images to produce animations that may be viewed on a Web page or other application. See also *JPEG* and *TIF*.

graduated filter A lens attachment with variable density or color from one edge to another. A graduated neutral density filter, for example, can be oriented so the neutral density portion is concentrated at the top of the lens' view with the less dense or clear portion at the bottom, thus reducing the amount of light from a very bright sky while not interfering with the exposure of the landscape in the foreground. Graduated filters can also be split into several color sections to provide a color gradient between portions of the image.

grain The metallic silver in film which forms the photographic image. The term is often applied to the seemingly random noise in an image (both conventional and digital) that provides an overall texture.

gray card A piece of cardboard or other material with a standardized 18 percent reflectance. Gray cards can be used as a reference for determining correct exposure.

grayscale image An image represented using 256 shades of gray. Scanners often capture grayscale images with 1024 or more tones, but reduce them to 256 grays for manipulation by Photoshop.

halftone A method used to reproduce continuous-tone images, representing the image as a series of dots.

high contrast A wide range of density in a print, negative, or other image.

highlights The brightest parts of an image containing detail.

histogram A kind of chart showing the relationship of tones in an image using a series of 256 vertical "bars," one for each brightness level. A histogram chart typically looks like a curve with one or more slopes and peaks, depending on how many highlight, midtone, and shadow tones are present in the image.

Histogram palette A new palette in Photoshop that allows making changes in tonal values using controls that adjust the white, middle gray, and black points of an image. Unlike the histogram included with Photoshop's Levels command, this palette is available for use even when you're using other tools.

hot shoe A mount on top of a camera used to hold an electronic flash, while providing an electrical connection between the flash and the camera.

hue The color of light that is reflected from an opaque object or transmitted through a transparent one.

hyperfocal distance A point of focus where everything from half that distance to infinity appears to be acceptably sharp. For example, if your lens has a hyperfocal distance of 4 feet, everything from 2 feet to infinity would be sharp. The hyperfocal distance varies by the lens and the aperture in use. If you know you'll be making a "grab" shot without warning, sometimes it is useful to turn off your camera's automatic focus, and set the lens to infinity, or, better yet, the hyperfocal distance. Then, you can snap off a quick picture without having to wait for the lag that occurs with most digital cameras as their autofocus locks in.

image rotation A feature found in some digital cameras, which sense whether a picture was taken in horizontal or vertical orientation. That information is embedded in the picture file so that the camera and compatible software applications can automatically display the image in the correct orientation.

image stabilization A technology that compensates for camera shake, usually by adjusting the position of the camera sensor or lens elements in response to movements of the camera.

incident light Light falling on a surface.

indexed color image An image with 256 different colors, as opposed to a grayscale image, which has 256 different shades of the tones between black and white.

infinity A distance so great that any object at that distance will be reproduced sharply if the lens is focused at the infinity position.

interchangeable lens Lens designed to be readily attached to and detached from a camera; a feature found in more sophisticated digital cameras.

Figure A.10 A shutter speed of 1/8th second is too slow to prevent blur from camera shake (top), but works just fine when the camera's image stabilization feature is turned on.

International Standards Organization (ISO) A governing body that provides standards used to represent film speed, or the equivalent sensitivity of a digital camera's sensor. Digital camera sensitivity is expressed in ISO settings.

interpolation A technique digital cameras, scanners, and image editors use to create new pixels required whenever you resize or change the resolution of an image based on the values of surrounding pixels. Devices such as scanners and digital cameras can also use interpolation to create pixels in addition to those actually captured, thereby increasing the apparent resolution or color information in an image.

invert In image editing, to change an image into its negative; black becomes white, white becomes black, dark gray becomes light gray, and so forth. Colors are also changed to the complementary color; green becomes magenta, blue turns to yellow, and red is changed to cyan.

iris A set of thin overlapping metal leaves in a camera lens that pivot outwards to form a circular opening of variable size to control the amount of light that can pass through a lens.

jaggies Staircasing effect of lines that are not perfectly horizontal or vertical, caused by pixels that are too large to represent the line accurately. See also *anti-alias.*

JPEG (Joint Photographic Experts Group) A file format that supports 24-bit color and reduces file sizes by selectively discarding image data. Digital cameras generally use JPEG compression to pack more images onto memory cards. You can select how much compression is used (and therefore how much information is thrown away) by selecting from among the Standard, Fine, Super Fine, or other quality settings offered by your camera. See also *GIF* and *TIF.*

Kelvin (K) A unit of measurement based on the absolute temperature scale in which absolute zero is zero; used to describe the color of continuous spectrum light sources.

Figure A.11 Jaggies result when the pixels in an image are too large to represent a non-horizontal/vertical line smoothly.

lag time The interval between when the shutter is pressed and when the picture is actually taken. During that span, the camera may be automatically focusing and calculating exposure. With digital SLRs, lag time is generally very short; with non-dSLRs, the elapsed time easily can be one second or more.

landscape The orientation of a page in which the longest dimension is horizontal; also called wide orientation.

latitude The range of camera exposures that produces acceptable images with a particular digital sensor or film.

layer A way of managing elements of an image in stackable overlays that can be manipulated separately, moved to a different stacking order, or made partially or fully transparent. Photoshop allows collecting layers into layer sets.

lens One or more elements of optical glass or similar material designed to collect and focus rays of light to form a sharp image on the film, paper, sensor, or a screen.

lens aperture The lens opening, or iris, that admits light to the film or sensor. The size of the lens aperture is usually measured in f-stops. See also *f-stop* and *iris.*

lens flare A feature of conventional photography that is both a bane and creative outlet. It is an effect produced by the reflection of light internally among elements of an optical lens. Bright light sources within or just outside the field-of-view cause lens flare. Flare can be reduced by the use of coatings on the lens elements or with the use of lens hoods. Photographers sometimes use the effect as a creative technique, and Photoshop includes a filter that lets you add lens flare at your whim.

lens hood A device that shades the lens, protecting it from extraneous light outside the actual picture area which can reduce the contrast of the image, or allow lens flare.

lens shade A hood at the front of a lens that keeps stray light from striking the lens and causing image flare.

lens speed The largest lens opening (smallest f-number) at which a lens can be set. A fast lens transmits more light and has a larger opening than a slow lens. Determined by the maximum aperture of the lens in relation to its focal length; the "speed" of a lens is relative: A 400 mm lens with a maximum aperture of f/3.5 is considered extremely fast, while a 28mm f/3.5 lens is thought to be relatively slow.

lighten A Photoshop function that is the equivalent to the photographic darkroom technique of dodging. Tones in a given area of an image are gradually changed to lighter values.

lighting ratio The proportional relationship between the amount of light falling on the subject from the main light and other lights, expressed in a ratio, such as 3:1.

line art Usually, images that consist only of white pixels and one color, represented in Photoshop as a bitmap.

line screen The resolution or frequency of a halftone screen, expressed in lines per inch.

lithography Another name for offset printing.

lossless compression An image-compression scheme, such as TIFF, that preserves all image detail. When the image is decompressed, it is identical to the original version.

lossy compression An image-compression scheme, such as JPEG, that creates smaller files by discarding image information, which can affect image quality.

luminance The brightness or intensity of an image, determined by the amount of gray in a hue.

LZW compression A method of compacting TIFF files using the Lempel-Ziv Welch compression algorithm, an optional compression scheme offered by some digital cameras.

Figure A.12 Even when the sun or another bright object is not actually within the picture area it can cause reduced contrast and bright areas in an image.

Figure A.13 When carried to the extreme, lossy compression methods can have a serious impact on image quality.

macro lens A lens that provides continuous focusing from infinity to extreme close-ups, often to a reproduction ratio of 1:2 (half life-size) or 1:1 (life-size).

macro photography The process of taking photographs of small objects at magnifications of 1X or more.

magnification ratio A relationship that represents the amount of enlargement provided by the macro setting of the zoom lenses, macro lens, or with other close-up devices.

Match Color A new feature of Photoshop that allows synchronizing color palettes between images to provide consistent hues.

matrix metering A system of exposure calculation that looks at many different segments of an image to determine the brightest and darkest portions.

maximum aperture The largest lens opening or f-stop available with a particular lens, or with a zoom lens at a particular magnification.

mechanical Camera-ready copy with text and art already in position for photographing.

midtones Parts of an image with tones of an intermediate value, usually in the 25 to 75 percent range. Many image-editing features allow you to manipulate midtones independently from the highlights and shadows.

mirror lens A type of lens, more accurately called a *catadioptric lens*, which contains both lens elements and mirrors to "fold" the optical path to produce a shorter, lighter telephoto lens. Because of their compact size and relatively low price, these lenses are popular, even though they have several drawbacks, including reduced contrast, fixed apertures, and they produce doughnut-shaped out-of-focus points of light (because one of the mirrors is mounted on the front of the lens).

mirror lock-up The ability to retract the SLR's mirror to reduce vibration prior to taking the photo, or to allow access to the sensor for cleaning.

moiré An objectionable pattern caused by the interference of halftone screens, frequently generated by rescanning an image that has already been halftoned. An image editor can frequently minimize these effects by blurring the patterns.

monochrome Having a single color, plus white. Grayscale images are monochrome (shades of gray and white only).

negative A representation of an image in which the tones are reversed: blacks as white, and vice versa.

neutral color In image-editing's RGB mode, a color in which red, green, and blue are present in equal amounts, producing a gray.

neutral density filter A gray camera filter reduces the amount of light entering the camera without affecting the colors.

noise In an image, pixels with randomly distributed color values. Noise in digital photographs tends to be the product of low-light conditions and long exposures, particularly when you have set your camera to a higher ISO rating than normal.

noise reduction A technology used to cut down on the amount of random information in a digital picture, usually caused by long exposures at increased sensitivity ratings. Noise reduction involves the camera automatically taking a second blank/dark exposure at the same settings that contain only noise, and then using the blank photo's information to cancel out the noise in the original picture. With most cameras, the process is very quick, but does double the amount of time required to take the photo.

normal lens A lens that makes the image in a photograph appear in a perspective that is like that of the original scene, typically with a field-of-view of roughly 45°. A quick way to calculate the focal length of a normal lens is to measure the diagonal of the sensor or film frame used to capture the image, usually ranging from around 7mm to 45mm.

open flash A technique used for "painting with light" or other procedures, where the tripod-mounted camera's shutter is opened, the flash is triggered manually (sometimes several times), and then the shutter is closed.

optical zoom Magnification produced by the elements of a digital camera's lens, as opposed to *digital zoom* which merely magnifies the captured pixels to simulate additional magnification. Optical zoom is always to be preferred over the digital variety.

orthochromatic Sensitive primarily to blue and green light.

overexposure A condition in which too much light reaches the film or sensor, producing a dense negative or a very bright/light print, slide, or digital image.

Figure A.14 Higher ISO settings lead to the random grain patterns known as noise.

pan and tilt head A tripod head allowing the camera to be tilted up or down or rotated 360 degrees.

panning Moving the camera so that the image of a moving object remains in the same relative position in the viewfinder as you take a picture. The eventual effect creates a strong sense of movement.

panorama A broad view, usually scenic. Photoshop's new Photomerge feature helps you create panoramas from several photos. Many digital cameras have a panorama assist mode that makes it easier to shoot several photos that can be stitched together later.

PC terminal A connector for attaching standard electronic flash cords, named after the Prontor-Compur shutter companies which developed this connection.

parallax compensation An adjustment made by the camera or photographer to account for the difference in views between the taking lens and the viewfinder.

perspective The rendition of apparent space in a photograph, such as how far the foreground and background appear to be separated from each other. Perspective is determined by the distance of the camera to the subject. Objects that are close appear large, while distant objects appear to be far away.

perspective control lens A special lens that allows correcting distortion resulting from high or low camera angle.

Photo CD A special type of CD-ROM developed by Eastman Kodak Company that can store high-quality photographic images in a special space-saving format, along with music and other data.

pincushion distortion A type of lens distortion in which lines at the top and side edges of an image are bent inward, producing an effect that looks like a pincushion.

pixel The smallest element of a screen display that can be assigned a color. The term is a contraction of "picture element."

pixels per inch (ppi) The number of pixels that can be displayed per inch, usually used to refer to pixel resolution from a scanned image or on a monitor.

plug-in A module such as a filter that can be accessed from within an image editor to provide special functions.

point Approximately 1/72 of an inch outside the Macintosh world, exactly 1/72 of an inch within it.

polarizing filter A filter that forces light, which normally vibrates in all directions, to vibrate only in a single plane, reducing or removing the specular reflections from the surface of objects.

portrait The orientation of a page in which the longest dimension is vertical; also called tall orientation. In photography, a formal picture of an individual or, sometimes, a group.

positive The opposite of a negative, an image with the same tonal relationships as those in the original scenes—for example, a finished print or a slide.

prepress The stages of the reproduction process that precede printing, when halftones, color separations, and printing plates are created.

process color The four color pigments used in color printing: cyan, magenta, yellow, and black (CMYK).

RAW An image file format offered by many digital cameras that includes all the unprocessed information captured by the camera. RAW files are very large, and must be processed by a special program after being downloaded from the camera.

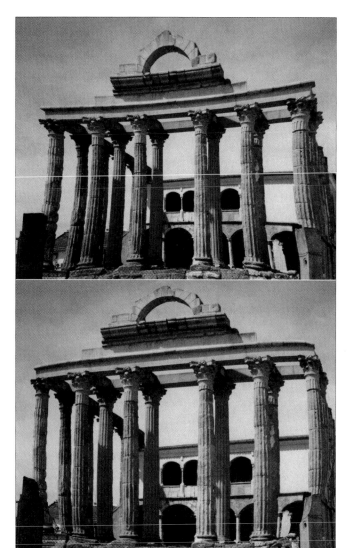

Figure A.15 This exaggerated example shows pincushion distortion (top) and barrel distortion (bottom).

rear-curtain sync An optional kind of electronic flash synchronization technique, originally associated with focal plane shutters, which consists of a traveling set of curtains, including a front curtain (which opens to reveal the film or sensor) and a rear curtain (which follows at a distance determined by shutter speed to conceal the film or sensor at the conclusion of the exposure).

For a flash picture to be taken, the entire sensor must be exposed at one time to the brief flash exposure, so the image is exposed after the front curtain has reached the other side of the focal plane, but before the rear curtain begins to move.

Rear-curtain sync causes the flash to fire at the *end* of the exposure, an instant before the second or rear curtain of the focal plane shutter begins to move. With slow shutter speeds, this feature can create a blur effect from the ambient light, showing as patterns that follow a moving subject with subject shown sharply frozen at the end of the blur trail. If you were shooting a photo of The Flash, the superhero would appear sharp, with a ghostly trail behind him.

red eye An effect from flash photography that appears to make a person eyes glow red, or an animal's yellow or green. It's caused by light bouncing from the retina of the eye, and is most pronounced in dim illumination (when the irises are wide open) and when the electronic flash is close to the lens and therefore prone to reflect directly back. Image editors can fix red eye through cloning other pixels over the offending red or orange ones.

red-eye reduction A way of reducing or eliminating the red-eye phenomenon. Some cameras offer a red-eye reduction mode that uses a preflash that causes the irises of the subjects' eyes to close down just prior to a second, stronger flash used to take the picture.

reflection copy Original artwork that is viewed by light reflected from its surface, rather than transmitted through it.

reflector Any device used to reflect light onto a subject to improve balance of exposure (contrast). Another way is to use fill in flash.

register To align images.

registration mark A mark that appears on a printed image, generally for color separations, to help in aligning the printing plates. Photoshop can add registration marks to your images when they are printed.

reproduction ratio Used in macrophotography to indicate the magnification of a subject.

resample To change the size or resolution of an image. Resampling down discards pixel information in an image; resampling up adds pixel information through interpolation.

resolution In image editing, the number of pixels per inch used to determine the size of the image when printed. That is, an 8 × 10 inch image that is saved with 300 pixels per inch resolution will print in an 8 × 10-inch size on a 300 dpi printer, or 4 × 5-inches on a 600 dpi printer. In digital photography, resolution is the number of pixels a camera or scanner can capture.

retouch To edit an image, most often to remove flaws or to create a new effect.

RGB color mode A color mode that represents the three colors—red, green, and blue—used by devices such as scanners or monitors to reproduce color. Photoshop works in RGB mode by default, and even displays CMYK images by converting them to RGB.

saturation The purity of color; the amount by which a pure color is diluted with white or gray.

scale To change the size of all or part of an image.

scanner A device that captures an image of a piece of artwork and converts it to a digitized image or bitmap that the computer can handle.

Figure A.16 Digital cameras usually have several features for avoiding the demon red-eye look, but you'll still get the effect when you least want it.

Figure A.17 Fully saturated (left) and desaturated (right).

Secure Digital memory card Another flash memory card format that is gaining acceptance for use in digital cameras and other applications.

selection In image editing, an area of an image chosen for manipulation, usually surrounded by a moving series of dots called a selection border.

selective focus Choosing a lens opening that produces a shallow depth-of-field. Usually this is used to isolate a subject by causing most other elements in the scene to be blurred.

self-timer Mechanism delaying the opening of the shutter for some seconds after the release has been operated. Also known as delayed action.

sensitivity A measure of the degree of response of a film or sensor to light.

sensor array The grid-like arrangement of the red, green, and blue-sensitive elements of a digital camera's solid-state capture device. Sony offers a sensor array that captures a fourth color, termed *emerald.*

shadow The darkest part of an image, represented on a digital image by pixels with low numeric values or on a halftone by the smallest or absence of dots.

Shadow/Highlight Adjustment A new Photoshop feature used to correct overexposed or underexposed digital camera images.

sharpening Increasing the apparent sharpness of an image by boosting the contrast between adjacent pixels that form an edge.

shutter In a conventional film camera, the shutter is a mechanism consisting of blades, a curtain, plate, or some other movable cover that controls the time during which light reaches the film. Digital cameras can use actual shutters, or simulate the action of a shutter electronically. Quite a few use a combination, employing a mechanical shutter for slow speeds and an electronic version for higher speeds. Many non-dSLR cameras include a reassuring shutter "sound" that mimics the noise a mechanical camera makes.

shutter lag The tendency of a camera to hesitate after the shutter release is depressed prior to making the actual exposure. Point-and-shoot digital cameras often have shutter lag times of up to 2 seconds, primarily because of slow autofocus systems. Digital SLRs typically have much less shutter lag, typically 0.2 seconds or less.

Figure A.18 Increasing the contrast between pixels (right) makes an image appear to be sharper than the unprocessed version (left).

shutter-preferred An exposure mode in which you set the shutter speed and the camera determines the appropriate f-stop. See also *aperture-preferred*.

sidelighting Light striking the subject from the side relative to the position of the camera; produces shadows and highlights to create modeling on the subject.

single lens reflex (SLR) camera A type of camera that allows you to see through the camera's lens as you look in the camera's viewfinder. Other camera functions, such as light metering and flash control, also operate through the camera's lens.

slave unit An accessory flash unit that supplements the main flash, usually triggered electronically when the slave senses the light output by the main unit, or through radio waves.

slide A photographic transparency mounted for projection.

slow sync An electronic flash synchronizing method that uses a slow shutter speed so that ambient light is recorded by the camera in addition to the electronic flash illumination, so that the background receives more exposure for a more realistic effect.

SLR (single lens reflex) A camera in which the viewfinder sees the same image as the film or sensor.

SmartMedia A type of memory card storage, generally outmoded today because its capacity is limited to 128MB, for digital cameras and other computer devices.

smoothing To blur the boundaries between edges of an image, often to reduce a rough or jagged appearance.

soft focus An effect produced by use of a special lens or filter that creates soft outlines.

soft lighting Lighting that is low or moderate in contrast, such as on an overcast day.

solarization In photography, an effect produced by exposing film to light partially through the developing process. Some of the tones are reversed, generating an interesting effect. In image editing, the same effect is produced by combining some positive areas of the image with some negative areas. Also called the Sabattier effect, to distinguish it from a different phenomenon called overexposure solarization, which is produced by exposing film to many, many times more light than is required to produce the image. With overexposure solarization, some of the very brightest tones, such as the sun, are reversed.

specular highlight Bright spots in an image caused by reflection of light sources.

spot color Ink used in a print job in addition to black or process colors.

spot meter An exposure system that concentrates on a small area in the image. See also *averaging meter.*

Figure A.19 Digital photographers can manipulate the color curves of an image to simulate one kind of solarization.

subtractive primary colors Cyan, magenta, and yellow, which are the printing inks that theoretically absorb all color and produce black. In practice, however, they generate a muddy brown, so black is added to preserve detail (especially in shadows). The combination of the three colors and black is referred to as CMYK. (K represents black, to differentiate it from blue in the RGB model.)

T (time) A shutter setting in which the shutter opens when the shutter button is pressed, and remains open until the button is pressed a second time. See also *B (bulb).*

telephoto A lens or lens setting that magnifies an image.

thermal wax transfer A printing technology in which dots of wax from a ribbon are applied to paper when heated by thousands of tiny elements in a printhead.

threshold A predefined level used by a device to determine whether a pixel will be represented as black or white.

thumbnail A miniature copy of a page or image that provides a preview of the original. Photoshop uses thumbnails in its Layer and Channels palettes, for example.

TIFF (Tagged Image File Format) A standard graphics file format that can be used to store grayscale and color images plus selection masks.

time exposure A picture taken by leaving the shutter open for a long period, usually more than one second. The camera is generally locked down with a tripod to prevent blur during the long exposure.

time lapse A process by which a tripod-mounted camera takes sequential pictures at intervals, allowing the viewing of events that take place over a long period of time, such as a sunrise or flower opening. Many digital cameras have time-lapse capability built in. Others require you to attach the camera to your computer through a USB cable, and let software in the computer trigger the individual photos.

tint A color with white added to it. In graphic arts, often refers to the percentage of one color added to another.

tolerance The range of color or tonal values that will be selected with a tool like the Photoshop's Magic Wand, or filled with paint when using a tool like the Paint Bucket.

transparency A positive photographic image on film, viewed or projected by light shining through film.

transparency scanner A type of scanner that captures color slides or negatives.

tripod A three-legged supporting stand used to hold the camera steady. Especially useful when using slow shutter speeds and/or telephoto lenses. See also *unipod*.

TTL Through the lens. A system of providing viewing through the actual lens taking the picture (as with a camera with an electronic viewfinder, LCD display, or single lens reflex viewing), or calculation of exposure, flash exposure, or focus based on the view through the lens.

tungsten light Light from ordinary room lamps and ceiling fixtures, as opposed to fluorescent illumination.

underexposure A condition in which too little light reaches the film or sensor, producing a thin negative, a dark slide, a muddy-looking print, or a dark digital image

unipod A one-legged support, or monopod, used to steady the camera. See also *tripod*.

unsharp masking The process for increasing the contrast between adjacent pixels in an image, increasing sharpness, especially around edges.

USB A high-speed serial communication method commonly used to connect digital cameras and other devices to a computer.

viewfinder The device in a camera used to frame the image. With an SLR camera, the viewfinder is also used to focus the image if focusing manually. You can also focus an image with the LCD display of a digital camera, which is a type of viewfinder.

vignetting Dark corners of an image, often produced by using a lens hood that is too small for the field-of-view, or generated artificially using image-editing techniques.

white The color formed by combining all the colors of light (in the additive color model) or by removing all colors (in the subtractive model).

white balance The adjustment of a digital camera to the color temperature of the light source. Interior illumination is relatively red; outdoors light is relatively blue. Digital cameras often set correct white balance automatically, or let you do it through menus. Image editors can often do some color correction of images that were exposed using the wrong white balance setting.

white point In image editing, the lightest pixel in the highlight area of an image.

wide-angle lens A lens that has a shorter focal length and a wider field-of-view than a normal lens for a particular film or digital image format.

zoom In image editing, to enlarge or reduce the size of an image on your monitor. In photography, to enlarge or reduce the size of an image using the magnification settings of a lens.

zoom ring A control on the barrel of a lens that allows changing the magnification, or zoom, of the lens by rotating it.

Index

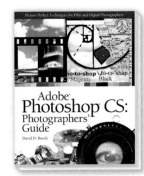